IMAGINATION'S CHAMBER

IMAGINATION'S CHAMBER

Artists and Their Studios

MICHAEL PEPPIATT
ALICE BELLONY-REWALD

A New York Graphic Society Book
LITTLE, BROWN AND COMPANY
Boston

WPBO +
P396 a

Library of Congress Cataloging in Publication Data

Peppiatt, Michael.
 Imagination's chamber.

 Bibliography: p.
 1. Artists' studios. 2. Artists—Psychology.
3. Models, Artists'. I. Bellony-Rewald, Alice.
II. Title.
N8520.B44 1982 702'.8 82-8004
ISBN 0-8212-1520-5 AACR2

Designed by Janis Capone

New York Graphic Society books are published by Little, Brown and Company. Published simultaneously in Canada by Little, Brown and Company (Canada) Limited.

Printed in the United States of America.

Preface

If an artist's work fascinates you, you naturally wonder about the way it evolved: what stylistic or personal elements went into it and how, in purely technical terms, it was made. Much of this information tends to remain unavailable, either because the artist has kept it secret or because no one has troubled to record it. Where you have most chance of running it to ground, however, is the place that over the years becomes a veritable archive of the artist's interests, methods, and dreams: his studio.

Even if you are fortunate enough to be allowed in there, the relationship between the studio and the work created within its walls may not be immediately apparent to you. Mondrian's studio in New York did indeed look like a three-dimensional Mondrian, as the photograph on page 160 shows. But, in many cases, the ties between the two are more diffuse and subterranean; the eye needs a preliminary training to pick up the clues and follow them to the valid conclusion.

A few attentive visits to artists' studios — in person or by means of this book — suffice to acquire a fresh perspective on creativity and the basis for a new kind of knowledge. Although it has never been attempted, art history can be told through the studio. The shape, the light, the location, the look, and the "feel" of a studio constantly shape the images conceived and produced there. What the space contains may exert an even greater influence. The works on the wall (whether the artist's own or by others whom he admires), the engravings or photographs he refers to, the books read, and the objects collected — to say nothing of the models and the assistants — form the constant background to the artist's activity and frequently play a specific role in what he creates.

The most direct clues can often be found in the tools and materials the artist keeps around him as he works.

Every studio has its stock of special devices, the secret essences and recipes that account for so much of an image's power. They might include an ancient treatise on anatomy or a couple of spray guns, finely ground lapis lazuli or a bottled mayonnaise that has proved useful as a binder; but they always constitute an amalgam of what the artist has learned from tradition and what he himself has found while pursuing a particular vision or deliberately searching for a new technique. An understanding of the enormously varied substances and methods that artists have used over the centuries may take one closer to the heart of visual creativity than volumes of fine aesthetic appreciation alone.

Each studio functions in its own unique way. Some artists live in as intense a reclusion as hermits in their cells; a jealous Muse bars the door. Others keep open house, treating their studio as a public launchpad for their ideas, their personality, and their work. To get a glimpse of the range, one need only compare the strict privacy of Balthus's atelier with Warhol's Factory — or Chase's palatial New York establishment with the refuge where Delacroix hurried to work "as other men run to their mistress." Many elements, some of them quite unexpected, go into making this diversity: not only the kind of space or contents or techniques used, but the artist's own temperament and habits, the tenor of his work, and even the visitors — influential critics, fellow artists, big dealers, poor poets, or simply friends — whose presence partly defines the studio's place in society.

Over the centuries, the studio has been everything: a factory staffed by slaves, a bustling Renaissance *bottega,* and an academy where all the learning in the world was relevant to art; a portentous showplace, like Chase's, or

the hub of a revolutionary movement, as the Bateau-Lavoir was for Cubism. Studios have been set up in boats, carriages, churches, tents, hotels, and at least one lion's cage. This book has concentrated on the evolution of the artist's studio in the nineteenth and twentieth centuries, first because it did not emerge as a distinct entity until the early 1800s; and second because from the mid-nineteenth century onward photography provided more abundant and exciting information about studios than had existed before.

One cannot fully appreciate what the modern studio means, however, until it is set in the context of its origins. Accordingly, the first two chapters follow the studio's development from its earliest beginnings to the founding of academies. This establishes a perspective in which, eventually, the lofts of New York may be compared in attitude and organization to medieval workshops (thus prompting the question as to whether the studio has not come full circle). The main body of the book, from Chapter Three to Chapter Ten, then concentrates on the leading studios in Europe and America from David, Ingres, and Delacroix to Picasso, De Kooning, and Hockney.

Whatever one sees or senses in an artist's studio, it becomes clear, affects one's attitude toward the painter or sculptor in question and the work he does. In many ways, the studio *is* the artist. Giacometti, to take a memorable instance, seemed inseparable from the dust-laden little room behind Montparnasse (see page 203) where he drew, painted, and modeled all through his life. In his, as in the greatest studios, the space (however dingy in real-estate terms) grew vivid with the eloquence of the images that had congregated there, and to him and his admirers, it was the only place where a Giacometti could be brought into existence — a uniquely fruitful matrix, or the asylum for his relentlessly reductive vision.

For the studio is the scene of the crime, obsessively committed, day after day. It is not only the laboratory, the alchemic kitchen, but the arena in which images are achieved or fail. It is the recess of vision, the shell of the artist's mind: imagination's chamber.

Acknowledgments

For their generous advice during the preparation of this book, we should like to thank Mlle. Jeannine Baticle, M. Jean-François Debord, Dr. Klaus Gallwitz and Mr. William McNaught. Of the many people who have helped in obtaining illustrations, we are particularly grateful to Miss Valerie Beston, Mr. Milton Esterow, Mme. Françoise Gaillard, Mr. Robert Gordon, Mr. David Grob, Mr. Jeremy Maas, Mr. and Mrs. Pierre Matisse, Mr. Hans Namuth and Mme. Arlette Sérullaz.

Special and very warm thanks are due to Mr. Adrian Dicks, Mr. David Fox, and Mrs. Muriel Wilson, who read the typescript and enabled us to clarify it in many places.

A number of friends offered us the constant encouragement and hospitality so welcome to authors in mid-labor. We should like to express our gratitude in this respect to Mr. Francis Bacon, M. and Mme. André Bernheim, M. and Mme. Otto Fried, Dr. Alberto Giorgi, Mr. Tino Perutz, and Mr. and Mrs. Howard Sloan.

Contents

Color plates will be found on pages 25–32 and 161–168.

IMAGINATION'S CHAMBER

The studio has become the crucible in which human genius, at the peak of its development, brings back into question everything that exists.

— DELACROIX

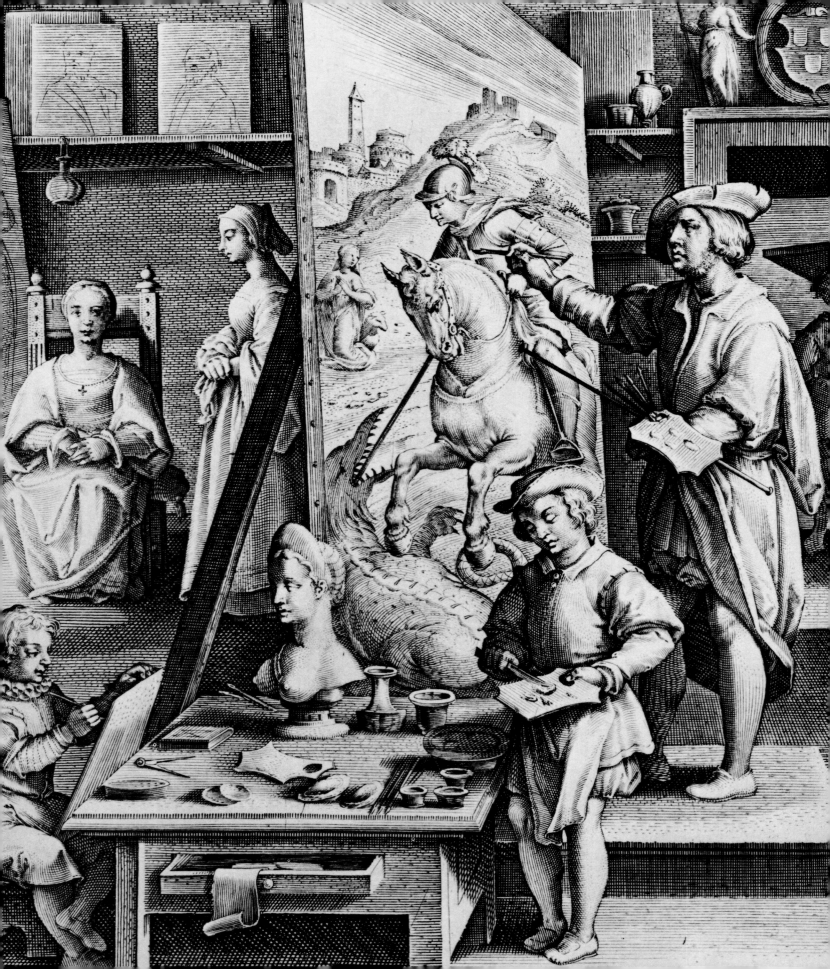

The Anonymous Workshop

The concept of the artist's studio that comes most readily to mind — a high-ceilinged room with ample north light where an artist can work alone and undisturbed — was established only in the course of the last century. Artists have worked in every space and circumstance, depending on the age they lived in, their social standing, and the technical requirements of the painting or sculpture they practiced. In fact, the studio, or working space, has changed as much as the artist himself, closely reflecting his development and providing a particular insight into the way art is made.

The history of the artist's studio falls principally into three periods. The first, about which we know least, is by far the longest, stretching from the origins of art through antiquity to the Middle Ages. As far as our subject is concerned, this period has one constant: the individual artist remains obscure, with a status between a slave's and that of a craftsman. Thus the space where he plied his trade was comparable to a cabinetmaker's or a goldsmith's. Similarly, he undertook every kind of decorative task, from painting shop signs to embellishing saddles.

As the artist emerges from this ancient anonymity, a second, better-documented period begins. Images showing painters and sculptors at work grow more frequent, and they are paralleled by an increasing number of treatises on art. In both, the implication has changed. Now the artist works not so much with his hands, like the uneducated artisan he had been, but *col cervello,* with his mind; as Leonardo insists, he can pursue his

vocation like a gentleman, in a fine house, "dressed as well as he pleases." So great a change — from craftsman to a person of learning, sought out by poets and princes — corresponded to a similar one in the appearance, organization, and contents of the place where these more consciously invented images were conceived. The sumptuous surroundings of Raphael or Leonardo's learned cell are a far cry from the workshop conditions of their medieval forebears.

Most Renaissance studios were open places, visited by all kinds of people and considered part of the mainstream of life. Even before the profound upheaval of the French Revolution, however, the artist's self-awareness and his situation in society had begun to change. And after the revolutionary fervor had died down, he felt increasingly conscious of a rift between himself and the general temper of his time. Freer, yet more isolated, he was forced to search for a new vision of the world and, with it, an identity, a social raison d'être.

That search has haunted the modern artist and taken him over the last two hundred years to every extreme. He has been revolutionary and reactionary, gentleman and artisan, magnate and pauper, recluse and international "star." At no other period could so many contrasting attitudes have coexisted, nor such a wealth of imagery and documents have been left behind. Consequently, the studios of this third period are of an unprecedented diversity; and we have chosen them as the main subject of this book because, one by one, they form a mirror-image of the evolution of modern art. That

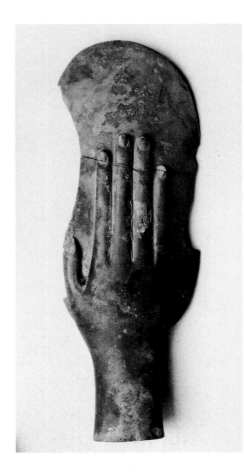

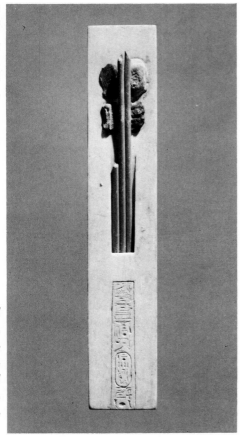

Egyptian faience palette in the form of a hand holding a shell, XIX–XXVI Dynasty (ca. 1319–525 B.C.), Metropolitan Museum of Art, New York. Egyptian palettes, which were also used to mix cosmetics, took many shapes, including those of animals and fish.

Egyptian ivory palette with paints and reed brushes, XVIII Dynasty (ca. 1570–1304 B.C.), Metropolitan Museum of Art, New York. This ruler-shaped palette, complete with prepared colors and brushes, belonged to Meka-taton, daughter of the audacious religious reformer Akhenaton.

image does not take on its full significance until it is viewed in a greater historical perspective. The aim of the following two chapters is to provide a background against which the modern studio may be seen more clearly.

Technique is the only aspect of prehistoric art to have received any satisfactory explanation. Quantities of tools — such as the flint burins, the palette stones used by painters to grind their colors, and the hollow bones that served to store them — have been found and catalogued; even lamps of animal fat with moss wicks have been identified as those that lit the dark recesses where the prehistoric artist traced his ageless pictures. Something of the methods used has also been established: they ranged from painting with the fingers to blowing the paint around a form (such as the artist's outspread hand) by means of a hollow tube or reed. This latter method was also employed to suggest such subtle, dif-

fuse effects as the thickness of a horse's mane. Little else is known for certain about the way these artists worked, although the consistently high quality of their images suggests that they might have received some form of preliminary training.

Black, made from wood charcoal or manganese oxide, and earth ochers, ranging from red through bister to yellow, had formed the entire palette of the prehistoric painters. To these the Egyptians added white, obtained from gypsum, green from copper ore, and blue from lapis lazuli; in time, they discovered how to mix these colors and obtain the intermediate tones. Once ground, the pigments were kept in animal skins (much like the bladders Europeans used for storing paint until the mid-nineteenth century), then mixed with gums as and when they were needed. Slate or schist palettes, sometimes in the form of a hand or a fish, were widely employed. As for brushes (which the prehistoric painters had fashioned from bits of hide or chewed stick), the

Image from the Book of the Dead, XXI Dynasty (ca. 1065–935 B.C.), Rijksmuseum van Oudheden, Leiden. Thot, god of wisdom, is represented as a painter in the process of completing the sign of truth and justice. On his palette are the two colors indispensable to scribes and artists of the time: black and red.

Egyptians used the reed, pounding the end into a splayed-out, fibrous tip.

Artists in ancient Egypt were rarely regarded as more than manual workers producing images in accordance with divinely inspired precepts. Seated figures, for instance, were usually represented with their hands on their knees; the men were colored a deep ocher, the women a pale yellow. The main function of such sculpture was to accompany important figures into the afterlife (one Egyptian word for sculptor being "He-who-keeps-alive"), but the artist's role was limited to executing preestablished images that complied in every detail with tradition. Studio workshops, with masters

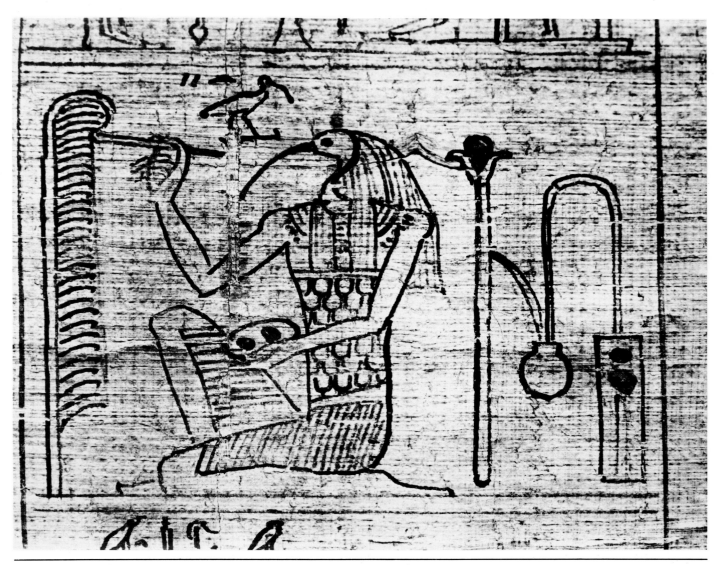

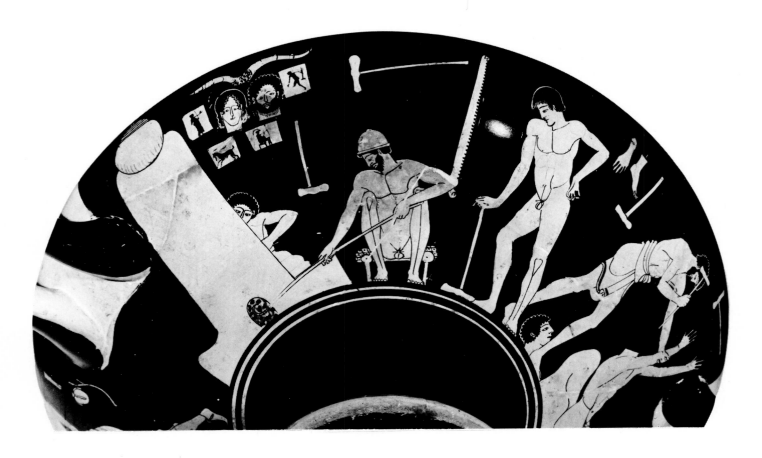

set over a number of assistants and apprentices, were frequently annexed to royal palaces or temples. This enabled court or religious officials to supervise all artistic production.

With a few celebrated exceptions, the artist remained as obscure in Greece as he had been in Egypt. In part this was because painting and sculpture ranked as manual trades, and for the Greeks manual work implied a slavelike status. A contemporary text puts shoemakers and sculptors in the same category, while Plutarch was to sum up Greek society's attitude toward artisans — and, by extension, artists — when he wrote: "We enjoy the work and despise the maker." Many of these despised makers indeed led a slavelike existence, decorating vast quantities of kraters and other vessels with mechanically repeated patterns.

Several different written sources record that painting on wooden panels as well as fresco painting was practiced in the preclassical period, but beyond a few fresco fragments nothing has survived. Encaustic painting, which preserves colors by mixing hot beeswax into

Greek bowl illustrating a sculptor's workshop, ca. 480 B.C., Staatliche Museen, Berlin. An artisan stokes the bronze foundry (left); behind him, studies and tools hang on the wall. On the right, a sculptor works on a headless statue (its head lies between his feet).

them, was employed for the decoration of boats, the Roman writer Pliny tells us, as well as in the better-known case of the Faiyûm funerary portraits. Only four colors — white, red, yellow, and black — were used by the "best-known" painters, whose reputation was such, Pliny recounts, that in order to buy one of their works "the wealth of a city could hardly suffice."

Sculpture, which we know principally through Roman copies, occupied a prominent place in Greek public life. Phidias' bronze statue of Athena, erected near the Parthenon, stood over forty feet high and could be seen from far out at sea, while at Olympia his monumental Zeus, with its ivory flesh and gold drapery, literally blazed under the strong sun. Phidias would have had a large, well-staffed workshop to help him with such publicly important commissions. A few other artists are known to have enjoyed recognition and favor. The painter Apelles, for instance, is remembered best as the man to whom Alexander the Great gave his favorite mistress; but he also held a position in Alexander's household akin to that of court painter.

Such exceptions to the general rule of anonymity were even rarer in Rome, where huge teams of unnamed artists toiled in factorylike, and often state-owned, workshops to feed a voracious market with reproductions of Greek sculpture. The majority of these artists were in fact Greek slaves, brought back to Rome by their new masters for this purpose. Statues soon became a symbol of civic and personal pride, lining avenues, dominating public places and ennobling the villas of the rich. In the late Roman and early Christian periods, however, painting overtook sculpture as the more important art. Whole workshops of specialist artists were hardly able to keep apace of the demand for portraits. Statesmen and other public figures had their likenesses made to be carried through the streets, either to seek support or simply to advertise themselves and their good services. Likewise, generals had the scenes of their victories immortalized, while litigants paraded images in support of their claims. Not to be outdone, Nero had a 120-foot portrait of himself displayed, but lightning struck and destroyed it in a trice.

Egyptian and Greek artists usually worked in or near centers of religious and royal power. The same was true of the medieval image-maker, whose "workshop" was usually wherever he happened to be working — in church, chapel, or castle. Again, like his predecessors lost in antiquity, the medieval artist was a craftsman, with no desire for "personal" expression (the very concept would have been meaningless), but extremely attentive to the technical excellence and durability of his product.

In the early Middle Ages, both masters and journeymen (originally so called because they were paid by the day) traveled far afield to practice their métier. If summoned to work on a large new church, they would frequently stay several years until the commission was completed. Or they might enter the service of a distant nobleman, where their talents were variously employed. Versatility was necessarily their hallmark, for they might at one point be called on to design pageantry costumes or tournament banners, and at another to execute a fresco cycle for a church.

Buon or "true" fresco had come down through the Roman artists, who, in turn, had inherited the basic recipe from the Greeks. Such recipes were all-important, for they represented at that time a virtual sum of knowledge about art. One of the standard twelfth-century treatises, *Diversarum artium schedula,* composed by the Benedictine monk Theophilus, reads like an artisan's manual: how to mix colors, how to prepare a wall for fresco painting, and so on. Some of the recipes grew extremely complex, with ingredients worthy of a witch's cauldron; but they reflect the medieval artist's overriding concern to improve his technique by finding brighter colors, say, or a binding agent that dried more quickly.

In the highly important art of illuminating manuscripts, the emphasis was also placed on technical perfection. Workshops known as *scriptoria* were set up for monks as well as some laymen to learn and practice this most painstaking form of decoration. The scriptoria varied from large, communal working spaces in Benedictine monasteries to cells among the Carthusians and Cistercians. In whichever case, the basic tools and materials were the same: stone slabs or porphyry mortars for breaking down the pigment; beakers, alembics, and a stove for refining the oils that were to bind the pigment; and hares' feet or wolves' teeth for smoothing the parchment down. Later, illuminating manuscripts became a secular

THE ANONYMOUS WORKSHOP

A Mural Painter Saved from Death, *an illustrated page from* Las Cantigas *of Alfonso X, second half of thirteenth century, Biblioteca Real, Escorial. Throughout the Middle Ages, artists were rarely considered as more than skilled artisans; accidents were frequent, and although regarded as working in the service of God, many church decorators were less fortunate than the one shown here.*

pursuit as well. Workshops were founded by monarchs and wealthy noblemen, such as the Duc de Berry, in whose service the Limbourg brothers completed the exquisitely fresh *Très Riches Heures.* Illuminators also set up their own shops; in Paris, for instance, the area around the Sorbonne University was famous for them by the end of the fourteenth century. We know from contemporary engravings that the back of the shop served as a working area, while the front, which opened directly onto the street, displayed the wares for sale.

Once they felt more independent of Church control, artists (like all other professionals of the time, including beggars, minstrels, and prostitutes) began to join guilds. They did not have a guild of their own for some time, however. In Brussels, for instance, they shared with goldsmiths and printers; in Bruges, with saddlers and glass-blowers; and in Florence, with doctors and apothecaries. No artist could set up a workshop until he had given proof of his competence (that is, a masterpiece) to the guild and had been accepted as a member. The guild then regulated the kinds of work he might

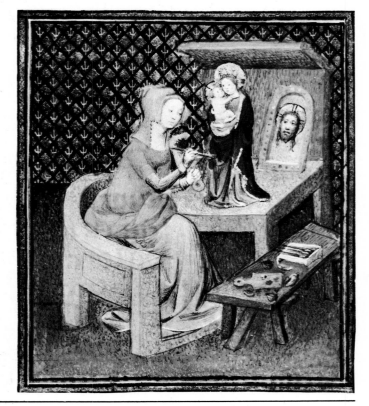

Irene the Painter, *a miniature illustrating a French translation of Boccaccio's* Noble and Illustrious Women, *1403, Bibliothèque Nationale, Paris. One of the earliest known representations of an artist in the studio surrounded by the tools of the trade, Irene is polychroming a statue of the Virgin and Child; her brushes, palette, and small pots of prepared paint are laid out on a side table. Other miniatures of the period indicate that easels already existed. For a later depiction of a miniaturist at work, see page 25.*

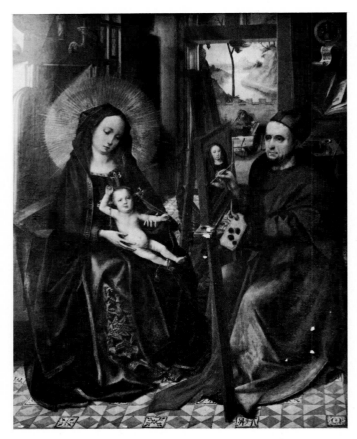

Colin de Coter (born ca. 1450–1455), St. Luke Painting the Virgin, *Eglise Notre-Dame-Allier, Vieure. Dated around 1507, the Coter panel gives a good idea of the instruments available to painters of the period. Both easel and palette have the form they were to retain for centuries, while the choice of colors has been voluntarily limited to four. Because he was held to have painted the Virgin, St. Luke became the patron saint of artists and was frequently represented in the process of painting; see also page 26.*

undertake, the way he should run his workshop, and often the quality of the materials he used. As well as assistants or journeymen, a master was allowed a number of apprentices. In return for board, lodging, and some instruction, the apprentices ground the colors, prepared the oils and other materials, and cleaned the brushes; they also kept the workshop scrupulously well swept, for a speck of dust could seriously mar a drying picture. Once they had mastered the basic techniques, apprentices might be allowed to assist in the underpainting of a panel (the stage when the overall design and tonal values of a picture were mapped out), then execute details in a landscape, and so on, until they had learned enough to serve as fully fledged assistants.

Toward the end of the Middle Ages, master artists began to command more social esteem. Privileged relationships between artist and ruler had not ceased to exist, of course, since Apelles and Alexander the Great. Thus Jan van Eyck was anything but an anonymous artisan, being "varlet de chambre" to Philip the Good of Burgundy and entrusted by the duke with several important missions — including two marriage negotiations, during which he doubtless made portraits of the ladies concerned. Giotto, to take one other example, was sufficiently famous to gain a mention in Dante's *Divine Comedy;* and his appointment as city architect to Florence in 1334 marks a significant moment in the artist's gradual rise in the social scale. By the end of the fourteenth century, the painter and theoretician Cennino Cennini expressed his view that the artist should be regarded as a man of learning and distinction. "Know that this work," he says, referring to painting in his *Craftsman's Handbook,* "is truly that of a gentleman and that it can be practiced while dressed in velvet."

"Your life should be regulated as if you were studying theology, philosophy, or other sciences," Cennini exhorted his fellow artists. Such dignified advice would hardly have been expended on men who were considered simple artisans. Yet artists were to remain bound to a workshop system for a considerable time. Throughout the earlier part of the Italian Renaissance, artistic activity stemmed almost wholly from the *botteghe,* which, with their hierarchy of *maestri, garzoni,* and *discepoli,* still closely resembled medieval workshops. But

the new thirst for knowledge could not be checked, and gradually it became an accepted fact that artists required, if not a humanistic education, then at least a grounding in anatomy and perspective. Leon Battista Alberti, in his treatise *Della pittura* (1436), went much farther, recommending that the painter be acquainted with all forms of knowledge relevant to his art, notably history, poetry, and mathematics. As this view became more widely accepted, there arose, as we shall see, academies founded to promote a deeper inquiry into the nature and practice of art.

Although Leonardo and Michelangelo came from the professional middle class, the preceding generation of Italian artists tended to be of humbler origin. The Pollaiuolo brothers, as their name suggests, were poulterers' sons; Uccello's father was a barber, Filippo Lippi's a butcher. Most painters of this period started out in

A Dutch Studio in the Sixteenth Century, engraving by Theodor Galle after a composition by Joannes Stradanus, Bibliothèque Nationale, Paris. Elegantly attired in velvet, the studio master completes his St. George *while an assistant executes a lady's portrait. One apprentice copies a bust, another cleans a palette, and two studio hands (right) grind and mix colors. The obvious skill, organization, and industry of this studio denote the growing importance accorded to the artist.*

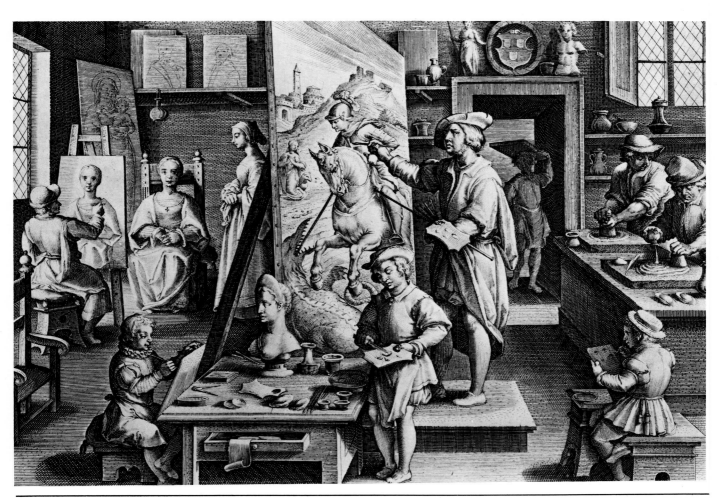

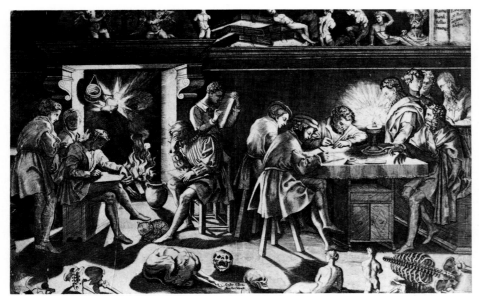

goldsmiths' shops, just as most sculptors were apprenticed, like their medieval forebears, to stonemasons. Donatello was received into the Florentine guild of St. Luke as a "goldsmith and stonemason." The "lesser" arts and crafts continued to attract these artists even when their reputation was solidly established. The Pollaiuolo brothers kept a goldsmith's business going within their extremely successful Florentine workshop, accepting commissions for engraving and embroidery design as well. Botticelli, Filippino Lippi, and Piero di Cosimo saw no dishonor in decorating the highly prized wooden chests known as *cassoni.*

By the sheer magnitude of their gifts, as well as the age's more appreciative disposition, Leonardo and Michelangelo clearly altered social attitudes toward the artist. Amplifying the theories of Alberti, Leonardo urged that painting was equal, and even superior, to the other liberal arts. "Poetry is superior to painting in the presentation of words," he remarked in a famous note, "and painting is superior to poetry in the presentation of facts. From this I judge painting to be superior to poetry. . . ." He also placed it far above sculpture, emphasizing how — unlike the sweat- and dust-covered sculptor — the painter "sits in great comfort before his work, well dressed, and wields his light brush loaded with beautiful colors. . . . He often works," Leonardo

concluded, in a perfect description of the Renaissance's new gentleman-artist, "to the accompaniment of music, or listening to the reading of many fine works."

In the observations he made on virtually every subject of interest to the artist, Leonardo did not omit the studio, recommending that it be a small room, for while "small rooms or dwellings discipline the mind, large ones distract it." Light, he went on, "should come from the north in order that it may not vary," adding with characteristic practicality that "if you have it from the south, keep the window screened with cloth." As to the best way of life for the artist, Leonardo advocated solitude, by which he also meant celibacy: "The painter and draftsman ought to be solitary, in order that the well being of the body may not sap the vigor of the mind." How far this small, peaceful room, with the artist pursuing his studies undisturbed, differs from the large, noisy, crowded *bottega!* In Leonardo's notes, the modern artist and the modern studio are born.

Through Leonardo alone, the study of anatomy and perspective progressed with astonishing speed. The artist himself dissected over thirty corpses in his desire to probe the mystery of the human body, and made hundreds of drawings for a book on anatomy. As for perspective, Leonardo believed that, without it, "nothing can be done well in the matter of painting." To facili-

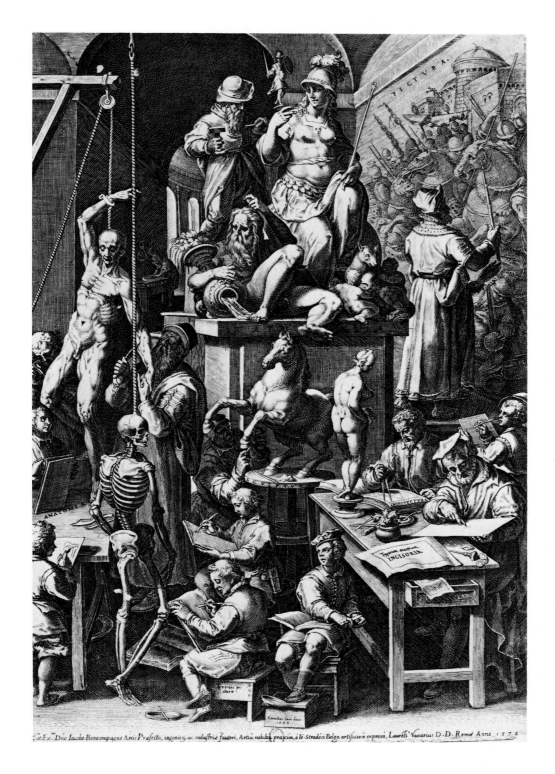

Allegory of the Arts, *ca. 1578, engraving, Bibliothèque Nationale, Paris. The artist was no longer an artisan but a man of learning, developing his skills by reflection and experiment. Academies allowed him to develop his knowl-edge, ennoble his art, and affirm his new status in society. The new intellectual complexity of the arts is amply illustrated in this allegory.*

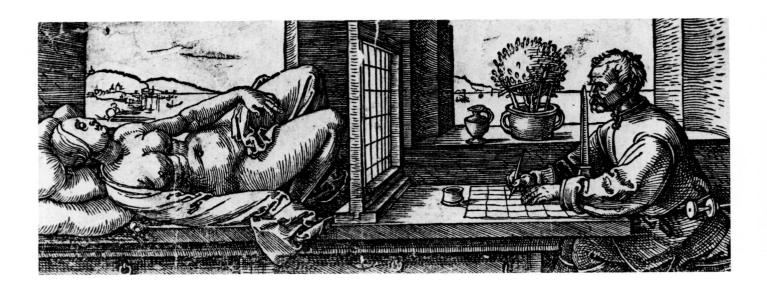

tate the correct rendering of an object in space, he designed a simple but effective optical device called the perspectograph. Inventions like these could be quickly and widely communicated by means of engravings, which remained the great disseminators of visual information until photographs replaced them. By 1525, in Nuremberg, Dürer was making experiments based on Leonardo's research into perspective and developing its practical application.

Meanwhile, in terms of social esteem and reward, Italian artists had scaled quite unprecedented heights. At his premature death, aged thirty-seven, Raphael left a palace, two houses, vineyards and land. His luxurious style of life and his friendship with the most powerful persons in Rome gave rise to a rumor that, had the painter lived, the Pope would have appointed him cardinal. Titian amassed even greater wealth, thanks not only to his fame as a painter but to his cunning and tenacity as a businessman — qualities that his correspondence with patrons over unpaid commissions admirably illustrates. He entertained on a princely scale and gained the highest honors that Emperor Charles V, his protector, could bestow, becoming Count Palatine and Knight of the Golden Spur. It is said, moreover, that when the emperor was visiting Titian in his studio, the painter dropped his brush and, unhesitatingly, the emperor bent down to retrieve it for him.

For many of the greater artists, the act of painting and sculpting had developed into an altogether more

Albrecht Dürer (1471–1528), Draughtsman Drawing a Reclining Nude, *ca. 1525, woodcut, Bibliothèque Nationale, Paris. For the inquiring Renaissance mind, art had to be based on scientifically verifiable facts. Dürer considered his experiments with perspective as a vitally important part of his life's work. In the final years, he assembled his theoretical findings and prepared them for publication.*

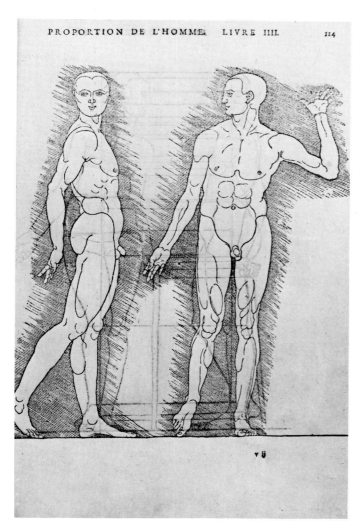

A plate from Dürer's treatise on the proportions of the human body, Bibliothèque Nationale, Paris. Originally published in Nuremberg in 1528, Dürer's treatise had been prompted by Leonardo's work on this all-important subject. The influence of the academies and the new approach to art as an intellectual exploration were responsible for contemporary artists' obsessive curiosity about the human body. Diagrams such as these were to become part of the stock-in-trade of all advanced studios.

self-conscious and anguishing process. Palma Giovane, who assisted the aging Titian in his studio, describes how the master built up his composition, then "turned the picture to the wall and left it for months without looking at it, until he returned to it and stared critically at it, as if it were a mortal enemy. . . . If he found something that displeased him, he went to work like a surgeon." The mixture of deliberation and spontaneity in his technique speaks of an intensely personal, searching attitude towards creation. "He never painted a figure *alla prima,*" Palma continues, "and used to say that he who improvises can never make a perfect line of poetry. The final touches he softened, occasionally modulating the highest lights into the half-tones and local colors with his finger; sometimes he used his finger to dab a dark patch in a corner as an accent, or to heighten the surface with a bit of red like a drop of blood. He finished his figures like this and in the last stages he used his fingers more than his brush."

More obsessive than any of his contemporaries, more racked by doubt in spite of his unique gifts and position, Michelangelo gave no thought to status or fortune in his consuming passion for work. When he started on the Sistine Chapel, he dismissed all assistants, and for the following four years toiled alone, preparing every stage in the execution of the vast fresco, and even grinding his own colors. In this most daunting of studios, the artist often slept fully dressed so that, if inspiration came in the night, he could get to work immediately, donning a curious hat in which a lighted candle could be placed, then climbing the scaffolding to lie under the vast canopy which had become the mirror of his heroic imagination. In Michelangelo — "Michel piu che mortal, Angel divino" — the concept of genius, with all its suffering and *terribilità,* was so fully embodied that even the greatest artists have lived in its shadow ever since.

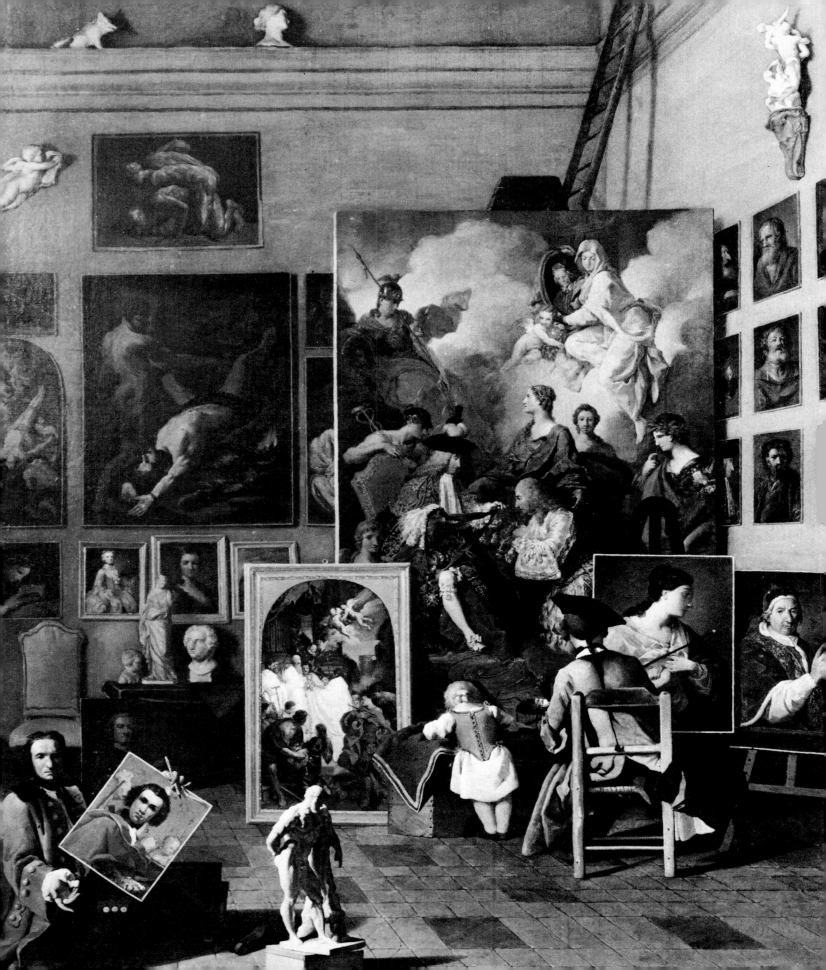

Palace and Academy

If Michelangelo spurned assistants, Rubens based his entire working life on them. In productivity and opulence, his Antwerp studios were one of the wonders of the age, and even today they remain the outstanding example of artistic organization on the grand scale. After a period at the very beginning of the 1600s as court painter to the Duke of Mantua, Rubens settled in Antwerp and built himself an Italianate palace equipped with a grand studio and all the amenities — including a picture gallery — that befitted a first-class workshop. The paintings produced there were based on the notion, quite inconceivable before the Renaissance, that a work's essential artistic value lay in its original concept: that is, in the master's preliminary study or cartoon. The rest was a question of skilled execution, considered far less important, especially as the master would supervise the final result. Rubens's time being much taken up by workshop administration and by his parallel career as a diplomat, this system enabled him to keep his assistants fully employed even when he himself was traveling on foreign missions.

Since success depended on the excellence of his studio hands, Rubens made sure that he was well seconded. Van Dyck came to him with a budding reputation and so evident a gift that Rubens allowed him to work on those most vital areas of a painting — notably the face — which he usually reserved for himself. Two of his other assistants, Jacob Jordaens and the animal painter Frans Snyders were established masters in their own right. The amount of work left to assistants was an im-

portant factor when it came to deciding on a picture's price. Rubens himself made the distinction clearly and unembarrassedly, informing prospective clients that a painting was "original, by my hand, and the Eagle done by Snyders" or "commenced by one of my pupils, after one I had made for his Most Serene of Bavaria, but all retouched by my hand." Fully aware of his ability to instill the spark of life into anything that came under his brush, Rubens personally recommended his pupils' copies for sale as "so well retouched by my hand that they are hardly to be distinguished from originals." Despite the enormous volume of work produced in Rubens's studio, the techniques and materials used were of such consistent quality that most of his paintings have remained unusually well preserved.

An outstanding feature of Rubens's studio was his art collection, which included three hundred of his own works, paintings by Van Dyck and other assistants, and fine examples of Van Eyck, Lucas van Leyden, Brueghel, and Brouwer. He also possessed countless drawings and engravings, which served his assistants and pupils as a kind of reference library, enabling them to study the achievements of other generations and schools.

Although the most illustrious, both at home and abroad, Rubens was by no means the only "painter-prince." His star pupil, Van Dyck, left the Antwerp studio to pursue an independent career which led him, during the last nine years of his life spent in London, to a position of privilege that no English painter had ever enjoyed. He painted several portraits of Charles I, in-

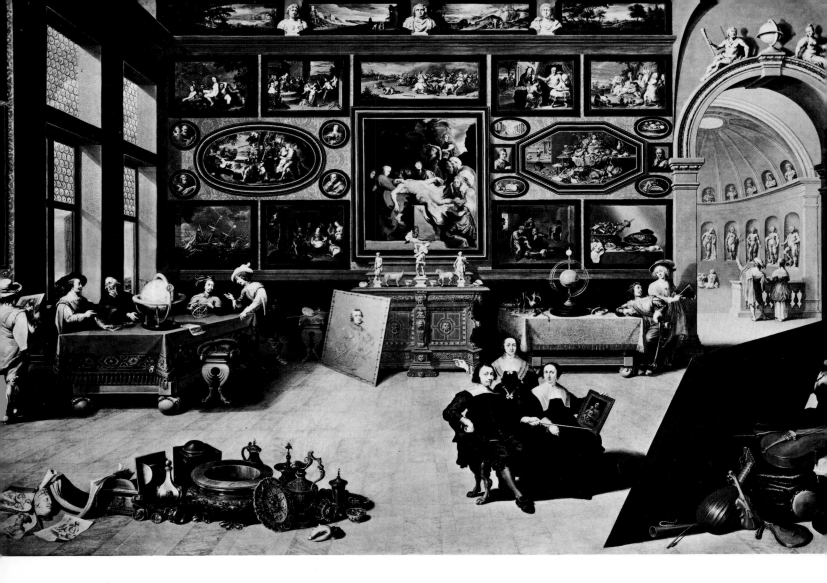

cluding a triple one dispatched to Bernini in Rome as a guide for the bust the Italian sculptor was making. The king showed his favor by frequently visiting the artist at his well-appointed house with its private landing stage on the Thames. Van Dyck's fame as a portrait painter enabled him to employ a team of assistants, or "drapery hands," to paint the sitters' costumes, arranged on dummies or lay figures specially for the purpose. His biographer, Roger de Piles, describes how Van Dyck "put the sitter in an attitude which he had previously meditated, and with grey paper and black and white crayons drew, in a quarter of an hour, the figure and drapery, which he arranged in a grand manner and with exquisite taste. He then handed over the drawing to skilful persons he had about him. . . ." Less vigorous in effect than Rubens, Van Dyck favored a grayer under-

Long believed to be an illustration of Rubens's art gallery in his mansion in Antwerp, this painting in the Palazzo Pitti, Florence, is now thought to represent another collector's assembled treasures. Rubens possessed a first-class collection of works by Van Eyck, Brueghel, and his own assistants, notably Van Dyck. The great Flemish artist and diplomat also collected antique sculpture, and added to his collection while traveling or by exchanging his own work for items he admired.

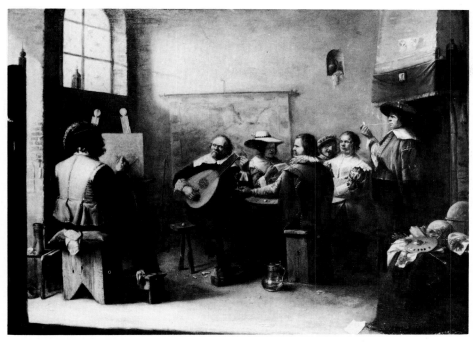

Joos van Craesbeck (1605– ca. 1668), A Painter in His Studio, *Fondation Custodia, Institut Néerlandais, Paris. Light streaming in from the window and the open door illuminates this seventeenth-century Dutch artist as he maps out his composition with white chalk. His subject is the five senses, personified by the company around the table. A palette, mahlstick, and globe occupy the small table on the right.*

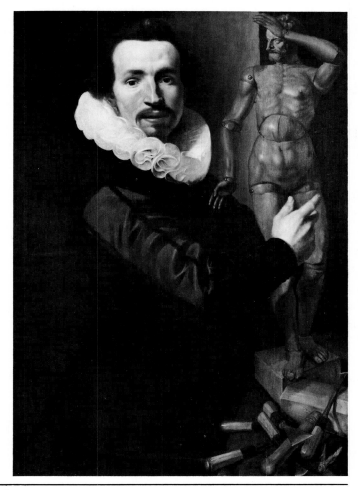

Werner van den Valckert (ca. 1580–1630), Portrait of a Teacher, *The J. B. Speed Art Museum, Louisville. With the aid of a superbly articulated mannikin, a master sculptor explains to his studio pupils the complexities of a particular pose. To understand and represent the human body perfectly was long the greatest ambition of artists.*

painting than his master's and thinner, drier color, which he applied in a more noticeably dragged manner. Some of his patrons appear to have realized the danger of their portraits' being principally the work of assistants. "Mind Sir Anthony," the Earl of Strafford wrote to his agent, "that he will take good pains upon the perfecting of this picture with his own pencil [that is, brush]."

Another painter to have benefited from a privileged, even close, relationship with a monarch was Van Dyck's exact contemporary, Velázquez. Having been trained at the Seville Academy, Velázquez became court painter in Madrid in 1623. He accompanied several embassies to Italy, but his mission was not, like Rubens's, political; he was charged with buying works of art for the royal collection. Velázquez had a studio in the palace where he moved with "the ease and poise of a nobleman" — which in fact he became when Philip IV created him a Knight of the Order of Santiago. He was in constant contact with the king, who greatly appreciated his company. When Velázquez died, after nearly forty years as court painter, the king confided to his diary that he was "abatido" — deeply dejected. Something of the strange mixture of formality and intimacy that characterized their relationship can be sensed in the interplay of planes and reflections which gives *Las Meninas* its extraordinary structure. Velázquez, nobly attired in a silk doublet bearing the insignia of his order, pauses for an instant, paintbrush in one hand, palette and mahlstick in the other; the king and queen seem abstracted into another universe in their mirror image; the infanta coquettishly displays her innocence; a court dignitary glances in from the far door; the dog drowses. The artist looks at his royal subjects, looks at himself: it is a painting about his role at court, about that court itself, and the act of seeing — the attempt to apprehend reality. A moment of life is held up to the eye, in what has remained the most profoundly inquiring image of the artist in his studio ever made.

Of the sculptors, no one else's studio came near to achieving the fame and influence of Bernini's. In addition to enjoying papal patronage, this immensely energetic Neapolitan filled a number of official posts, thus assuring his studio — the largest in Italy, and hence no

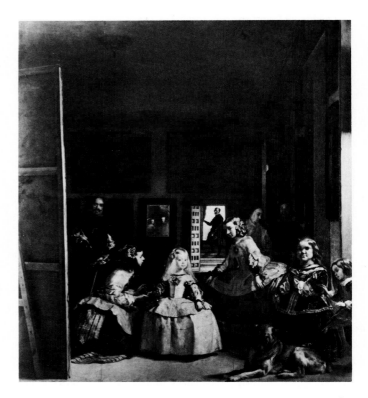

Velázquez (1595–1660), Las Meninas, *1656, Prado, Madrid. As court painter to Philip IV, Velázquez had a studio in the royal palace and was in frequent contact with the king, who ennobled him. In one complex image, Velázquez records his role at the Spanish court, the court itself, and the underlying impermanence of even the grandest mortals. The artist is now sufficiently proud of his calling to represent himself at work in the presence of his monarch.*

doubt anywhere in the world — of a constant flow of commissions, both for sculpture and architecture. His reputation equaled Michelangelo's, and when he traveled, crowds gathered to catch a glimpse of him. Despite the stigma that still attached to stone-carving as the most "dirtying" of the arts, Bernini was so much at ease in his role as a sculptor that he received Queen Christina of Sweden in "the same rough and soiled dress he usually wore when working the marble"; Her Majesty, the Florentine writer Filippo Baldinucci reported, went as far as "touching his dress with her own hand as a sign of her admiration for his art."

At the height of his fame, the aging artist was invited by Louis XIV to redesign and complete the Louvre Palace. Traveling in great pomp, with a draftsman and an assistant sculptor in his retinue, Bernini was received with every consideration in Paris as the man who had changed the face of Rome. The visit was not a success, however, and the Louvre remained the jealously guarded preserve of French architects. The great Italian's views on art were nonetheless much in demand. The lecture he gave at the French Academy is interesting for the emphasis with which it confirms that the old workshop methods of training had been superseded. Significantly, he referred to those who had hitherto been termed apprentices as "students," and insisted that, far from busying themselves with workshop chores, they should be studying "plaster casts of all the finest antique statues, bas-reliefs and busts, so that they can learn to draw in those antique styles and from the outset familiarize their minds with beauty." The classical ideal was all-important; so much so that should one make students "draw from nature at the beginning, one ruins them. Nature is nearly always feeble and puny." The era of art academies and, in the best sense, an "academic" approach to art had begun. Before outlining the way it transformed the artist's universe, we should look at one last studio of the old style — because, being Rembrandt's, it remains a quintessence.

Dramatic uncertainty characterized the period in which Rembrandt and his seventeenth-century fellow artists struggled to make their way. The Dutch guilds, with all that they represented in terms of security and constraint for artists, had begun to weaken, but no

Rembrandt (1606–1669), The Artist in His Studio, *ca. 1628, Museum of Fine Arts, Boston. Far from the patrician self-confidence of Velázquez in his palatial studio, this young Dutch artist (believed, because of his diminutive size, to be Gerrit Dou, Rembrandt's pupil) seems overawed by the task before him. The bare, barnlike atelier and the painter's inelegant dress recall how precariously most artists lived, particularly when, as in seventeenth-century Holland, traditional forms of patronage had disappeared.*

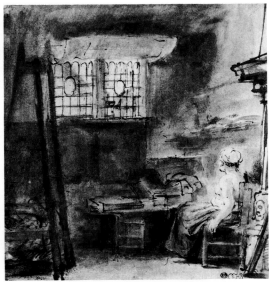

(Left) Rembrandt, The Studio School, *Fondation Custodia, Institut Néerlandais, Paris. While comparatively young and successful, Rembrandt was much in demand as a teacher. He took some pupils into his own house and rented a warehouse for others. Even established painters were drawn to him not only because of his personal prestige, but because as a studio master he was allowed to hire a nude model — a practice that was otherwise illegal.*

(Right) Rembrandt, The Artist's Studio, *Ashmolean Museum, Oxford. This wash drawing, ca. 1655, shows how Rembrandt lit his own studio. Its four windows could be covered or opened to focus the daylight on one single area or to diffuse it. Here the two bottom panes are shuttered so that the light falls from above onto the half-naked model.*

royal or other patronage had replaced them. For the first time in history, artists were producing first, without a commission, and then attempting to sell. A particularly fragile situation evolved, in which works of art were hawked on the street or at markets, and artists were forced into quite unrelated employment in order to survive. Thus Jan Steen kept an inn, Jan van Goyen traded in tulips, and Meindert Hobbema became a tax collector. Rembrandt himself prospered at the outset of his career but later fell victim to the fluctuations of fashion, as well, of course, as to his own extravagance and mismanagement.

The house he bought in Amsterdam (now a Rembrandt museum) during his first flush of fortune contained a studio for the artist himself, workrooms in the attic for his pupils, and an art gallery crammed with rare pictures and unlikely curios. Rembrandt drew and painted his studio on several occasions. It had four windows with shutters that enabled the artist to focus the

even north light on whatever he chose — his canvas alone, his canvas and the model beside it, the model alone, and so on. At the height of his popularity, he was besieged by young painters eager to study under him. A number of them lodged in the attic (as Rembrandt's first pupil, the meticulous genre painter, Gerrit Dou, had done before them), while others congregated for life drawing under Rembrandt's supervision in a warehouse that the artist had rented for the purpose. For reasons of propriety, models were not allowed to pose nude outside a master's studio or class. Another advantage for the would-be artists consisted in being able to copy the exotic costumes and props — halberds, cuirasses, animal skins, precious glassware — that Rembrandt had accumulated for his historical and Biblical scenes.

When insolvency forced the artist to sell his house in the late 1650s, an inventory was drawn up. The liquidators allowed him to keep the tools of his trade: the easels, palettes, canvases, brushes, paints, the tables

where materials were prepared, and the mirrors he used for painting his own portrait. But everything else, above all the contents of his precious *kunstkamer,* was to be put up for sale: not only the antique sculpture, terrestrial globes, and baskets of plaster casts of every section of the human anatomy, but all the works this incomparably percipient collector had brought together of the great masters from Brueghel to Rubens, Schongauer to Raphael, Michelangelo to Titian. Not the least moving of the items auctioned was Rembrandt's copy of Dürer's treatise on perspective. For just under twenty years, this studio overlooking the Breestraat had been what every seventeenth-century artist might have wished his studio to be: a practical workshop and an astonishing museum, a room for dreaming great images and a school where

the hard facts of technique and sound workmanship could not be fudged.

Rembrandt, like Rubens and virtually every artist before him, had been apprenticed in his youth, and in turn he had taken apprentices, making his ideas and expertise available to them with unusual generosity. Once art came to be seen more as a learned calling than a trade, however, young aspirants required a tuition that went well beyond the age-old grounding in technique. The newly formed academies corresponded to this need. From the late sixteenth to the late nineteenth centuries, they were to replace the studios or *botteghe* as centers for learning about art. Naturally, they adopted a great deal of studio lore, and the studios themselves, for the

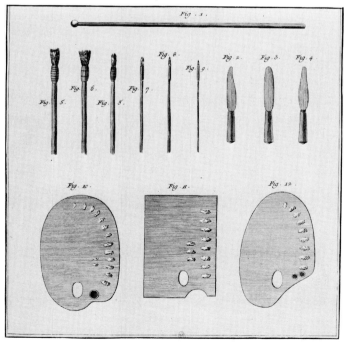

These two illustrations from Diderot's Encyclopédie *show the range of tools used by painters in the eighteenth century. It is interesting to note the variety of brushes, palette knives, and palettes, as well as the complex piece of furniture used to hold colors and the bladder (fig. 8) in which ground pigments were stored before being mixed for use.*

Pierre Subleyras (1699–1749), The Artist's Studio, *Fine Arts Academy, Vienna. This painting about painting recounts the French artist's life from his early days — when he worked with his little daughter beside him and his back turned to the world — to illusionless middle age (when, in fact, he contracted an incurable illness and died). The paintings hung around the studio were famous in their day and still form a graphic account of the artist's career.*

greater part shorn of pupils, became more private places. But the two remained bound by an interaction: a new technique or style discovered in the one eventually found its way into the other. Moreover, when former students set up in their own studios, the atmosphere, contents, and ways of working automatically reflected those of the academy in which they had been taught. Indeed, as academies had grown out of studios, so studios grew in many ways to resemble academies.

The first "academies" were essentially discussion groups. To foster the exchange of ideas in suitable surroundings, Renaissance artists and thinkers organized informal meetings, such as those that took place in the famous Medici sculpture garden. But the first academy to have elected members and a teaching program was founded by Giorgio Vasari, under the joint patronage of Cosimo de' Medici and Michelangelo, in 1563, in Florence. Similar bodies sprang up, notably in Rome, where the Accademia di San Luca opened in 1593, and over the next century they became a living force in European art. Founded in 1648, the French Academy was not set on its redoubtable course until Colbert took it in hand in 1661; five years later, French art students had their eyes fixed ambitiously on Rome, where a school (known simply as the French Academy in Rome, and still active today) had been founded to allow the best of them to study the antique *in situ*. Most cities with a claim to culture eventually established an academy of their own; by 1790, over one hundred of them existed in Europe, while in 1805, the first American academy was inaugurated in Philadelphia.

Academies were steeped in various interpretations of the classical ideal. Thus works of classical antiquity, chiefly in the form of plaster casts, dominated the drawing class. By tirelessly copying them, academicians believed, students would be brought closer to the one true source of art — "our good ancient Greeks," as Poussin called them, "inventors of all beautiful things." Life classes existed, but with Nature considered "nearly always feeble and puny," human models did not come into their own until the nineteenth century, when, as the following chapters show, they occupied the center of the stage in school and studio alike.

More mechanical means of demonstrating the way the body looked and worked were to hand. There were

Miniaturist at Work in Ghent, late fifteenth century. University Library, Ghent. Made to illustrate a copy of Cicero's *Rhetoric,* this miniature shows the Greek painter Zeuxis combining the best features of five models to produce a portrait of the ideal woman. Above are two other scenes from the life of the celebrated painter: watching young men wrestle, and choosing his five models from a group of virgins.

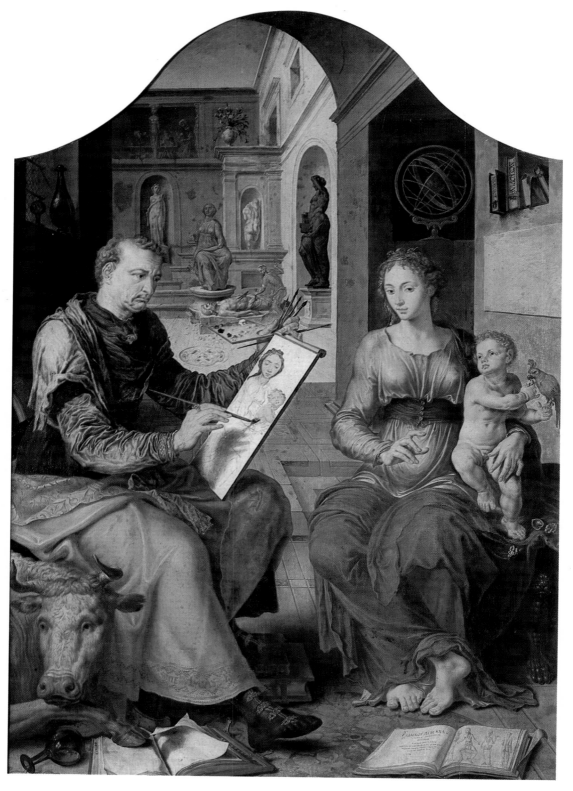

Maerten van Heemskerck (1498–1574). *St. Luke Painting the Virgin,* ca. 1530. Musée des Beaux-Arts, Rennes. Elegantly attired and surrounded by symbols of wealth and learning, this artist is clearly no artisan. Throughout the Renaissance, painters insisted on being considered, like poets, as gentlemen; a few lived as such, but many others continued as heads of small firms or *botteghe,* with skilled assistants to help them execute their numerous commissions. As suggested by the figure in the background, sculpture continued for some time to be regarded as a more manual — hence less elevated — activity.

François Boucher (1703–1770). *The Painter in His Studio*. Louvre, Paris. This remarkably realistic image of a young painter in his studio reflects the natural, integrated role of artists in eighteenth-century society. No longer a trade, art had become a profession, with established rules and a hierarchy. The young man in this nonchalant studio scene was probably a pupil, or even an assistant, of Boucher's, and the painting in progress a copy of the master's *Neapolitan Shepherd*.

Louis-Léopold Boilly (1761–1845). *Young Woman Seated in Front of an Easel*. Pushkin Museum, Moscow. The prominence of antique busts in this charming studio attest to the continuing importance of the classical ideal, yet the atmosphere is suffused with a gentle romanticism. Traditional attitudes as to what was acceptable as subject matter were about to be swept away by the new spirit, and the studio was to become a more private place, where unfettered, personal visions might take form.

Jean Alaux (1786–1864). *Ingres' Studio in Rome,* 1818. Musée Ingres, Montauban. The buxom Madame Ingres pauses at the studio doorway to gaze in at her husband relaxing from the strenuous labors of his art. Ingres, who spent much of his life in Italy — first as a student, then as an independent artist, and finally as director of the French Academy in Rome — played the violin to calm his nerves, which became so frayed while he painted that he frequently burst into tears. Ingres' friend Alaux has emphasized the luminous calm and intimacy of the young master's two-roomed studio in Rome.

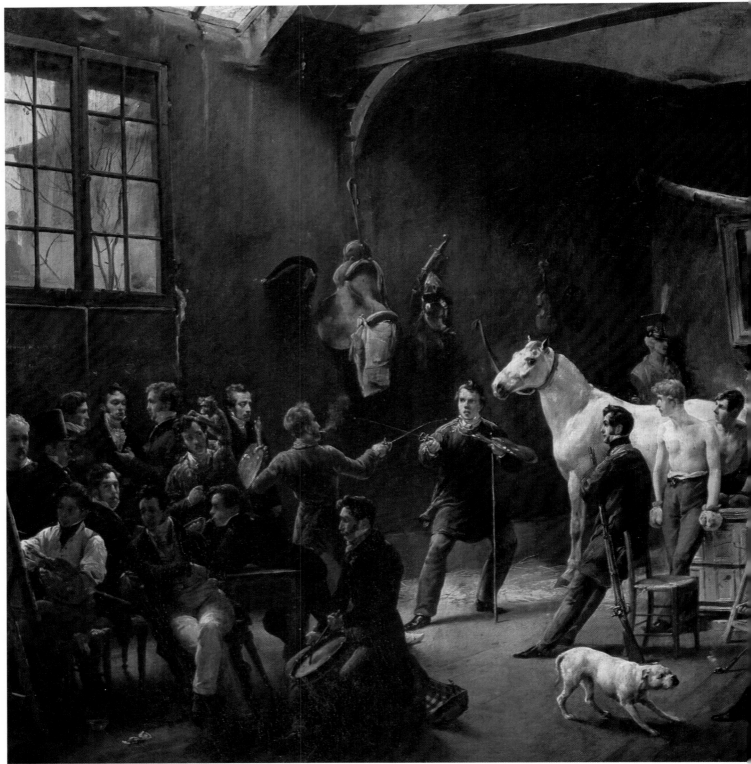

Horace Vernet (1789–1863). *The Studio*. Private Collection, Paris. Dashingly virile, Vernet (fencer on left) balances brushes and palette in one hand while making a thrust with the other. The son and grandson of painters, he was noted for his extraordinary prowess in depicting battle scenes and horses. A taste for factual exactitude led him to fill his much-visited studio with all the appropriate models and trappings, including military music, which roused him to go into painting as into a glorious war.

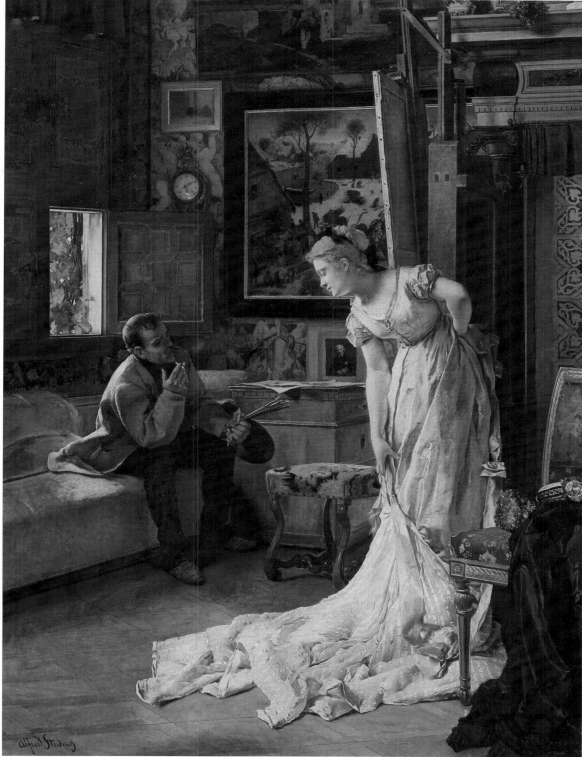

Alfred Stevens (1823–1906). *The Studio,* 1869. Royal Museums, Brussels. Enormously successful in his day, the Belgian-born Stevens settled in Paris, where he became a close friend of Manet and built up a reputation by painting superficially brilliant portraits of fashionable Parisiennes. In this richly furnished studio, a haven of elegant charm with just the right hint of eroticism to suit nineteenth-century middle-class taste, the painter pauses to consider the model's pose. Behind him, the light has been focused by opening one of the four shuttered windows — a method already in use in Rembrandt's Amsterdam studio.

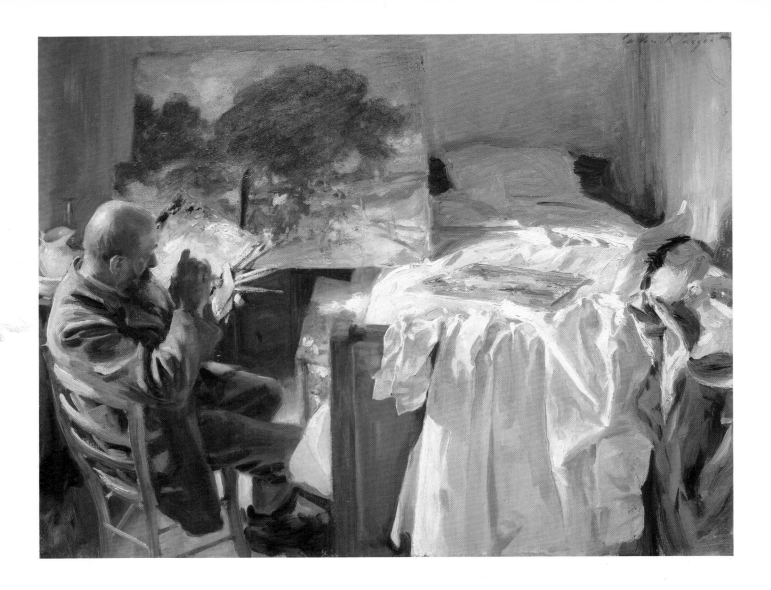

John Singer Sargent (1856–1925). *An Artist in His Studio,* 1904. Museum of Fine Arts, Boston. For all its brilliant virtuosity, Sargent's study of a painter contemplating his work is a sober account of the exalted hopes and bitter disappointments that inevitably accompany dedicated artistic activity. The studio is a partially converted hotel bedroom in Italy, and the painter is shown sunk in shadow as he analyzes his latest *plein-air* compositions.

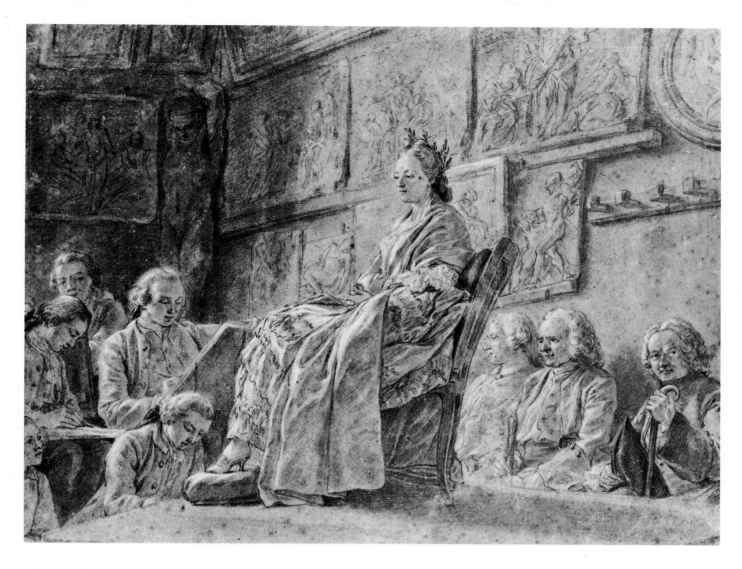

Charles Nicolas Cochin II (1715-1790), The Prize for "Expression" at the Académie Royale, *Musée Carnavalet, Paris. The French Academy trained young artists to create within a set of rigid dos and don'ts. Lectures, courses, competitions, and prizes were all aimed at inculcating a preestablished notion of beauty. This drawing shows students competing to capture the model's likeness — the result to be judged by the Academicians seated behind.*

courses in anatomy and dissection (still current in some art schools until a decade or so ago!) as well as casts of various anatomical sections. There were also articulated wooden mannikins, ranging from a few inches in height to life-size, at which point they are known as lay figures. In use since antiquity, mannikins helped both students and mature artists keep in mind a general idea of mass, proportion, and attitude while working on a human figure without the benefit of a live model. Finally, there were the curiously beautiful "flayed figures": that is, mannikins that revealed the complex interplay of muscle and sinew beneath the skin (see page 44).

In a number of countries, France in particular, academies grew to have as great an importance in artists' lives as the guilds that they had supplanted. While

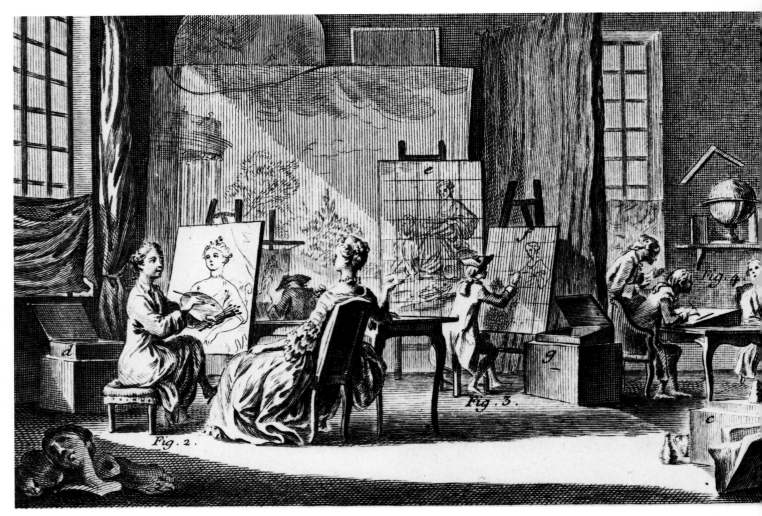

Fig. 2.

Fig. 3.

membership was not obligatory, official appointments and commissions tended to be reserved for academicians, so that artists who did not or could not join might generally reckon on a lean time. The French Academy was distinguished by a particularly strict sense of hierarchy and order in all things. Its members were graded according to the subject of their art. History painters came first, portraitists next, and landscape and genre painters last. The same spirit required that students be kept on a short leash: they began by making many copies of officially admired drawings, graduated to copying plaster casts, and only when they had proved proficient in these were they allowed to draw directly from models. Taste and beauty, art itself, academicians thought, could be broken down into categories and wholly explained. Some idea of the extreme codification that the academy encouraged may be gained from the

treatise written by Charles Lebrun, director of the French Academy, on how artists might best depict human passions. In what he calls "simple love," for instance, "the Forehead will be smooth, the eyeballs shall be turned. The Head inclined towards the Object of the Passion, the Eyes may be moderately open, the White very lively and shining. . . . The Nose receives no alteration." Should an artist want to represent horror, then: "the Eyeball . . . will be drawn down to the under Lid; the Mouth will be open, but closer in the middle than at the corners, which ought to be drawn back. . . ."

Such highly formalized attitudes were occasionally criticized — Hogarth railed against the "ridiculous imitation" in England of the "foolish parade of the French Academy" — but they became current, in modified form, in most other European countries. By the nineteenth century, the academy had a tentacular hold over

both artists and public opinion; for inventive and independent minds, it seemed to bar all horizons with its deadweight of convention. What had begun as a liberating means of association, enabling artists to cast off the constraints of the guilds, had in its turn grown oppressive. The battle between the old academic order and the new romantic urge for unfettered self-expression raged through much of the nineteenth century. The ground on which it was fought, generally in solitude and silence, was the artist's studio. Ivory tower, rallying point, or subversive cell, the studio became, more intensively than ever, the privileged space where ideas and attitudes were made anew.

(Left) Diderot's Encyclopédie *gives this characteristically detailed illustration of the artist's studio in the eighteenth century. Politeness, ease, and learning dominate the spacious room with its practical paint-chests and commodious stepladders for large compositions. Here, to paint was to please. The Revolution did away with such frivolous ideas: a new moral earnestness was about to invade the studio.*

(Above) Delight, *an engraving after Charles Lebrun (1619–1690), Bibliothèque Nationale, Paris. The manual published by Lebrun, director of the French Academy, indicated very precisely how human passions should be drawn. Here is his illustration of what Delight should look like. To succeed, Academy students were well advised to follow prescribed rules rather than anything they saw in nature.*

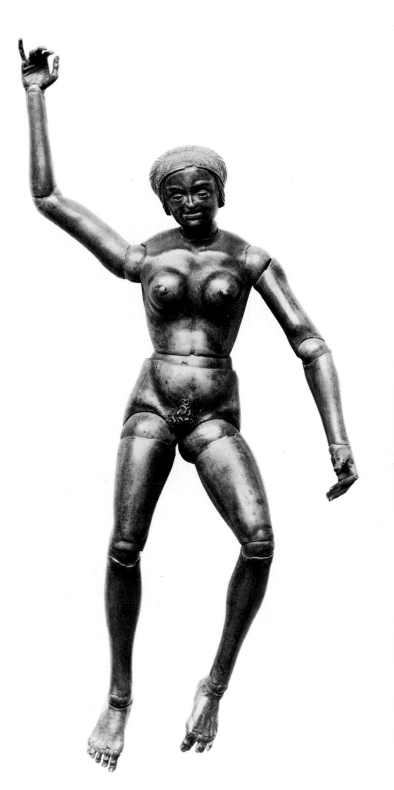

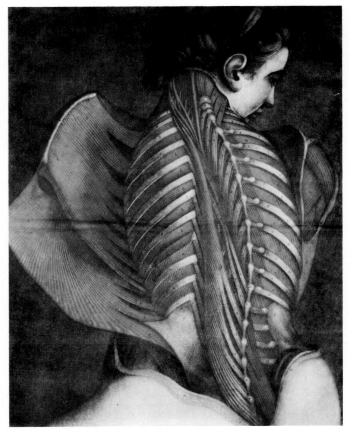

Studio mannikin, southern German, ca. 1520–1530, height 8¾ ins., Staatliche Museen, Berlin. Mannikins of all kinds and sizes were a regular feature of artists' studios from the fifteenth to the nineteenth centuries. They were used to study particular positions and show how a cloak, for example, would fall over folded arms. Live models were expensive and hard to find.

Anatomical engraving by Duverney-Gauthier, 1745, Bibliothèque de l'Ecole des Beaux-Arts, Paris. More visually striking than scientifically exact, this engraving served to instruct both medical and art students. Courses in dissection became part of the curriculum of art schools and continued in many cases until a couple of decades ago.

Drawing Room at the Felix Meritis Academy in Amsterdam, *by Adrian Lelie, 1797, Bibliothèque Nationale, Paris. By the end of the eighteenth century every large European city had its official art school or academy; art had been codified and was often taught by a set of barely flexible methods. This Amsterdam school enabled students to draw either a living model or a "flayed figure" showing the interplay of muscle and sinew in the human body.*

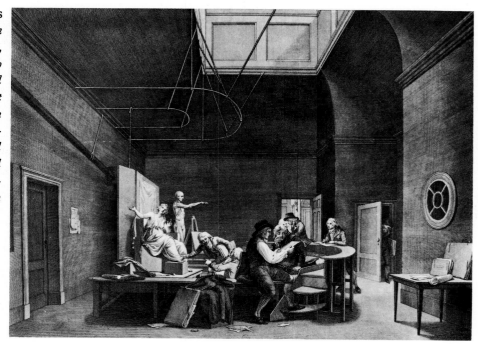

Matthew Pratt (1734–1805), The American School, *1765, Metropolitan Museum of Art, New York. Born in Philadelphia, Pratt was already well established as an artist when he left for London in 1764 to study under his famous compatriot, Benjamin West, whose studio became a home away from home for American painters. Here West is shown standing beside Pratt and commenting on his drawing.*

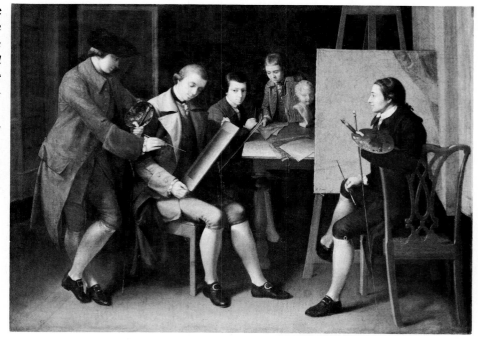

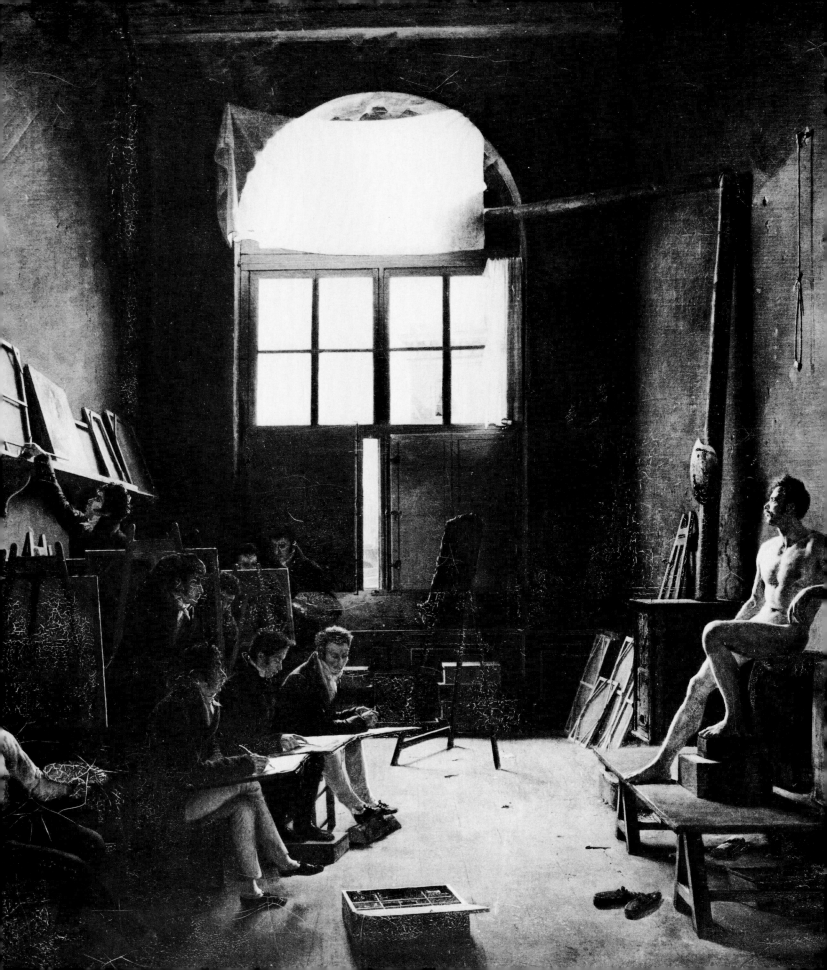

Revolutionaries in the Louvre

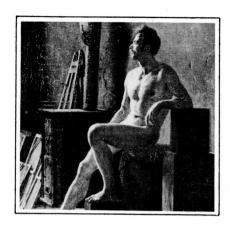

Throughout the eighteenth century, privileged French artists had their studios and living quarters in the Louvre. The custom went back to Henri IV who, in 1608, had made over to the city's foremost artisans and artists the apartments beneath the palace's Grande Galerie, which runs parallel to the Seine. This decision to fortify the "alliance between the fine arts and the nobility" had been well received by the artists. To have a studio in the Louvre was to have "arrived": one lived, rent-free, in a center of power that not only housed the Academy but was also a source of important commissions.

When Chardin, for instance, was invited by Louis XV to take up residence in the Louvre in 1757, he was able to assume quite reasonably that, from then on, he and his second wife would be clear of any pressing financial need. A slow, rather laborious painter in what was held to be a most minor genre, Chardin had known less palmy days. He had been born, the son of a billiard-table maker, in an area of modest artisans and shop-keepers on the Left Bank, opposite the Louvre. When his early attempts at historical compositions failed to please, the young artist tried the less highly considered genre of still lifes and interior scenes. His first studio turned out quite naturally to be the kitchen, where the copper cauldron, pewter plates, and ladles that he quietly immortalized were to hand; he became locally famous for such compositions, and friends would actually come around with a fresh rabbit or fish for him to paint. Full of admiration for his painterly skills, fellow artists

bought his work now and then. But times were hard, and on one occasion Chardin exchanged a painting to have a coat to put on his back.

Some improvement in his material circumstances has been deduced, amusingly enough, from the fact that the potatoes and onions of the first period were supplanted by spices, melons, and strawberries. But the first major development in Chardin's career came when, as a result of the attention his work had attracted in the Place Dauphine's large and informal annual open-air exhibitions, he was elected to the Academy. For nearly twenty years, he was the Academy's treasurer and the person in charge of the delicate task of hanging the members' pictures in all its exhibitions. A second marriage, to a widow of means, brought added prosperity, but Chardin continued to live modestly. His studio above the family apartment on the rue Princesse was a simple room divided by a partition, with a working area on one side, and a space to receive the occasional client on the other; opposite, on the same landing, was that fount of inspiration, the kitchen.

No one appears ever to have seen Chardin at work. Because his production, particularly when he was young, had been small and his range limited (he often made several copies of one still life), he gained a reputation for laziness. In fact, he worked slowly and painstakingly in the privacy of his modest room, building up his layers of scumbled color in one small area after another and using his thumb (according to Diderot, who had not seen him at work either) to tamp down the pigment

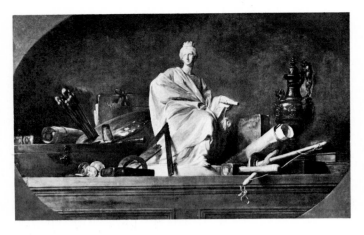

Jean Baptiste Siméon Chardin (1699-1779), The Attributes of the Arts, *1765, Louvre, Paris. An eminent member of the French Academy and the beneficiary of spacious lodgings in the Louvre, Chardin was particularly conscious of the hard-won dignity surrounding his profession as artist. As with his more homely still lifes, he made several paintings on this and such related themes as the attributes of music and science, treating each in the same serenely emblematic manner.*

when it was almost dry. That privacy was maintained when the artist moved to his four-bedroomed apartment at the Louvre and found himself living among old friends, for not even they, it seems, were allowed to discover how this exquisite craftsman achieved the profound brilliance and harmony of tone that made great art out of the most commonplace scenes.

Another, more open and gregarious inmate of the Louvre was Fragonard, whose studio became a miniature museum of the taste of his time. For a few months he had been the pupil of the temperamentally quite dissimilar Chardin, who thought little good of him. The young southerner then studied under Boucher and won the prize that enabled him to round out his education at the French Academy in Rome. A budding reputation as a history painter in the grand manner assured him of election to the Academy, after which he turned to the lighthearted, erotic themes that better suited his temperament. His constant good humor, ready wit, and ability to burst into song for no apparent reason endeared the *"petit papa Fragonard"* to the Louvre's artist community — which by then was several score strong. His wife,

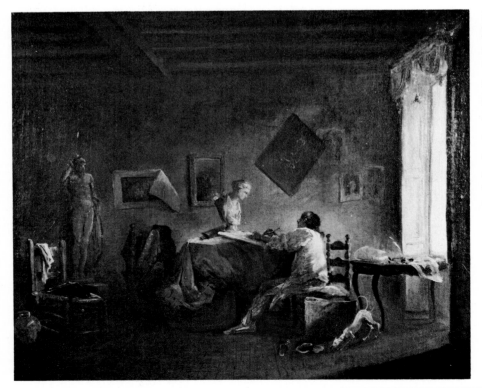

Hubert Robert (1733–1808), The Painter's Studio, *Boymans van Beuningen Museum, Rotterdam. Called "Robert of the Ruins" because he specialized in nostalgic scenes of crumbling classical monuments, Hubert Roberts shows his casually clad artist sketching a bust to exercise his graphic powers. With its jumbled clothes and pictures hung awry, the ordinary room that serves the artist as a studio has the charm of authentic intimacy.*

a proficient miniaturist, was given a wide berth as a battle-ax, however; her far younger, prettier sister, Marguerite Gérard, who had formed part of the ménage since childhood, was to become the passion of Fragonard's later life. She was also his pupil and his model, either posing or painting in his studio every day. Good professional models were not easily come by, and when Fragonard was painting female figures, he often also referred to the scores of drawings he had made of an actress with whom he had had an earlier, stormy liaison.

Being well in favor and prosperous, Fragonard lived quite lavishly (insofar as his wife, whom he called "the

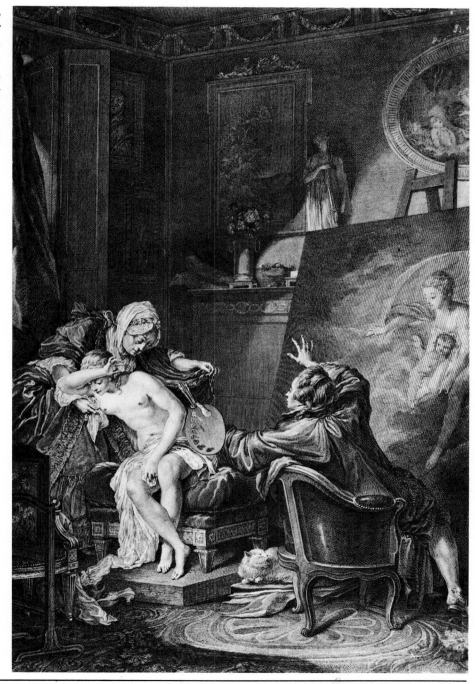

Jean-Michel Moreau (1741–1814), The Honest Model, *engraving after J.-F. Schall, 1770, Bibliothèque Nationale, Paris. Models disposed or indisposed in the artist's studio were a favorite subject for lighthearted eighteenth-century painters. Here the model turns from the artist's enraptured gaze while a chaperone begins to clothe her startled nudity.*

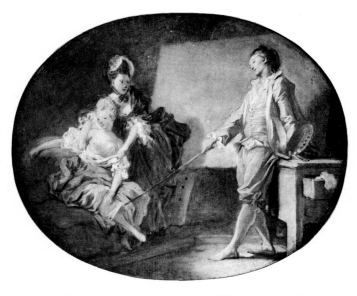

Honoré Fragonard (1732–1806), The Model's First Session. *Musée Jacquemart-André, Paris. A great lover of gaiety and ladies, Fragonard indulges in wishful thinking by showing himself as a young man lifting the skirts of his model, Marguerite Gérard — who was also his pupil and sister-in-law, living with the painter and his redoubtable wife in the artists' colony that occupied part of the Louvre.*

Fragonard, Visit to the Studio, *Bibliothèque Nationale, Paris. The crowds of relatives, friends, and idlers who clustered around the artists' studios at the Louvre contained a sprinkling of serious art experts and collectors. Most sales were made in the studio, where even the busiest artist found time to show his work to a prospective client.*

cashier," allowed him to) and his studio had a certain air of luxury. Like his master Boucher, he had built up a connoisseur's collection of engravings, paintings, and objects, some of which he had brought back from Rome. The walls were decorated by Fragonard himself, and the furnishings were those of a fashionable salon — except for the swing that the amiable artist had installed. Visitors to this easygoing, joyful studio included not only the prominent artists of the day but men of letters, such as Fragonard's friend Diderot, and a number of influential patrons. Their presence never prevented him from working, for along with his gay exuberance Fragonard possessed unusual facility. He excelled in every technique, from pastel to engraving, and was known to have dashed off at least one fine portrait in an hour.

The frothy abandon of Fragonard's scenes, with their implicit celebration of the *ancien régime,* militated against him once the Revolution got under way. Ruined and with no future as an artist, he was briefly employed as a museum consultant; but he died penniless and forgotten. The Louvre as Fragonard had known it in his heyday had been a lively, gregarious place, where a whole family might live with only a partition separating them from their neighbors. Schools of pupils and hierarchies of relatives and children had trooped daily in and out of the studios, accompanied by occasional clients and a fair sprinkling of idlers. During the Revolution, this happy-go-lucky situation was precipitated into chaos. A horde of new artists laid claim to studios in the former royal palace, thus doubling the number of residents. Walls were pierced, stairways sealed over, and corridors appropriated: anarchic constructions mushroomed throughout the vacated space, until the building became structurally unsound at certain points. Nevertheless, out of this chaos, there emerged a man whose capacity to direct the course of art has rarely been equaled.

To say that Jacques Louis David formed a whole generation of painters in his rooms at the Louvre would be an understatement. He molded them, eye and soul, to a set of rigorous beliefs. Within a few months, the studio of objets d'art, courtesans, and erotic banter had been definitively banished; as if to underline the fact, Fragonard's son, who was studying with David, burned his father's collection of engravings in the name of

The Painter's Studio, *attributed to Marguerite Gérard (1761–1837), Musée d'Art et d'Industrie, St.-Etienne. Panache does not preclude expertise and a certain lightly worn learning in this portraitist's artistic snuggery. Against a background of antique statues, solemn tomes, and a globe, everyone poses — not only the subject, but her fiancé and family, and the enraptured artist too.*

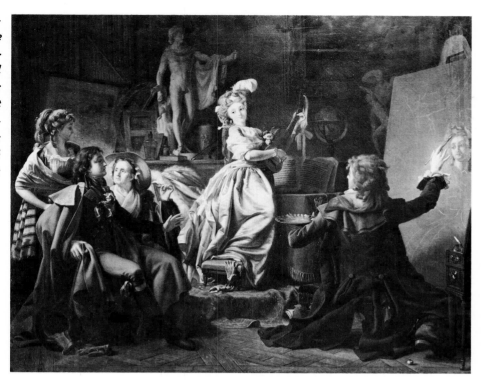

Louis-Léopold Boilly (1761–1845), Houdon's Studio, *1803, Musée de Cherbourg. The famous French sculptor stands in slippers surrounded by his artistic triumphs: Voltaire seated in a chair, and behind, on the shelves, busts of Molière, Benjamin Franklin, and Catherine II of Russia. A fine model and two students complete this precisely detailed scene.*

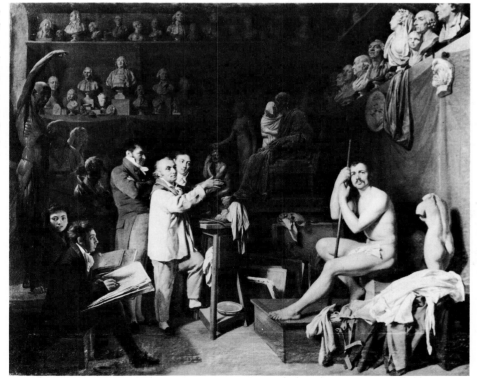

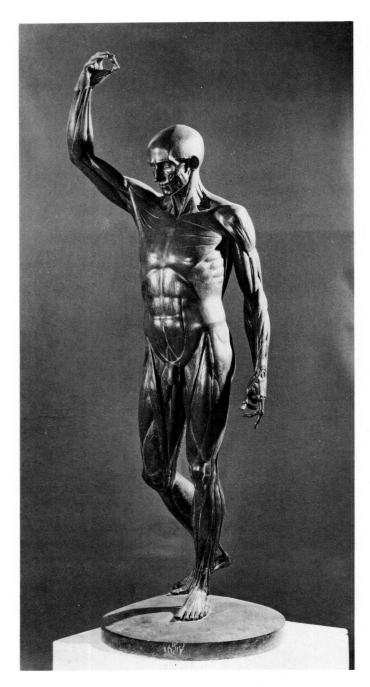

Jean-Antoine Houdon (1741–1828), The Flayed Figure, *Ecole des Beaux-Arts, Paris. Visible in the preceding illustration, this most famous flayed figure of all was originally made as a sculpture of St. Bruno. It demonstrated the interplay of muscle and sinew so well, however, that copies of it for the use of students appeared in academies and studios throughout the nineteenth century.*

"good taste." A new moral seriousness dominated. The purpose of art was not to please a decayed aristocracy, but to educate and inspire the people. Noble images, according to a tradition that went back to Greece and Rome, bred noble thoughts. As leader of the arts, David was calling for pictures of "heroism and civic virtue," which would "electrify the [people's] soul, and plant the seeds of glory and devotion to the fatherland."

Besides his own atelier, this "Napoleon of the arts" had two teaching studios at the Louvre. One was called the "Atelier des Horaces" because it contained the famous *Oath of the Horatii,* which, having drawn huge crowds when exhibited in Rome and Paris, established David as the head of the new school of harder, purer thought. This room, according to a pupil's description, was forty-five feet long by thirty wide: painted olive gray, it had a single window nine feet high. The most prominent feature was the bulky stove, center of attraction in winter for naked models and pupils alike; responsibility for keeping it alight fell to the latest "new boy" in the class. The furniture consisted above all of antique copies specially made to serve David and his followers as a guide for their classical interiors. Apart from a yellowing palm tree, the studio had a most traditional range of aids and devices: mannikins of various sizes, plaster casts of the body and copies of antique heads or statues. Tunics and togas were also much in evidence, according to an English visitor, for whom the atmosphere of the room recalled the "finest hours of Greece."

The "Atelier des Elèves," the other teaching studio on the floor above, was similar except for a dais on which the model posed. Exactly what position the model should take at the beginning of each session was hotly debated by the pupils, since the pose would be the focal point of their new study and open to moral or narrative interpretation. Often David was asked to make the decision. Work then got under way, with the pupils engaged in drawing seated nearest the model, while those who were painting stood behind them at their easels. From time to time, David did the rounds and commented on each student's effort. His judgments tended to be brief and categorical, with special scorn being meted out to anything that reminded him of the way art had been taught at the Academy (which, as the Revolution's

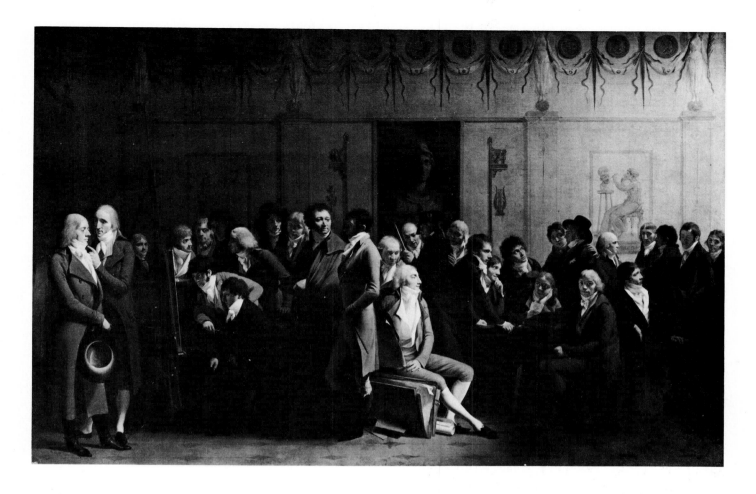

Louis-Léopold Boilly, Meeting in Isabey's Studio, *1798, Musée du Louvre, Paris. Before the Revolution, Eugène Isabey had painted frivolities; after having been threatened with the guillotine, however, he let his republican convictions come to the fore. The elegant disorder and picturesque charm of Robert's or Fragonard's studio has given way to the neoclassical severity of Isabey's, where Directoire notables gather for discussion.*

leader of the arts, he had abolished). "Look at those arms," he would say. "They look as though they had been strung up by strings, the way models were kept strung up in impossible postures at the Academy." He would then make more general observations or talk about the problems he was encountering in his own work. Occasionally, much to the students' delight, David would inspect the latest caricature — usually of one pupil by another — to have appeared on the atelier's paint-splashed and graffiti-covered walls.

The Louvre studios became a legend in David's own lifetime. To be able to call oneself an *élève de David* was a privilege coveted by a host of zealous young artists, and at one point David was taking in about sixty pupils, for half of whom he generously waived all fees. Part of his great aura derived, of course, from his proximity to power and the unique position he filled. Under Robespierre, he had been responsible for all major decisions concerning the arts, including the extensive visual prop-

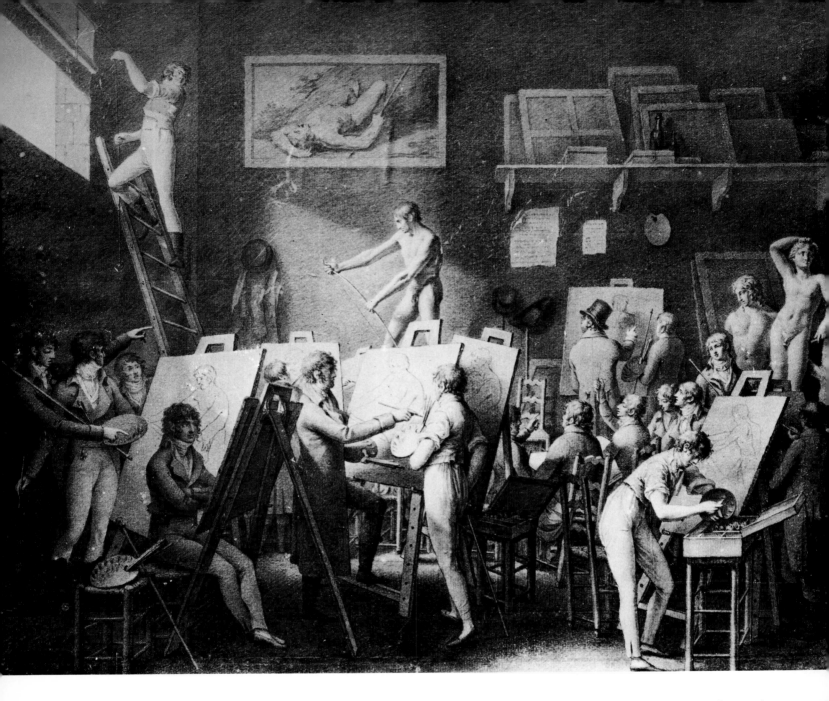

aganda that accompanied Revolutionary celebrations such as the Feast of the Supreme Being. Under Napoleon, he was established as *Premier Peintre* and so entered the most fruitful artist-patron relationship of the age. While Bonaparte had been characteristically quick to perceive the advantage of having a renowned painter record his acts and deeds, David saw in him not only the emperor but all the ancient virtues incarnate. "O my friends," he exclaimed one day to his rapt pupils, "what a beautiful head he has. It is pure, it is great, it is as

Jean-Henri Cless, David's Studio, Musée Carnavalet, Paris. David's two teaching studios at the Louvre (he had a third for personal use) were the hub of artistic activity after the Revolution. Here, amid Greco-Roman models (on one of which a student is adjusting the light), an entire generation of French artists was formed in the belief that the purpose of art was to educate and elevate the beholder by scenes of exemplary conduct.

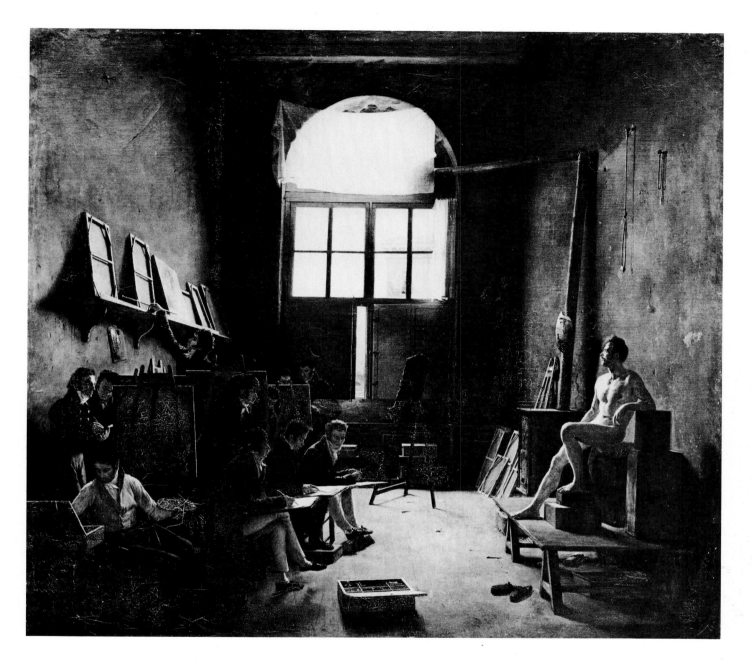

Léon Cochereau (1793–1817), Inside David's Studio, *ca. 1814, Musée du Louvre, Paris. Painted by a pupil of David's, this picture provides an excellent eyewitness account of the master's studio in what is now the French Institute (on the Left Bank, opposite the Louvre — from which all resident artists had recently been evicted). No frills can be found in this place of dedicated study where students sketch and paint a model called "Polonais," who was much sought after for the elegance of his body and his unblemished skin.*

beautiful as the antique. There is a man to whom altars would have been raised in ancient times."

The impatient conqueror, who once allowed David fifteen minutes to seize his likeness, kept his First Painter fully occupied. David was commanded to record the most "memorable occurrences" of the emperor's reign: *Napoleon Crossing the Alps,* the *Coronation,* and *The Emperor Distributing the Eagles* provide ample proof of the artist's willingness to obey. Studios in which to execute a work on the scale of the *Coronation,* which contains over a hundred individual portraits, were hardly easy to find. In fact, they had to be created; and David, who was used to working in all circumstances, set up his atelier in a church — first at the Eglise des Feuillants, near the Tuileries Gardens, and then at the Eglise du Collège de Cluny, beside the Sorbonne, which the Minister of the Interior had hired specially for him. Almost four years' work went into this huge composition. David had been present at the crowning ceremony, but as he planned the painting he also kept by him engravings of previous coronations, such as Louis XIV's at Rheims. To help him decide on the overall distribution of his enormous cast, he used a device similar to one that Poussin had made famous: inside a maquette of the choir at Notre-Dame, he placed numbers of tiny figures, moving them around until he found the positioning and the lighting effect he required. Once the *Coronation* was completed, Napoleon and his court visited David in his church studio. An awesome silence reigned while the emperor walked slowly up and down in front of the thirty-foot-long picture, examining every detail. Finally, he turned and said: "Well done, David, very well done! You have correctly guessed my own intention in representing me as a French gentleman. . . . David, I salute you."

The only other artist in Europe to have gained a following and a prestige comparable to David's was Antonio Canova. This immensely successful sculptor had established his skills at such an early age that by the time he was seventeen, in 1774, he owned his own workshop. While still very young, he had been converted (the term scarcely exaggerates the importance of the change) to neo-classicism. This new, severely simplified style of sculpture spread rapidly through Europe, and Canova

Napoleon Visiting David in His Studio, *lithograph by Emile Lassalle (1813–1871), Bibliothèque Nationale, Paris. To execute his huge painting of Napoleon's* Coronation, *David set up his studio in a church. After nearly four years' labor, the picture was completed. Napoleon, accompanied by his court, carefully inspected the work, then warmly congratulated his First Painter.*

became its most sought-after practitioner. At the height of his career, he was sufficiently famous for a visit to his huge sculpture establishment to be considered a "must" by all important travelers to Rome — so much so that its entrance was regularly thronged with carriages and liveried attendants. The studio itself, a German admirer reported, was made up of a "number of large halls" in which "one finds all the sculptural works together that are being done in Rome nowadays." Their combined effect, the report continues, evoked "the workshops of the ancients in which the images of the gods and heroes of the Greeks were created." Thus antiquity, to contemporary eyes, had been reborn in the artist's studio, even though Canova considered himself very much more than the artisan that his Greek ancestor had been. Access to the outer halls, where assistants toiled with hammer and point amid blanching clouds of marble dust, was easy enough; but few visitors entered the

Francesco Chiaruttini (1748–1796), Canova's Studio, 1786, pen and wash, Museo Civico, Udine. Master of the greatest sculpture workshop of his day, Antonio Canova fashioned the clay models for his new works and left their actual carving to highly able assistants, intervening only to give the finishing touches. A tour of his impressive establishment was considered a "must" by all fashionable visitors to Rome.

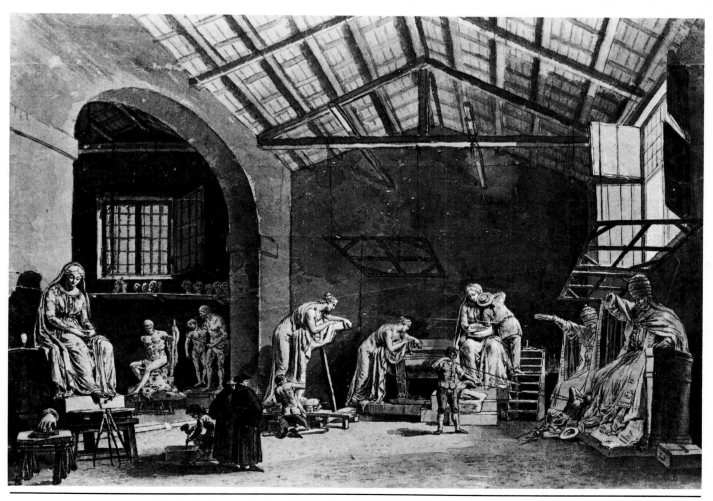

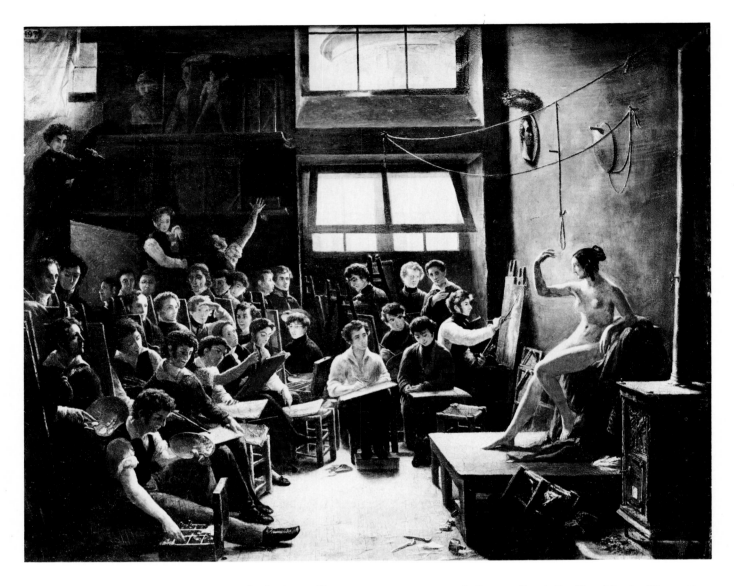

room where the master himself worked. According to several observers, including Stendhal, Canova concentrated on fashioning the models for new sculptures — first in wax, and then, life-size, in clay — but delegated the actual carving to his studio hands, who ranged from simple marble-cutters to established masters. Only at the very last stage did he intervene to give the *ultima mano* — the final polishing, which he usually undertook at the end of the day, by candlelight. Canova's patrons included Napoleon, of whom he did many busts and two nude statues. The volume of work which passed through the studio was huge and included such impressive foreign commissions as a *George Washington* for the state capitol of North Carolina.

Auguste Massé, Baron Gros' Studio, *Musée Marmottan, Paris. As David's most devoted follower, Gros organized his studio along the same lines as his master. Painted by one of Gros's pupils, this charmingly naive picture underlines the students' rapt attention. The model, seated on the dais (traditionally near the stove), has been asked to take up a rather difficult pose. To maintain it, she will probably have recourse to the overhead ropes, designed for that purpose.*

"Go and see the seductive worker of marble frequently," David advised his pupils before they set out for Rome, "but beware of copying him, for his false, affected manner is calculated to lose a young man." The Revolutionary studio echoed with cautions against straying off the path of high-purposed, classically inspired art. Fervor to demonstrate purity of ideal led some of David's pupils to indulge in absurd affectations. A group calling themselves *les Primitifs* grew their hair long, donned Greek-style cloaks, and recited Ossian — believed to be a third-century Scots bard, then found to be a contemporary, James Macpherson — by moonlight in the Bois de Boulogne. Although a prime advocate of the importance of line over color in painting, David disapproved of the exaggerated linearity and anemic tints of their now-forgotten scenes of antique or bardic grandiloquence. His disappointment was far keener, however, in the case of Anne-Louis Girodet and François Gérard, two clearly gifted students who, in his view, had betrayed the "true style" by consciously seeking "poetic" effect and concentrating on the minor genre of portraiture. Thus he was all the more insistent that Antoine Gros, his most dedicated follower, should devote his energies to the grand task of history painting. "Hurry, hurry, my dear friend," David wrote from Brussels, where he had gone into exile after Napoleon's fall, "thumb over your Plutarch and choose a subject familiar to everyone." But the temper of the time had already changed. Martial valor and civic fortitude, the themes that had dominated David's studio, no longer had the same capacity to inspire; more exaltedly individualistic and emotive subjects fired the new generation. In Gros, the two currents conflicted so fiercely that, although he had succeeded in a romantic vein, he felt compelled in later life to revert to Davidian classicism. He fell completely from public favor as a result and committed suicide.

The most successful of David's pupils was undoubtedly Ingres, who established a style and an artistic theory that became one of the great defining influences of the nineteenth century. This brilliantly endowed, complex, and contradictory man was born under the *ancien régime,* in 1780, and lived until 1867, thus witnessing the Salon des Refusés and the first stirrings of Impressionism. David must have thought well of him, since he had

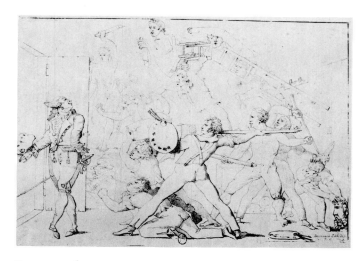

Return of the Royal Academy, *ca. 1814, lithograph by Pierre-Nolasque Bergeret, Bibliothèque Nationale, Paris. Having been abolished by David during the Revolution, the French Academy was reinstated in 1816. Any semblance of a return to the ways of the* ancien régime *(represented by the figure on the left) was hotly opposed by David's pupils, who, in this satirical lithograph, arm themselves with studio equipment to defend their republican ideals.*

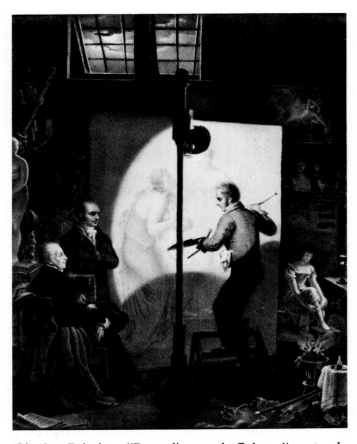

Girodet Painting "Pygmalion and Galatea," *copy by Adèle Chavassieu of a painting by François Dejuinne, Civica Galleria d'Arte Moderna, Milan. Girodet, another of David's outstanding pupils, frequently worked by artificial light. In this dramatized scene, the young painter mounts his ladder under the benign gaze of Count de Sommariva, a noted collector (seated), while a model puts on her stockings.*

the young Ingres paint both details of furniture and parts of the figure in his famous *Madame Récamier*. He changed his mind later and pronounced Ingres "mad," complaining that in his former student's drawings "the necks have goiter, joints are disconnected, and arms and legs a third too long or too short." David's judgment may well have been influenced by the discovery that yet another of his gifted pupils had strayed from the path of true art by hankering after subjects in which stoic virtues were not always to the fore. It is, of course, as a consummate draftsman that Ingres marked the artistic thought of his time. "Drawing," he once stated, in a famous phrase later inscribed in art schools the world over, "is the probity of art." That line should always dominate color in a painting was the basis of Ingres' creed, his raison d'être as an artist, and he propagated it by every means. His insistence was such that at times it seems as if he were clinging to line for moral support as the disquieting forces of Romanticism swirled up around and inside him.

Ingres spent a good deal of his long life in Rome (see illustration page 29), first as a student and a struggling young artist, and later as director of the French Academy there. When he came to set up his studio in Paris, he would have looked, like so many of his predecessors, to the Louvre as both the cheapest and the most prestigious address. But the chaotic Revolutionary interlude during which ateliers of every kind and activity had sprung up inside the old palace was at an end. By the first few years of the nineteenth century, the interior had become a shambles and a suspected center of political (that is, anti-Napoleonic) intrigue, while the gardens were famed as an open-air brothel. The emperor inspected the building in 1805 and brusquely ordered its evacuation: "Get them out of there!" Thus an army of artists had to find new quarters. Empty convents provided studio space for some, while a hundred others were lodged with their families in the Sorbonne, which was renamed the Museum of Arts. The Sorbonne remained a gigantic artists' hotel for twenty years, acquiring a reputation for conviviality marred at the very end by the dramatically horrible suicide in 1821 of Constance Mayer, pupil and mistress of Prud'hon, who had become famous as court painter to Napoleon's empresses. Ingres himself worked for a time in a convent, the Couvent des

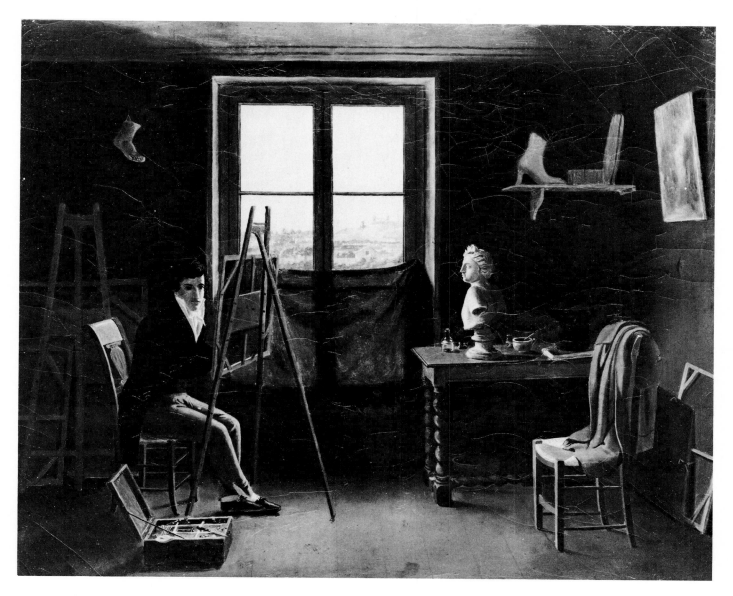

Léon Cochereau, The Artist's Studio, *ca. 1815, Musée des
Beaux-Arts, Chartres. This young artist, whose painting
of David's studio has been reproduced on page 47, died
in his mid-twenties. His own studio, which he painted for
a patron, denotes eager application and slender means.*

Capucines, before finding a more conventional studio, in 1825, on what is now the rue Visconti, on the Left Bank, close to the Seine. His working methods were characterized by regular, unsparing application and criticism; he painted with unusual speed, then repeatedly reworked certain passages, convinced that a new, unsurpassable perfection lay just within grasp. After a strenuous bout of painting, he would relax by playing the violin (a fact so widely known in France that a *violon d'Ingres* has come to mean a hobby). But nervous tension frequently caused him to burst into tears. One of his most famous sitters, Louis Bertin, recalled that while his portrait (now in the Louvre) was being painted, "Ingres would be weeping and I consoling him." When visitors came into the studio of the highly strung master to watch him at work, he would sometimes exclaim, "It's enough to make you weep," and proceed to do so.

Ingres' particular sensibility recoiled in terror at the well-established belief that art students should possess the rudiments of anatomy, dismissing that hard-won achievement (for which Renaissance artists had been obliged to steal corpses) as a "chose horrible." There was no point, he insisted, in an artist's knowing what he could not see. A number of the pupils whom he taught in a studio adjoining his own clubbed together to buy a skeleton as a means of learning more about the human figure. But Ingres froze at the very sight of it, and refused to enter the room until the offending object had been removed. Even though he came to be regarded as a pillar of the Establishment, Ingres professed the greatest distrust of most official forms of art education. "Don't go to the Ecole des Beaux-Arts," he would admonish his pupils, known collectively as *les Ingres,* "it's a place of perdition. Or if you have to, go through without looking to right or left." His own teaching program was easily summed up in the words with which he greeted each new pupil to the studio: "We will begin by drawing," he used to say, with the air of someone who was hiding a present behind his back, "we will go on drawing, and then we will continue to draw." What impressed his students most was the way the master corrected their sketches — with such incisive strokes of his thumbnail that they cut through the paper.

"Is my influence good?" Ingres once asked himself rhetorically, while director of the French Academy in Rome. "Yes, excellent! Yes, the best ever! Would these miserable enemies of mine, these crooks and hypocrites, prefer to have bad doctrines prevail? They are still smarting from the deep wounds which the truth and beauty of mine have inflicted on them. . . . It is impossible that the public will not, at long last, prefer me to them." Aggressive self-justification remained typical of Ingres even at the peak of his official success, which included being elected to the French Senate. Like his own master before him, this passionate advocate of linearity condemned all artistic development that did not correspond to the rules he had laid down. For Ingres, to give one's imagination and feelings full rein through the voluptuously expressive means of color, as Delacroix did, amounted to an unspeakable depravity. And yet it was just such a dangerous taste for color that was to revolutionize attitudes to art once again and remain the chief preoccupation of most leading studios for the rest of the century.

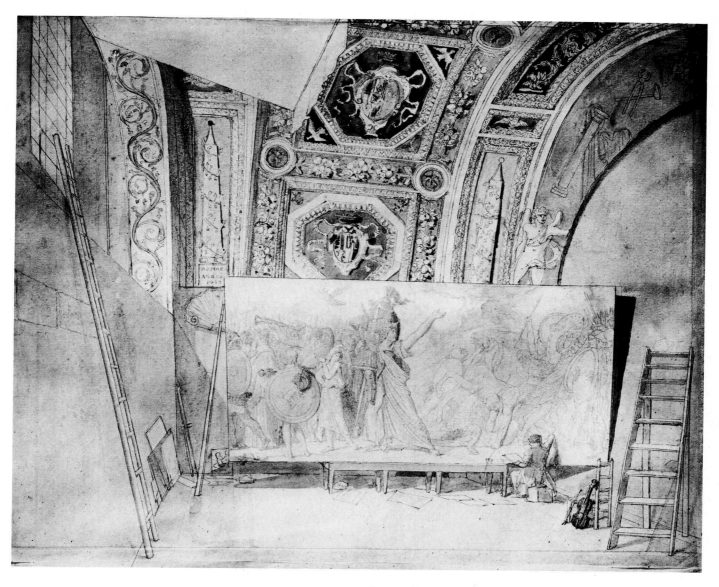

Jean Auguste Dominique Ingres (1780–1867), Self-Portrait in Santa Trinità dei Monti, *ca. 1812, Musée Bonnat, Bayonne. Faced by the problem of finding a sufficiently large studio to execute his* Romulus Conquering Acron, *Ingres adopted David's solution and set to work inside the impressive Roman church of Santa Trinità dei Monti. Behind him as he works is his celebrated violin, which he played for relaxation from the intense nervous strain of painting.*

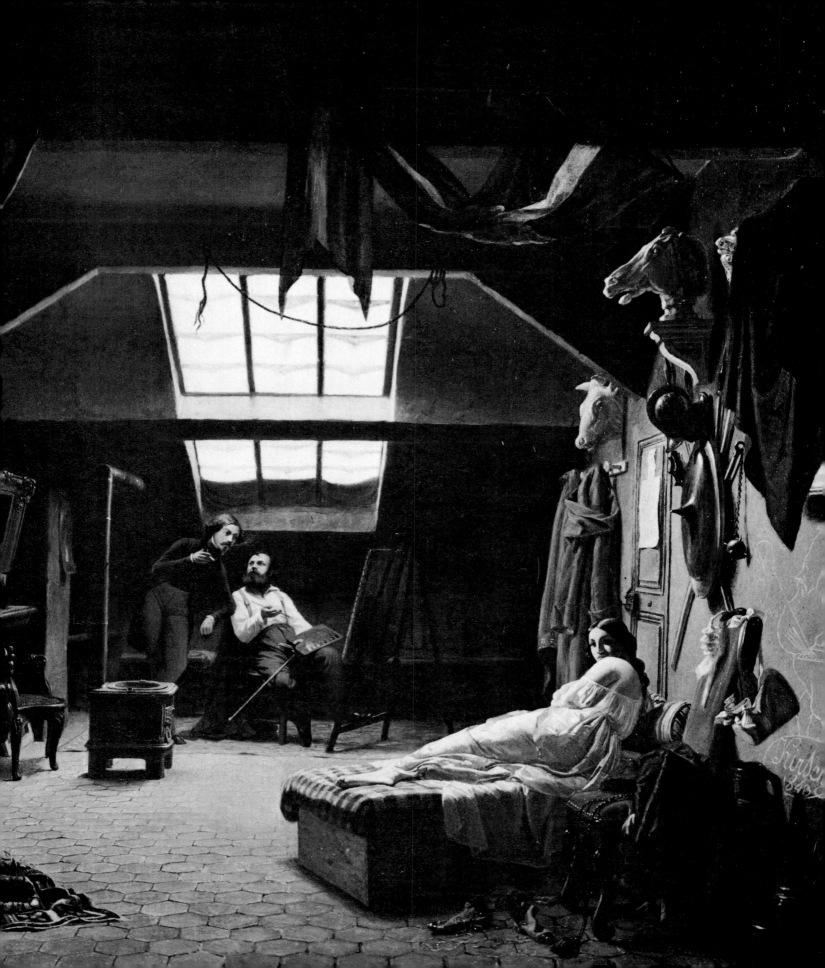

Romantic Cell, Realist Atelier

Do you know what a painter's studio is,
Bourgeois reader?
 It is a whole world;
A universe apart with nothing to recall
The world we live in.

 THEOPHILE GAUTIER, 1831

Barely a generation separates the sternly moralistic, classicizing attitudes of David's atelier at its most influential and the new myth of the artist as a being apart, beyond the gross incomprehension of the crowd. If we believe Gautier, himself a painter before he turned to poetry, and many other leading writers of the time, an abrupt transformation had taken place. Gone the socially conscious, enthusiastically didactic studios born of the Revolution, and in their stead private rooms, closed to all but the initiate, where dreams such as no one had ever glimpsed struggled to be born. It was partly true, and partly the effervescent mystification that accompanies new movements like spray over a wave. The most important studios of this period assimilated the most diverse influences from past and present, whether they were called classical, romantic, or realist. Tradition and everything that was new in art met, to take one outstanding instance, in the studio Géricault rented specially to execute his greatest painting, *The Raft of the "Medusa."* With his dandyish approach to life, his love of exalting action that alternated with a morbid melancholia, Géricault was the prototype of the romantic artist. But to prepare and complete the *"Medusa,"* this handsome, rich, and successful young painter went to work with a brutal determination and sense of exactitude that set him and the conventional notion of the romantic creator poles part.

Before beginning on his ambitious subject (a shipwreck involving cannibalism, which had created a national uproar), Géricault studied all available informa-

tion about the event, interviewed the survivors, and had one of them, a carpenter by trade, build him a scale model of the ill-fated raft. Then he chose a large studio, between Paris itself and what is now the suburb of Neuilly. It stood opposite a hospital. Géricault had already made frequent visits to the Paris morgue in order to accustom himself to the sight and smell of corpses, some of which he drew. From the hospital, he obtained a variety of severed heads and limbs, which he kept in the studio to observe the effects of decomposition for the bodies he was to paint strewn over the raft. Some of these gruesome specimens he kept under his bed, greatly to the discomfort of his assistant, who slept in the same room.

Then, to fortify his resolve to remain locked up in this grim setting until the huge composition was complete, Géricault shaved off his blond hair — no mean sacrifice for a gallant who used to have it curled each time he went to a ball. And for eight months he hardly stirred from the corpse-infested space, laboring from daybreak to dusk, obsessed, in his own words, "to shine, to illuminate, to astonish the world." In the actual execution, he took considerable risks. Instead of making the traditional preparatory sketches for every section, he simply transferred a contour sketch onto the canvas, then painted each figure directly from a specially hired model. The fast-drying oils he used prevented him from going back over what he had already painted, so that each brush stroke could be considered crucial. Having climbed up his painting ladder, Géricault would first

Théodore Géricault (1791–1824), Portrait of an Artist in His Studio, ca. 1818, Louvre, Paris. Determined "to shine, to illuminate, to astonish the world," Géricault became the very prototype of the Romantic artist, daring, passionate, and doomed to an early death. The skull and anatomical fragments in this eloquently direct portrait recall the artist's special interest in depicting scenes of death, disease, and insanity.

stare long and hard at the model, then begin to work up the corresponding figure with an intensity that riveted the few onlookers allowed into the room. When he had finished one of the bodies heaped or sprawled across the raft, he began on another, so that piece by piece an awe-inspiring tumult of flesh sprang into existence on an otherwise virgin canvas. The effect, according to one of the artist's young followers, was of a vast, roughly blocked-out sculptural frieze, and it worked so powerfully on Delacroix, seven years Géricault's junior and a passionate admirer, that he bolted out of the studio and ran home like a man possessed. Overcoming tremendous self-doubts, Géricault had the *"Medusa"* ready for the Salon of 1819, where it created a sensation. One critic saw it as a desecration of the finest ideals in art, and he cried out in his review: "David, where are you?" But for the rising generation, it announced art's renewed potential as a direct expression of the times.

Before taking up his vigil in the *"Medusa"* studio, Géricault had lived at the foot of Montmartre, in an area nicknamed La Nouvelle Athènes, which had recently become fashionable for young artists and writers. His garden there adjoined a studio that was the opposite not only of his own but also of Gautier's "universe apart with nothing to recall / The world we live in." It belonged to Horace Vernet, Géricault's mentor, born the son and grandson of successful painters in his father's lodgings at the Louvre — and it had everything to recall "the world we live in," from social braggarts to pretty flirts, to say nothing of obstreperous animals (see page 30). A dab hand at horses and battle scenes that were prized for their unprecedented realism, Vernet dazzled his throngs of visitors by the ease and vigor with which he painted — gifts that eventually won him the director-ship of the French Academy in Rome. Not unlike David Hockney or Andy Warhol today, he was capable of working amid all kinds of distractions that others (notably Géricault, who could not bear so much as a whisper in the studio) would have found maddening. With a "sportive monkey or a hind" attached to his easel, one admirer records, Vernet was regularly to be seen "handling his palette and his gun in turn, smoking like a Spaniard, singing like an Italian, fencing with his foils . . . shooting his pistol or starting a boxing bout." This whirlwind of energy went as far afield as Africa and

Anonymous, The Painter Léon Cogniet in His Studio with a Pupil, *Caisse Nationale des Monuments Historiques, Paris. Elegantly posed against the ladder he employed on particularly large compositions, Léon Cogniet (1794–1880) was enormously famous in his day both as a painter and a teacher. Meissonier studied briefly in his atelier, represented here in its most Romantic aspect; and Delacroix became a close friend of this now forgotten master.*

Mexico to study battle sites before tackling them in paint. As soon as he returned, his spacious atelier was besieged by old friends, enabling him to resume work amid "military commands, drum rolls, horn calls, the clatter of foils and the discordant sound of an ancient piano."

This congenial hubbub recalls the Louvre colony where Vernet had been born, but how distant it sounds from the intense solitude of the greatest studio of the period. Eugène Delacroix had been eager enough for friendship and pleasure as a very young man, but he soon withdrew from the usual round of amusements to devote himself to his art. This discipline was not achieved without a struggle, as we know from the artist's journal, the most

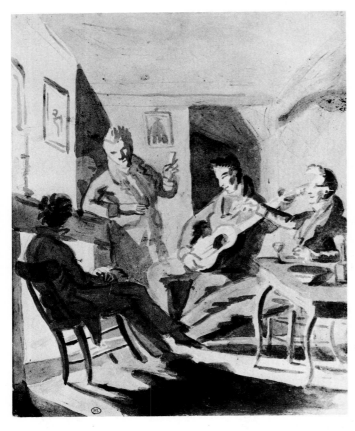

Eugène Delacroix (1798–1863), New Year's Eve, *1818, Musée du Louvre, Paris. Far from being the ascetic recluse of later years, the young Delacroix adored conviviality. This rapid wash drawing shows the artist, leaning on the mantelpiece, proposing a toast to three bosom friends in the temporary studio he had fixed up in his sister's Paris flat.*

complete logbook of studio life ever written. Delacroix was born into a distinguished family (the rumor that Talleyrand was his real father has never been disproven, while, in any case, his legal father became foreign secretary during the Directoire). His means were nevertheless limited, and he began what turned out to be an unusually arduous career in the simplest of studios: the attic of his sister's Paris flat. In that small room with the mansard roof, Delacroix completed *Dante and Virgil Crossing the Styx,* which he exhibited in the Salon of 1822. This first offering — from an artist of twenty-four — was well received. But his subsequent entries, *The Massacre at Chios* and the gorgeously colored *Sardanapalus,* were attacked with that particular ferocity that the nineteenth-century Establishment meted out to artists who challenged stylistic convention.

The sensitive, cultured Delacroix was thus accused of being a "dauber" and a "drunk." More damaging still, he was struck off the list of artists eligible for State commissions. Yet official disapproval only strengthened his belief that the aesthetic strictures propounded by David and his school were no longer valid. "Enough of doing David!" he once exclaimed, convinced that the rigid classicism of "that icy star" should now give way to brilliant color and dramatic movement. For part of the year 1823, he shared a garret studio on the rue Jacob with the English watercolorist Thales Fielding (Bonington was another of Delacroix's English friends); then, after several temporary Left Bank addresses, he crossed the river in 1845 and set up in a converted gymnasium on the rue Notre-Dame de Lorette. In that "so closely guarded studio" (as his young admirer Baudelaire described it), Delacroix was able, over the following ten productive years, to give full expression to his belief.

Lit by a huge window and decorated mostly by the artist's own works, this studio contained none of the props — "no rusted armor, no Malayan kris, no ancient Gothic scrap iron" — that Baudelaire sarcastically observed being used for inspiration by the more anecdotally minded painters of the time. Books were always apparent, for Delacroix ransacked literature for new themes, insisting on the artist's right to treat whatever fired his imagination — whether it came from Byron or Sophocles. Like Géricault, he also believed that contemporary political events, such as the Greek war of

Delacroix, A Corner of the Studio, *Musée du Louvre, Paris. This wash drawing of 1824 depicts a working area of the studio on the rue Jacob which Delacroix shared for a time with the English landscapist Bonington. Books, like those piled beside the print folder, were a major and permanent feature of all Delacroix's studios, for much of his painting was closely bound up with the literature he admired.*

independence, could provide subjects at least as stimulating as the conventionally accepted ones of antiquity. His trip to North Africa had provided him with another wealth of themes, and the same readiness to seize on whatever might open up new avenues for art allowed him to respond immediately to photography, whose invention was announced in 1839. "If a man of genius used the daguerreotype as it should be used," he noted in his journal, "he will raise himself to hitherto unscaled heights." Having become a founder-member of France's first photographic society, Delacroix had photographs made of his models, arranging the pose and deciding on the lighting himself. Thereafter he always kept photographs beside him. They were useful not only for general reference about the human figure (and as such far more accurate and stimulating than the engravings which Delacroix, like every other artist, had used hitherto), but also as specific aids for continuing work once a model had left.

A Variety of Models, *engraving, Bibliothèque Nationale, Paris. Models formed an essential part of the nineteenth-century studio, and each professional tended to have his or her specialty. This caricature shows in barely exaggerated form some of the types, ranging from a girl who poses only "for the hands of duchesses" to an old man with cringing mien who specializes in allegorical scenes about charity.*

Photography never replaced models in the nineteenth-century artist's studio. Their presence, naked and unsupervised in a private studio, had become legal only since the Revolution, and their importance tended to increase as the century advanced. In a time of strictly maintained propriety, this secluded contact with a nude woman not unnaturally stirred the public imagination, and the newspapers regaled their readers with many a suggestive caricature of intimacy beside the easel. Female models were frequently attractive and of easy virtue; it is known (from notes he left in Italian) that Delacroix, like many other artists, did have casual liaisons with several of his models — whom he would often begin to draw only after they had left the studio. But the best models, who tended, like actors, to specialize in certain roles, were considered reliable assets — almost good omens — in the execution of a work. One male model named Dubosc posed in all the leading studios from the ages of seven to sixty-two, thus running the entire gamut of roles; he became famous for his exceptional ability to hold a pose for so long that, at the end of a session, he had literally to be straightened out! Other models were sufficiently proud of their profession to haunt the Salons and show off to friends and visitors by pointing out the various figures for which they had posed.

Passing intimacies had no effect on the strict discipline of Delacroix's life. His days were organized with the sole aim of applying himself as wholly as possible to his art. "I go to work as other men run to their mistress," he once said, and to his pupil Pierre Andrieu, he confided that painting was "the greatest recreation I can give myself. At my easel, I forget the problems and cares that are the lot of all of us. . . . Work as much as you can: that's the whole of philosophy and the right way of organizing one's life." Despite fragile health, Delacroix executed not only a huge number of easel paintings but also several monumental decorative schemes, notably for the Louvre's Salon d'Apollon (where the first "Salon" exhibitions were held), the libraries of the Chamber of Deputies and the Senate, and the great church of Saint-Sulpice. These "orgies of work," as Baudelaire called them, were planned with intense deliberation; we know this from the artist's friends and assistants, and above all from his journal, which is studded with observations about technique. It became of

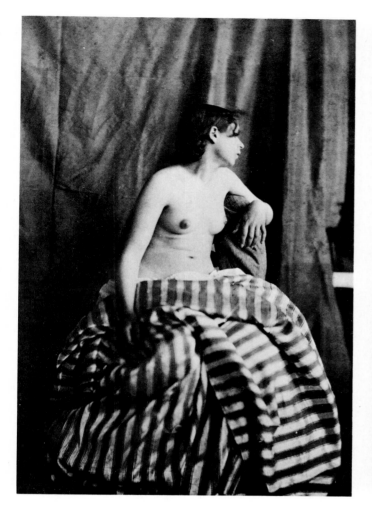
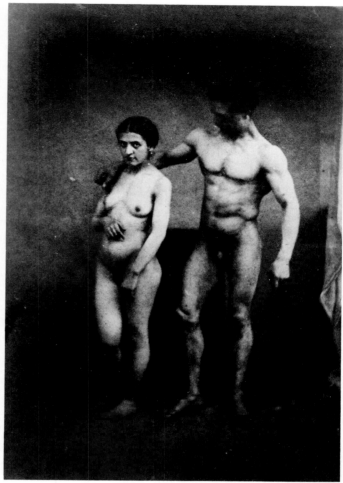

Two Photographs of Models Used by Delacroix, Bibliothèque Nationale, Paris. Delacroix quickly realized photography's potential as an aid and stimulant to painting. He had photographs taken of his favorite models and used them to continue working once the models had left.

paramount importance to the artist before he embarked on a new work to establish the complex relationship of color tones he would use. Color to Delacroix was what line was to Ingres: the heart and soul of painting. A great deal of his time in the studio was spent experimenting with the infinite variations of color; he would often take strips of differently painted canvas and pin them in various combinations on the wall until he had found the harmony he was looking for. Then he would build up on his palette the color scheme that had satisfied him best, a palette that Van Gogh later called "the most beautiful in France." By that stage, the composition was largely established in his mind. "When I have arranged the whole combination of contrasts of tone on my palette," he told Andrieu, "my picture is made."

At the end of 1857, Delacroix moved into a house

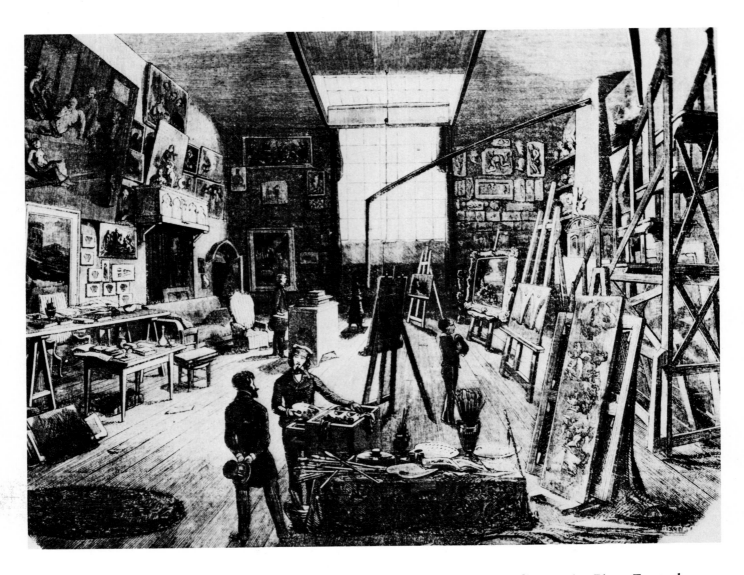

Delacroix's Studio in the Rue Notre-Dame de Lorette, *engraving from* L'Illustration, *1852. Formerly a gymnasium, this spacious, well-lit, and well-heated studio provided Delacroix with an ideal haven from 1845 to 1857. Surrounded by paintings (many by himself) and a good selection of books, the artist led an increasingly solitary, work-obsessed life, enlivened by occasional visits from his mistress Madame de Forget and his friends George Sand and Chopin, all of whom lived nearby.*

with an adjacent studio on the Place Furstenberg, a charming, peaceful little square behind the Boulevard Saint-Germain. In the five years that remained to him, the artist worked with as fierce a concentration as ill health would allow, going straight from bed to studio and painting often without a break even to eat until midafternoon. "All my ambition is bounded by these walls," he said of the handsome, spacious studio, which stands in its own delightful courtyard — a pocket of quiet in which the artist could take gentle exercise. The apartment and the studio have been turned into an official Delacroix museum. It is especially moving for anyone who knows the evolution of the artist's work and has read the *Journal,* with their parallel quests for personal truth, to visit Delacroix's studio — that "crucible,"

as he described it, "in which human genius, at the peak of its development, brings back into question everything that exists."

Delacroix's forty years of activity spanned a period of unprecedentedly rapid stylistic change that began with the last works of David and ended with the early essays of a gauche, but determinedly original, young Aixois named Cézanne. In the middle of this accelerated development stood Gustave Courbet, not unlike a pivot on which the course of art was to turn from Romanticism to Impressionism. After painting a number of highly romantic portraits, Courbet underwent a decisive change of attitude and rejected anything that might be considered as "idealistic." "Painting should abandon both the historical scenes of the Classical school," he recommended, "and poetic subjects from Goethe and Shakespeare favored by the Romantic school." Their place was to be taken, Courbet believed, by things — preferably the landscapes, animals, and peasants he had known as a child — at their most ordinary and unvar-

Delacroix's Studio, Place Furstenberg, Paris. In the last seven years of his life, Delacroix worked in this spacious studio, which he completely refurbished. Being in delicate health, he appreciated the peaceful courtyard and the proximity of his living quarters (at the top of the steps). The studio and the apartment now constitute a Delacroix Museum.

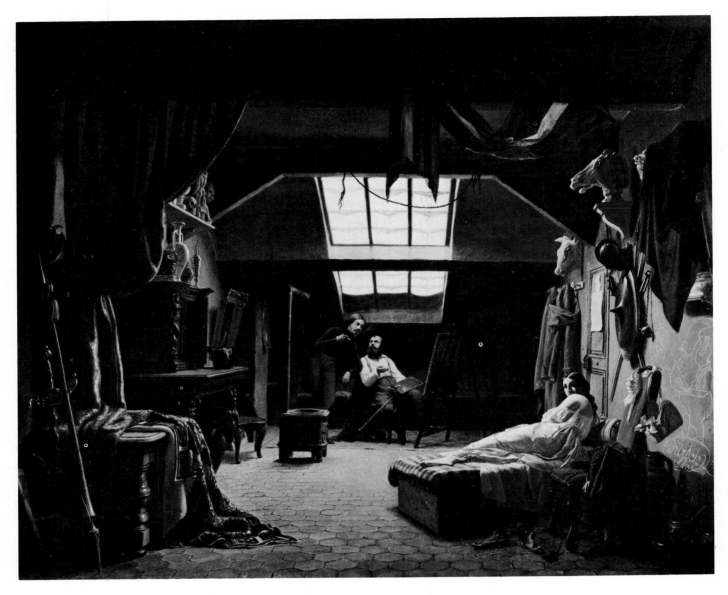

Anonymous, Artist and Model in the Studio, *photograph from Roger-Viollet, Paris. Though clearly signed and dated ("Kirsch, 1843"), this evocative painting remains in search of further information about its author. The charm of bohemian life in a garret is amply evoked, nevertheless. The anecdotal and decorative aspects of the scene indicate how familiar the notion of a Romantic artist's studio had become by the mid-nineteenth century.*

nished. The duty of art was to show life as it was, without prejudice or emotion. "I look at a man," the artist declared, "as I look at a horse, a tree, or any other object in nature." This brand of objectivity, with its underlying socialist inspiration, was what came to be called realism.

Far from the secrecy of Géricault's or Delacroix's studio, Courbet's was an open, free-and-easy place where, if you were likely to prove a convert to realism or add to the notoriety of this inordinately vain artist, you were warmly welcome. Visitors to his large, bare atelier — in a converted priory on the rue Hautefeuille on a site now occupied by the Paris Medical School — remarked on the exuberance with which he talked, smoked his pipe,

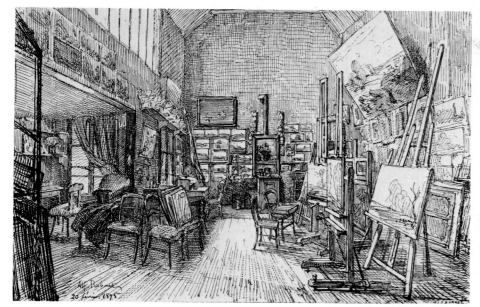

Corot's Studio, *engraving after a drawing by Alfred Robaut, 1875, Bibliothèque Nationale, Paris. Although he did much of his work out of doors, Corot kept a magnificently practical studio in Paris, which he used both for painting and as an exhibition area for pictures he was willing to sell.*

and painted all at once. The image they have left of Courbet around the age of thirty is of a Rabelaisian colossus, whose tremendous vitality allowed him to put away a keg of beer and dash off a sizable painting, both in record time, with the artist himself commenting loudly on his own prowess.

He did not begin work until late, often not until after a copious lunch, particularly if he had been out on the town, drinking and bragging, the night before. When the critic Castagnary, later Courbet's staunch supporter right to the difficult end, paid his first visit to the rue Hautefeuille studio, Courbet was just waking up. While the rambunctious realist got dressed, Castagnary was free to inspect the "vast, lofty room," lit by a window overlooking the street. What struck him most was the needy, empty look of the place. "The furniture was limited in the extreme: a tired-looking, rep-covered sofa, half-a-dozen odd chairs, an old pot-bellied chest of drawers, and a pedestal table littered with pipes, empty beer mugs, and old newspapers. Everything was half-submerged under an avalanche of paintings of every size and description — some of them framed and hung, others stacked face-inward to the wall. In the middle there was a free space for the easel, with a portrait in progress. The corners were taken up by enormous rolls of canvas, which looked like a ship's sails carefully stowed

away." The day had not yet come, Castagnary sarcastically notes (thinking of the *pompier* ateliers, illustrated in the next chapter), for the "show-off studio . . . waxed and polished, with its high-warp hangings, Henri II furniture, Japanese curios, grand piano, Chinese vases, and rare plants, with everything to impress the bourgeois and keep prices up. We were still at a time of working studios, whose beauty came from their size or the quality of their light; but, even for those primitive days, Courbet's studio was as simple as a cenobite's cell."

That cell set up reverberations that shook society more strongly than we are able to imagine today, mainly because artists no longer have the power they had in the nineteenth century to challenge and destroy a whole period's image of itself. Courbet's work, with its emphasis on ordinary landscape, unsentimental cattle, and the common man (so common as to be politically subversive), was for many an intolerable affront, a slap in the face by an uncouth vulgarian. Emotion ran sufficiently high for gendarmes to be posted round his canvases to protect them when they were shown at the annual Salon, that vast moment of truth for public and artists alike. This did not prevent Courbet's fleshy *Baigneuses* from receiving an outraged smack across the buttocks from Louis-Napoleon during his official visit. Nor, certainly, did it shield Courbet from written attacks, such as the

Goncourts' condemnation of him as a blind man wielding a camera "who stops to sit down [and take a picture] wherever there is a dunghill." But, with his gargantuan appetite for publicity of any kind, Courbet relished the prospect of a battle and trumpeted his opinions ever more loudly in the smoke-filled brasseries where he held court.

Attracted by this booming bonhomie and the rather simplistic theories (drawn in part from his friend, the socialist thinker Pierre Joseph Proudhon, whose portrait he painted), a group of students and enthusiasts persuaded Courbet late in 1861 to open a teaching studio where the principles of realism could be put into practice. A suitable location was found on the rue Notre-Dame-des-Champs, a street lined with convents and studios in Montparnasse. Courbet proved himself resolutely realist from the first by avoiding the usual run of models, with their idealistic poses, and plumping for livestock as fit subjects for unvarnished pictorial truth. Every day, from a pasture just beyond the city limits at the Porte de Versailles, a peasant drove a suitable animal down the rue de Vaugirard toward Courbet's studio, to the great merriment of his neighbors. Once inside, however, the beast met with deadly seriousness. Castagnary left a full description of the scene: "Standing on spread-out hay, with dilated eye, lowering his black muzzle and swinging his impatient tail, a red bull, marked with white, was tied by the horns to a ring of iron strongly sealed in the wall. It was the model. The noble animal, disturbed at being the center of all eyes, moved about on its solid legs, scarcely maintaining its pose. Did it come from the pastures of Normandy, the plains of Poitou, or the meadows of Saintonge? I do not know, but it had a fine form and its mottled garb pleased the eye. So many easels, so many artists. Each worked in silence. The black-bearded master came and went, distributing his hints, and each time taking up the palette to demonstrate more clearly."

The venture did not last more than a few months, even though the artists and intellectuals of Paris had been split over whether such ways were deeply significant or deeply silly. Courbet himself tired of it all. Fortunately, he always found time in between such parallel political or didactic activities for more important things. Before opening his teaching studio, he produced a huge

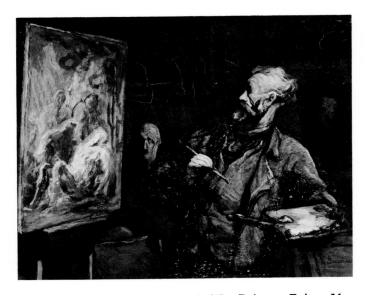

Honoré Daumier (1808–1879), The Painter, *Reims Museum. An extraordinary eyewitness of his fellow man, Daumier seizes that vital instant when the painter steps back to judge what is emerging on his canvas. In a few strong lines, the mystery of the artist face to face with the mystery of his work is brilliantly evoked.*

Courbet's Studio, engraving by Albert Prévost, 1862, Bibliothèque Nationale, Paris. Egged on by students longing to be free of conventional training, Courbet opened a teaching studio where hard-core realists could meet and make studies of the cattle and peasants specially brought in as models. The idea of having cows to pose caused an uproar in Paris salons; but Courbet himself tired of his role as teacher and closed the studio after a few months.

composition that has given rise to more interpretations than any other painting of the century: *The Painter's Studio.* In this enigmatic allegory, the burly Courbet, brushes, knife, and palette in hand, works on a landscape of his beloved native Franche-Comté, while on either side of him two unrelated groups of people fill out the large bare room. Courbet himself gave it the following subtitle: "A real allegory defining a seven-year period of my artistic life." In a long letter to his friend and fellow realist, the writer Champfleury, he explained that the painting contained the "moral and physical history of my studio. . . . The scene is set in my Paris studio.

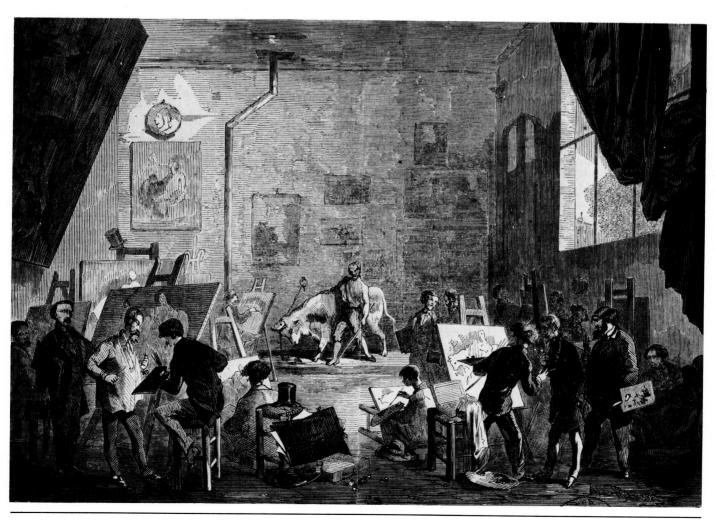

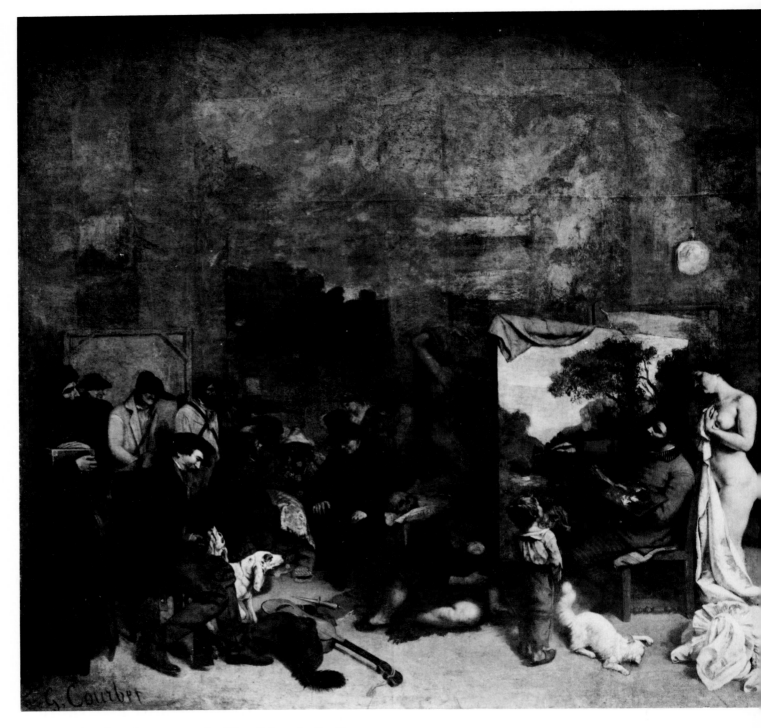

Gustave Courbet (1819–1877), The Painter's Studio,
*1855, Musée du Louvre, Paris. In Courbet's complex
allegory, whole sections of contemporary life are recorded
in precise detail. The studio here becomes the eye of the
world, the touchstone of an entire civilization.*

ROMANTIC CELL, REALIST ATELIER

The picture is divided into two halves. I am in the middle painting. On the right, there are the 'shareholders,' that is to say, my friends, the workers, the art-lovers. On the left, the other, commonplace world: the people, the destitute, the poor, the wealthy, the exploited, the exploiters — those who thrive on death." Courbet then gives a detailed description of each of the painting's characters, from the Jew holding a casket on the far left to Baudelaire dipping studiously into a large book on the right. Belonging to the studio proper are the nude female model (for which Courbet closely followed a photograph of a model), the academic model strung up into an unnatural, but by no means improbable, pose, and the plumed hat, guitar, and dagger strewn over the floor.

The last-named elements may be interpreted safely enough as Courbet's rejection of both classicism (exemplified in the model's artificial posture) and romanticism (whose props have been cast on the ground). Several esoteric explanations have been advanced for the composition's other elements. One gives the libertarian philosophy of Charles Fourier as the key to the entire picture; another has deduced a complex set of references to freemasonry; and a third, more simply, decodes it as an "allegory of self-fulfillment," an interpretation that at least stays within the bounds of what we know of Courbet's narcissistic temperament. Society as a whole, it is clear, has been brought into the studio and divided by the pivotal figure of the artist. And this might be the simplest explanation of all: the studio is shown as the crossroads of society, a place where new definitions of life are forged and recorded, with the artist, like Shelley's "unacknowledged legislator," as the final arbiter of civilization. "This is how we really are," Courbet appears to be saying, "and we can go no farther until we have accepted this objective view of ourselves." Never before had the studio been accorded such consummate importance — as a mirror held up to an epoch, confronting it with an unadorned, unidealized identity.

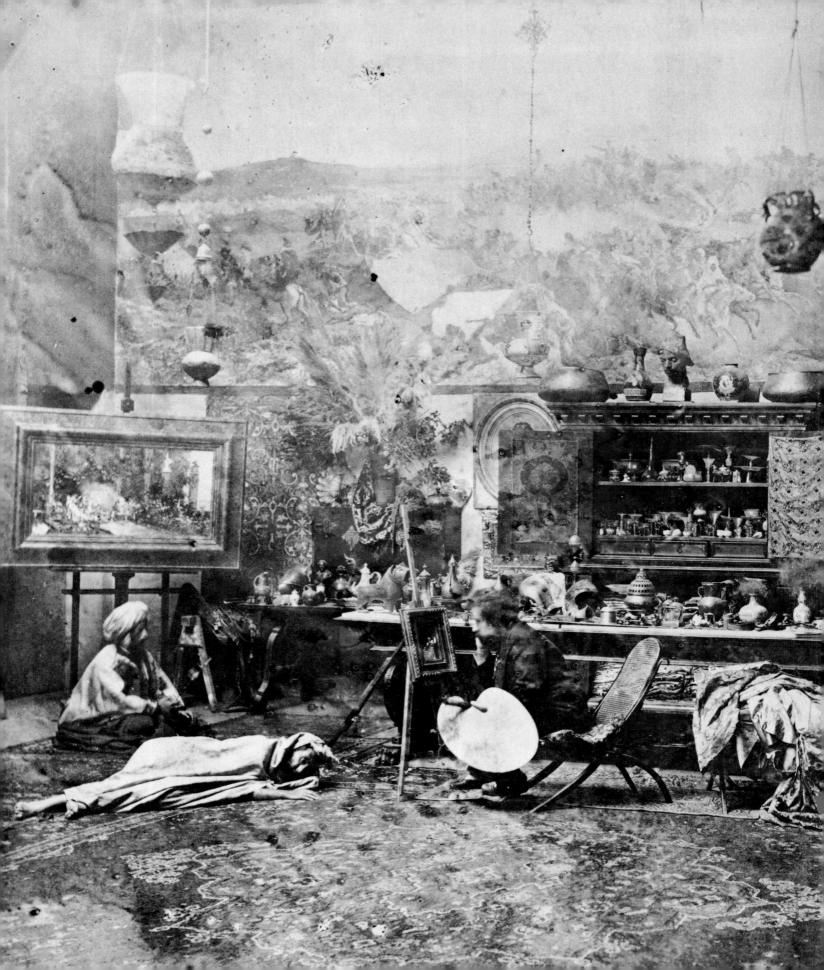

Society Favorites

The term *pompier* has been applied, loosely enough, to most of the successful artists of the latter half of the nineteenth century. It derives from a studio practice already popular in David's time: when models posed as Greek gods or warriors for a classical scene, they were given — as an aid to credibility — firemen's helmets to wear. From this faintly absurd artifice, the word *pompier* (meaning "fireman" in French) has come to designate whatever later generations, recoiling from the tastes of their forebears, have found pompous or false in the art of that era. Some of the painters and sculptors grouped under the vast *pompier* umbrella are more interesting and certainly more individualistic than subsequent changes in taste have allowed. They were, at least, highly representative of the artistic attitudes of their age, which, in turn, were wonderfully captured and reflected in their studios.

These artists — for whom "society favorites" seems a better, because less automatically derisive, term — were an international phenomenon. What Alma-Tadema and Lord Leighton were to London, Gérôme and Meissonier were to Paris, Hans Makart to Vienna, Franz von Lenbach to Munich, and, for instance, William Merritt Chase to New York. The list could be extended almost indefinitely. What these numerous artists shared, however, was less a common aesthetic (though this existed) than an ably promoted official renown and astonishing prosperity. Their studios were a potent symbol of this success, showplaces for their owners' wealth and finesse, and thus — in a time when dealers were still rare — re-

assuring sanctuaries in which admirers might be best persuaded to buy. Many such studios, like the one represented by the Belgian Alfred Stevens on page 31, literally existed for nothing but show, with the real work of painting kept almost prudishly out of sight. They were generally vast, with a split-level picture-storage gallery at one end, and, like the fashionable apartments of the time, they tended to be portentously somber. Tapestries and dark, massive furniture were often deliberately chosen to enhance the impression of established wealth, while a profusion of the most diverse objects attested to the breadth of the artist's taste and learning. Chase's huge atelier in the West Tenth Street Studio Building (the haven of America's "society favorites") contained items so numerous and dissimilar as to be virtually unclassifiable, ranging from stuffed cockatoos, Japanese umbrellas and Egyptian pots to Puritan high-crowned hats, weather-beaten sails and, according to a report of the time in the *New York Art Journal,* a "unique collection of woman's foot-gear." The overall effect, wrote one contemporary, was of a "veritable glimpse of heaven, a shrine into which [one] entered with bated breath and deep humility."

Such bewildering arrays of objects were not for decorative purposes only, however, but for work as well, and because of them, these studios may now be seen as archives of the major influences on the art of the time. One of the greatest influences, of course, was photography. Despite the widespread anxiety that this new invention had "dealt a death blow to Art," most artists de-

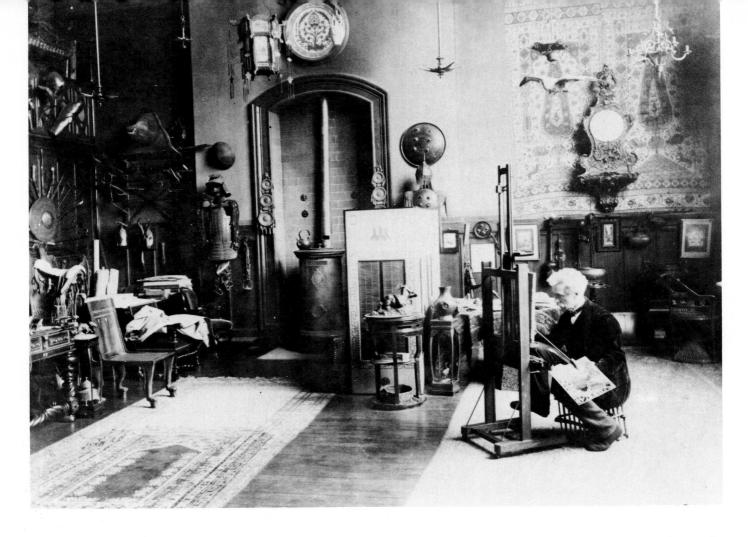

This corner of Jean-Léon Gérôme's studio on the Boulevard de Clichy, Paris, shows some of the Oriental objects, arms, and armor that the artist used in his photographically exact renderings of the life and landscape of North Africa.

rived specific stimulus from it. Photography had, after all, been developed by artists (both Daguerre and Fox Talbot started out as painters) for the use of artists; and no self-respecting studio was without its own collection, which often included photographs taken by the artist himself. When he died in 1904, after a long and officially distinguished career, the celebrated Gérôme, for instance, left twenty-eight large volumes of photographs (now in the Bibliothèque Nationale, Paris), which he had consulted regularly as an aid to his painting. He was in fact so conscious of striving for photographic exactitude that he imagined his art would be best remembered as a faithful documentary record of life in the "Orient."

The "Orient," which frequently meant one's own country's colonies in the Near or Middle East, proved a tremendous source of inspiration. From his six trips, mainly to Turkey and Egypt, Gérôme brought back not only an extremely useful stock of photographs and

Gérôme (1824–1904), Pygmalion and Galatea, *1892, Metropolitan Museum of Art, New York. Having taken up sculpture late in life, Gérôme would naturally have found a particular piquancy in the famous legend of the sculptor Pygmalion falling in love with his own marble statue. The sculpture and painting by the far wall clearly recall Gérôme's own work.*

sketches, but also crateloads of costumes, arms, furniture, and ceramics. Thus, for the rest of his industrious life, he was well equipped with aide-mémoire for a wide range of Oriental scenes, as one can see from the photograph of him painting in a corner of his studio on the Boulevard de Clichy. But he never went to the lengths of his English contemporary, Frederic Leighton, who coolly reconstructed a complete Arab interior in his mansion (now a studio-museum) beside Holland Park in London. The huge hall, faced with ancient tiles collected in the East by Leighton and his friends, contains an *alhacen,* or wooden alcove, set halfway up one wall, delicate moucharaby screens (to filter the never very fierce London light) and a black marble pool with a fountain.

The Great Studio in Leighton House is equally evocative of Victorian self-assurance — and more precisely of a man who, from 1878 to his death in 1896, was an immensely respected president of the Royal Academy.

One of the outstanding attractions of Leighton House is the Arab Hall, a monument to the fascination which Leighton and so many other contemporary artists felt for the Orient. Few nineteenth-century studios were without traces of this interest in the newly colonized countries of the Near and Middle East.

Set between a "picture gallery," where Leighton housed his private collection, and a smaller "winter" painting room, the Great Studio measures sixty feet long, twenty-five feet wide, and seventeen feet high. Among its notable features are casts of part of the Parthenon frieze and of Michelangelo's Madonna tondo. To the right of the picture-storing area is a small door that originally led to the servants' quarters. Through this humble entrance came the artist's models as well as those picture dealers who wanted to buy directly from the revered Lord Leighton. The dealers were informed on their arrival that the paintings for sale had prices marked on them and that any decisions to buy should be communicated to the butler. When one dealer suggested that there might be room for some negotiation, Leighton made the memorable reply: "I never enter into discus-

The "Great Studio" in Leighton House, London (built in 1866, and now a museum), admirably illustrates the importance accorded to an artist's working space in Victorian times. As a leading painter and president of the Royal Academy, Lord Leighton owed it to himself to have a studio on the most impressive scale; its furnishings and decoration denote the scope of his interests and ambitions.

The principal effect of photography on painters was to make them more conscious of the virtues of rendering appearance as realistically as possible. Photographic exactitude became the new keynote, for many artists were convinced they had to prove themselves as capable of faithful reproduction as the camera itself. Great pains were taken to achieve this end. The outstandingly successful Léon Bonnat, for instance, kept a cadaver strung to a cross while he was painting his crucifixion scenes. Of Meissonier, the archrealist, it was said that he had "a memory like an almanac"; at all events, he

A close friend of Gérôme and his traveling companion to North Africa, Gustave Boulanger was highly admired for the precision of his classical and oriental scenes. Surrounded by plaster casts and souvenirs of his foreign travels, he is seen sketching a child model; once the model grew tired, the artist could use the mannikin on the right for drapery or costume studies.

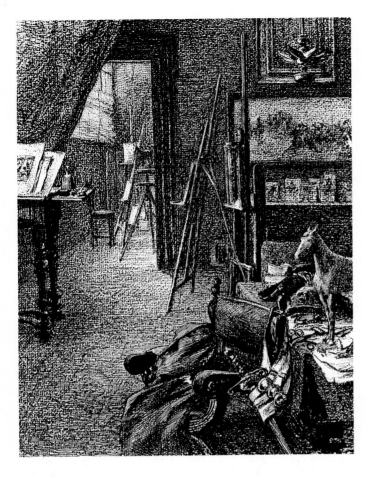

Ernest Meissonier's view of his studio gives an impression of light, uncluttered space and efficiency, while the model horse and the sword denote two of the artist's favorite themes. Meissonier (1815–1891) went to fanatical lengths to achieve a realism in his painting that could compete with photographs on their own terms.

went to what appear fanatical extremes to obtain verisimilitude. Before painting in the ground on his picture of Napoleon's retreat from Russia, he waited for snow to fall around his Paris studio; having ordered his servants to trample through it in order to produce a churned-up appearance, the master then set up his easel in the bitter cold and completed his scene. For another painting, he had a cavalry charge executed across a field near his country estate — so that he could catch a certain effect of downtrodden wheat. On a further occasion, when he discovered that horses went by too quickly for him to note their movements exactly, Meissonier had a small railway installed on his property in order to keep pace. He felt he knew the way horses moved so well that when he first saw Muybridge's photographic studies he accused the camera of falsification. Later, however, he became a total convert, keeping Muybridge's photographs at hand and even giving a public projection of them in his studio.

Meissonier engendered a brief dynasty of highly exact, military artists. His pupil, the once-famous Edouard Detaille, spent his working life in a studio that looked like something between a military museum and a quartermaster's store. "Everything was clean, tidy, polished, ready for parade," a visitor recounts. "The artist, fully dressed, clean-shaven, not a hair out of place, would paint, standing before an easel or perched on a stepladder. In front of him would be a uniformed model, seated astride a fully harnessed lifesize horse of papier mâché. . . . Rows of cardboard heads, which Detaille himself had painted, bearing wigs, carabineers' helmets, shakos, hats decorated with silk cords or feathers, of all kinds and of all countries, were ranged on shelves against one wall. Around and about were panoplies of sabers, swords, bayonets, lances, and armor from all over Europe." With his friend Alphonse de Neuville, Detaille performed the considerable technical feat of painting two "panoramas" of famous battles. Fifty feet high and as much as four hundred feet long, these vast compositions were put on show in specially constructed circular buildings where the public stood in the middle and looked at the brilliantly lit carnage, so realistically painted it seemed to be taking place beneath their eyes.

Neuville, who had a similarly successful career, made no bones about his love of things military, either. His

Taken in 1883, this photograph shows the extremely successful military painter Edouard Detaille standing in front of the immense "panorama" that he and his friend Alphonse de Neuville had painted of a particularly savage encounter in the Franco-Prussian War of 1870. To achieve its astonishing realism, which regularly attracted crowds of spectators, the two artists had rehearsed the various events and strategies in their studios like two seasoned generals.

Stuffed horses, military headgear, and weapons formed an unchanging background to Neuville's studio, where they were used both as specific models and for general inspiration. During the Franco-Prussian War, Neuville sketched battles as they were being fought, often from dangerously close quarters, in order to give his paintings a documentary power of conviction.

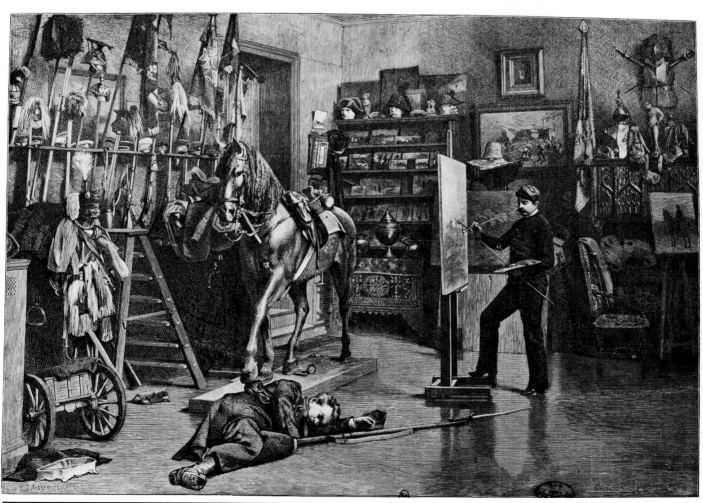

Although engaged on a very small painting, the once fervently admired Spanish painter Mariano Fortuny is shown here in his studio in Rome in 1872, surrounded by sufficient models and motifs for a series of monumental canvases. Models such as the cringing Arab on the carpet were invaluable aids to striking an exact note of realism in an age when lifelike appearance in art was highly prized.

taste was more dramatic than Detaille's, however. Buckled cannon, blood-darkened mattresses, and mud-caked straw formed the grim environment of his labors, and whenever he moved into a new studio, he would pull out a revolver and fire several shots into the walls — just to work up a warlike atmosphere.

But war was only one of the major themes in which artists strove to create images that would startle by their seeming closeness to real life. There lingered on, often very successfully, those whom Pissarro labeled "les faiseurs de Grecs" ("the ones who do Greeks"). At the top of this category came Sir Lawrence Alma-Tadema, the indefatigable Dutch-born artist who moved to London and became one of the great darlings of the English art world by producing canvases that purported to show real life in glorious, picturesque antiquity. "If you want

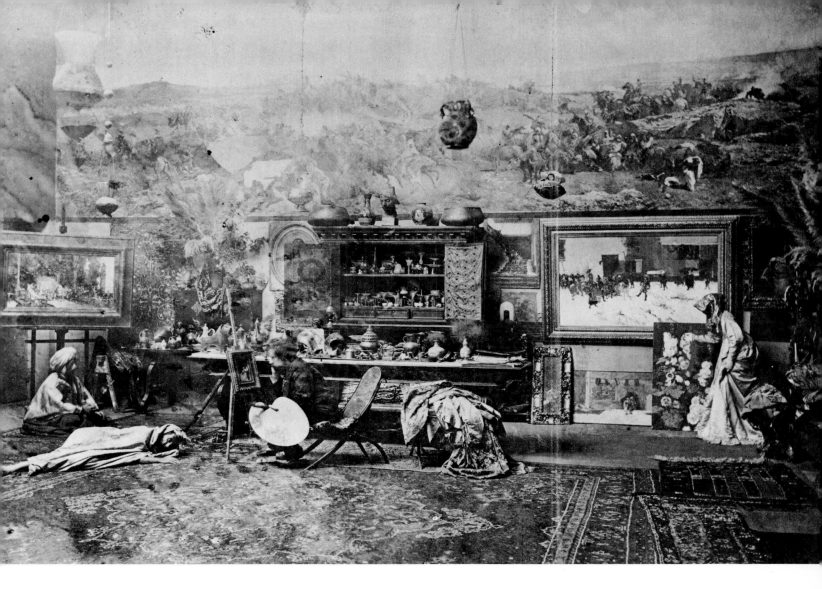

to know what those Greeks and Romans looked like," he roundly declared, "come to me. For I can show not only what I think, but what I know." This was no idle boast: Alma-Tadema never embarked on a new subject, whether it was *Agrippina Visiting the Ashes of Germanicus* or *The Sculptor's Studio in Ancient Rome,* without the kind of research that would nowadays seem more appropriate for a documentary film. A photograph of 1863 shows the artist in dark suit and bowler hat conscientiously measuring a marble plinth at Pompei; no detail of dress or habitat was ever carelessly overlooked. His "Victorians in togas" did not convince everyone, though. The sharp-eyed Whistler saw these pretty-pretty, half nostalgic, half discreetly erotic scenes as "five o'clock tea antiquity." But they were executed with such assured outlines and delightfully fresh colors

that collectors in that sentimental age would have been pained to think that so great a specialist as Alma-Tadema were not giving them an almost eyewitness account of the truth.

"Sad specialists," Baudelaire called them, and warned against the dangers of slavishly copying nature. In a lighter, ironic vein, Oscar Wilde congratulated W. P. Frith, another hugely successful English artist, for having "done so much to elevate painting to the dignity of photography," while Zola dismissed Meissonier's meticulous genre scenes as "the small change of Art." Yet these specialists openly rejoiced in their expertise, developing theories, castigating adepts of other schools (Gérôme branded the Impressionists as a tribe of "Turks and Kurds"), and promoting their interests by every means — such as the photographs they had taken

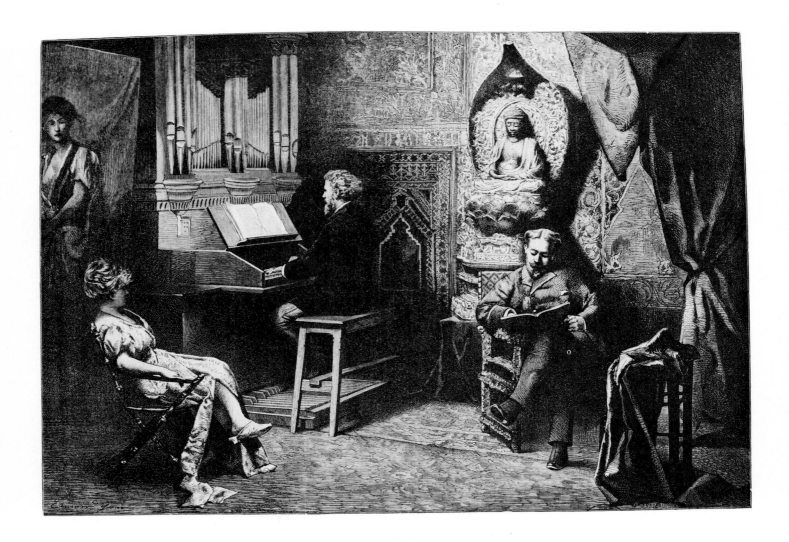

Several of the higher flights of imagination are symbolically reunited in this evocation of the portraitist Carolus-Duran's Paris studio. For many people in the second half of the century, the artist's studio was the high place of culture as well as a privileged area where social restraints were relaxed.

of themselves in their many-splendored studios. In purely technical terms, they had made no significant advance on David (the "Turks and Kurds" were to do that), but they impressed the majority of their contemporaries by an undoubted capacity to produce images that rivaled the camera while giving reality a more pleasing glow. This ability to please brought them every conceivable official honor, and all the prominent personalities of the time, in whichever capital, made it their business to be received in the veritable shrines of art that were their studios. The portraitist Carolus-Duran, for instance, was used to having the great ladies of the day, such as Mrs. William Astor or Mme. de Pourtalès, sit to him while their husbands or friends hovered in the background. Partly to fend off the boredom of such

sessions, this friend of Courbet and Manet made something of a spectacle of the way he painted. He would "fence" with his paintbrush, according to a contemporary critic, tipping in a detail then dancing back to judge the effect before leaping in to mark another point. Carolus-Duran was perpetually concerned with keeping the studio atmosphere just right. Having begun to paint a nude while the full summer sun poured through his atelier window, he was distressed to find autumn closing in — but solved the problem by having a greenhouse speedily erected in which he could finish the picture in an ambience of undiminished luminosity.

Even though these artists were often the most ordered of individuals, living to a strict, demanding timetable, such "eccentricities" came almost to be expected of them, and their foibles and fancies provided a first-class source of gossip. The prominent animal painter Rosa Bonheur, for instance, fascinated both English and French society. She had started out in relative poverty as the daughter of a socialist painter, who gave her and his three other children an excellent technical grounding in his own studio. Rosa's passion for animals immediately oriented her as a painter. She continued her studies not only in front of the masterpieces in the Louvre, but also in the abattoirs. In order to pass more freely among the rough employees there, the young girl took to dressing as a man. This curious custom, which later proved particularly convenient for riding and sketching out of doors, stayed with her — to the disapproval of many contemporaries. "She was just getting down from her horse," an acquaintance recounts of a chance meeting with Bonheur, "and was attired in a masculine costume that was really grotesque. It consisted of a frock coat, loose gray trousers with understraps, boots with spurs, and a queer hat." To continue wearing these kinds of clothes in public, Bonheur had to obtain from the police a document allowing her the "right of impersonation." But this did not prevent her from being arrested once as a man dressed up as a woman — a suspicion only confirmed by the vigorous resistance she put up.

Rosa Bonheur established her studio (formerly occupied by the sculptor Pierre-Jean David d'Angers) on the rue d'Assas, beside the Luxembourg Gardens. Interest in her affairs was diminished neither by the fact that she lived there with another woman, her companion

Rosa Bonheur, the celebrated animal painter, kept her models at hand in an annex to her Paris studio. Later, when she set up her studio in the country, near Fontainebleau, the menagerie grew to include such exotic creatures as a yak and a lion cub.

Habitually attired in men's clothes and a great smoker of cigarettes, Rosa Bonheur became the subject of many tales as her fame grew in France and abroad. The visit that the Empress Eugénie paid her in her country studio was a mark both of Rosa Bonheur's unusual prestige and of the importance accorded to certain artists throughout the century.

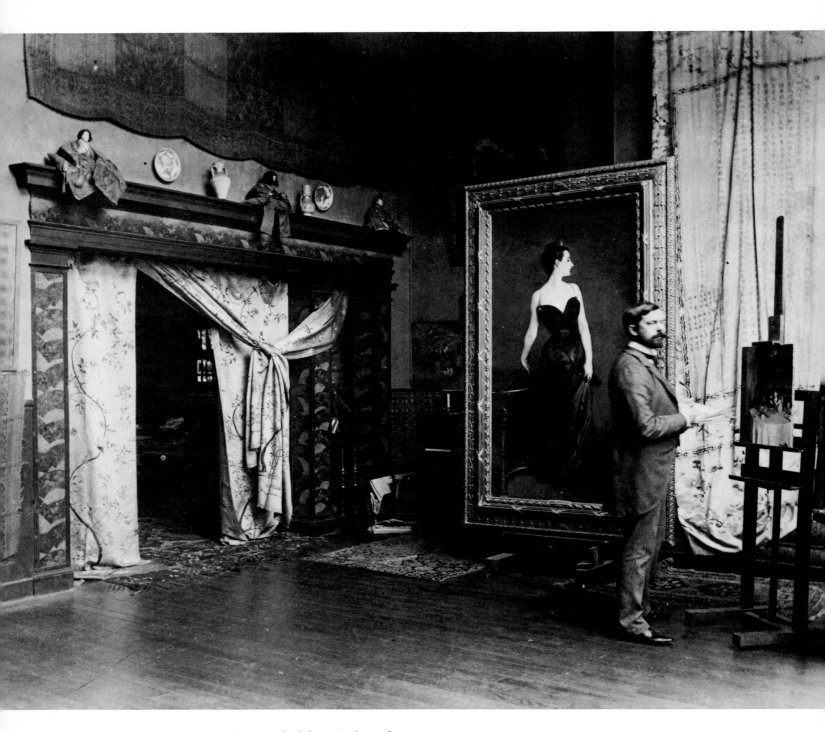

John Singer Sargent *is photographed here in formal pose beside* Madame X, *one of the society portraits for which he became famous. The comparative sobriety of his Parisian studio is partly explained by the fact that he needed few props for his portraits, yet the Japanese dolls and the silk hangings confirm that he was not immune to contemporary fashions and influences. See also page 32.*

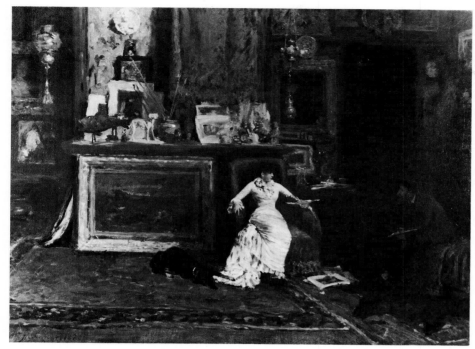

William Merritt Chase (1849–1916), The Tenth Street Studio, *1880, St. Louis Art Museum. A relaxed and intimate impression of what the American artist vowed, on his return from studying in Europe, would be "the finest studio in New York." Its great size and impressive collection of objects gained for it a reputation as the "sanctum sanctorum of the aesthetic fraternity." See also page 178.*

throughout life, nor by the diversity of animals the artist kept as "resident models" for her painting. This unusual ménage attracted more attention still as the chain-smoking, tweed-trousered Mlle. Bonheur became an international celebrity — thanks, in part, to the able management of her London-based dealer, Ernest Gambart (whose art-market coups had earned him the nickname "Gamble-art"). *The Horse Fair,* which she called "my Parthenon frieze," was put on tour in England and acclaimed as a masterpiece. It had netted a considerable profit in admission fees alone before being sold to Cornelius Vanderbilt for $52,000 — then a staggering sum for a work by a living artist. Increasingly prosperous, Bonheur and her companion moved to a house they had acquired near the forest of Fontainebleau. In Paris, she had already listed her collection of animals as "one horse, one he-goat, one otter, seven lapwings, two hoopoes, one monkey, one sheep, one donkey, two dogs, and my neighbor Madame Foucault." Now she was able to add even more exotic creatures, such as a yak, a gazelle, an eagle, and a lion cub. At the height of her fame, Bonheur received a visit in her country studio from the Empress Eugénie, who personally appointed her Chevalier of the Légion d'Honneur.

"Gueux comme un peintre" ("poor as a painter") was a common expression throughout the nineteenth century, and many a family did their utmost to dissuade a starry-eyed son or daughter from taking up art as a profession. Beside the few dozen artists to achieve real recognition and sometimes spectacular prosperity were countless needy creatures moldering away in obscure rooms, reduced to painting shop signs or doing other inglorious tasks to keep body and soul together. Even for the most talented and iron-willed, conditions were tough, and any young novice who dreamed of an exalted or carefree Bohemian life got a rude awakening as soon as he enrolled in art school — where naked initiation ceremonies, bullying, dirty jokes, and disciplinarian teachers created an atmosphere akin to English boarding schools of the same epoch. The Goncourts' *Manette Salomon,* one of the many novels to reflect the period's fascination with the artist's life, contains a realistic reaction to the idea that art was basically a soft option: "The bourgeois think our life's a bed of roses, that we're not half killed by the blasted work! But you know what it's like: art class from six in the morning to midday; then lunch off tuppence worth of bread and tuppence of fried potatoes; then the Louvre, where we paint right

through the afternoon . . . then, in the evening, back to school, from six to eight, for the model. And, after that, when you get back home . . . just try and find the time to eat! Oh, it's wonderfully healthy all right, what with the cheap eating-places, the snags and the snares, the slaving for the competitions, with a tired stomach and a tired head. . . . Go on with you, you need some constitution and a strong frame to take it!"

To get through the rigors of art school, then make one's way from being a young unknown to an artist of promise required fortitude and a rare capacity for work. For all their love of luxury and display, the leading artists worked with a regularity and a single-mindedness that would be admired by professionals in any field. Meissonier, who was unusually resilient, was able to keep painting for thirteen hours a day, after which he would relax by riding, swimming, or canoeing down the Seine. Gérôme would bolt his meals, creating chaos in the kitchen by demanding all courses at once so that he could return to his easel with the least loss of time; he was a highly influential teacher at the Ecole des Beaux-Arts for thirty-nine years, and, quite late in life, added sculpture to his range of activities. The sheer acreage of Alma-Tadema's highly finished paintings bespeaks intense industry, while Leighton was as active in presiding over the Royal Academy as he was prolific in producing alabaster-skinned goddesses. Nevertheless, like Dickens and Zola, their contemporaries in literature, these immensely hardworking artists found time to lead strenuous social lives.

A successful new painting galvanized public opinion in a way which an immensely popular new film might do nowadays. When Holman Hunt's *Christ in the Temple* was exhibited in a Bond Street gallery, it became a sensation overnight; crowds queued to pay their shilling to get a glimpse of the subtly lit composition, hung like a glittering jewel in a darkened room. Meissonier's portrait of *General Desaix* created no less a stir when it was revealed that Cornelius Vanderbilt had paid $60,000 for it; another of the meticulous master's works was bought as a present for Queen Victoria during her state visit to Paris. It was small wonder that, surrounded by such high favor, these artists took their position in society so seriously. Some of them grew exceedingly rich (one of the most highly paid, William

A Newcomer Arrives, *lithograph after a painting by Hippolyte Bellangé, 1832, Bibliothèque Nationale, Paris. Art students were greeted much as new boys at English public schools of the same period were. Initiation rites included being stripped to the skin and made to sing. The barbaric welcome and grueling working conditions dissuaded many would-be artists from continuing on the hard road to recognition.*

More down-to-earth than many painters' studios of *the* time, the sculptor Emile Frémiet's workroom contains a haphazard-looking platform, a section of armor, and a bull's head — of which the first two, at least, have helped him in this evocation of a knight of old.

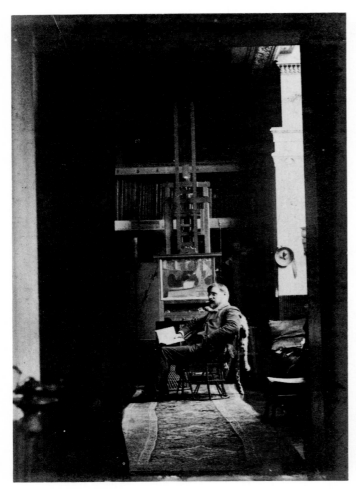

Photographed here in a reflective pose beside his easel, Sir Lawrence Alma-Tadema thrilled Victorian society with his picturesque evocations of life in classical times. He researched each of his pictures thoroughly to ensure topographical accuracy.

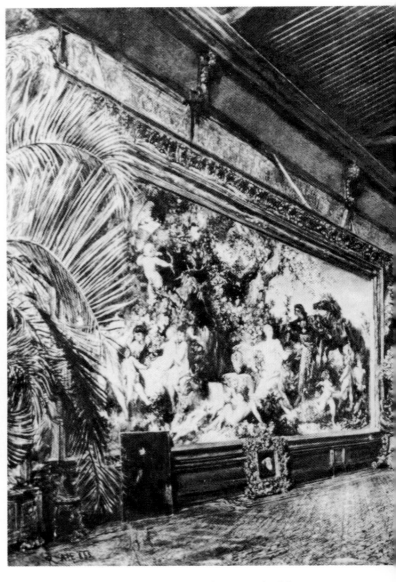

Hans Makart's Studio in Vienna, photographed by a contemporary in the early 1870s. Makart (1840–1884) was Vienna's great society favorite, comparable to Chase in New York, Alma-Tadema in London, and Lenbach in Munich. Pageant and decoration were his speciality, and the inflated atmosphere of his studio-palace his masterpiece.

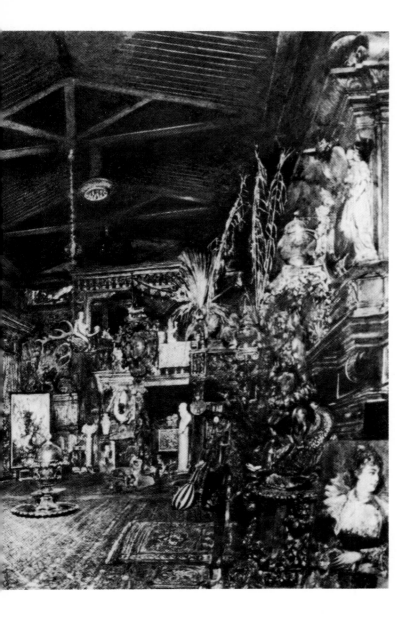

Bouguereau, jocularly complained: "I lose five francs every time I go and have a pee"), and they were determined to live in a correspondingly grand style. Alma-Tadema spent years and the present-day equivalent of £1,000,000 decorating the mansion he owned in St. John's Wood, London. He had a seventeenth-century Dutch-style studio built for his artist wife, and for himself a vast atelier with a dome faced in aluminum, which gave the air a silvery sparkle that he hoped to incorporate in his paintings, and his colors were indeed seen to grow brighter as a result.

The Casa Tadema, as it came to be called, was a resplendent affair through and through, with marble floors and walls, doors modeled after those the artist had most admired at Pompeii, fountains and an atrium complete with mosaic pavement. The overall effect, one visitor enthused, was "quite literally like nothing on earth, because to enter any of its rooms was apparently to walk into a picture. Lady Tadema's studio, for instance, might have been a perfect Dutch interior by Vermeer or de Hooch. Tadema's, on the other hand, conjured up visions of all the luxury, the ivory, apes, and peacocks of the Roman civilization with which his art was largely preoccupied." Hans Makart's extravagance in his Viennese mansion was on a similar scale; visitors came away from his studio with an impression of countless grottoes, fountains, palm trees, and exotic animals darting down halls lined with rare works of art. Similarly, when Frith, himself no stranger to wealth and fame, visited Meissonier and Detaille in their Parisian ateliers he was astonished to find a magnificence surpassing that of Lord Leighton, who was "pretty decently lodged."

Toward the end of the century, a curious osmosis occurred. The successful artists of the day had set out to acquire the life-style of the wealthy bourgeois whom they hoped to secure as their main patrons. Thus the messy, arduous side of painting was played down and emphasis given to the studio's more enticing aspects — sumptuous furnishings, witty conversation, or the glimpse of a half-naked model. Collectors and socialites quickly warmed to the privilege of being allowed into the studio, that magical place where art seemed to spring out of thin air. In fact, they were so seduced by the whole studio aura that they began to set up their own "studios" — either away from home (which was

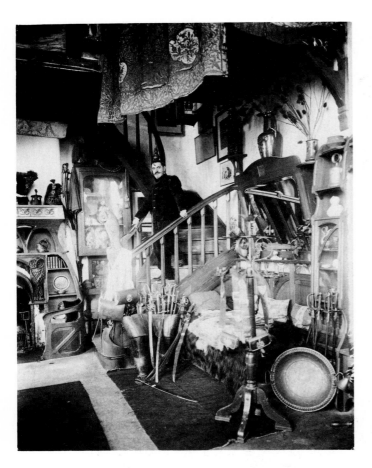

ideal for keeping a mistress) or as a den in which to be vaguely "artistic" or pensive. So, having provided a useful background for many celebrated artists, this kind of display studio became in the end nothing but a decor, a husk in which aesthetes could indulge in make-believe and husbands lead a double life. By this time, however, the center of artistic action had completely shifted. And for the artists who were planting their easels in fields and on riverbanks, those dark, overfilled ateliers already resembled the monuments of a bygone age.

Swords galore enliven the studio of this anonymous military painter, who poses proudly for posterity among the paraphernalia of his art. Toward the end of the century many successful artists used their studio as a showplace alone and did the real, messy work in a less impressive room.

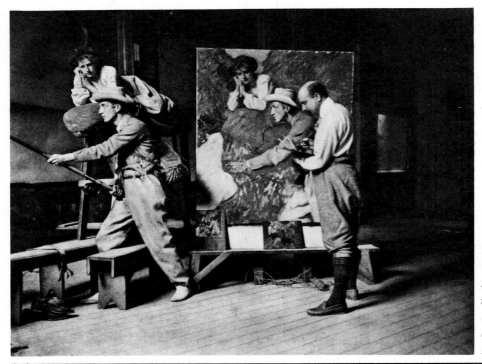

This photograph of the English painter Charles Wellington Furse illustrates the vital importance of models to many nineteenth-century artists. One can see that Furse first set up his models' complex pose, then proceeded to transfer it quite literally to the canvas.

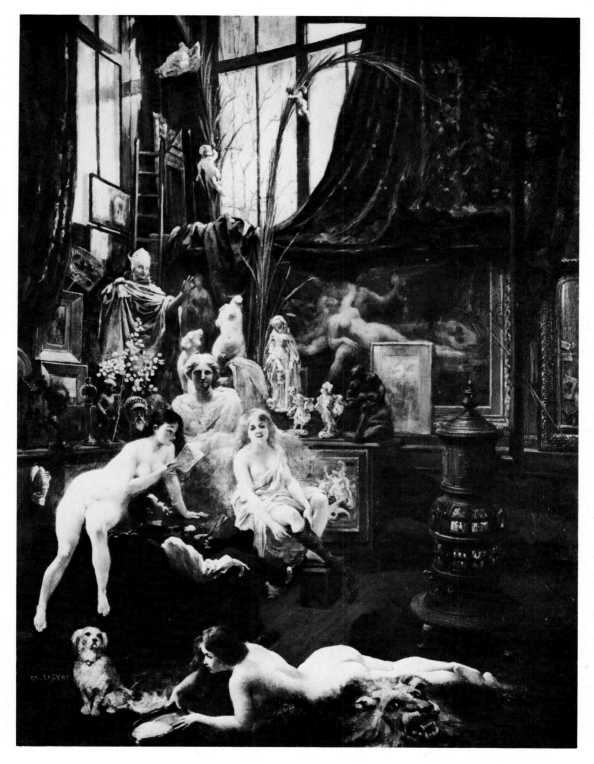

Adolphe La Lyre, The Painter and His Models, *ca. 1880, G. Schurr, Paris. Part of the popular myth that surrounded the artist's studio in the nineteenth century derived from the presence of nude models. The idea that,* *unlike ordinary mortals, artists lived without any sexual constraints finds an aptly fulsome expression in this picture.*

Studio Recluse and Open-Air Fanatic

While the Gérômes and Lord Leightons sat in their mighty studios dictating public taste, a more exacting, innovative breed of artists was beginning to make itself known. At the outset, these had little in common beyond a critical attitude toward official art and a desire to put modern reality — the actual world they saw around them — on their canvas.

They could not have made a more provocative choice. Convention accepted the wildest flights of fantasy: Alma-Tadema might conjure up pretty visions of Rome, Gérôme or Ingres run riot in casbah and harem. But the very notion of painting the ordinary everyday — a street corner or a laundress — was offensive. It struck at a basic belief. One became an artist to develop the ideal, not to relay the vulgar and banal.

For these young men, the studio atmosphere had become unbreathable. Academic precepts lay on it as heavily as court etiquette. There was a hierarchy of subjects surrounded by an intricate protocol as to how they should be treated. There were rules and traditions, no less tenacious for being debased. "Poetic effect" required that nudes be mistily idealized and that landscapes always be exotic or picturesque. Outline still predominated over color, which on the whole was kept discreetly mute. Precisely rendered detail and a highly polished surface were also much encouraged.

The most pressing need for the new artists was not so much to "rebel" against convention, as we tend to see it today, but more simply, and more radically, to make reality the touchstone of their art. Their reaction

was less theoretical and less self-consciously defiant, than Courbet's. Banded together as Independents and later dubbed Impressionists, they had no social or philosophic ax to grind. Cézanne's summing up of Monet, "Only an eye, but my God, what an eye!" might have been applied to all of them. They were consummately visual, concerned only to render what they saw before them with as much force and immediacy as they could.

This attitude was bound to collide with the prevailing view. The Establishment artists discussed in the previous chapter were also concerned with producing a certain notion of "reality," and on some points — such as their fascination with photography — they were closer to the Impressionists than is usually recognized. But their "reality," though often scrupulously exact in contour and measurement, tended to be as exotic, anecdotal, or idealized as they could contrive. The antique or oriental collections and the improbably posed models they kept around them made up an artificial reality that they were technically equipped to render with a startling surface likeness. And, in this sense, their studios acted as a screen between themselves and the everyday, shutting out the ordinary life that for them had no place in art.

The Impressionists were all the keener to tear down this screen for having been brought up in its shadow. Official art attitudes could not be escaped. They pervaded the Louvre and the Salon exhibitions, the Académie and the Ecole des Beaux-Arts, the private teaching ateliers and, naturally, the studios of those who had "ar-

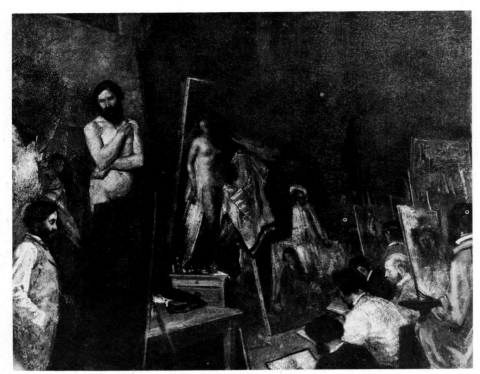

rived" and who safeguarded the system. Manet, who like Degas was born into the ruling class and had every incentive to become another Establishment artist, reacted against the tradition-laden atmosphere from the start. He had enrolled to study under the history painter, Thomas Couture, who had recently completed his *Romans of the Decadence,* an orgiastic piece that won him much renown. But Manet found Couture's atelier ludicrously artificial, even though he attended it from 1850 to as late as 1856. "I don't know why I'm there," he complained to his friend Antonin Proust. "Everything that meets the eye is ridiculous. The light is false and so are the shadows. When I get to the atelier, I feel I'm going into a tomb." Equally ridiculous, in Manet's view, were the unnatural, "classical" poses that the models held — often, as we have seen, with the help of ropes strung from the ceiling. The pose was a central part of the atelier ritual, and in voicing his scorn, Manet offended not only his master but also the legendary Dubosc, who in his lifelong career as a professional model had posed as everything from cherub to elder in the most influential studios of the century. "It's hard to be rejected by a young man like you," Dubosc told him

aggrievedly. "Thanks to me, there's more than one who's got to [the French Academy in] Rome." "We're not in Rome and we don't want to go there," Manet retorted. "We're in Paris, so let's stay here!"

For artists and people of fashion, Paris was the center of the world; and Manet, who belonged to both categories, distilled its brilliance in a few sheerly painted scenes of city life. He would have thought it absurd to leave Paris, either to seek inspiration abroad or, like his younger colleagues, Monet and Renoir, to go tramping round the countryside when one could paint comfortably in a studio in town. In many ways, he still adhered to established tradition; and throughout his life he remained very conscious of official success, envying, for instance, the prize-laden career of the facile Carolus-Duran ("Manet is in despair," Degas remarked, in one of his harsh but revealing *mots,* "because he cannot paint atrocious pictures like Carolus-Duran"). His various studios were a far cry from the impressive, curio-filled salon-ateliers of the more socially favored artists, however. Plainer and more workmanlike, they became centers of the city's intellectual life; for Manet, whom young painters sought out like a guru, was established

Recorded at a choice moment of intense activity in this photograph of 1892 or 1893, Augustus Saint-Gaudens's class at the Art Students League was once a byword for daring modernity in New York. Like most of his successful contemporaries, Saint-Gaudens had studied in Paris and so was able to pass on ideas and techniques he had absorbed in Europe.

Henri Fantin-Latour (1836–1904), The Batignolles Studio, *1870, Jeu de Paume, Paris. The famous group portrait — showing, from left to right, Scholderer, Manet (with brush), Renoir, Astruc (seated), Zola, Maître, Bazille, and Monet — still carries the force of a manifesto. In this sober studio on the Right Bank, in the recently developed Batignolles area favored by the new generation of artists, the revolutionary notion of bringing art closer to everyday reality found unanimous support.*

early on as the leader of the new generation. The outstanding writers of the day, from Baudelaire and Gautier to Zola and Mallarmé, were among the most frequent visitors because they particularly relished the combination of pretty women and influential men in the privileged atmosphere of the studio, then at the very height of its social mystique.

Not only did Manet keep a kind of intellectual open house there (even the solitary Cézanne, having heard of Manet's praise for his still lifes, paid him a visit); he also threw his studio open — in 1876, after his entries had been rejected by the Salon — so that the public could judge his work *in situ.* By that time, his studio on what was then the rue de Saint-Pétersbourg, in the new residential area round the Gare Saint-Lazare, was an estab-

lished favorite with a wide circle of Parisian personalities, several of whom felt moved to describe it. It struck one as being "of a monkish simplicity — not a useless piece of furniture, not a knickknack, but everywhere the most brilliant studies on the walls and the easels." For another, this former fencing school (in which Manet was reputed to keep the counter portrayed in his *Bar at the Folies-Bergère*) constituted a "vast room paneled in old, dark oak with a beamed ceiling. . . . A pure, soft and absolutely even light comes from the windows looking out onto the Place de l'Europe. The trains pass very close by, whirling their plumes of white smoke. The floor shudders and quivers underfoot like the deck of a boat in motion."

Another feature, which gave rise to gallant conjecture, was the split-level gallery, once used for judging fencing bouts, which Manet had screened off, like a secret bedroom, with crimson satin curtains. But although it became the headquarters for much that seemed new and brilliant in the life of the city, Manet's studio remained essentially a place of concentrated experimentation.

His technique, based on a contrast between light and shadow, with little half-tone, and an apparent spontaneity of brushwork, had been established early on in his career. In time, he lightened his palette, eschewing his beloved black (which had become anathema to the Im-

(Left) Pissarro contemplates a canvas in his studio at Eragny, near Pontoise, northwest of Paris. When this photograph was taken, around 1895, the painter had been living in Eragny for ten years. After a financially precarious and rootless existence, Pissarro was to make his home at Eragny until his death in 1903.

(Right) The workmanlike simplicity and order of Pissarro's studio is well illustrated in this photograph from the family archives. The artist consults a folder of drawings, while behind him one can see in neat array the materials and tools of his trade. A number of his own small-format works and a palette hang on the wall behind the easel.

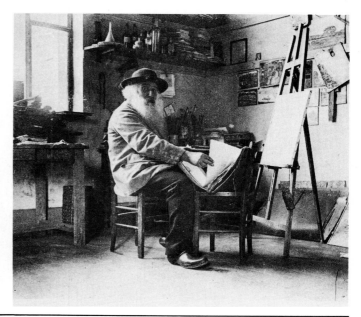

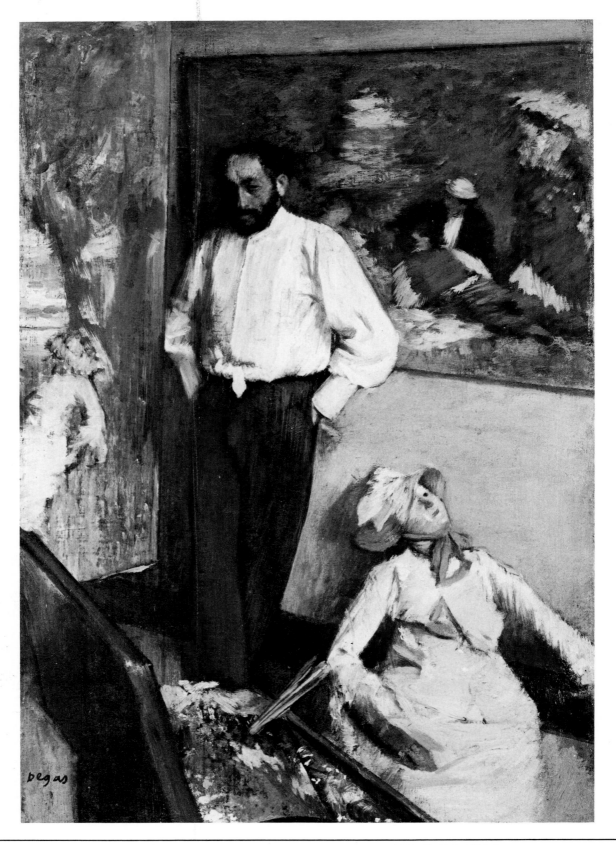

STUDIO RECLUSE AND OPEN-AIR FANATIC

pressionists), and widened its range. Like every ambitious artist of his time, Manet was concerned with being right up to the moment in anything that might give his painting a greater force of reality. Thus he did not hesitate to leave the studio to witness an episode of the Civil War — the battle between the *Alabama* and the *Kearsarge* off Cherbourg, which he sketched from the bridge of a tug before working it up into a fine, large painting This interest in contemporary events also prompted him to compose the hauntingly realistic *Execution of the Emperor Maximilian.* Like Géricault before him, Manet reconstructed the grisly event by means of news dispatches, and he had a squad of soldiers with raised muskets pose for him in the studio. Here, however, he had one signal advantage over Géricault: a sheaf of photographs of the event.

Though far from open, the studio of Edgar Degas resembled his friend Manet's in that the most diverse elements of the reality outside were gathered there, subtly blended and transformed. With his penetrating skepticism, Degas was keenly aware of the inherent artificiality of image making. Unlike Pissarro and Monet, he never came to believe in planting his easel on bridge or meadow side and trying to seize the fleeting impression of light on nature. For one thing, the strong sun hurt his eyes (he spent his last years in semiblindness); for another, such a spontaneous attitude toward art was quite foreign to him. "No art has ever been less spontaneous than mine," he remarked with habitual incisiveness. "What I do is the result of reflection and study. Of inspiration, spontaneity, temperament I know nothing." On another occasion, he put it even more succinctly: "The air one sees in masterpieces cannot be breathed." Solitary and obsessive, Degas was a studio painter par excellence. He might venture forth to racecourse or ballet, make sketches, or even take photographs, but then, for the real alchemy of turning the everyday into durable art, he returned to the familiar routine and propitious atmosphere of his atelier.

A work of art, Degas once observed, has to be executed with the same forethought and care as a crime. The studio that he long occupied on the rue Victor-Massé, in the Pigalle area, and where he plotted so many of his works presented a scene of monomaniac concentration and guile. Few enough people glimpsed

this cell of secret dreams, particularly as Degas grew older and more misanthropic and his work more astonishing. Paul Valéry, the poet, recounts how even Degas' intimates never knew how they would be received, then proceeds to describe a successful visit to the master's lair. "It was one of his good days. He let me into a long room, under the rooftops, with a bay window (whose glass was rarely cleaned), where daylight and dust met happily. Piled up together there were the tub, the dull-colored zinc bath, the well-used peignoirs, the wax dancer with her skirt of real muslin in a glass case, and the easels, stacked with snubnosed, bandy-legged, charcoal creatures holding their mane of hair taut in one hand and combing it with the other. Alongside the window vaguely warmed by the sun ran a narrow mantel piled high with boxes, bottles, pencils, pastels, etching needles, and those things that have no name that might come in handy one day. . . ."

The overall impression was of a gentle, dust-laden chaos. The dealer Ambroise Vollard recorded that once an object found its way into the studio, it never left again nor even changed its position, but sank into the visual rubble which the artist knew by heart. Most of the rubble was directly related to one or other of the many techniques with which Degas constantly experimented. Whether the medium was pastel or oil paint, engraving or sculpture, the artist researched into forgotten, traditional methods, invented new ones, or combined existing techniques. Thus some of his works, as noted by the writer George Moore, a familiar figure in all the artists' haunts of the period, were "begun in water colour, continued in gouache, and afterwards completed in oils." When using pastel, in which he discovered a whole range of unsuspected subtleties, Degas frequently passed steam over the top layers, then reworked them with a brush or his fingers. Similarly, he drew some of the oil out of his oil paint, which he then diluted with turpentine in order to produce a pigment that, while easy to apply, gave a dry, chalky effect. In later life, as a proven expert and innovator, Degas used to lament the decreasing standards of technical knowledge: "Beauty is a mystery, but no one knows it anymore. The recipes, the secrets, have been forgotten. A young man is put in the middle of a field and told, 'Paint.' And he paints a sincere farm. It's idiotic."

Fascinated by photography, Degas took many portraits of his friends and himself. This self-portrait shows him in painter's smock — a typical moment in a life devoted to experimentation in the studio.

That young man might in fact have been any one of Degas' slightly younger contemporaries. Monet, certainly, came to painting with a completely different attitude from Degas'. He did not have the once wealthy aristocrat's culture nor his collection of fine paintings and Japanese prints. Neither could he, at least in the beginning, indulge in Degas' passion for photography (which, like the Japanese prints, deeply influenced Degas' sense of composition) nor share his exacting taste in models. For much of his career, Monet remained too hard up to have any kind of permanent studio; and often he was hardly able to afford paints, canvases or food. The lack of an atelier in itself rarely bothered him. In the early days, he shared more than one studio

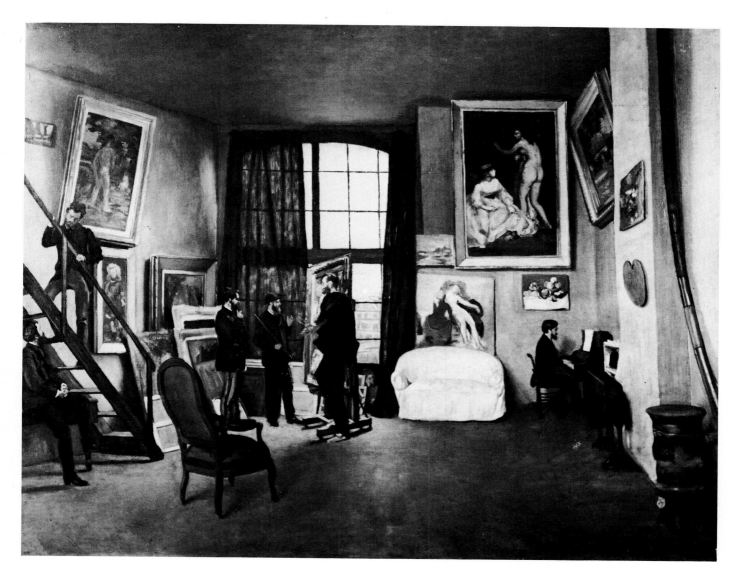

Frédéric Bazille (1841–1871), The Artist's Studio, *1870, Musée du Louvre, Paris. Renoir sits on a table chatting to Zola above him on the stairs, Manet and (behind him) Monet look at the painting on the easel, while Bazille (painted afterward by Manet) stands, palette in hand, beside them in this famous evocation of the young painter's studio in the Batignolles.*

with the better-provided Frédéric Bazille, whose painting of *The Artist's Studio* admirably illustrates the comradeship that united the Impressionists and their friends (when Bazille had finished painting, Manet took his brushes and added the portrait of Bazille himself). Then Monet moved out of Paris and began to paint regularly in the open air, setting up his easel beside Renoir's in field or on riverbank to capture the liquid splendor of light. Like his mentor, Eugène Boudin, he felt that "everything painted directly on the spot always has a strength, a power, a vividness that one doesn't get again in the studio."

Usually Monet dispensed with preliminary sketches and studies, working directly and rapidly on a thinly

prepared canvas, blocking in the main areas of color, then concentrating on specific images until the overall effect satisfied him. Like Degas, he first soaked much of the oil binder out of his paint, which he applied in a dragged fashion to evoke the flickering, fragmented effects of light. Although directness and spontaneity were the qualities he aimed for, Monet frequently retouched his paintings; from time to time, he would lose the result already achieved and then, in fury, destroy the canvas altogether — a practice shared by his friend Cézanne when the fit was on him. Eminently resourceful, the needy Monet made the best of whatever circumstances offered, however. No sooner did he have a little money in hand from a sale than he followed Daubigny's example and set up a makeshift studio on a small boat at Argenteuil, so as to get as close as possible to the fleeting mysteries of the sun dancing on water.

Such ventures, with all their potential for comic mishaps, were made easier by recent inventions like the tin tubes that had replaced skin bladders (still in general use in Delacroix's day) as containers for color. The *plein-air* painter's life was facilitated, too, by such innovations as the collapsible easel, which permitted him to roam the countryside without being saddled like a donkey. Chemical research had also considerably widened the range of colors available. Writing to his dealer, Paul Durand-Ruel, Monet describes his palette as consisting of cobalt blue, cadmium yellow, vermilion, deep madder, emerald green, and white — all of them, except vermilion and white, colors that had been invented in his own century.

In 1883, Monet settled in Giverny, beside the Seine, and remained there until his death in 1926. The latter years, thanks to the artist's perseverance and his dealer's zeal, were relatively prosperous, allowing the robust Monet to indulge his taste for good living. When he traveled to London, for instance, he put up at the Savoy, then the most modern luxury hotel in the world, and turned his riverside suite into a studio, from which he painted the Thames (Sargent, the highly successful portrait painter, recalls having seen some "ninety canvases littering the room"). On the Giverny estate (now a Monet museum), the painter and his family lived well but without ostentation, their main extravagances being an excellent table and a squad of six gardeners to tend

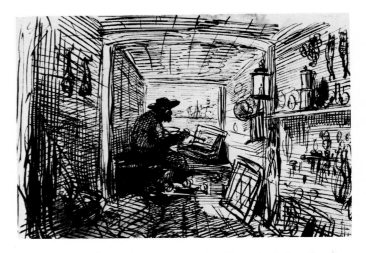

Charles Daubigny (1817–1878), The Artist's Floating Studio, *1857, Musée du Louvre, Paris. Using the lid of his paintbox for an easel, Daubigny shows in this charming pen-and-ink sketch how the little studio he set up on his son's boat enabled him to observe the movements of water at close, but relatively comfortable, quarters.*

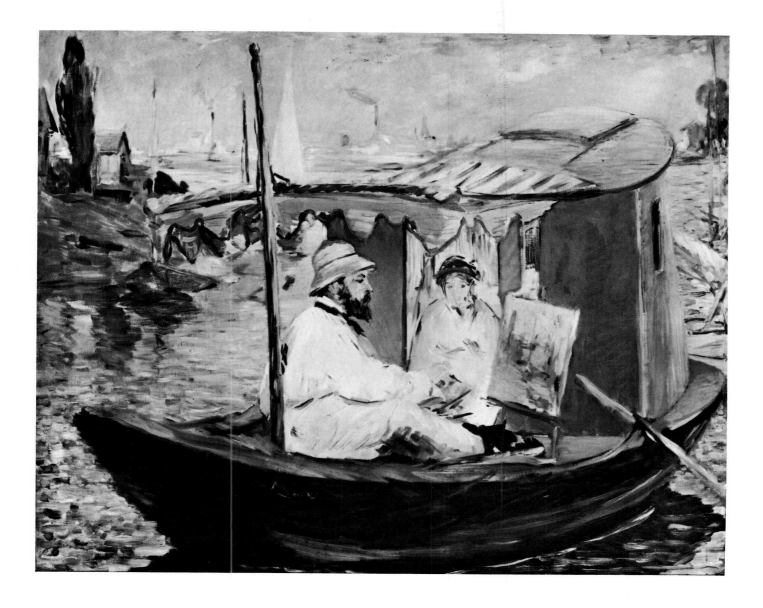

Edouard Manet (1832–1883), Monet Painting on His
Boat at Argenteuil, *1874, Neue Pinakothek, Munich.
One great poet of the beauty of light on water here
represents his peer and fellow Independent at work on
the boat he rigged up to help him with his river scenes.
The dark, portentous studios of Establishment artists such
as Gérôme or Lord Leighton seem suddenly to belong to
a far-off, forgotten epoch beside the sunny ease of Monet's
makeshift atelier on the Seine.*

the flower beds and the famous lily pond. As the paint-
er's reputation grew, the slumbering village of Giverny
was invaded by artists and art students from as far afield
as America and Japan. Parasols mushroomed in the
neighboring fields as smock-coated individuals straight-
ened easels and got to grips with a landscape or per-
suaded one of the local girls to model for them. Sky-
lights began to transform the Giverny rooftops, for at
one time no fewer than forty studios could be counted in
this village of three hundred native residents.

Monet himself ended up with three ateliers, which
formed part of the guided tour to which the artist
treated a few privileged friends such as the statesman

Georges Clemenceau or companions-in-arms like Mary Cassatt and Cézanne. One of the ateliers had been turned into a salon-cum-museum where he kept a collection of his own pictures, not a few of them having once been left with tradesmen in lieu of payment and subsequently bought back. Works by other artists — Monet owned over a dozen Cézannes, for instance — and an array of fine Japanese prints decorated other parts of the house. The second — or real, working — studio proved insufficiently large for the monumental series of *Water Lilies* that Monet began when already an old man. As a result, a third or "large" studio was specially constructed: forty-nine feet high by thirty-nine wide and seventy-five long, this hangarlike space was lit by a correspondingly vast opening in the ceiling, which was equipped with a system of awnings that allowed the artist to modify the incoming light as he wished. And so, after a lifetime of preparation in the open air, it was to this impressive, made-to-measure atelier that Monet returned to paint the crowning work of his career.

"Ah what dreams, and of the wildest kind, I built up," a young enamored Cézanne wrote to his former school friend Zola. "I said to myself, if she can put up with me, we'd go to Paris, I'd become an artist. . . . I thought, just like that, we'd be happy, I dreamed of paintings, of a studio on the fourth floor." Of the dream, only the studio and, very slowly, amid acute self-doubt and the mockery of others, the paintings came true. After years of being scorned in Paris and disregarded in his native Aix-en-Provence, this morbidly sensitive and tormented man withdrew increasingly into a solitary routine built around his art alone. "Isolation, that's all I'm fit for," he later told the young painter Emile Bernard. "At least that way no one can get their claws into me." Contact with others seemed so threatening, indeed, that Cézanne once ordered his housekeeper to make sure her dress never brushed him.

After his mother's death and the sale of the Jas de Bouffan, the family house that he had loved and

Palette in hand, the aging Monet stoops to take a brush before returning to work on the vast Water Lilies *series for which this magnificent studio at Giverny had been specially constructed.*

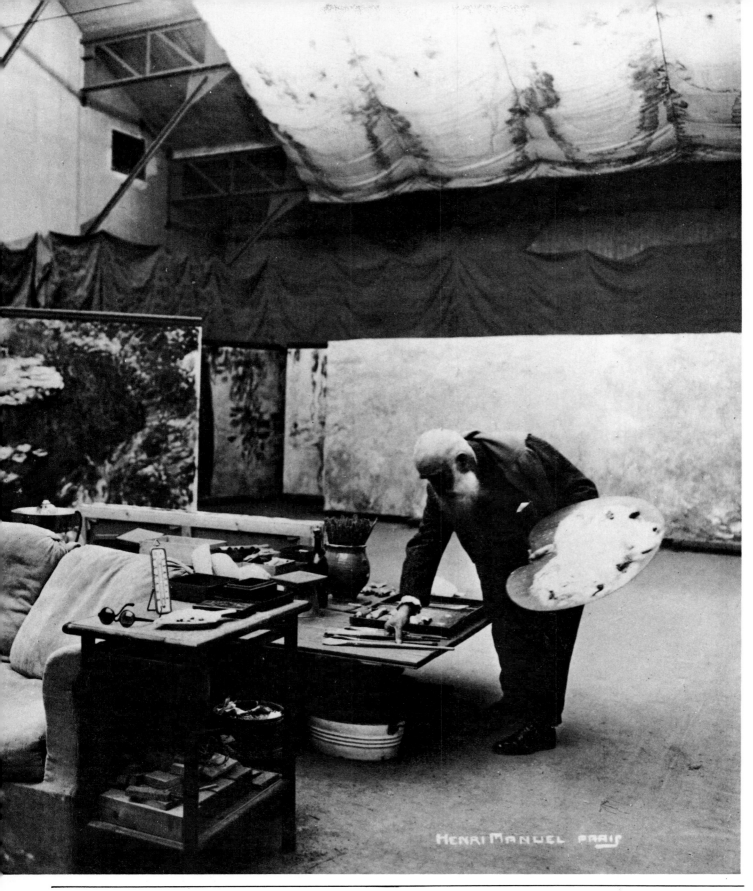

HENRI MANUEL PARIS

painted, Cézanne moved into the center of Aix, choosing a building with an attic that he could turn into a studio. His days tended to be quite uniform. He would rise at dawn, go to first Mass ("Mass and a shower," he used to say, "that's what keeps me together"), then warm up by making drawings of plaster casts for an hour before tackling the works in progress. His method of painting tended to be painstakingly slow, with each touch of color having to fit into a complex overall harmony. Often the painter would stare at his canvas for a good fifteen minutes before making a new mark, and some pictures were worked on intermittently for years before he felt satisfied. "My sensation," he explained, "cannot be expressed straightaway."

Cézanne had, in fact, turned sixty-three by the time he began to work in a studio designed specifically for him. The initial impulse to build a studio probably came from his desire to concentrate on the large *Bathers* series, for which his attic studio no longer proved adequate. Having found a suitable plot overlooking the city, he built a small house that had rudimentary living quarters on the ground floor and a studio, with a fine view of Aix, occupying the entire second floor. Now a museum, this studio is lit by a very large window to the north, with a slit through which large works could be passed, and two southerly windows looking out toward Aix. Just beneath the studio lies the small garden tended by Vallier, whom Cézanne's portraits have kept from oblivion.

Unlike Monet, Cézanne took little interest in comfort, and the furnishings were predictably sparse. But he brought with him the precious components of his still lifes: the plaster Cupid (reputedly by Puget), the stoneware olive jars, and the various skulls, as well as the table on which he assembled them and the old rug that served as a backdrop. These ritual objects were arranged with infinite care; under the fruit that accompanied them, Cézanne sometimes placed a coin so as to obtain the exact angle he required. (He could be similarly demanding of his sitters; Vollard recounts that he was roundly cursed by Cézanne, during a portrait session, for not sitting "like an apple.") A few prints or photographs — notably of works by Rubens and Delacroix, whom Cézanne admired passionately — enlivened the studio walls, while the center of the room was taken up

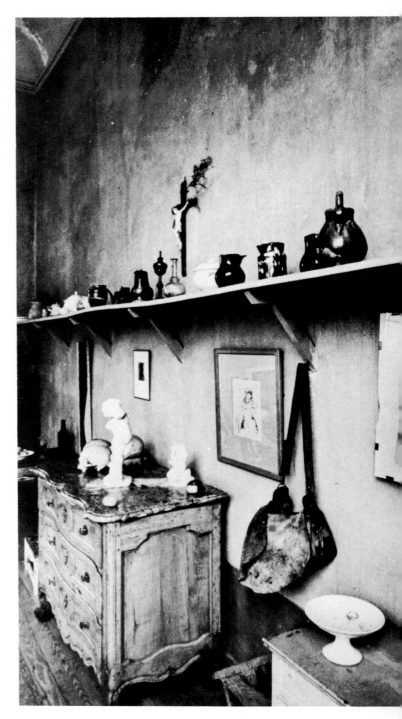

The game-bag used for carrying materials to paint outdoors, as well as the jars, the Cupid, and the skulls that appear in Cézanne's still lifes are among the objects preserved in his studio (now a museum) in Aix-en-Provence.

Parasol, paintbox, and palette conjure up the memory of the elderly Cézanne trudging under the fierce Provençal sun toward the landscape of his choice. The Aix studio allows the visitor to live for a moment in the painter's lonely, obsessive routine.

This still life reassembled in Cézanne's studio in Aix recalls the extreme care with which the artist built up each composition before beginning to translate it into paint. The Provençal olive jar shown here became famous as a frequent feature of his still lifes.

by the easel and steps that had been made specially to enable the artist to paint his large versions of *The Bathers*. Folders of reproductions of favorite works by other artists and numerous rolled or stretched canvases stood in the corners, along with Cézanne's equipment for painting out-of-doors: the portable easel and paintbox, the parasol, and the game bag into which the artist stuffed other equipment or food before setting off toward his celebrated motifs.

It is a moving experience to stand in this large, light room — as the Provençal sun beats audibly down, or in midafternoon, after the great heat, when the crickets resume their dry, obsessive chant — and imagine the aging painter, forever in doubt, pausing a long moment before adding one more touch to his complex edifice of color. It is moving above all because of the contrast between the artist's lonely hesitation and the fundamental manner in which he was altering art for generations to come. In this context, so ordinary an object as an old leather game bag becomes charged with significance, and the entire studio, though not specially remarkable in itself, breathes the magic of revelation.

To go from Cézanne's studio to Rodin's is to evoke in an instant the diversity and vigor of nineteenth-century art. Both men renewed tradition profoundly, but their characters and their careers could not have been farther apart. Where Cézanne drew into himself, barring his studio to all but a few odd devotees, Rodin expanded, even overreached himself, turning his art into a matter of national, and then international, importance. Where Cézanne fled friends, women, and society as a whole, Rodin knew everyone who counted and seduced most women within reach, so that his various studios at times became as much public showrooms or hideouts for love affairs (the model's screen proving most handy) as places of work.

Rodin had started out, inauspiciously enough, as an ornamental mason, employed to embellish doors, staircases, and even bedsteads and mirrors. His natural skill got him a job with Carrier-Belleuse, who ran an atelier on *bottega*-like lines where a small army of designers, modelers, polishers, and foundrymen produced quantities of decorative sculpture in tune with the taste of the times. Rodin continued to haunt the museums and to study; but he was thirty-eight before he had completed his first, purely personal, free-standing sculpture. Entitled *The Age of Bronze,* its astonishingly lifelike appearance created a scandal, and Rodin was accused of simply having made a direct cast of the model. This was the first of several noisy collisions with the artistic Establishment; as a result, Rodin became famous for his antiacademic views, and his studio the rallying point for young sculptors eager to break the mold of aesthetic convention.

The studio played a central role throughout Rodin's prolific career. He had many studios and often, as with his mistresses, several at once. The first was an extremely makeshift affair in a former stable, so cold in winter that Rodin continued to grumble about it many years after. As his reputation grew, however, he was able to pick and choose. To execute the famous (and never completed) *Gates of Hell,* for instance, Rodin was given a studio at the Dépôt des Marbres, which housed all the marble bought and earmarked by the state for public statues. Amid vast blocks of stone and an impressive array of plaster casts, a handful of favored sculptors worked in the various studios allotted to them. Rodin was frequently seen there, a solid, peasantlike silhouette against the mountains of marble, working side by side with Camille Claudel, the most passionate love of his life and herself a talented sculptor who occasionally modeled parts of Rodin's own figures.

At the core of Rodin's attitude toward art was his veneration of the body, which he saw as "a walking temple . . . an architecture in movement." He employed a great many models, of all ages and types — indeed, they were so numerous and so different while *The Gates of Hell* was under way that Rodin used to refer to his studio as "Noah's Ark" — and he liked to have them not posed but moving around as he worked. This was highly unconventional, of course, for academic tradition required a model to assume a specific attitude and hold it without budging. Rodin, quite to the contrary, would wait until a particular pose was suggested by the models in movement, ask them to stop, then rapidly fashion in plaster what he had glimpsed. Working in plaster suited Rodin's spontaneous temper, whereas — like Canova, for instance — he found stone-carving less congenial. As a result, he tended to concentrate on the plaster originals and leave much of their enlargement, or

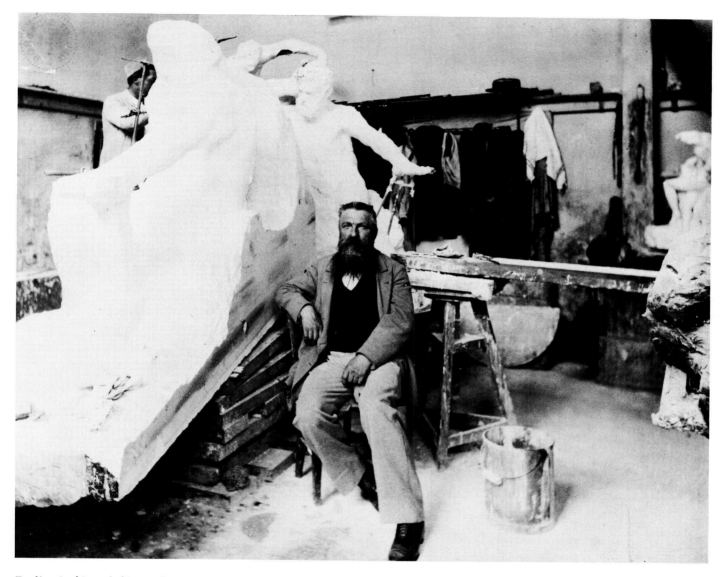

Rodin fashioned his sculptures in clay and usually left their execution in stone to his assistants, several of whom were outstandingly able. Here he sits for the camera in his austere, workmanlike studio while an assistant works on the early version of his Victor Hugo.

translation into stone, to his assistants — some of whom, like Emile Bourdelle and Aristide Maillol, were to become famous sculptors in their own right.

Most of the interest of Rodin's studio lies, of course, not only in what it looked like or what it contained but also in what was created there and what can be deduced from the space and its contents of the way the sculptor went about his work. Certainly, Rodin's studios had little of the upholstered glamour that society had come to expect of its successful artists. Edmond de Goncourt was struck by "the walls splashed with plaster, his miserable cast-iron stove, the cold humidity coming from all the great 'machines' of wet clay, which were wrapped in rags." And Rilke, for a short time Rodin's secretary and

a lifelong admirer, wrote of the artist's secret places of work (as opposed to his much-visited official studios) that they "were like cells, bare, poor and gray with dust, but their poverty was like the great gray poverty of God, out of which trees bud in March." It was in these bare, gray rooms, rather than in the more magnificent showplaces he later acquired, that Rodin brought singlehandedly to sculpture many of the liberating changes that the Impressionists had brought to painting.

At the height of his fame, Rodin had a house at Meudon, just outside Paris, and rented most of the ground floor of the superb Hôtel Biron (now the Rodin Museum), beside the Invalides. The Meudon studio had originally been built to house Rodin's works at the Great Exhibition of 1900. Its design — a rotunda surrounded by a colonnade — so pleased the sculptor that he had it reerected in his garden, and a visit there became de rigueur for anyone of note passing through Paris. Edward VII paid a call, for instance, to commission a bust of his latest flame (the American-born Duchess de Choiseul, who was subsequently to wreak havoc in the aging Rodin's life). George Bernard Shaw and Gustav Mahler also came to sit to him, while Nijinsky was captured leaping through the air like a messenger from the gods. Clemenceau sat for his bust, too, but complained it made him look like a "Mongol general."

Rodin clearly relished success. He used his flair for public relations and business to the full, and he exulted in such honors as his doctorate from Oxford — to the extent that he would regularly pace his garden wrapped in a bizarre combination of stately academic robes and everyday beret. But by the time Rodin was an old man, sated with fame and sufficiently weary to return to the long-suffering Rose (whom he married after a liaison that had lasted fifty-two years), the impetus that the Impressionist painters and he had given to aesthetic experiment had been taken over by others. It reappeared in the most startling fashion in a setting diametrically opposed to the nature-inspired, peasantlike atmosphere of Monet's or Rodin's studio: a near slum, in a rundown area of Paris, inhabited by a few expatriates who were about to accomplish a revolution more radical than anything that had ever happened before in the history of art.

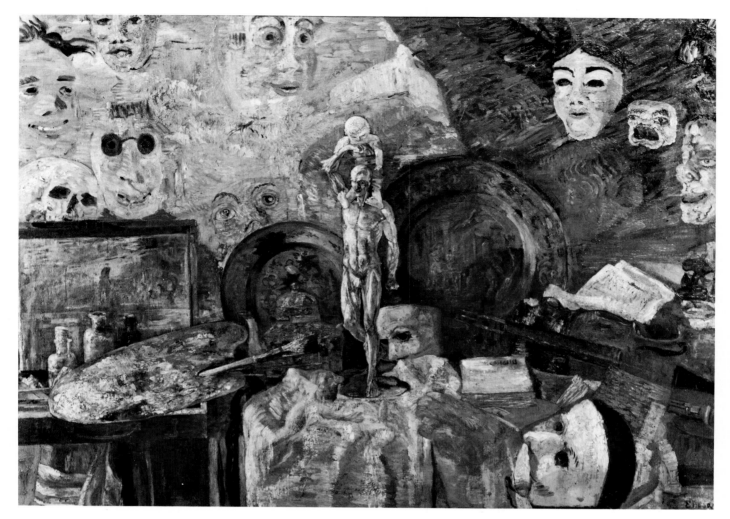

James Ensor (1864–1949), Studio Objects, *1889,* **Private Collection, Ghent.** *The* fin-de-siècle *lies heavily on this grotesque and disquieting vision of the artist's studio. For most of his long life, Ensor worked in a makeshift space over the family shop in Ostend. The sense of anxiety in this picture is so strong that only the studio mannikin appears to have any solid substance at all.*

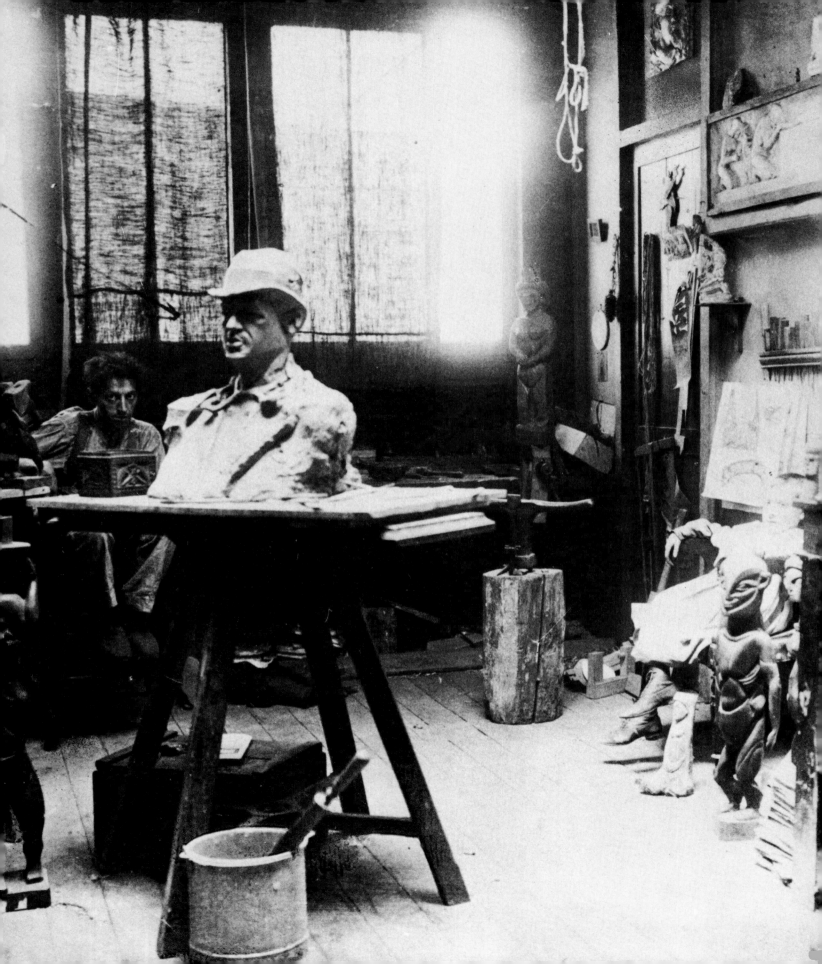

Group Ateliers:
The Radical Aesthetic

For an independent young artist touched by the turn-of-the-century fever to break with tradition and create anew, there was one place to be. It is not enough to say that the place was Paris, for Paris was also the academic capital, the seat of convention, and the very stage of *pompier* success. Yet not far from the Plaine Monceau, the fashionable residential area where society favorites governed the arts from their grandiose studios, a new hub of artistic activity had formed, in what was then the village of Montmartre.

Four windmills and a vineyard still graced this slumbering hillside in the first years of the twentieth century. But neither the local white wine nor the soothing spectacle of sheep at pasture drew artists to Montmartre as much as the low rents and the bohemian atmosphere. With the first influx of outsider artists came members of other marginal or disreputable professions. Bars, cabarets and whorehouses flourished in the cheap tenements. Henri de Toulouse-Lautrec, who drank so steadily that it was said his moustache had never been dry, spent much of his time in these establishments, both to enjoy himself and to work; brothels provided him with the natural models in real-life settings that he preferred. Lautrec had settled in Montmartre out of choice rather than financial necessity, and his split-level studio had the unusual luxury of a bathroom, as well as a rowing machine on which the deformed but keenly athletic painter exercised. Parties with lots to drink and plenty of pliant models made his studio a center of attraction. Occasionally a wild-looking visitor would en-

ter this boisterous scene, place a new painting in full view, and wait for a reaction. But even in that most liberal gathering, there was not enough sympathy or understanding to hold Van Gogh for long; after all, even the similarly mistreated Cézanne called him mad. At this time Van Gogh was living and working in his brother Theo's modest apartment on the neighboring rue Lepic. He grew restless after a while and headed south in the hope of founding a "community studio" where several artists might work together in harmony; but the only outcome of this cherished dream was the artist's tragic breakdown after sharing his quarters in Arles with Gauguin. Several other famous, and happily less ill-fated, artists contributed to make Montmartre the undisputed center of creativity for a couple of decades. Georges Seurat and Paul Signac, to take one notable instance, worked side by side in studios on the Boulevard de Clichy — the street where the lonely, blind Degas came to the end of his long career in 1917.

The artists who flocked to Paris from all over the world in the early decades of the century generally had one characteristic in common: lack of means. Many of them arrived like refugees, with little baggage and less French, and instinctively they sought out compatriots who had weathered the first rigors of this seductive but pitiless capital. Artistic communities thus sprung up wherever studio space could be had for next to nothing (or even nothing, nocturnal migration with all one's worldly goods in a wheelbarrow being a prominent feature of *la vie d'artiste* of the time). Forced gregarious-

GROUP ATELIERS: THE RADICAL AESTHETIC

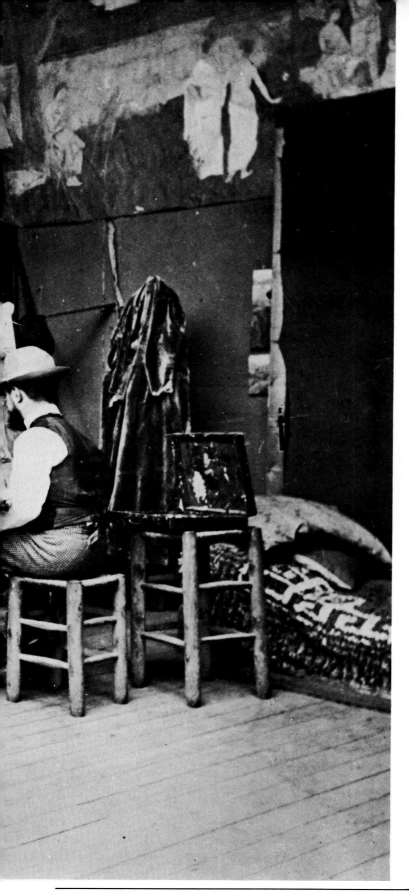

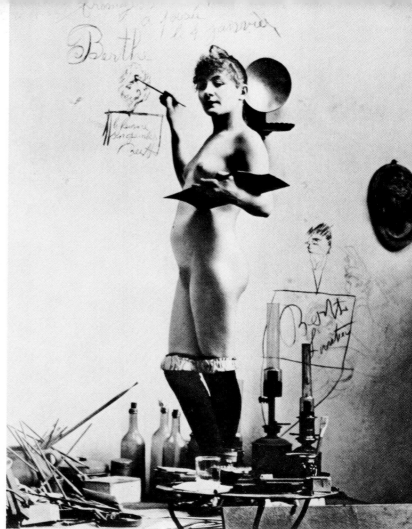

Art, women, and alcohol were the three passions of Lautrec's life, and he demonstrated a prodigious appetite for each. Dated January 4, 1890, this photograph is eloquent of the easygoing, licentious atmosphere of his studio: the naked model, known as "la môme Fromage" or "The Cheese Kid," scrawls a caricature on the wall. Old bourgeois suspicions of immorality in the studio were fully corroborated here.

The hangarlike space of Toulouse-Lautrec's studio in Pigalle became charged with excitement by the presence of his paintings and the poignant myth surrounding the artist himself. In this photograph, Lautrec puts the finishing touches to La Danse au Moulin Rouge, 1890, which shows La Goulue, "Queen of the Cancan," in action with her partner.

Baptized the "Acropolis of Cubism" by the poet Max Jacob, the Bateau-Lavoir consisted of a maze of more or less insalubrious studios whose unique advantage lay in their low rent. A certain joie de vivre *nevertheless prevailed, and parties, practical jokes, and general highjinks lightened the daily routine. Here, a group of inmates strikes artistic poses for posterity.*

ness and shared poverty dominated, but they did not crush the stronger spirits; in the more successful of these makeshift arrangements, a tough kind of gaiety prevailed.

When Picasso arrived in Paris, he naturally gravitated to the Spanish colony in Montmartre. Although he had intended to push on as far as London (a move, incidentally, which might have changed the whole course of modern art), the young foreigner settled in 1904 in what turned out to be the liveliest, most ramshackle artistic phalanstery since the Louvre's last days as a maze of "revolutionary" artists' studios. The Bateau-Lavoir — or, quite literally, "Washhouse Boat" — as this lugubrious warren atop Montmartre was called, had been frequented by painters (notably Gauguin) since the 1890s. During the time that Picasso kept a studio there, its inmates included Kees Van Dongen and Juan Gris, as well as the poets Max Jacob and Pierre Reverdy. Although cheap, this wooden tenement was uncomfortable and unhygienic in the extreme: bitterly cold in winter, unbearably stuffy in summer, it had no gas, electricity, or even water (which had to be fetched from a pump outside). The whole building was so obvious a liability no company would insure it; and, eventually, in 1970, it was in fact destroyed by fire.

As the meeting place for the city's avant-garde and the room where the *Demoiselles d'Avignon* was painted, Picasso's studio in the Bateau-Lavoir might be singled out as the most important space in the history of modern art. No doubt the idea would have made the Spanish artist and his ever-present cronies (known as *la bande à Picasso*) roar with laughter, because the room looked anything but important. One of the building's inmates, the writer André Salmon, summarized it as a "wooden painting hut, with a nondescript round table from a second-hand furniture store, an old couch for a bed, and an easel." Fernande Olivier, who lived with Picasso during his Bateau-Lavoir period, had worked long enough as an artist's model not to be put out by studio discomforts. But she recalled the "mattress on four legs in the corner" without nostalgia, then went on to give the following disenchanted description: "A completely rusted cast-iron stove with a yellow earthenware basin served for washing. . . . In another corner, a miserable little chest painted black did as an uncomfortable seat.

"My studio windows," Picasso has written, no doubt proudly, on this postcard of the Bateau-Lavoir. The ramshackle tenement was enlivened by his presence from 1904 to 1909, and he rapidly became its leading figure. Without the brief ferment of revolutionary ideas of which Picasso was the main instigator, the Bateau-Lavoir would have moldered on in obscurity.

A cane chair, easels, canvases of every size, tubes of paint scattered over the floor, bottles of turpentine . . . no curtains. In the drawer of his table Picasso kept a tame white mouse, which he took great care of and showed to everybody."

This shedlike room had one feature that was to characterize the most palatial of Picasso's subsequent ateliers: an extraordinary muddle of rubbishy odds and ends fanatically hoarded for some rarely revealed purpose. "I only like objects of no value," the painter used to insist rather proudly; and a carpet of cigarette packets, torn magazines, old tins and jars, bits of cloth and metal grew beneath him wherever he worked. They would have had the merest anecdotal interest if Picasso had not touched them, magicianlike, into art. For sud-

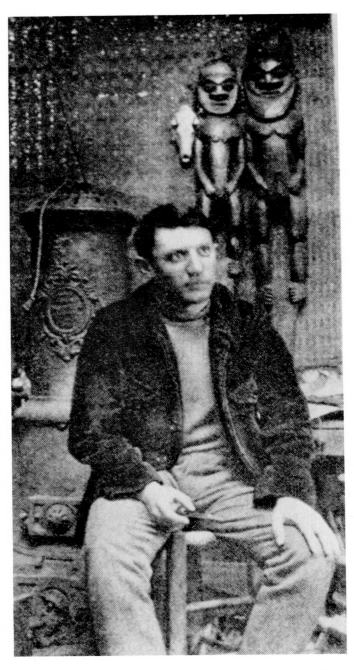

denly in this studio, and later throughout Europe, the materials used for centuries to make works of art were no longer regarded as sacrosanct. Things as trivial as a Métro ticket, as banal as newsprint, now assumed a potential aesthetic significance — and abruptly called into question all the technical formulas and lore artists had developed so patiently since the Middle Ages.

As one might expect in a studio where bits of litter could take on a startling new existence overnight, there were none of the traditional aids, props, and devices that continued to characterize the majority of other artists' ateliers: no plaster casts or engravings, no costumes or arms, no assistants, and virtually no models. But numerous books, ranging from Mallarmé's poems (recommended by Picasso's bosom friend, Max Jacob) to Sherlock Holmes stories, lay scattered round the studio. Hanging on the walls were reproductions of paintings by El Greco and, most important, the African and Oceanic carvings that, though not of particular value in themselves, were to be one of the determining influences on the *Demoiselles d'Avignon*.

Picasso appeared so gregarious during these years of radical invention, so ready to welcome famished compatriot or indigent wag, that no one knew how he found time to work. Fernande herself, forever battling in vain against the workroom chaos, claims not to have eaten a single meal alone with him in their five years together at the Bateau-Lavoir. But whatever time Picasso lost by chatting and japing during the day, he made up at night. By means of a highly impractical, dangerous oil lamp, which sent flickering shadows across the canvas and undoubtedly altered his vision, the artist would paint until dawn, and with such intensity that he was able at times to complete two or even three pictures. However difficult his financial situation became, Picasso always found a way of procuring the materials he needed, even if he had to scrape off an old painting in order to have a canvas for something new. "Genius knows no obstacles," Degas once remarked, and Picasso had a gift not only for getting by when others would have been marooned in penurious gloom but also for enjoying himself. By some wizardry he came up with the few *sous* needed to haunt the local circuses (such as the Cirque Medrano, which had fascinated Degas, Lautrec, and Seurat) as well as the Montmartre bars

When this snapshot of Picasso was taken in his studio at the Bateau-Lavoir in 1908, the young artist had already acquired a reputation as one of the most remarkable painters of his generation. The shock of the Demoiselles d'Avignon *(which the African statuettes on the wall immediately call to mind) was so intense that Picasso's friends and patrons treated the painting as an aberration.*

However frequently he moved from studio to studio, Picasso never failed to leave his imprint on the space where he worked. A couple of years after leaving the Bateau-Lavoir, he set up for a while in this studio on the Boulevard Raspail in Montparnasse; the construction photographed here has since disappeared.

Of all the objects in Derain's studio, by far the most original and influential were his African masks and statuettes. African art became as important to the studios of the early twentieth century as classical statuary had been to those of David's time.

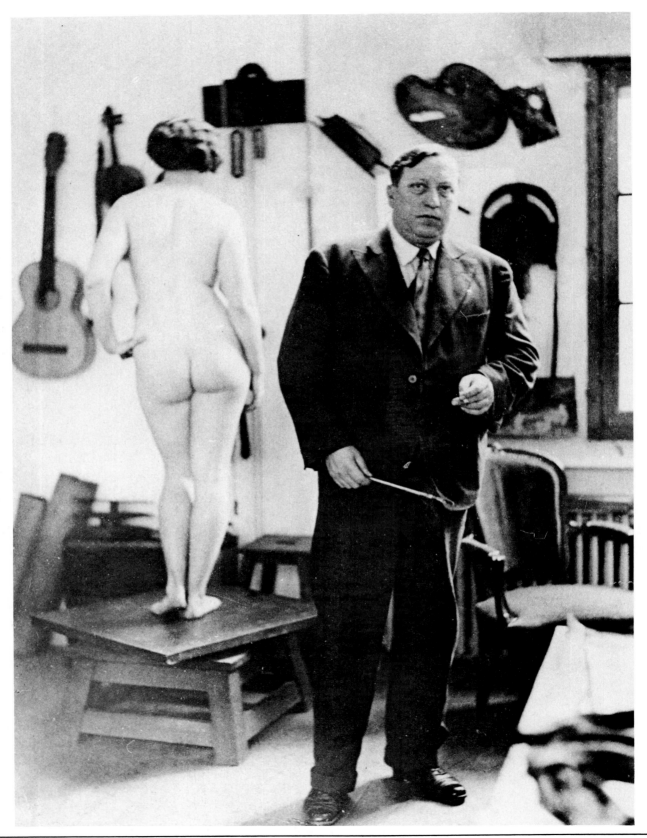

GROUP ATELIERS: THE RADICAL AESTHETIC

Brush in hand, André Derain pauses like a conductor in his Paris studio before continuing work on a nude. The room contains a fascinating array of objects, from model ships and terrestrial globes to African sculpture. On the wall behind the nude one can see Derain's palettes and some of the musical instruments of which, like Rubens and many other artists before him, he kept a choice collection.

and cabarets. Dressed in workman's blue overalls (nipped at the waist, when he was in dandyish mood, with a red Catalan sash), Picasso would regularly sally forth surrounded by his taller friends, Derain, Vlaminck, and Braque: "Napoleon flanked by his *maréchaux*" was Gertrude Stein's description of the group. And in the Bateau-Lavoir itself, virtually anything was good for a laugh, from schoolboy pranks to fancy-dress farces or full-scale parties, such as the legendary banquet the inmates organized in honor of the great naive painter Douanier Rousseau ("You and I are the greatest painters of our time," the Douanier confided sagely to Picasso, "you in the Egyptian style, I in the modern"!). But the wildest buffoonery did not prevent the most searching experiment, for Picasso had already begun to turn over in his mind the painting that was to challenge the foundations of Western art.

During the winter of 1906, when the rain dripped through the roof and some mornings were so unbearably cold that neither the artist nor Fernande stirred from bed, Picasso completed the first drawings for the *Demoiselles d'Avignon*. They took all his attention for several months, and the farther he went with them the more a disturbingly new pictorial vision bodied forth. "Picasso was in a state of anxiety," his friend André Salmon noted. "He turned his canvases to the wall and abandoned his brushes. . . . Day after day, and often through the night, he drew. . . . Never had work been so unrewarding, and there was none of Picasso's previous youthful enthusiasm when he started on the large canvas that was to be the first fruit of his research." Since the fine-weave canvas Picasso normally used proved insufficiently strong for so large a composition, the artist had it backed with stronger material and mounted on a specially constructed stretcher. Once all the preparations had been made, a few days' concentrated work sufficed to execute the long-deliberated painting.

Years later Picasso claimed that African sculpture had not been consciously on his mind when he began the *Demoiselles*. It is true that he had been visiting the Louvre frequently and looking at everything from Egyptian to Romanesque and Gothic art, and the two figures most clearly influenced by the newly discovered *art nègre* (on the right of the picture) were in fact

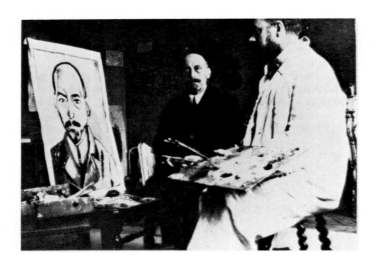

Dressed like a surgeon, Matisse examines his portrait in progress (later dated 1916) while his sitter, the collector Michael Stein, maintains an exemplary immobility. Of all the Stein family, Michael was the closest to Matisse.

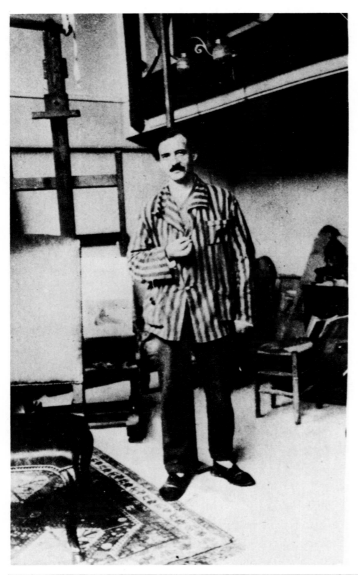

This rare and touching photograph of Maurice Utrillo as a comparatively young man shows him attired in a convict's pajama top about to start painting in his Paris studio. Drink and drugs — his other two major pursuits — often led him to the local police station, where, in return for a bottle of wine, he would willingly dash off one of his peculiarly atmospheric views of Paris.

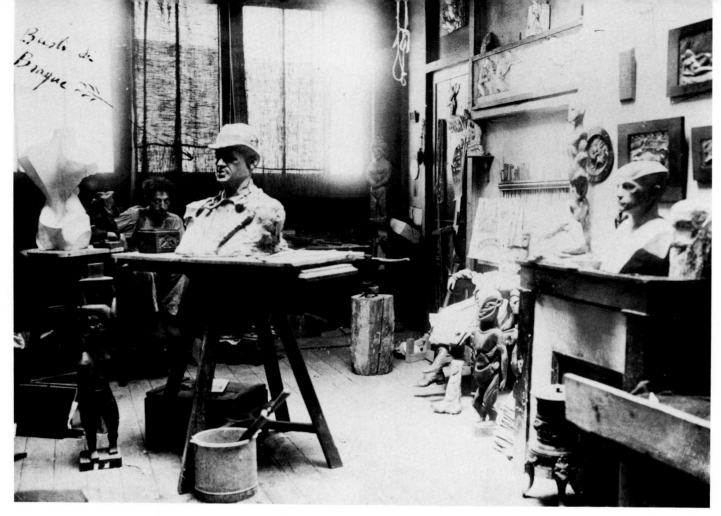

Bust de Braque

Two elements in the picturesque clutter of the studio belonging to the metal sculptor Auguste Agero date it as belonging to the "heroic" period of the Bateau-Lavoir. One is the bust of Braque, who visited Picasso regularly. The other is the Negro sculptures, which were to become as familiar a sight as North African objects had been in nineteenth-century studios.

painted last. But it appears that, although he did have a number of "primitive" works beside him as he worked, Picasso's interest in African sculpture was not in fact fully wakened until afterward, when he visited what was then the "ethnographic" section of the Sculpture Museum at the Trocadéro. This led him to remark, in retrospect, that African art had been as vital to his generation as Japanese prints had been to Van Gogh's.

Derain, Vlaminck, and Matisse were all enthusiasts of African art, a fact that might have prepared them to some degree for the shock of the *Demoiselles* — the way it appeared to reject, deliberately and brutally, any notion of visual sense. But Matisse saw the picture as a deliberate spoof on modernism and grew very angry, while Derain confided to the dealer Daniel-Henry Kahnweiler that no one would now go near Picasso's studio — either to look or to buy — and that "one day we'll hear that Pablo has hanged himself behind his big painting." A period of near-ostracism ensued, but it was short-lived, and the Bateau-Lavoir soon resumed

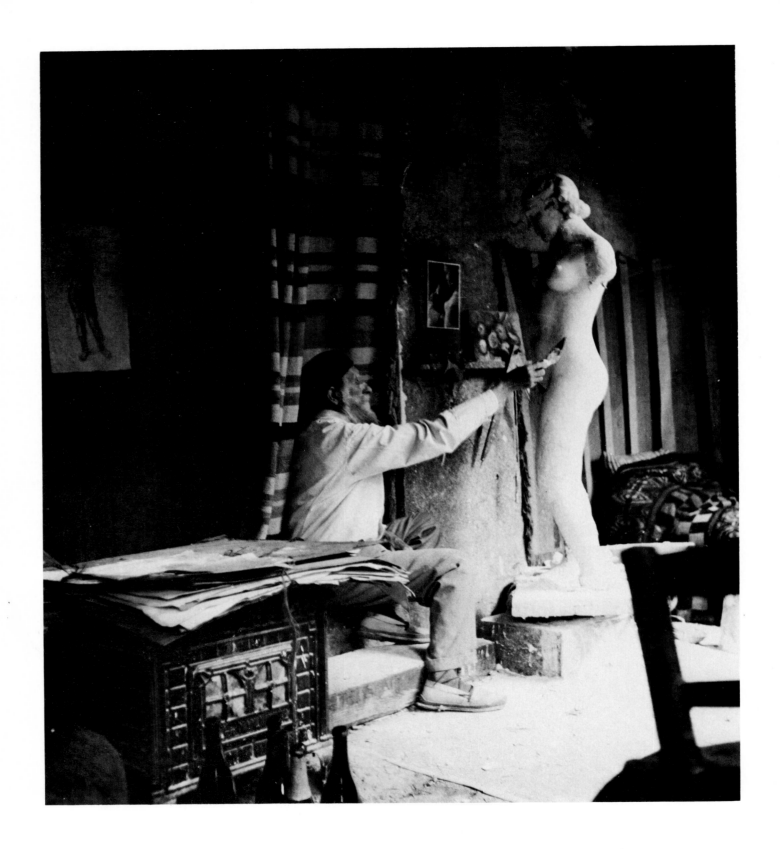

GROUP ATELIERS: THE RADICAL AESTHETIC

A lifelong friend of Matisse and an artist of similarly independent outlook, Aristide Maillol devoted his career to recreating a classical ideal of female beauty. By emphasizing the static, monumental aspects of the human form, he challenged Rodin's belief in the necessity of movement in sculpture.

its role as meeting place for the avant-garde. The poet Guillaume Apollinaire, later baptized the "emperor and pope of cubism" because he launched the movement so successfully, became an assiduous visitor, bringing powerful potential allies like Félix Fénéon, who had championed Seurat (but who considered Picasso most gifted as a caricaturist). Collectors and dealers were extremely welcome, of course, and the concierge had been trained to speed in the more affluent visitors while keeping the less "serious-looking" ones at bay. Gertrude Stein, who claimed to have sat to Picasso — a quite unusual occurrence — at least eighty times for her portrait, continued to take a dedicated interest in his development, as did Vollard and the young Kahnweiler, virtually the only person to like the *Demoiselles* right away and subsequently Picasso's dealer for sixty years.

Even Picasso's new friend Georges Braque found the aggressively original work difficult to swallow — and he said so very clearly: "It's as if, instead of one's usual food, one had to eat tow and paraffin"! The year 1907 had consisted of one revelation after another for the methodical Normandy-born artist. There had been the posthumous Cézanne retrospectives at the Salon d'Automne and the Bernheim-Jeune Gallery; then came the decisive encounters with Apollinaire, Picasso, and Kahnweiler, who was to put on a one-man show (still a rare event in those days of large, mixed exhibitions) of Braque's work the following year. For all his calm exterior and patient manner, Braque had already traversed one period of fierce iconoclasm, but, as he wisely concluded of his Fauve experience, "you can't stay in a state of paroxysm forever." At the outset, nothing seemed to predispose two individuals as different as Braque and Picasso — the one apt to take two years over a painting, the other, all spontaneity and change, three hours! — to join forces in the most daunting stylistic adventure of the century. But from 1909 until World War I, the friendship deepened into a unique model of close cooperation. "The things that Picasso and I said during those years," Braque summed up, "will never be said again. Nobody could say them, and even if they were said nobody could understand them. . . . It was rather as if we were climbers, roped together. . . ."

In 1910, Braque moved into a studio on the rue Cau-

laincourt in Montmartre, within easy walking distance of Picasso (who was by then installed in a comparatively comfortable studio apartment on the Boulevard de Clichy). A contemporary photograph shows Braque relaxing with his accordion — exactly like Ingres with his violin — in an orderly, well-lit room whose walls are festooned with tribal carvings and musical instruments, both of them elements that, like the small round table or *guéridon,* were central to many of his paintings. Unlike Picasso, who was not happy until immersed in a propitious mess, Braque favored an uncluttered space where he could concentrate on the works in hand without interruption from passing friends. He had no use for professional models, more particularly since the objects in his studio provided him with a whole range of subjects, and he differed from most painters in preferring a south, and hence variable, light to a more even northern one.

"My cubism was a means I created for my own use," Braque once explained with revealing candor, "and its primary aim was to put painting within reach of my own gift." Like his fellow climber, Braque sought by instinct to break the mold of accepted visual thought, to chart new regions for the mind and eye, believing that "real discoveries are made beyond the bounds of knowledge." Yet his working methods were far from the fiery bursts of inspiration such a phrase conjures up; he painted with patient regularity, with an attention to detail, a desire to see "a job well-done," that recall his early apprenticeship as a house painter. He took a correspondingly long time over his pictures, walking to and fro, adding a dab of paint, retiring once more to contemplate it, then moving in again to correct a nuance. "One must wait," he said once in the middle of a new work. "One never knows where the call will come from."

"In Cubism," Picasso stated, "you paint not what you see, but what you know is there." The definition applies nicely to the work of the third member of Cubism's inner circle, Juan Gris. Following the call to Paris, Gris left Madrid in 1906 and headed straight for the cheap and partially Hispanic Bateau-Lavoir, where poverty (scarcely alleviated by money from the caricatures the artist drew on the side) was to keep him until 1922, five years before his death. Kahnweiler was quick to

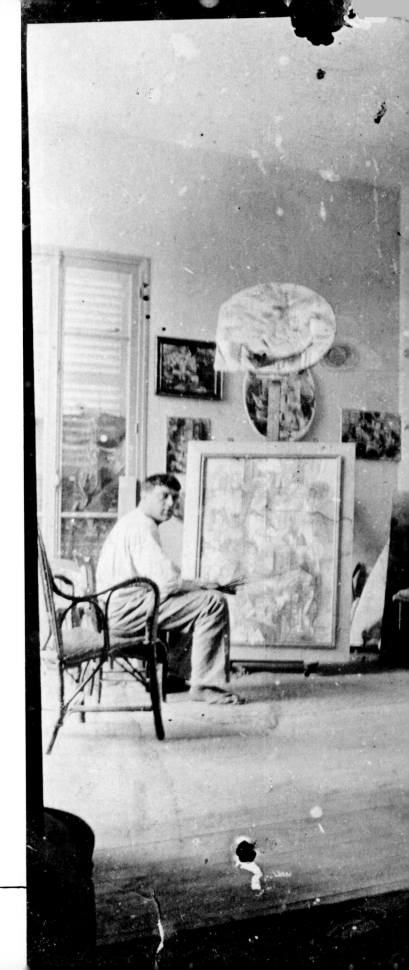

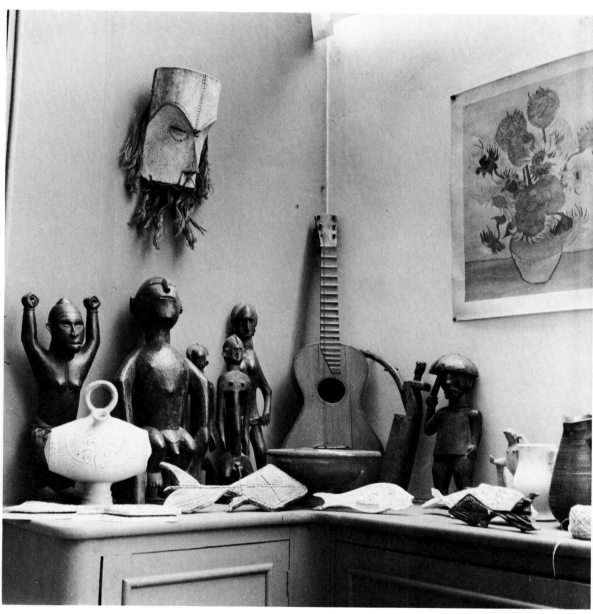

(Left) Within a few minutes of the Bateau-Lavoir, Georges Braque's studio on the rue Caulaincourt appeared comfortable, almost luxurious, compared to his new friend Picasso's. In this photograph, dated 1910, Braque is working on a large Cubist composition. The still life on the pedestal table in the foreground seems to anticipate his subsequent work.

This corner of Braque's studio clearly illustrates a number of his dominant interests. A superb tribal mask faces a reproduction of Van Gogh's Sunflowers, while African statuettes flank that most Cubist of instruments, the guitar. Fish complete this dictionary of Braque's favorite forms.

A number of courageous and charming women braved the hardships of the Bateau-Lavoir — hunger, cold, absence of gas, electricity, and even running water — and rendered the artists' lives there considerably less grim. Here Juan Gris poses in his studio with his wife, Josette, who shared the artist's most difficult years through World War One.

spot Gris' obsession for work (Max Jacob recounts how Gris would always stroke a dog with his left hand, so that his painting hand would be kept out of danger), and eventually his soberly immaculate compositions attracted attention from such influential sources as Gertrude Stein and Léonce Rosenberg. Gris' specifically intellectual development of the new Cubist vocabulary put him at the center of a group of similarly minded artists that included Auguste Herbin and Otto Freundlich. Once Picasso pulled up stakes, however, and began his long odyssey from one Paris studio to another, the Bateau-Lavoir never regained the effervescence and intensity it had enjoyed during the "heroic" period of the *Demoiselles d'Avignon*.

This crumbling but essentially sympathetic institution, which Picasso always recalled with affection, had one counterpart. At the opposite end of the city, in an even more dilapidated area centered on the Vaugirard slaughterhouse, stood the other rickety Paris cradle of modern art. Known as La Ruche ("the beehive"), it was an idiosyncratic circular structure that had been transformed from an exhibition pavilion for wine into an artists' colony in 1902 by a successful *pompier* sculptor, Alfred Boucher. This philanthropist decreed that artists of every persuasion and nationality should be able, for a minimal rent, to live and work in La Ruche's numerous wedge-shaped studios (popularly compared to slices of Brie cheese). As an extra munificence, Boucher also provided free models and a communal exhibition space for the new inhabitants — whom he indulgently called "my bees."

Art is a most exacting vocation; even today, when material conditions tend to be considerably less hard, only a handful of the aspirants who set out to be artists actually have the conviction and resilience — to say nothing of the talent — to persevere. In the early twentieth century, however, artists determined to break with convention found it almost impossible to survive. Except for a few people of rare perception like Sergei Shchukin, the Steins, or Kahnweiler, no one would then have dreamed of paying to have their appearance "cubed up" by Picasso or otherwise assaulted by those wild color animals, the Fauves. Moreover, with such challenging visions in mind, decorative work, such as the window shades Pissarro painted, or the portrait

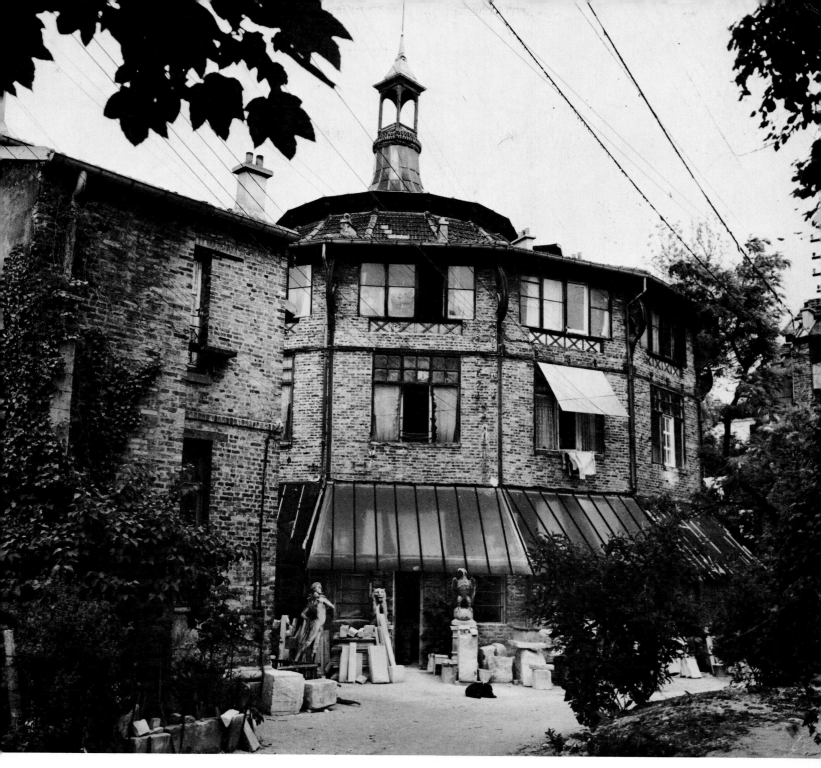

La Ruche, or "Beehive," was founded in 1902 by a phil-anthropic pompier *artist to house up to two hundred painters and sculptors. Like the Bateau-Lavoir, the build-ing's main attraction was its low rents. Artists as diverse as Léger and Soutine, Modigliani and Rivera, occupied at some time one of its wedge-shaped ateliers.*

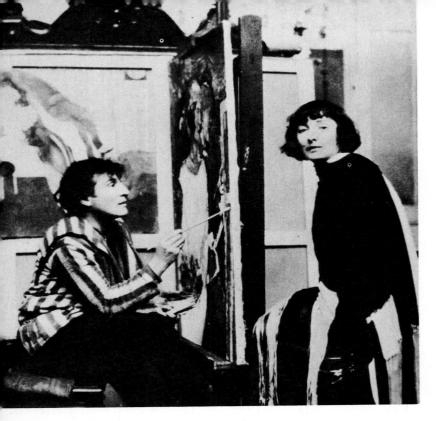

A youthful Marc Chagall pauses at his easel while his wife, Bella, turns toward the camera. Arriving in Paris in 1910, Chagall made straight for La Ruche and stayed there until the outbreak of war. Although he welcomed the opportunity to work at low cost, he was also glad to leave and find himself a studio of his own.

(Opposite) Lithuanian by birth, the sculptor Jacques Lipchitz came to Paris in 1909. He took a studio in Montparnasse, but spent a great deal of time at La Ruche, where he felt at home among artists of backgrounds similar to his own. Quick to realize the importance of Cubism, Lipchitz set about translating its discoveries into sculpture.

sketching Ingres did in Rome, was a far less obvious and acceptable means of making some ready cash.

Given these discouraging conditions and the unprecedented number of artists in Paris, La Ruche never lacked "bees." They swarmed from every country, and indeed continue to do so today. But the heyday of this picturesque (and certainly incommodious) institution was during the 1920s and 1930s, when La Ruche appears to have housed half Montparnasse, including Modigliani, Soutine, Lipchitz, Archipenko, Léger, Zadkine, Rivera, and Chagall. Sculptors had their studios on the ground floor, to facilitate the transport of work, while painters were dotted round the two upper stories. As the demand for ateliers grew, other constructions, ranging from small villas to sheds, grew like mushrooms in the shadow of the central rotunda, with the result that as many as two hundred individuals were at one time packed away into volumes of varying size to draw, paint, sculpt, or dream.

Chagall, or Chagaloff, as he was on arrival from Russia in 1910, made straight for this cheap and anarchic artists' community. He stayed and worked there for four years, but his memories of the period have none of Picasso's robust nostalgia ("When I was at the Bateau-Lavoir," the Spaniard exclaimed toward the end of his life, "I was famous. A painter. Not some curious animal!"). In fact, Chagall was miserable at La Ruche, and his dominant memory remains the cloacal smell that clung to the place. His studio, on the rotunda's second floor, was typical in its bare poverty of several hundred other ateliers where young artists lived almost exclusively on hope. "On the floor, beside reproductions of El Greco and Cézanne," Chagall recalls, "lay the remains of a herring which I used to cut in two — the head end for one day, the tail end for the day after." Like many another young painter, Chagall could not afford an easel, so he simply pinned his canvas to the wall. His highly personal imagery and the fact that he worked at night — when the others, as he says, "were making love or bombs" — put him at the receiving end of a series of practical jokes (such as old boots and other junk tossed through his window). But Chagall had come a long way to work, and he was not to be deterred. "While in the Russians' studio a wronged model was sobbing, while the Italians were playing the guitar

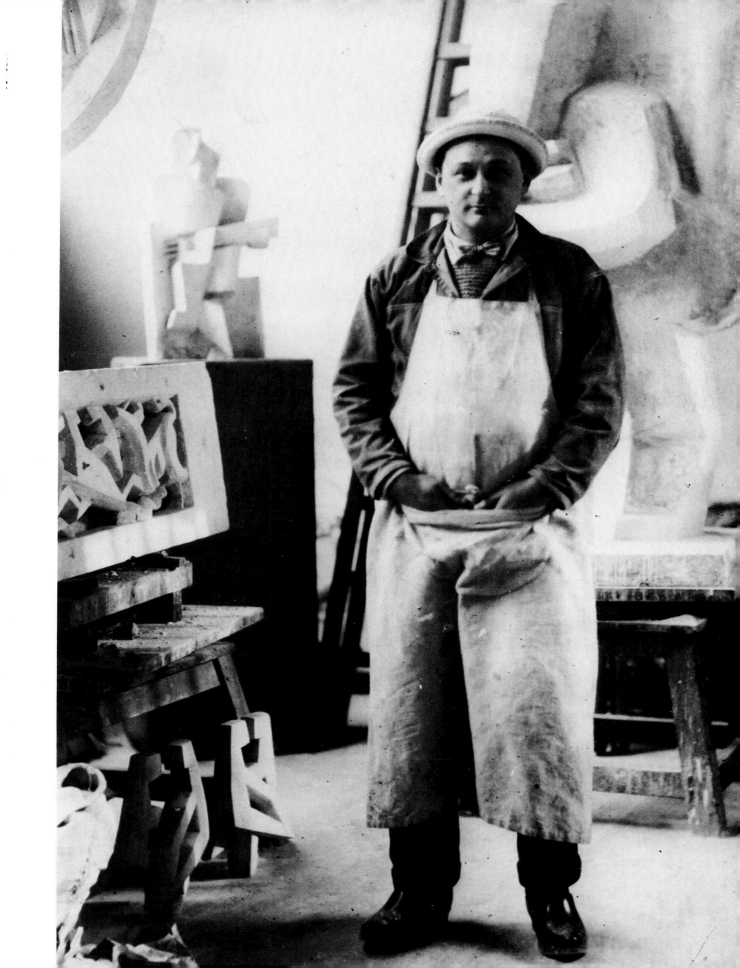

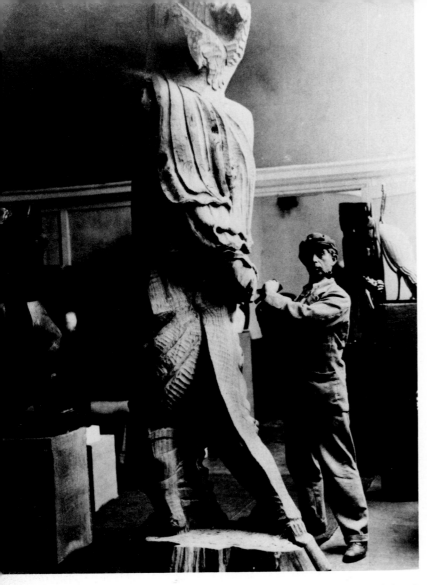

Defiant despite many years of disappointment and hardship, the Russian-born Ossip Zadkine stands with raised tools beside his massive wooden sculpture. Soon after his arrival in Paris in 1909, he moved into a studio at La Ruche that, although "sinister" and "stifling," provided him with all the basic means for his Cubist-influenced sculpture.

and singing, and the Jews discussing, I was alone in my studio, a kerosene lamp beside me. . . . I spent whole nights like that."

At dawn, his silent vigil was interrupted by the terrified bellows of cattle being led to the slaughter. Chagall's healthy reaction was to incorporate cows into his pictures, but less resourceful artists quailed and dreamed of escaping into wealth and comfort. One of the most miserable of them — so miserable and so difficult that Chagall refused to share a studio with him — was Chaim Soutine, who, after years of near-starvation, lived out a Montparnasse myth by becoming momentarily affluent and lording it from a chauffeur-driven limousine; those of his fellows who hoped to benefit in the form of a square meal from this sudden flush of wealth were sharply disabused. Few friends though he had, Soutine could count on the loyalty and support of Modigliani: the "prince," as he was called, because of his good looks and generosity. Modigliani's first home in Montparnasse was in fact a tin-roofed outhouse that Soutine had once inhabited, and he regularly took refuge in La Ruche when the need arose. The sympathetic Italian encouraged the pestilential Russian in his work (which included painting decomposing fowl and sides of meat) and took him drinking, with disastrous results, around the Montparnasse bars.

One ambition that seems to have united most of La Ruche's artists was to get out of their studios as soon as possible. Rats, fleas, and mosquitoes combined with despair, hunger, and the unavoidable presence of others to make flight eminently desirable. Even Léger, whom no one would accuse of being a softy, found the conditions hard and the atmosphere oppressive. "One lived as one could," he recalled, going on dourly to describe a meal of cat sauteed in vodka, which he shared with a group of "nihilist" Russians who had dug themselves in there. Léger first met Braque and Picasso in 1910, while he was living at La Ruche, and by 1917 he had evolved his curvilinear version of cubism — or "tubism" as it was baptized. Tradition and radical innovation came together in Léger's case in a most revealing manner. Living by expedients — he is reputed, for instance, to have painted thirty fake Corots — he made his way through several art schools, including the archpompier Jean-Léon Gérôme's class at the Ecole des

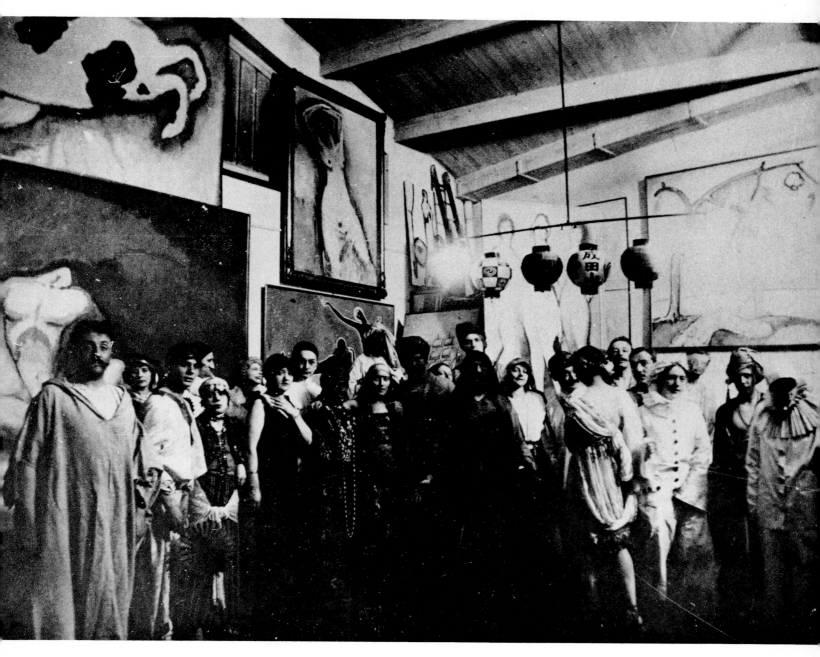

Having worked in one of the Bateau-Lavoir's pokiest studios during Picasso's stay there, the Dutch artist Kees van Dongen had sufficient success with his Fauve-influenced portraits to rent a spacious, independent studio in Montparnasse. His fancy-dress balls were a highlight of the Paris art world.

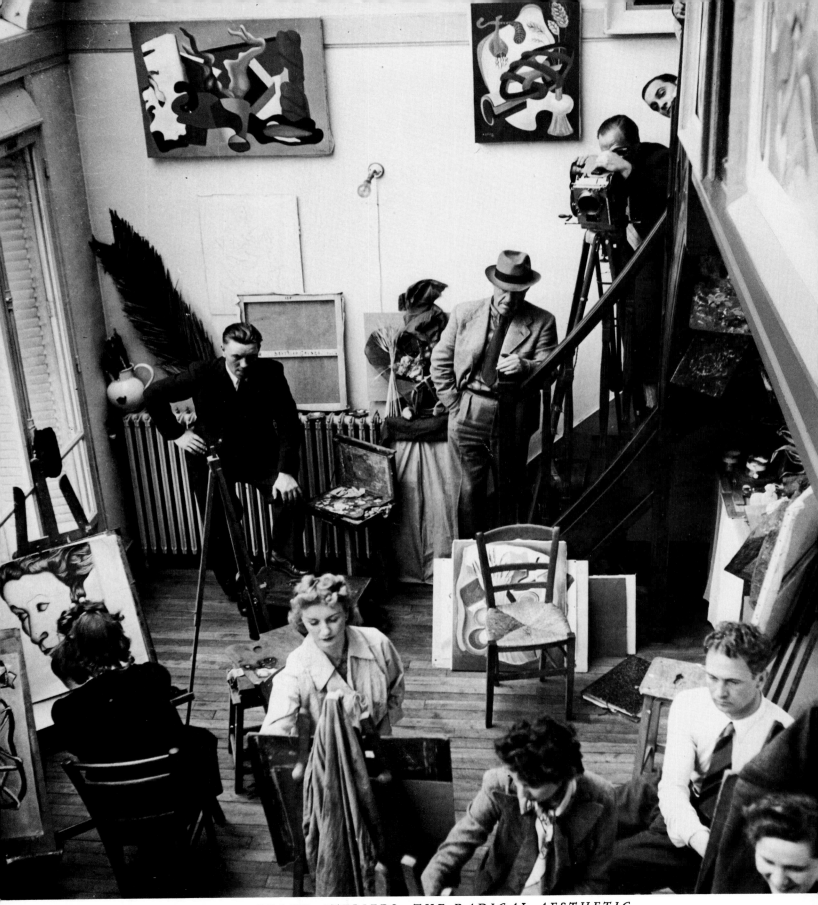

GROUP ATELIERS: THE RADICAL AESTHETIC

*Fernand Léger (in hat), once an inmate of La Ruche, is being filmed here in the famous teaching atelier he opened in Paris. The arch-*pompier *artist Gérôme had been Léger's teacher, and Gérôme's own teacher had been taught by a pupil of David. Thus an academic tradition can be traced linking Léger's most famous pupil, Nicolas de Staël, to Napoleon's illustrious "First Painter."*

Beaux-Arts. Once he was sufficiently well known, Léger himself opened an art school, and Nicolas de Staël became one of his pupils. Thus a direct link, a kind of apostolic succession, was established between one of the first artists discussed in detail here, David, and a near contemporary, Staël. For before teaching Léger, Gérôme had sat at the feet of the once-famous Paul Delaroche, who had himself learned under David's star acolyte, Jean-Antoine Gros. And so, even when tradition appeared to have been most effectively broken, all kinds of subterranean strands remained — for what has happened may be transformed but never effaced.

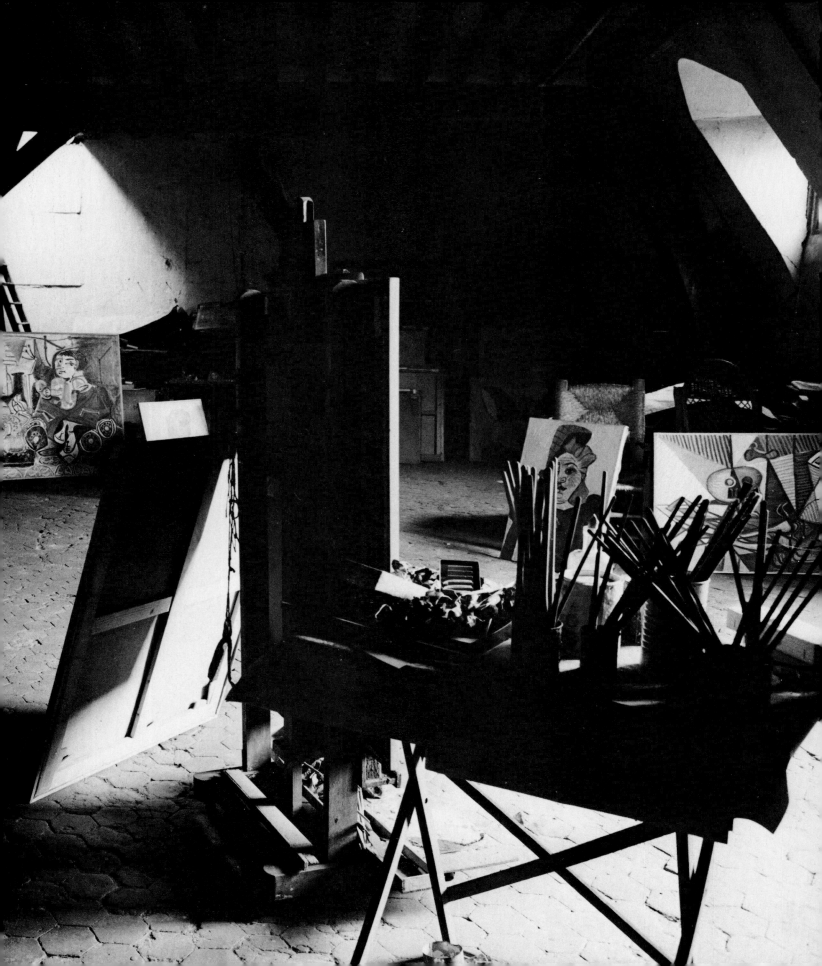

Reality Remade

The rest of the world had not stood still while the Cubists were compounding their revolutionary vision. Most large cities had been caught up in the young century's surge towards the new. Moscow, Zurich, Milan, and Munich, for instance, each witnessed a resounding attack on the established values of art. As if in anticipation of the larger upheavals to come, artistic movements swept across Europe in wavelike succession, bringing about unprecedented changes. At no time in history had there been a transformation in intellectual attitudes comparable to the one that took place in the quarter-century that separates the end of Impressionism from the advent of Dada and the founding of the Bauhaus.

Theory, discussion, meeting, and manifesto produced a great deal of the impetus behind these movements. In many cases, artists were called on to leave their private, solitary studios and participate in joint ventures that might entail anything from hammering out a group aesthetic to holding a public demonstration. Thus the studio in itself was frequently of secondary interest — a place less of reflection than of execution alone — or it took on the nature of an assembly point, a temporary HQ. The members of Die Brücke, for instance, transformed a butcher's shop in Dresden into a communal atelier where they could work or discuss their aims with friends (who usually served as models). With an equal lack of regard for artistic and social convention, Die Brücke held its first exhibition in a lamp factory on the outskirts of town. An even bigger show of scorning traditional practice was put on by the Italian Futurists; and

their chief theoretician, Filippo Marinetti (whose tireless iconoclastic energy earned him a reputation as the *caffeina dell'Europa*), would doubtless have recommended Futurist artists to open their easels beside roaring cannon, smoking automobiles, or "surgical trains that pierce the blue belly of mountains."

Futurist studios were on the whole of minor interest since the style itself was not deeply original but rather an impressive mixture of divisionism, cubism, and brilliantly simulated movement. The obsessive interest in movement led the Futurists to make a special study of the cinema and the recent achievements of photography — X-ray and sequential photography in particular. Like their French contemporary Marcel Duchamp, they became fascinated by the "chronophotographic" experiments of Etienne Jules Marey as well as by the "fotodinamismo" of their compatriot Anton Giulio Bragaglia. In this way, having played so important a role in nineteenth-century studios, photography became a central feature of the Futurists' equipment and so manifest in their art that a critic of the time dismissed their whole endeavor as "nothing more than the instantaneous photograph of a sneeze." Though not great technical innovators, the Futurists were admirably quick to sense what was in the air and make bold use of it. For centuries artists had never considered working with anything but such hallowed materials as oil paint or marble. With Braque and Picasso, heterogeneous scraps and oddments had suddenly begun to be put aside for eventual ennoblement into art; and at the same time, Um-

berto Boccioni, the leading Futurist sculptor, was rambunctiously recommending that thenceforth marble and bronze be replaced by "glass, wood, cardboard, iron, cement, horsehair, leather, sheets, mirrors, electric lamps, etc."

Much of the impact of Futurism — as with Dada and Surrealism — came from its public declarations, so that in many senses it belonged more to the street than to the studio. The reliance on a group aesthetic was to take its toll, however, as one can see from the lamentable later work of those Futurists who survived World War One. When the theoretical possibilities of the movement had been exhausted, Giacomo Balla — who had taught Gino Severini and Boccioni — sank back into painting slick society portraits, recorded in a series of photographs of his studio taken in the 1930s.

With truly original artists, the studio remains almost invariably a place of specific interest, a kind of textbook of the way an artist works and sometimes even a work of art in itself. Wherever Paul Klee happened to be working, for instance, he built up an orderly jungle of objects that stimulated him most. Both the places he worked in and what he kept there, though, would have seemed an affront to the prominent artists of the day — and not least to Klee's professor at the Munich Academy, Franz von Stuck, a "society favorite" greatly esteemed by the Bavarian bourgeoisie.

Early in his career, the Swiss-born Klee had a studio in a ruined little rococo palace in Schwabing, Munich's traditional "bohemian" quarter. Though the roof leaked straight into the studio, the space and the light proved more than adequate; and Klee found additional advantages in the fact that Wassily Kandinsky's studio and the tranquil Englischer Garten were just next door. Among the objects he kept around him as he worked was an astonishing profusion of natural forms ranging from coral and mollusks to sprays of dried flowers, leaves, pieces of bark, and minerals. He delighted in studying the fantastic shapes that nature took, and he made a special collection of seaweeds, placing them between two sheets of glass and displaying the result under the title "Baltic Sea Forest." Klee also went about collecting children's drawings with almost fetishistic thoroughness: he kept those he himself had done as a child, those by his son Felix, and many others by his

An able craftsman as well as a uniquely gifted artist, Paul Klee is seen here in his Bauhaus studio in Weimar putting the finishing touches to a frame he has made. Wherever Klee worked, he surrounded himself with primitive art objects, children's drawings, and every kind of natural form, from minerals to seaweed, to stimulate his imagination and suggest new ways of "taking a line for a walk."

Dated 1925, this photograph shows the painting area of Klee's Weimar studio. It was not unusual for him to have half a dozen canvases under way at the same time, yet a certain orderliness always reigned. This aspect so struck the anything but orderly Picasso that, when he visited Klee, he compared the latter's studio to a "laboratory."

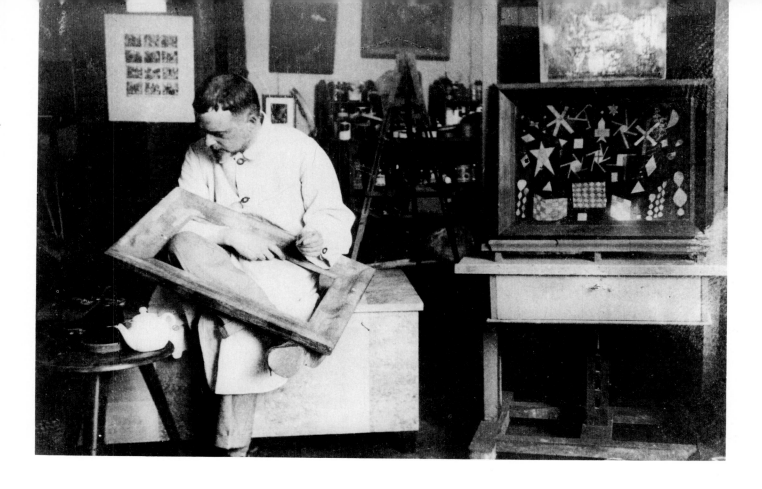
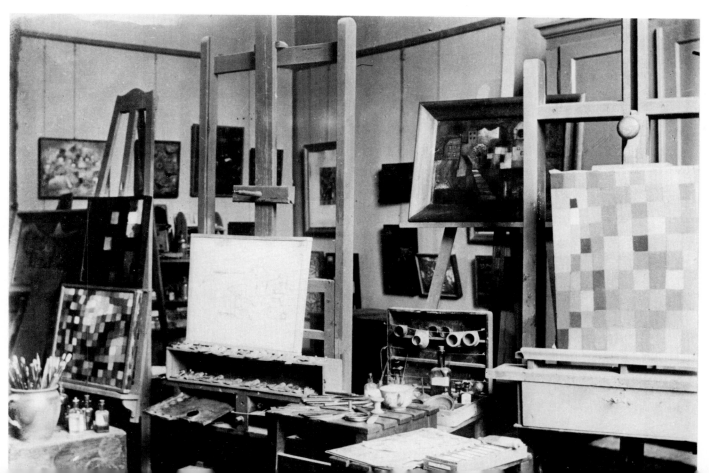

Description as a "laboratory" would certainly have fitted Kandinsky's various studios, and Kandinsky himself, often attired for painting in a black morning-suit and a wing-collar, impressed visitors by his dignified calm. Photographed here in his Paris studio in 1936, the great pioneer of abstraction inspects an item from the neat rows of painter's equipment — which includes such traditional tools as mortar and pestle.

friends' children. African masks and weapons, as well as things nearer home, such as Bavarian glass paintings, rounded out his large and varied collection, which also naturally included the artist's own artifacts. The painter Lyonel Feininger, who exhibited with Klee in the Blaue Reiter shows, remembers Klee's studio as being dotted around with "contraptions pieced together of flimsy materials such as gauze, wire, bits of wood, some capable of being moved by draughts of air, others manipulated by a tiny crank — ships of weird design, animals, marionettes and masks, which he made for a Punch and Judy show for Felix."

But the most memorable aspect of Klee's studio was the very volume of work that was constantly, and quite visibly, under way. Not only was the space thronged with easels, each displaying a work in progress; it was also hung with a clothesline on which watercolors had been pegged to dry. However preoccupied the artist became with the teaching he undertook with such enthusiasm, his own creative activity was never allowed to suffer as a result. Like most serious artists, Klee realized that only by regular, hard work could he come fully into his own. "Here, in my atelier," he wrote to his wife, Lily, from the Bauhaus, "I'm working on half a dozen canvases, and drawing and thinking about my teaching course. Social life at Weimar doesn't exist as far as I'm concerned. I work, and talk to no one throughout the day."

By the end of his unusually fertile life, Klee had produced no fewer than ten thousand works. Yet his studio, although encumbered by canvases and objects, always retained a certain methodical neatness. When Picasso visited Klee in Bern a few years before the latter's death, he was struck by the orderly nature of his studio, which he compared to a "laboratory." At an even further extreme from the unchecked chaos that Picasso enjoyed having around him as he worked was the studio of Klee's great Bauhaus companion Kandinsky. With its meticulously arranged rows of bottles, the Russian painter's pristine working space was frequently compared to an apothecary's shop and his personal appearance to that of an illustrious professor or high-ranking civil servant. "Visiting him in his studio for the first time, I believe it was late 1922," recounts another Bauhaus colleague, Herbert Bayer, "I was very much impressed to see him

dressed in a black morning-suit and a wing-collar, on his left arm the academic type of palette (large teardrop shape), painting in the most controlled way without getting any spots on his suit." Klee and Kandinsky had lived side by side in the Gropius-designed atelier-houses at the second location of the Bauhaus in Dessau. By looking at and discussing each other's work regularly, they exerted a mutual influence: Klee's painting grew stronger in its emphasis on structure, while Kandinsky's became lighter and more delicate.

It was Kandinsky who experienced what one might call the great studio illusion, and as a result changed the course of art. "It was the hour of approaching dusk," he noted in his precise, circumstantial fashion. "I came home with my paintbox after making a study, still dreaming and wrapped in the work I had completed, when suddenly I saw an indescribably beautiful picture drenched with an inner glowing. At first I hesitated, then I rushed toward this mysterious picture, of which I saw nothing but forms and colors, and whose content was incomprehensible. Immediately I found the key to the puzzle: it was a picture I had painted, leaning against the wall, standing on its side. The next day I attempted to get the same effect by daylight. I was only half successful: even on its side I always recognized the objects, and the fine finish of the dusk was missing. Now I knew for certain that the object harmed my painting."

Once the offending object had been plucked out, abstract art was well and truly born. Amid the revolutionary or mystical fervor that attended so much of the creativity of this period, from the Futurists' inspired ranting to the intense spirituality of Kandinsky or Mondrian, it comes as a relief to find one of the century's greatest painters stating that, ideally, a work of art should have the effect of a "good armchair." This would sound absurdly frivolous or "bourgeois" coming from anyone of lesser stature than Matisse, for whom, despite his air of monumental calm, painting was an ordeal, causing extreme nervous tension and bouts of weeping (as it had for Ingres), as well as sudden outbursts of fury. Matisse was another artist who believed that nothing of value could be achieved without regular and prolonged effort. From the moment he realized his

vocation as an artist (leaving a secure position as notary's clerk in 1892 for the hazards of an Ecole des Beaux-Arts apprenticeship), he regulated everything in his life to favor the excellence and abundance of his production. He had the good luck, after a spell under the arch-*pompier* Bouguereau, to be taught by the Symbolist painter Gustave Moreau. This "maître charmant," whose imposing Paris studio now serves as a public museum of his work, encouraged his pupils not so much to follow blindly the academic routine of copying plaster casts and specially posed models as to develop an eye for life in the street and visit the latest exhibitions in the galleries.

Being virtually chained to his easel and drawing table, Matisse was keenly conscious of the places where he spent his working life; and, in time, like Braque and Picasso, he produced several outstanding compositions on the atelier theme. His first studio was an ordinary enough room at 19 Quai Saint-Michel, whose main advantages were cheapness (Albert Marquet was quick to move in as soon as Matisse moved out) and an incomparable view over the Seine to Notre-Dame. In this exiguous, humble space, where he and his wife lived until 1908, Matisse developed from being a young painter of promise into the acknowledged leader of what one critic called the "barbarous and naive games" of Fauvism. The new style, with its startlingly direct appeal through intense contrasts of color, had grown as much out of discussion as out of solitary experiment. Derain and Vlaminck, whom Matisse had first met at the 1901 exhibition of their joint hero, Van Gogh, were working side by side in a tumbledown restaurant at Chatou, outside Paris, which they had turned into a rough-and-ready studio admirably suited to their attack on convention. Matisse became a frequent visitor, and the conversations *à trois* proved one of the main catalysts for their daring new proposal to use color as the only vital component of painting. The *Portrait of André Derain* that Matisse painted in 1905 contains a concise statement of Fauvist beliefs: the warm reds, oranges, and yellows of the sitter's head clash with maximum violence against the cool greens and blues of the background.

While the scandal provoked by the new style still raged — "Matisse makes you mad" ran a favorite Mont-

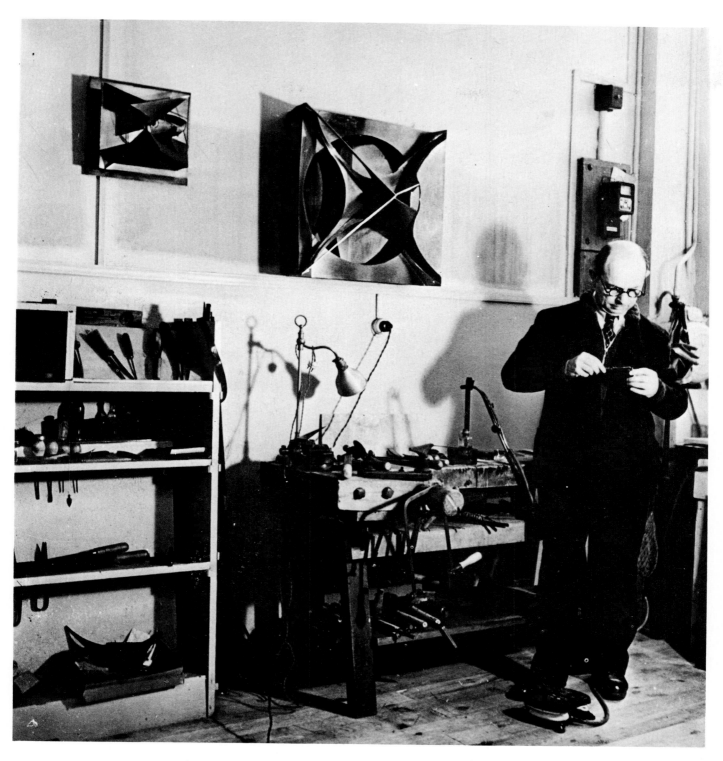

After the artistic revolution that flared up and as quickly faded in Russia, Antoine Pevsner went to Paris to develop his constructivist beliefs in sculpture. This view of his studio, photographed shortly after World War Two, sug- gests how workmanlike Pevsner's approach was to art; indeed, only the sculpture on the wall differentiates it from an ordinary machine shop.

The studio was so important to the Romanian-born sculptor Constantin Brancusi that he bequeathed a large number of his works to the French nation on condition that they be exhibited within the studio walls. His studio (photographed here by Brancusi himself) now forms an annex to the Beaubourg Museum in Paris.

Brancusi's gleaming shapes did not come into being immaculately, as this view of the darker corner of his studio attests. The sculptor both lived and worked in the well-proportioned but monastically plain space; he made its few pieces of furniture himself.

parnasse graffito — Matisse felt sufficiently assured of the support of a handful of discerning collectors to leave the Quai Saint-Michel studio for a house in the green suburb of Issy-les-Moulineaux. There he set up his studio on the ground floor and later had a prefabricated workroom, ten meters square with a partially glazed roof, erected in the garden. This latter construction (recommended to the artist by the photographer Edward Steichen) was used by Matisse as a studio for the two large decorative panels, *Dance* and *Music,* that his great Russian admirer, Sergei Shchukin, had commissioned for his Moscow residence. An American visitor to Matisse's house in 1912 wrote a detailed description of this garden structure, where Matisse also painted the famous *Red Studio* (page 161): "The studio, a good-sized square structure, was painted white, within and without, and had immense windows (both in the roof and at the side), thus giving a sense of out-of-doors and great heat. A large and simple workroom it was, its walls and easels covered with large, brilliant and extraordinary canvases ... my main recollection is of a glare of light, stifling heat, principally caused by the immense glass windows, open doors, showing glimpses of flowers beyond, as brilliant and bright-hued as the walls within." It is interesting to note here that Matisse had tended earlier to keep his finished paintings out of sight "because they reminded me of moments of overexcitement and I did not like to see them again when I was calm."

Diversity of styles and a prolific output characterized the period at Issy. "Soon the enormous studio was filled with enormous statues and enormous paintings," Gertrude Stein, who admired and collected Matisse, observed with deadpan humor. "This was the period of the enormous for Matisse." For large-scale works, the artist also had the run of the former Convent of the Sacré-Coeur, near the Invalides, where students of all nationalities came to draw, paint, and sculpt under his stern eye. Contrary to a popular belief that he was a kind of wild man whom a few daubs of garish color would placate, Matisse showed himself to be a firm advocate of traditional academic discipline — both for his pupils and for himself. When the artist first decided to take up sculpture, for example, he enrolled at an evening course like any beginner, and later, in Nice, he would drop into the local academy from time to time

The German artist Hans Bellmer photographed himself here in the presence of his constant studio companion — his "artificial girl," an erotic mannequin that inspired him to make many other artifacts and drawings on the theme. His far-reaching anatomy of desire drew him into the Surrealist fold in Paris, where he spent the latter part of his life.

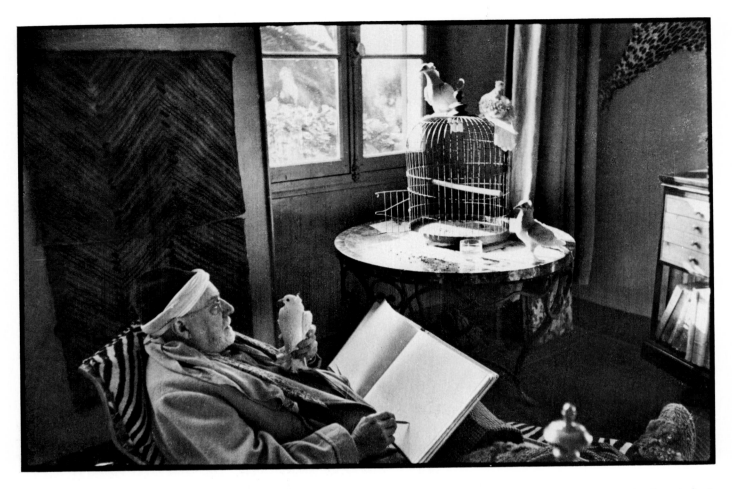

Models of every kind, and women in particular, were essential to Henri Matisse. Whenever human models were unavailable, he turned to plants, birds, or the cherished store of objects which went with him from studio to studio. Toward the end, Matisse kept as many as three hundred birds of different species around him as he worked.

and start copying plaster casts with the single-mindedness of an ambitious apprentice.

In the same traditionalist vein, Matisse insisted on the importance of having a live model, in his art school (which only lasted about three years) as in his own studio. During the early Quai Saint-Michel days, when money had been scarce, Madame Matisse had frequently posed for him. Yet as soon as he set to work on his first major sculpture, *The Serf,* Matisse made a point of securing the services of Bevilacqua — a muscular professional whom Rodin had used — for no fewer than five hundred sessions. As he became more affluent, Matisse gave free rein to his taste for working from models, so much so that, once he had settled in Nice, he used to dread carnival time, when his models would abandon him to join in the fun! "They are the main theme of my work," he admitted. "I am absolutely dependent on my model. . . ." *The Painter and His Model* of 1917, set in the Quai Saint-Michel building (where Matisse had

rented another studio), and *The Artist and His Model*, painted two years later in a hotel room in Nice, eloquently convey the mixture of professionalism and intimacy of this unique relationship, which for centuries has been at the heart of European painting and sculpture.

From 1916 on, Nice became increasingly the center of Matisse's life. He began by spending the winter in cavernous hotels along the Promenade des Anglais, then took an apartment in the old city overlooking the sea. When he began on the mural for the Barnes Foundation of Merion, Pennsylvania (most of Matisse's principal collectors, as it happens, were American), an altogether larger space was required. The most suitable area for this vast new *Dance* panel, which was to measure thirteen meters long by three and a half high, proved to be a disused movie theater. It is amusing to think that in this way Matisse ran the entire gamut of studio space, from a deconsecrated convent such as artists had used just after the Revolution to the most contemporary location imaginable.

As he grew older and ever more absorbed in his adventure with color, Matisse found living in a hotel once again best suited to his needs; in 1938, he moved into a suite of rooms at the Hôtel Regina, an imposing turn-of-the-century pile that looks down on Nice and the Baie des Anges from Cimiez. In these spacious rooms, Matisse re-created his universe of cherished objects, plants, and birds. He had always been a discerning collector, and at one time owned a couple of Courbets, Cézanne's *Three Bathers*, a Gauguin, two Van Gogh drawings, and a bust by Rodin. Having been one of the first European artists to take an interest in "primitive" sculpture, Matisse naturally had an extensive collection of African objects. He and Picasso exchanged spectacular gifts and examples of their work, so that Matisse also possessed a fair number of his greatest rival's paintings. Certain pieces of furniture became indispensable to the aging artist and, like the hallowed tobacco jar and pewter pitcher, they were frequently incorporated into his paintings. Huge cages capable of housing up to three hundred birds were another striking feature of the Cimiez studio. As with the philodendrons he loved to have around him, the birds provided Matisse with a subject he could always turn to whenever the less dependable human models were not to hand.

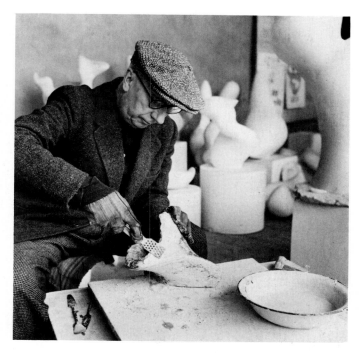

Well covered to withstand the cold damp of a sculptor's atelier, Jean Arp smooths down an element he is about to add to a work in progress. After an active career in Dada and the Surrealist movement, Arp withdrew increasingly into the solitude of his atelier in the green Paris suburb of Meudon — a place already made famous for sculpture by the villa Rodin kept there.

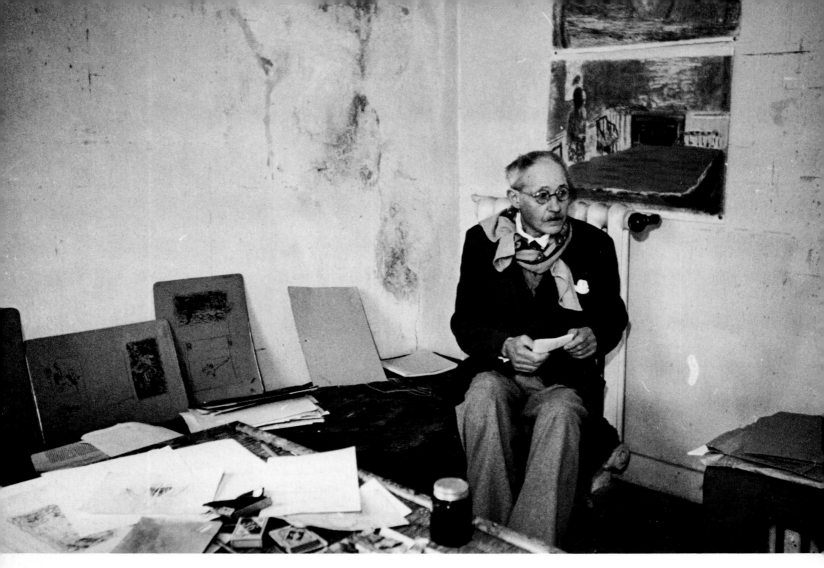

As great a lover of the Midi as Matisse, Pierre Bonnard (photographed here by Henri Cartier-Bresson) is shown surrounded by lithographs and sketches in the small bare studio at Le Cannet, behind Cannes, where he took refuge — with his wife and only model, Marthe — during World War Two.

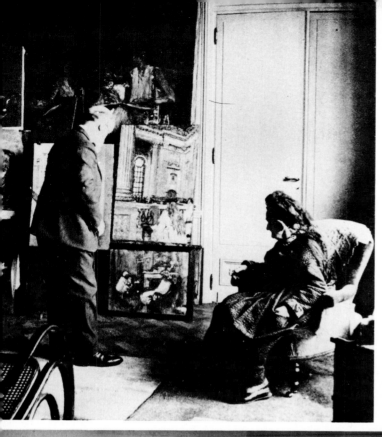

Photographed in 1927, the middle-aged Edouard Vuillard is seen between the two poles of his existence: his painting and his mother. Having once shared a studio with Bonnard and Maurice Denis, where the Nabi movement evolved, Vuillard retreated, like Bonnard, into a small, domestic world which he recorded with unique sensitivity as well as impressive technical daring.

Although in his mid-seventies, the frail-looking Bonnard perched on a ladder like a fresco painter in order to complete his larger compositions. Whether he was painting views of Le Cannet, nudes, or interiors, his real subject was the violent, exotic, or mellow explosions of Mediterranean light.

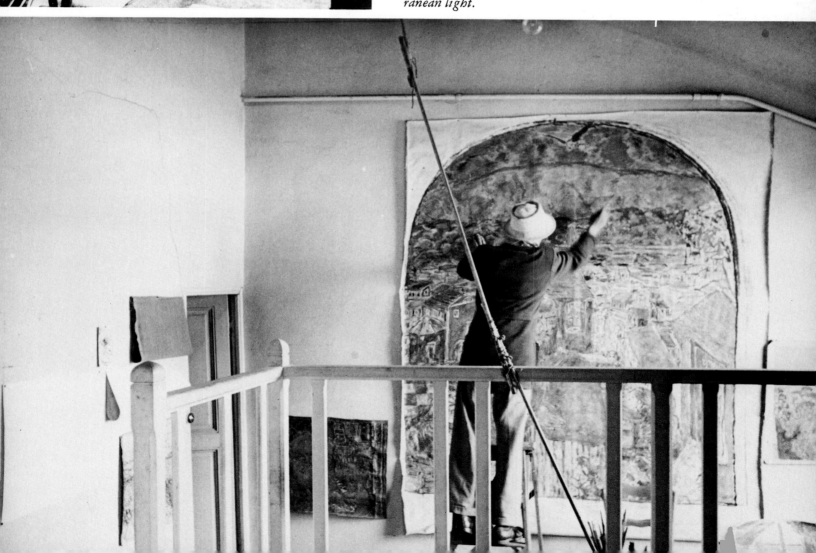

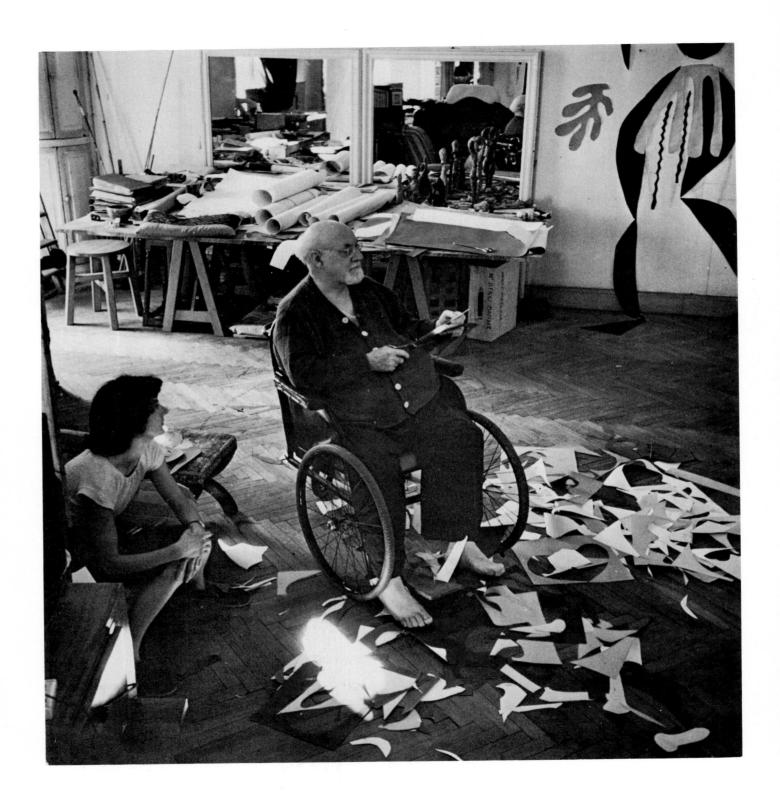

REALITY REMADE

Photographed at the age of eighty-two in his spacious studio apartment at the Hôtel Regina above Nice, Matisse works on one of his cutouts under the intent gaze of a young model. On the far wall, beside a group of African statuettes, one can see part of a huge cutout of Josephine Baker, whose performances held Paris spellbound.

The story of Matisse's studio life appears quite staid when set beside the extravagant vagabondage of the period's other titan. Once he was clear of the Bateau-Lavoir's picturesque poverty, Picasso established an attitude toward the places where he worked that lasted throughout his long, migrant life. The space might be anything from a château, like Boisgeloup, to a bourgeois apartment or a factory, such as the disused perfumery in Vallauris, but Picasso imposed his personality on it, filled it with his works, then turned the key in the door and moved to a different setting. The only common denominator between the various places was that none of them could be called a studio in the traditional sense of a high-ceilinged space with abundant natural, preferably northern, light. At Boisgeloup, for instance, the graceful Normandy château that Picasso used in the 1930s, the focal point became the seventeenth-century stables, where the artist sculpted his large heads of Marie-Thérèse Walter and installed a press for his graphic work. The famous rue des Grands-Augustins studio, to take another example, was the attic of a rather run-down but elegantly classical Paris town house. Its dormer windows would not have satisfied many painters' requirements, but Picasso was long used to working by electric light, having concluded that if a painting looked good in its harsh glare, it "would look good anywhere." Though spacious, the attic proved barely large enough to contain the *Guernica* canvas, which Picasso painted there in 1937. The painting, which is over eleven by twenty-five feet, had to be tilted back to clear the overhead beams, and Picasso painted the upper portion, precariously enough, by standing on a ladder and reaching over with a long brush.

The Grands-Augustins studio, with its vast, rarely fueled stove ("Spaniards are never cold," Picasso defiantly replied to a Nazi offer of coal during the war) and its romantically desolate air, remained a pocket of relative freedom in occupied Paris, and after the Liberation it became a symbol of resistance and renewal. At the opposite end of the scale from this noble garret was "La Californie," the villa in Cannes where the artist spent the mid-fifties (page 162). A rather pretentious Belle-Epoque building with marble fireplaces and abundant stucco decoration, "La Californie" had the signal advantage of a large garden and a gatekeeper to protect

In the bleak winter of 1940–1941, Picasso worked in the studio on the rue des Grands-Augustins where he had painted Guernica. *For lack of fuel, the wonderfully sculptural stove that rises between Picasso and his Afghan hound, Kasbec, rarely functioned. "Spaniards are never cold," Picasso told the Nazi officers who offered him coal.*

The famous Grands-Augustins studio was in the mansard of a fine seventeenth-century house (since converted into offices) on the Left Bank beside the Seine. Picasso liked the oak beams, tiled floor, and volume of the attic; since he worked a great deal by electric light, the small lateral windows did not bother him.

REALITY REMADE

the by now world-famous artist's privacy. Within a few weeks, the leisurely villa was transformed into a picture-producing powerhouse. Picasso worked in virtually every room. The kitchens were turned into engraving and lithography workshops so that the artist could put his hand to graphic work whenever he wanted. Former salons were cleared of their furniture to make way for Picasso's use; they were never redecorated, but simply invaded by a mass of crates, easels, unframed canvases, and so on. Wherever a nail happened to have remained in the wall, a painting or a favorite photograph or an African mask was hooked onto it. Gifts, books, outlandish costumes and spectacular hats, forgotten meals, unopened boxes mingled to create the general chaos that the artist found most stimulating to his work.

The word *chaos* would have been indignantly rejected by Picasso. For him, each of the many rooms where he worked was a visual bank, a store of complex associations, and he resisted any attempt at ordering their prodigious muddle on the grounds that tidying things up was the surest way of losing them! After leaving "La Californie," Picasso re-created his brilliant, vital disorder within the Château de Vauvenargues. But this nobly severe castle, at the foot of the Mont Sainte-Victoire, just outside Aix-en-Provence, proved too remote. A couple of years later, in 1961, the artist moved once again, this time settling for good in another villa, Notre-Dame-de-Vie, in the hills above Cannes. From this last vantage, Picasso was able to enjoy a perspective that many artists would envy. Several of his most important former studios, filled with priceless paintings and forgotten bric-à-brac, still belonged to him. They were rarely visited, but at any moment Picasso was able to step back quite literally into the rooms of his past and savor the continuing mystery of places where a personal vision destined to change the look of the world had taken form.

Plants, African objects, and his own paintings formed the only decoration of Braque's Paris studio. Built to the artist's specifications, this calm, spacious room looked due south. To filter the unusually strong light (which most painters prefer to come from the north), the huge window was whitewashed, then hung with canvas drapes.

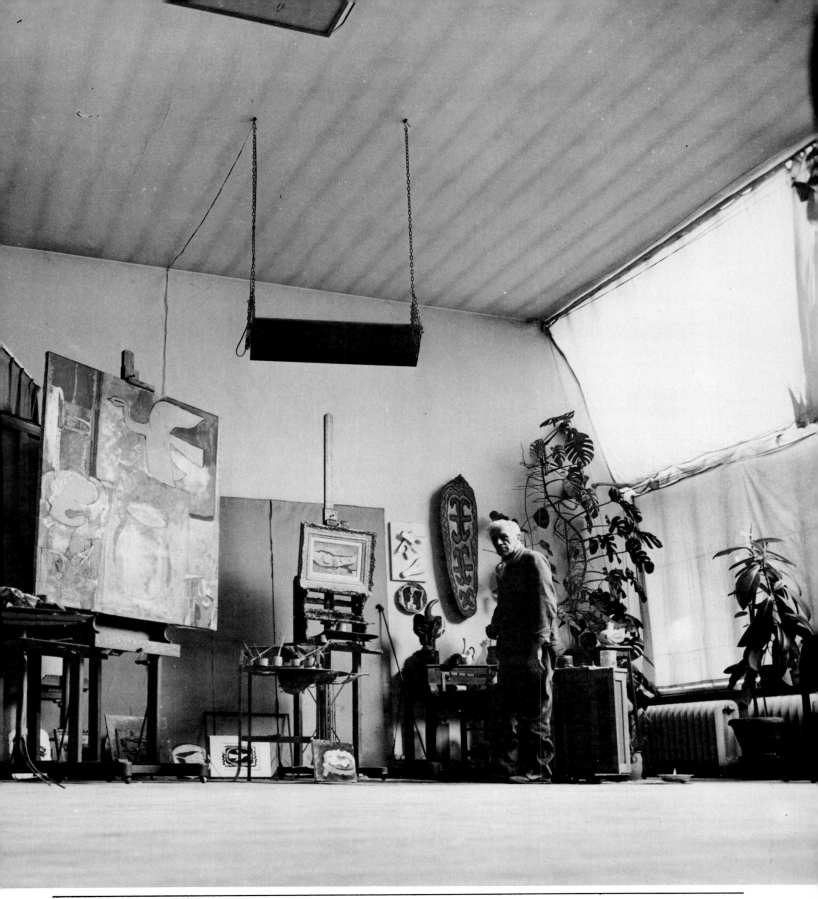

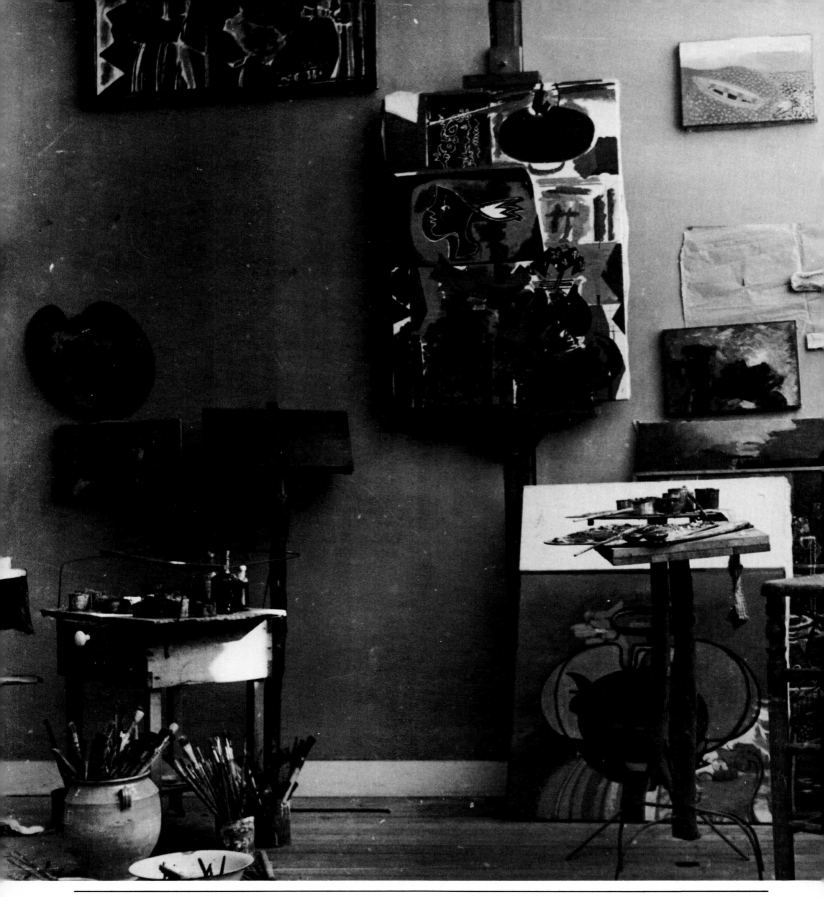

REALITY REMADE

"This is where it all goes on," Braque said as he took a visitor into his atelier at Varengeville on the Normandy coast. The country studio served Braque as a retreat from Paris, and many pictures were begun in one place and finished in the other. The little stands and tables shown here were made by Braque, who had first trained as a house-painter and decorator.

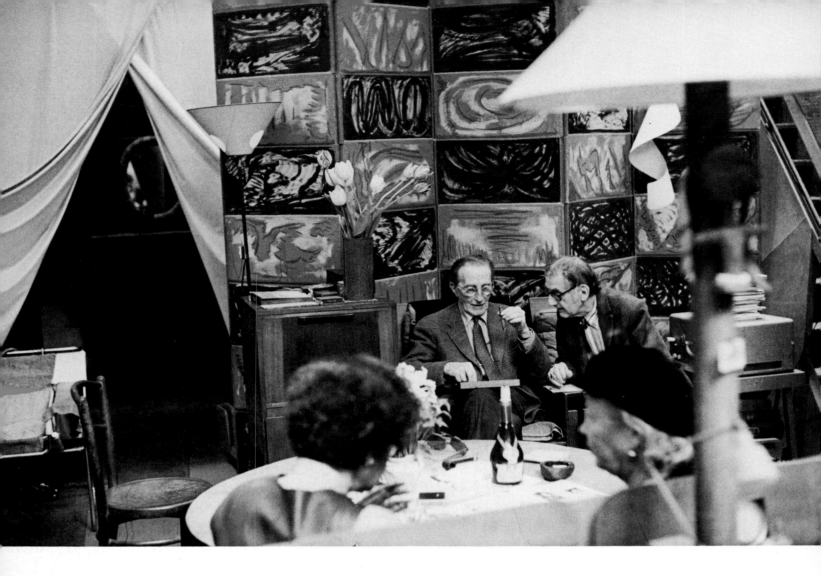

Neither castles nor disused factories but two practical, well-constructed, workmanlike studios provided the poles of Georges Braque's later career. In 1925, as soon as finances permitted, he had a house built on the southern edge of Paris, near the Parc de Montsouris. The top floor of the artist's comfortable new house was given over entirely to the atelier. Unconventionally enough, Braque had specified that it should be lit by a huge expanse of window facing due south. But, as Leonardo had recommended in his *Notebooks,* this strong, variable light was cunningly filtered. Once the window was in place, Braque had it whitewashed, then hung with finely woven canvas drapes. The studio itself, which contained nothing that was not directly pertinent to his work, was divided into two by a large curtain, against which Braque had placed a number of easels, arranged

so that he could go from one to the other to give a new direction or a finishing touch. More pictures, some of them turned face inward, were stacked against the wall, awaiting the painter's final judgment — which sometimes required years — as to whether they were completed or needed to be reworked before they left the studio.

In the perfect sobriety of this Parisian atelier, every detail stood out as an essential part of an intensely personal ensemble. Visitors naturally noticed the African carvings and the green plants drinking in the specially muted light. They were struck, too, by the lectern on which sketchbooks had been laid out so that the artist could consult them (like a "cookbook," he used to say) for new ideas. Equally impressive was Braque's carefully ordered arsenal of paints, pots, brushes, palettes, pen-

(Opposite) Chess gradually replaced art as Marcel Du-
champ's main interest. Here he ponders a move in the
garage that his fellow player and old friend Man Ray
had converted into a studio apartment beside Saint-Sul-
pice in Paris. True to his legend of effortless creativity,
Duchamp let himself be photographed while relaxing or
playing chess, but rarely in the process of working.

(Below) Staring at us through the easel is Duchamp's
brother Jacques Villon, who distinguished himself first
as a Cubist, then as a painter of highly personal land-
scapes. This rather solemn room in the Paris suburb of
Puteaux was used by the artist both for working and liv-
ing. Above him one can see a head sculpted by the third
brother, Raymond Duchamp-Villon.

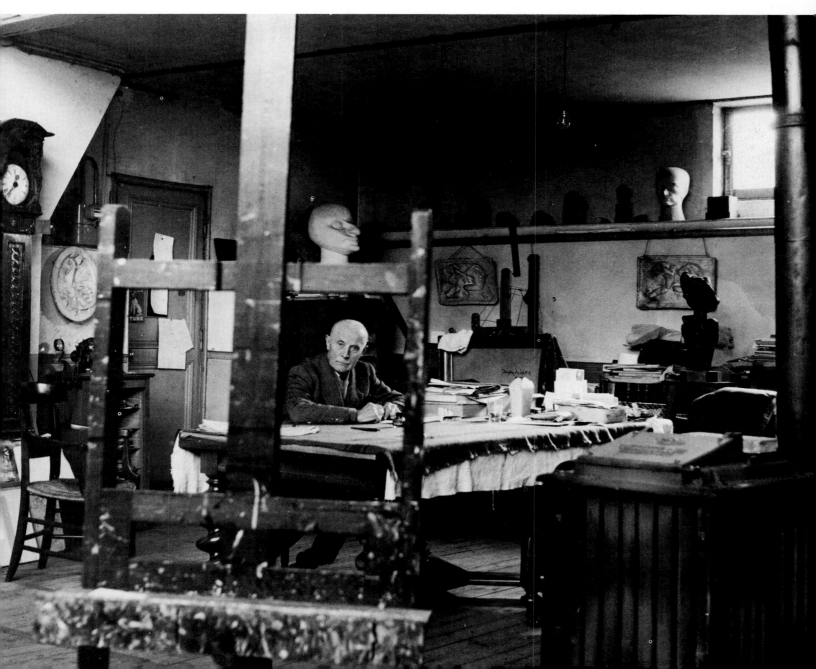

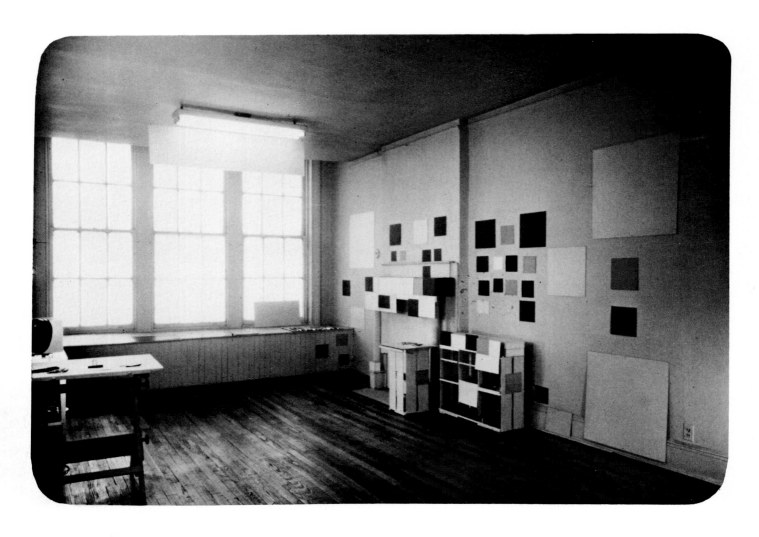

cils, and other tools, flanked by some of the objects —
vases, fruit dishes, musical instruments — that this con-
summate craftsman incorporated into his still lifes.
The sense of the studio as a kind of hyphen between the
everyday and the realm of art was particularly strong in
Braque's case; and comparison with a laboratory or an
alchemist's den is unusually apt, since the artist experi-
mented with all kinds of additions to his paint, mixing
in ash, tobacco, wood shavings, sand, and metal filings.

"Well," Braque remarked to a visitor to his atelier at
Varengeville on the Normandy coast, "this is where it
all goes on." The second studio, very similar in its spare,
sober atmosphere, had been built at the end of the gar-
den and provided a perfect counterpart to the city work-
room. Braque regularly transported paintings in prog-
ress (lashed to the top of his Bentley) from one studio
to the other, so that they benefited from two different

*Situated at 15 East 59th Street, Piet Mondrian's New
York studio appears as luminous and immaculate as one
of his geometric compositions. The Dutch painter arrived
in New York in 1940 and had an immediate influence
on artistic development in the city. This photograph was
taken in 1944, the year he died.*

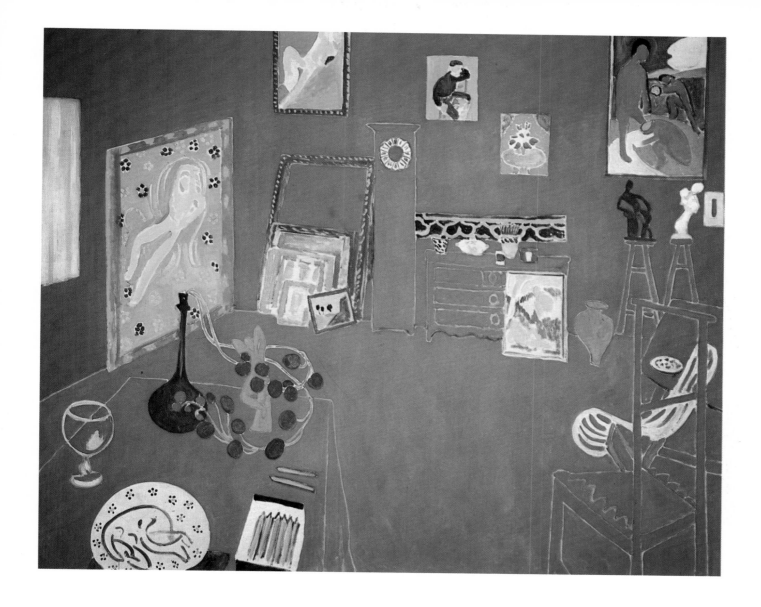

Henri Matisse (1869–1954). *The Red Studio,* 1911. Museum of Modern Art, New York. A studio may convey an artist's entire universe: Matisse's many compositions on the theme reveal to what extent his world was contained within the atelier walls. *The Red Studio* is an extraordinarily direct statement.

These are my paintings, the artist declares, and this is my feeling about them. Matisse's real-life studio was in fact painted white, and he himself claimed not to know why his vision of it had been translated into such an emotionally charged expanse of red.

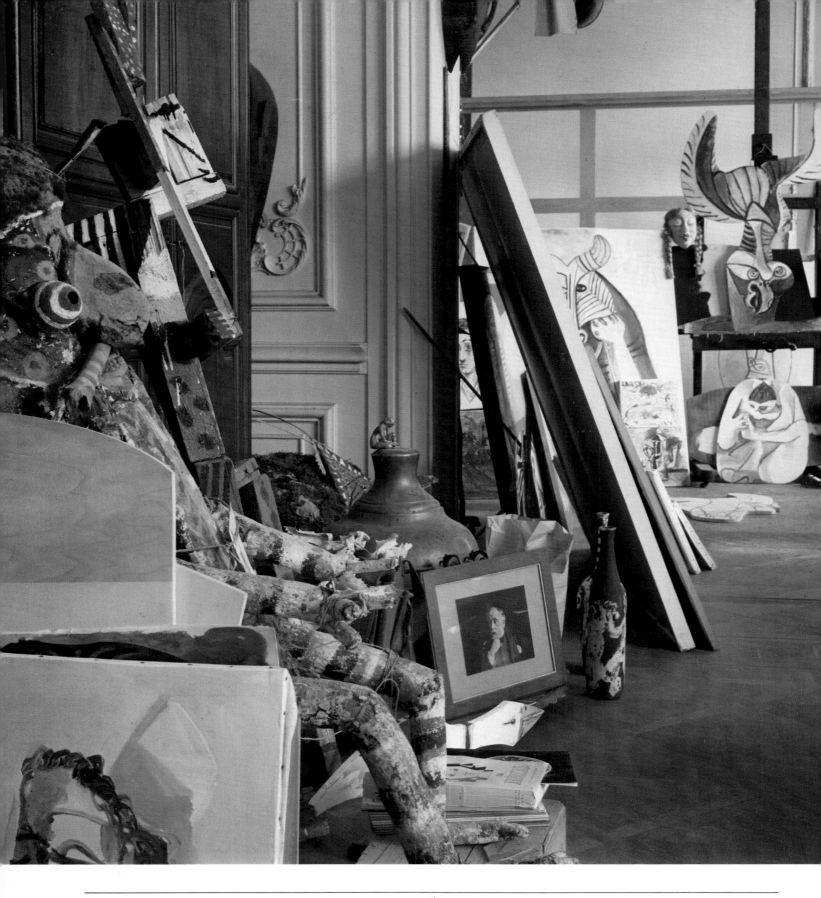

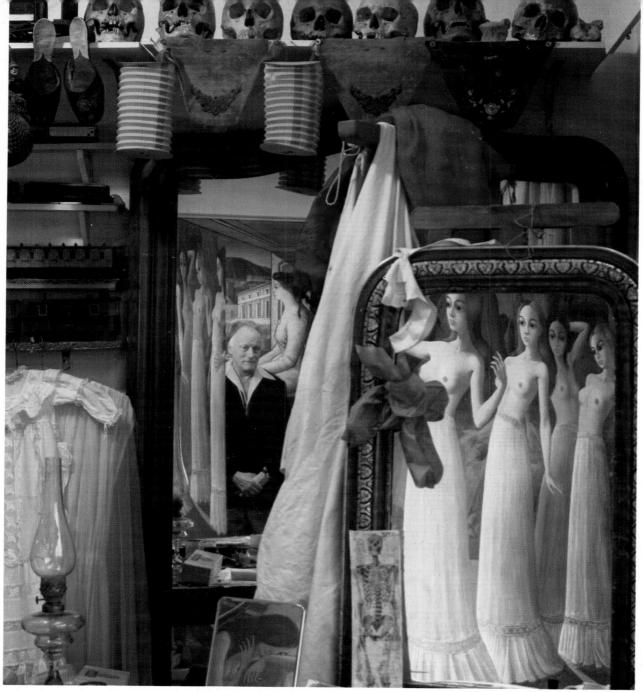

Pablo Picasso (1881–1973). Picasso never had a conventional studio but created propitious working spaces wherever he went, from château to factory to ordinary apartment. This corner of a room at "La Californie," the villa in Cannes where he settled in the mid-1950s, reveals the haphazard assembly of objects the artist liked to have around him as he worked. Prominent are the splendid New Hebridean figure (a gift from Matisse), one of the painted wooden sculptures Picasso had been making at the time, several of his own canvases, and, propped against the large jar, a photograph of Degas, whose work the Spanish artist collected. As soon as one room became overcrowded, Picasso moved to another and began all over again.

Paul Delvaux (b. 1897). Artist, painting, and studio become part of one grandiose illusion in this photograph of the Belgian artist Paul Delvaux. The painter's dominant themes are clearly indicated: love, death, and, above all, the strangeness of life, which we forget merely by becoming accustomed to it. Amid skulls, draperies, and nubile girls, the artist hovers like a magician, a creator of illusions — and, inevitably, one of those illusions himself.

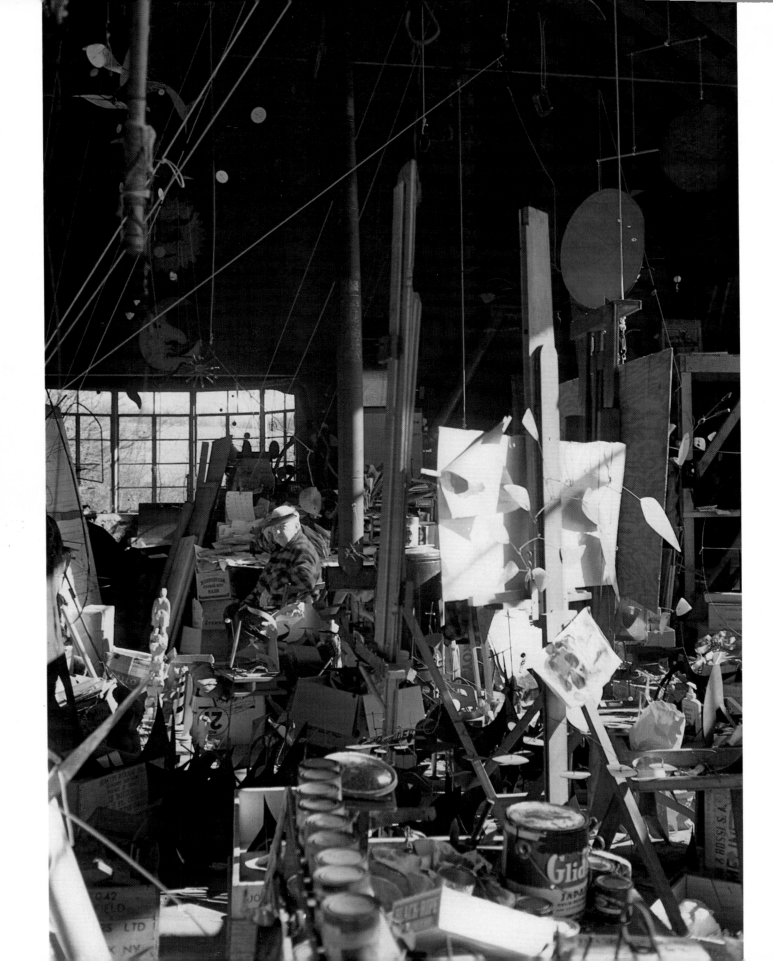

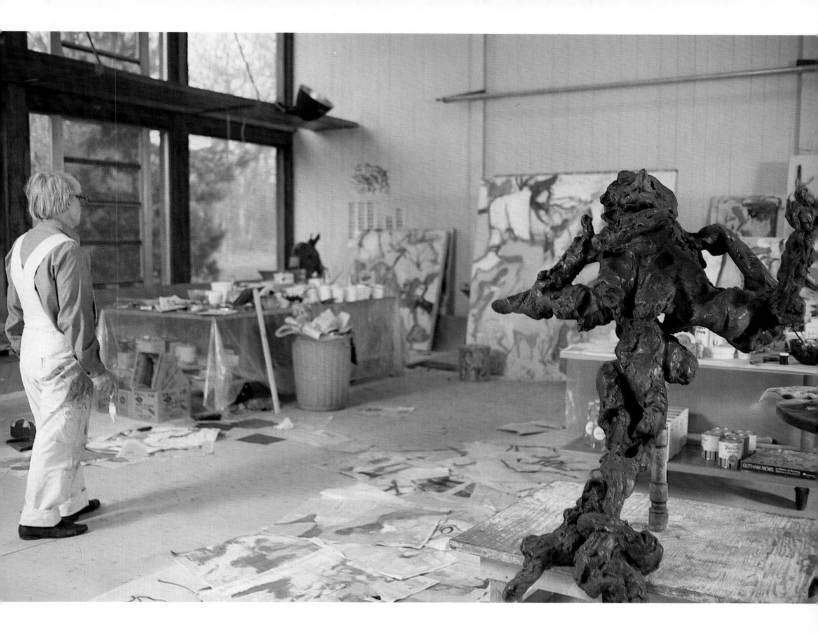

Alexander Calder (1898–1976). Like Vulcan at his forge, Calder pauses amid a profusion of tools, metals, and materials in the studio of his colonial farmhouse in Roxbury, Connecticut. Famous on both sides of the Atlantic for his soaringly graceful "mobiles" (so named by Duchamp), Calder kept several studios in France and America during his lifetime, and each of them resembled a machine shop or small factory more than a traditional artist's studio. As the son and grandson of sculptors, Calder knew from the start that a studio's only real importance was its conduciveness to work.

Willem De Kooning (b. 1904). It was not until 1963, when his reputation had become widely established, that Willem De Kooning left the modest Manhattan studio where he had begun his famous *Women* and settled in a more spacious workroom built especially for him at Springs, near East Hampton, Long Island. The new atelier took several years to complete, but the result has given De Kooning an ideal opportunity to work on his painting and sculpture (represented in this photograph by the bronze *Bar Girl*) with a maximum of ease and practicality.

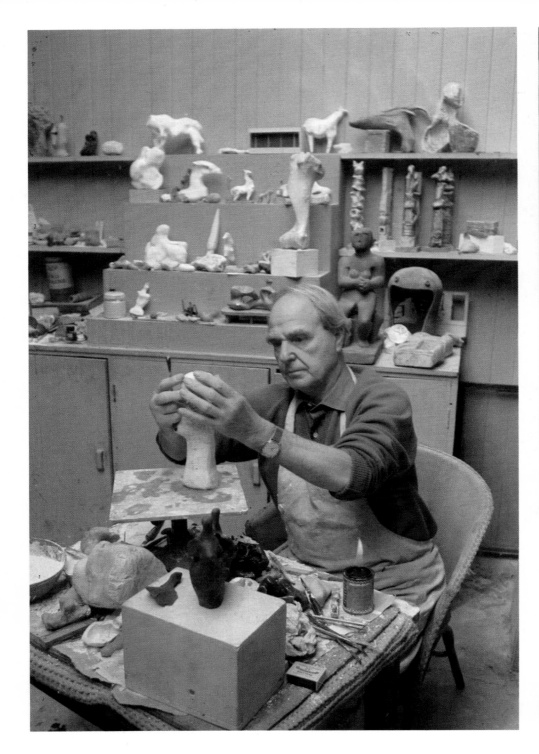

Henry Moore (b. 1898). To accommodate the many sides of his activity, Moore has set up no fewer than nine studios on the farmhouse property in Hertfordshire where he has lived since 1941. One studio serves for engraving, another for monumental commissions, a third for polishing finished sculpture, and so on. Here Moore is at work on a new model in his maquette studio, surrounded by examples of his own work as well as some of the natural shapes — from pebbles and shells to elephant skulls — from which he draws his main inspiration.

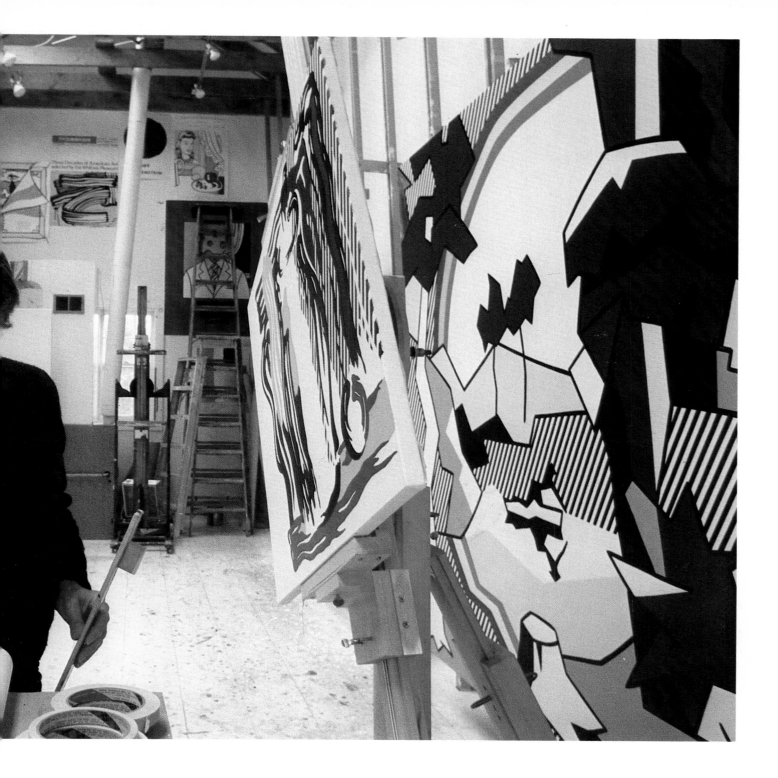

Roy Lichtenstein (b. 1923). Painting and sculpting on a larger scale than most of their European counterparts, American artists have found correspondingly larger studios necessary, thus setting a worldwide fashion for loftlike ateliers. Not only the space but the techniques and tools have changed. In taking methods until then used only in commercial art, Lichtenstein widened traditional painting's technical range. The admirable volume of his studio has allowed him not only to paint large compositions, but also to sculpt and do graphic and ceramic work.

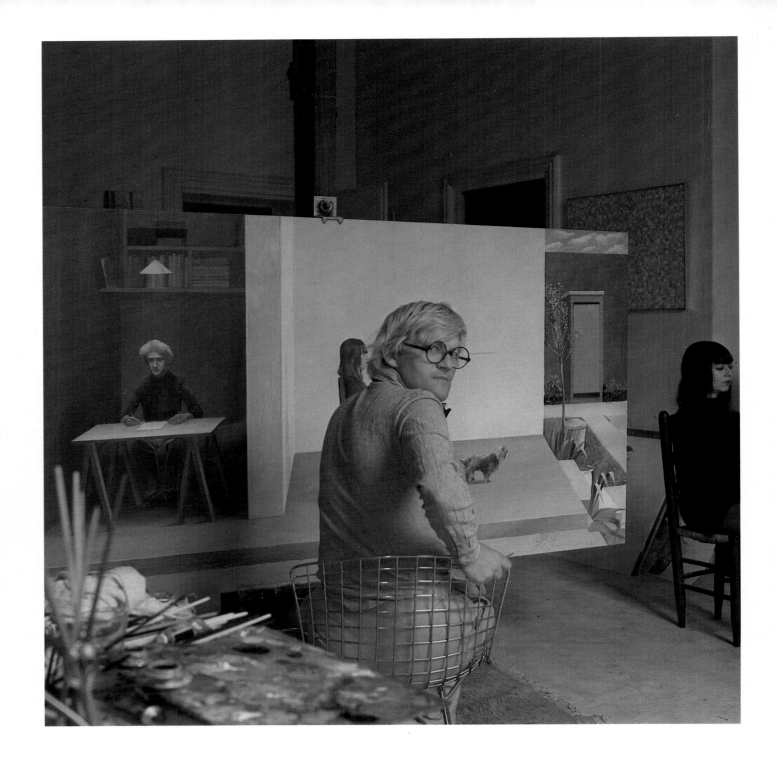

David Hockney (b. 1937). One of painting's great itinerants, Hockney has been able to work as successfully in a North African hotel as a London sitting room or California villa. Here the artist is shown in an apartment in the heart of Saint-Germain-des-Prés. Hockney has always enjoyed portraying his friends, and the model for this painting (seated on the right) is the late Shirley Goldfarb, an American painter who became an integral part of the Paris cultural scene.

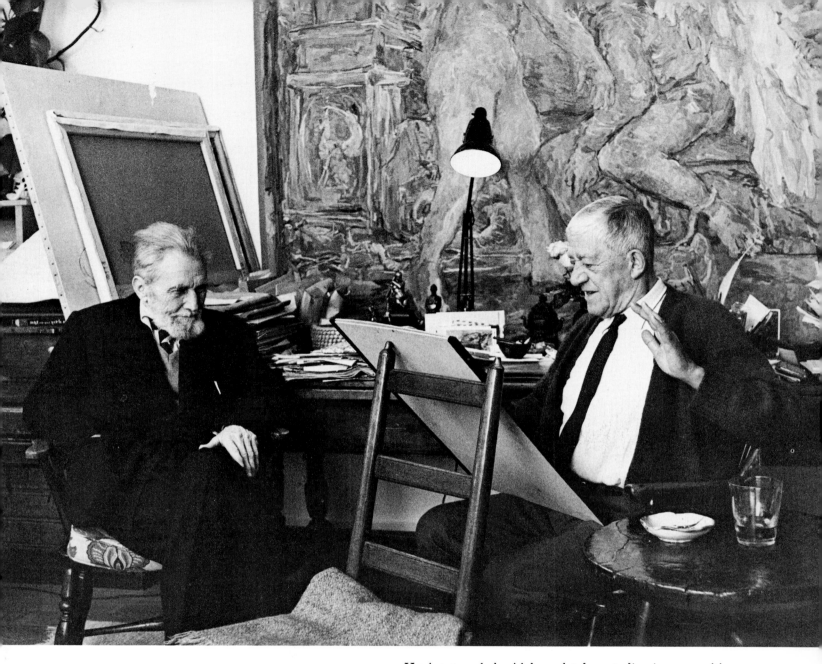

Having traveled widely and taken studios in many cities, Oskar Kokoschka was prepared to work in any of the rooms of the house where he finally settled near Montreux, Switzerland. Using the back of a chair as an impromptu easel, he can be seen here beginning a portrait of the poet Ezra Pound.

lights and a subtly altered approach. One of the dominant motives of Braque's quest was, as he phrased it, to "get as close to reality as I could." In his maturity he looked less to the outside world, to nature beyond his whitewashed windows, for the reality he was seeking than to the innate mystery of appearance, with its ever-shifting frontier between "reality" and illusion. This metaphysical problem lies perhaps at the heart of Braque's famous series of *Ateliers:* they are paintings about painting, about the near-infinite possibilities of two-dimensional patterning within an invented space. But their theme strikes other, deeper chords. The atelier is like the artist's mind itself, full of changing images and colors. It is an emblem of creativity: imagination's chamber.

Some studios harbor a personal world that appears barely touched by the larger artistic movements raging outside its walls. Surrounded by intricately patterned hangings and the elements of still lifes, the Russian painter Jean Pougny, long resident in Montparnasse, puts one in mind of countless, lesser-known artists whose universe is contained entirely within the four walls of their workroom.

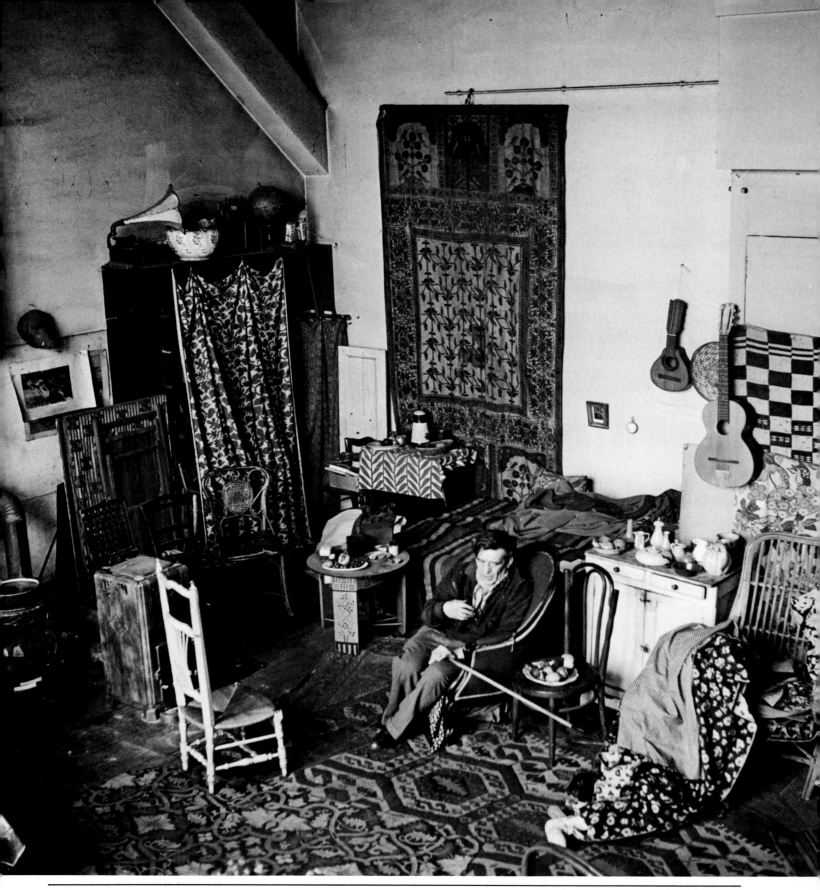

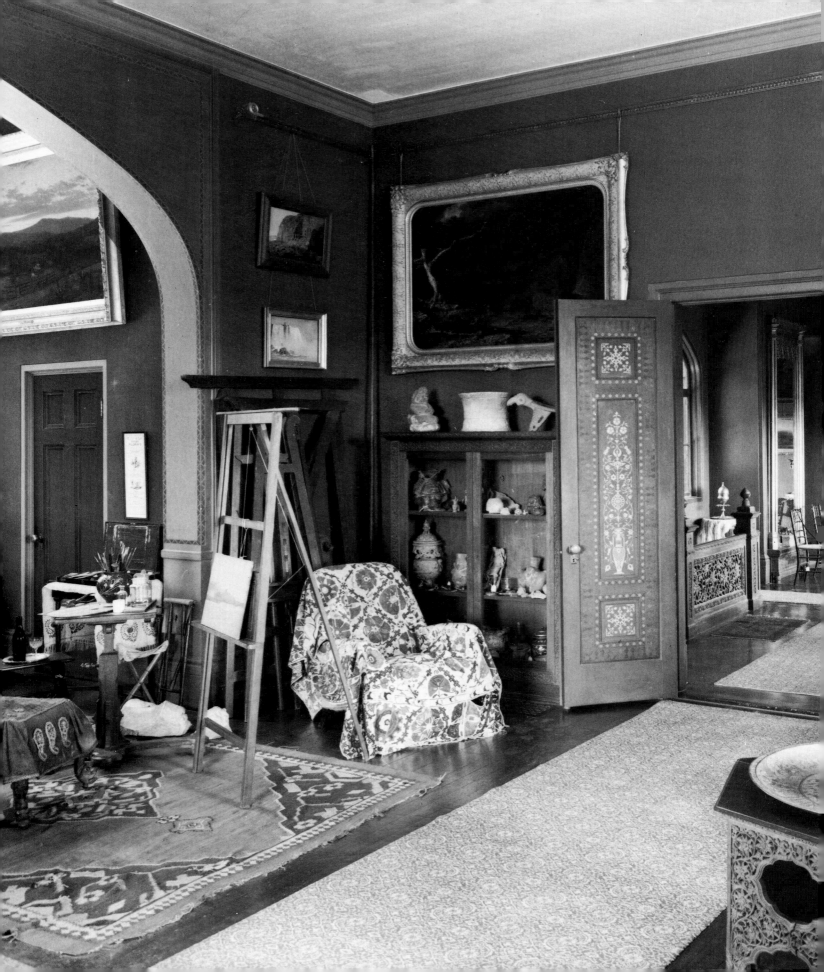

Studios of America

It appears self-evident today that a distinctly American studio exists. No sooner are the words said than one sees a very large, plain, whitewashed space in a building that once functioned as a factory or a warehouse, frequently in a dilapidated part of town. There might be a chair or two, a couple of photos or images tacked to the wall, but the emphasis of the place is entirely on the work under way. Nothing connects it to the plush, well-filled ateliers our grandfathers and great-grandfathers admired. Not only is there no attempt at a reassuring comfort and ostentation (quite the reverse!), but virtually every established studio practice and every piece of equipment has changed. In this bare modern room, palette and easel, punch and mallet would look like heirlooms. The canvas is spread directly on floor or wall, and a person dressed not in velvet but workman's dungarees goes at it with housepainter's tools and huge pots of industrial paint, or operates trip-hammer and acetylene torch in an acrid, machine-shop atmosphere. Yet this freedom from the past was achieved only after many generations of American artists had absorbed centuries of tradition.

Up until the 1930s, when the loftlike atelier made its tentative debut, the leading American studios closely resembled their European counterparts. When Frederic Edwin Church built his painter's castle above the Hudson River, he was not unmindful of the hybrid splendor in which his peers were lodged in London, Paris, and Vienna. Similarly, William Merritt Chase vowed he would make his Manhattan studio as exotically impressive as anything he had seen during his six years of study and travel in Europe. Yet even the most slavish imitations of the way prominent artists were established abroad ended, naturally enough, by acquiring an irreducibly American note. And for every Church and Chase, there were scores of more humble artists who lived by painting anything from shop signs to portraits, setting up their "studios" wherever commissions were to be had, and then moving on like the itinerant artists of Europe during the Middle Ages.

Church's master, the highly gifted Thomas Cole, began his career in just this way. English-born, but having arrived in Philadelphia as a young man in 1818, Cole was keenly aware of the new nation's untapped visual wealth. "All nature here is new to art," he noted, and with no further apprenticeship than having watched another painter at work, he set off across the country with a knapsack full of canvas, raw pigments, and the other tools of the trade. Naturally, the untutored young artist accepted all requests, however inglorious, such as touching up unflattering portraits left behind by other itinerant painters. The odd success nevertheless occurred, as when he was asked to paint "the visage of a military officer"; this turned out to be his "best likeness" since, he said, "I could hardly miss it. 'Twas all nose, and in the background a red battle." Cole did not come into his own, however, until he journeyed up the Hudson River in 1825. With the fervor of one who had suddenly discovered his true calling as an artist, he sketched the magnificent spectacle before him, then carried the result back

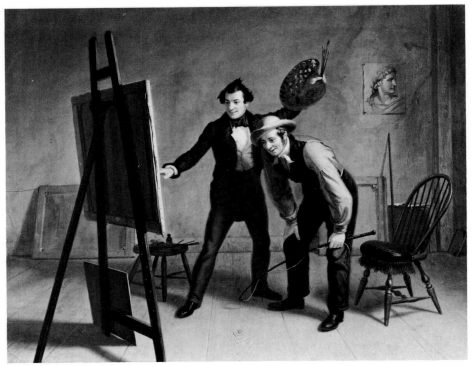

to his garret in New York City, where, "perpetually fighting with a kind of twilight . . . elbowed and pushed by mean partitions," he worked up on canvas the vast yet detailed and luminous vision of nature that was to be variously interpreted by a whole school of American landscapists.

By the time he was twenty-eight, Cole was established as America's leading painter. Like most successful American artists throughout the century, he went on an extended tour of Europe; yet he was in no way awed by the old continent's great centers of artistic tradition. Indeed, he openly criticized the later landscapes of Turner (whose previous work he much admired) and left London convinced that he had "done more than all the English painters. . . ." Shortly before his death in 1848, Cole was to return to Europe and lock himself in a Roman studio so as to work out of sight of the Italian old masters who, unlike the English, gave him a crippling sense of artistic inadequacy. But his work as a great initiator had been accomplished, and passion for landscape on the grandest American scale been sparked in his most successful pupil, Frederic Church. Schooled for three years by Cole in the latter's Catskill studio, Church lost

no time in establishing the pattern of his painting life. Having spent the whole summer traveling and sketching out of doors, he would return, fit and bronzed as a sportsman, in October and disappear into his New York City studio — to emerge a pallid wraith, used up by too much work, in the spring. Until he retired to his dream castle, "Olana," built on a bluff overlooking the Hudson, Church worked in the famous West Tenth Street Studio Building, mentioned in Chapter Five as the hub of America's "society favorites." A prodigious amount of energy went into each of Church's huge, meticulously accurate compositions. They were researched during voyages that took the intrepid artist as far afield as Ecuador, Greece, the Near East, and (to gain a firsthand familiarity with icebergs) Labrador. Hundreds of oil sketches were made *in situ* and brought back to New York, where they were transformed through the artist's dexterity and prodigious visual memory into landscapes so full of natural fact that for one of them an essay-length guide was produced to direct the spectator's eye to various salient points.

The canvas in question was *Heart of the Andes,* finished in 1859. It was eagerly awaited, and when the mo-

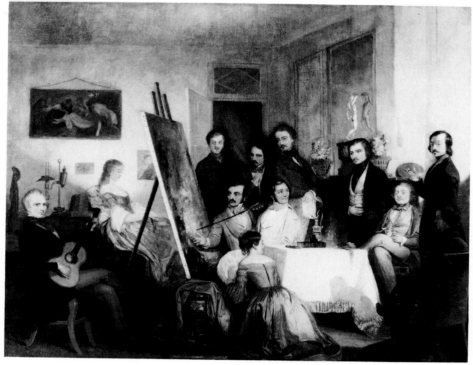

Thomas P. Rossiter (1818–1871), A Studio Reception, Paris, 1841, *Albany Institute of History and Art, New York. Until well into the present century, an extended visit to the great European capitals was considered a vital part of an American artist's education. Rossiter himself — portrayed here in the eminent company of Healy, Durand, Kensett, and Huntington — spent six years studying in Europe.*

ment came to reveal the painting to the public, Church shut out all natural light from his studio and spotlit the work by means of clustered gas jets set in silver reflectors. Exotic plants and sumptuous hangings heightened the impression of a magical event: a distant land brought in all its real-life splendor to the heart of New York! The exhibition became a roaring success, netting nearly $600 a day in entrance fees; and the picture later drew crowds in a dozen major European cities. Like his counterparts in France and England — the Gérômes and Alma-Tademas — Church aimed at absolute fidelity to measurable fact in everything he painted, and like them he worked regularly from photographs and stereographs. In the West Tenth Street studio, likened by one enthusiast to a "great alchemist's laboratory," whole portfolios of documents were assembled to assure the accuracy of each composition. *Jerusalem* was not begun until a photographer had provided special panoramic views of the city. Collections of tropical birds' eggs and butterflies, backed up by a comprehensive natural history library, formed part of the archives of this remarkable atelier in Greenwich Village. Yet however impressive, it was dwarfed by Church's subsequent extravaganza.

"About an hour this side of Albany is the Center of the World," the artist wrote to a friend. "I own it." By 1872, Church had moved into what must be the most ambitious studio-palace ever built. Called "Olana" (from the Arabic meaning "our place on high"), this lofty mansion was a grand architectural fantasy in the "Victorian-Persian" style, designed by the artist and incorporating polychrome towers, brick "minarets," and Oriental interiors. The studio wing, part Mexican, part Oriental in inspiration, contained a gallery and a rooftop observatory that provided an unparalleled view over the Hudson to the Catskill and Berkshire mountains. Here Church planned to make astounding new studies of the storms and sunsets that had always fascinated him. But a chronically rheumatic wrist prevented him from working, and the splendid studio — with its Tiffany silver, its Shaker rocking chair and pictures by Cole and Murillo — remained essentially a showplace of the artist's eclectic tastes.

"Olana" was only one of a considerable number of studios to have sprung up "like a picket line" along the Hudson River. Albert Bierstadt, German-trained and immensely successful as limner of the grandiose West,

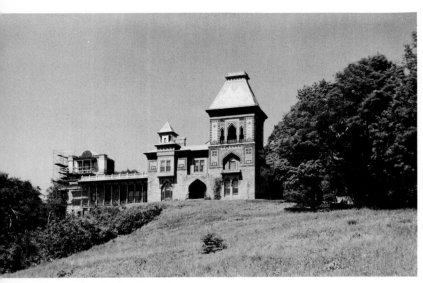

"*About an hour this side of Albany is the Center of the World*," wrote the landscapist Frederic E. Church, adding, "*I own it.*" He referred to Olana, the studio-palace he built in the 1870s in "Victorian-Persian" style above the Hudson River. With its polychrome towers and oriental interiors, Olana (now a museum) forms a monument to the painter's taste for the exotic and grandiose.

Part Mexican, part oriental in inspiration, Olana's studio wing contains a gallery and a rooftop observatory commanding a superb view across the Hudson to the Catskill and Berkshire mountains. Church planned to make astounding new studies of storms and sunsets here, but a chronically rheumatic wrist prevented him from working in this studio of his dreams.

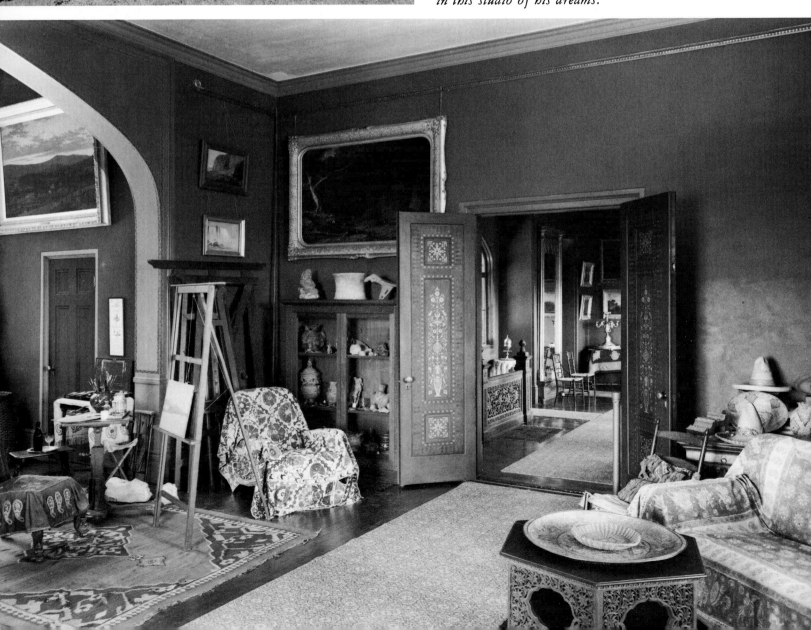

commanded such high prices from the international élite that he was able to build a painter's castle overlooking the Tappan Zee. Called "Malkasten" (and since destroyed by fire), it contained thirty-five rooms, including a seventy-five-foot-long studio, which the vigorous artist had enlivened with Indian artifacts, wapiti heads and other shotgun trophies. Several painters had studios specially constructed to contain live animals; George Inness, for instance, created a "zoological glasshouse" in which he was able to depict the animals of his choice against a variety of backgrounds without ever leaving his comfortable interior. The Long Island genre painter, William Sidney Mount, made the contrary arrangement. Following his belief that "the painter should have no home — but wander in search of scenery and character," Mount devised a horse-drawn studio that allowed him to amble down country lanes and execute "portraits, pictures and landscapes — free from much dust, heat and cold — during windy and stormy weather." Several rustic scenes later, Mount sang the praises of this atelier on wheels as the "extract of the very best studios in the world."

With true American practicality, artists set up their studios in the most unexpected places whenever commissions seemed to be forthcoming. After specializing for a time in huge, rapidly painted political banners, George Caleb Bingham established himself in a hut at the foot of Capitol Hill and waited for famous statesmen to come and sit to him for their portrait; none did, and Bingham turned, more rewardingly, to depicting life on the Missouri. Other eager portraitists opened their easels in the New York Stock Exchange and dashed off an investor's likeness before a change of fortune could intervene. Many of those fortunate enough to have some kind of a painting room had no other accommodation and were obliged, as one contemporary noted, to "bivouac at night in their studios or offices amid . . . plaster casts, boxing-gloves, easels, squares of canvas, skulls, fencing-foils, portfolios, pipes, armor, weapons and sketches."

Such makeshift arrangements would not have been tolerated, naturally, by the grandees of American art, many of whom at some point in their careers kept a studio in the prestigious West Tenth Street Building. Church and Chase were long resident there, and other

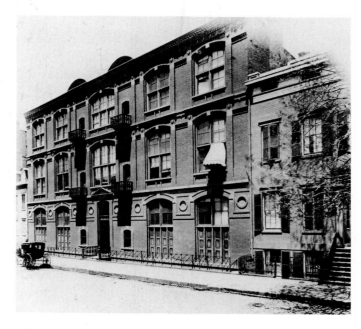

The Studio Building on West Tenth Street provided the focal point of New York's artistic life in the last decades of the nineteenth century. Built specifically in the 1850s to accommodate artists (and demolished a century later), the building housed Church, Bierstadt, Kensett, Homer, and the flamboyant society painter, William Merritt Chase.

noted inhabitants included Bierstadt, Sanford Gifford, Emmanuel Leutze, Martin Heade, and Winslow Homer. Thus the building, which continued as an artists' community until it was pulled down in 1955, provided the focal point of New York's artistic life for several decades. Most of the studios opened into one another; and although, like less fortunate artists' rooms, they harbored "all sorts of odds and ends of old drapery and knick-knacks thrown about in tangled, picturesque confusion," they lent themselves admirably to showing off new work to a select public of potential collectors and proven cognoscenti. These visits gradually grew into full-scale "artists' receptions," outstanding social events to which invitations were coveted. Every trace of toil was removed from the studio and the most salable paintings hoisted to best advantage amid artistically scattered potted plants and curios. The artists, for their part, trimmed their beards, donned their Sunday best, and stood by their studio doors to greet visitors. Music and a buffet were often provided, particularly in Chase's studio, which had once been the communal exhibition area and so was by far the largest space in the building. As prodigal as he was successful, Chase entertained like a rajah, giving studio parties that were described as the "sensation of the 1880s." The fabled Carmencita, invited by John Singer Sargent, danced there with such éclat that some of the ladies present tore off their jewels and cast them at her feet. Chase's Russian greyhounds, macaws, and cockatoos never failed to make an impression, while for the single-minded art enthusiast there were, as one visitor records, "faded tapestries that might tell strange stories, quaint decorated stools, damascened blades and grotesque flintlocks."

One might leave these busy interiors and follow similarly well established artists to their summer haunts, to the sketching parties or relaxed painting schools they set up in prosperous villages along the eastern seaboard; take further note of their eccentricities and extravagances, and conclude that it was a golden age of popularity and ease for artists. That would, of course, be a false impression. America might take to her bosom a painter who skilfully conveyed the image of her prosperity and grandeur. But anyone less successful than the handful of "society favorites" tended to suffer, if not materially, then at least from a crippling sense of isola-

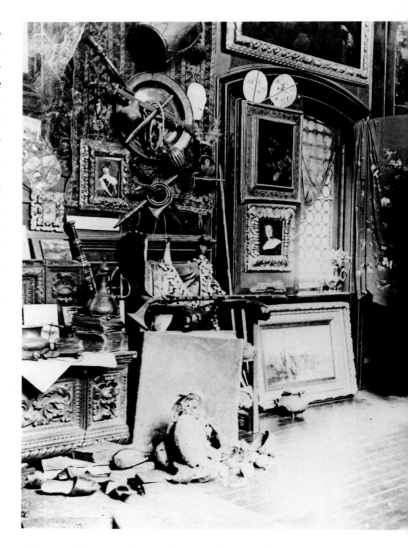

Chase took over the Studio Building's exhibition gallery and transformed it into the most luxurious and famous atelier in the city. Exotic plants and animals, picturesque objects, and costly hangings provided a background not only for his painting but for studio parties described as the "sensation of the 1880s." See also page 85.

At the farthest possible remove from the curio-filled interiors of Church and Chase were stone-carving studios, such as this one in Hoboken, New Jersey, where William Zorach — born in Lithuania, but trained entirely in America — is shown completing a large work entitled The New State of Texas.

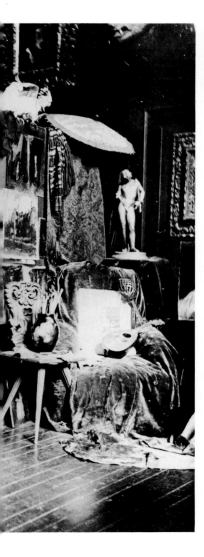

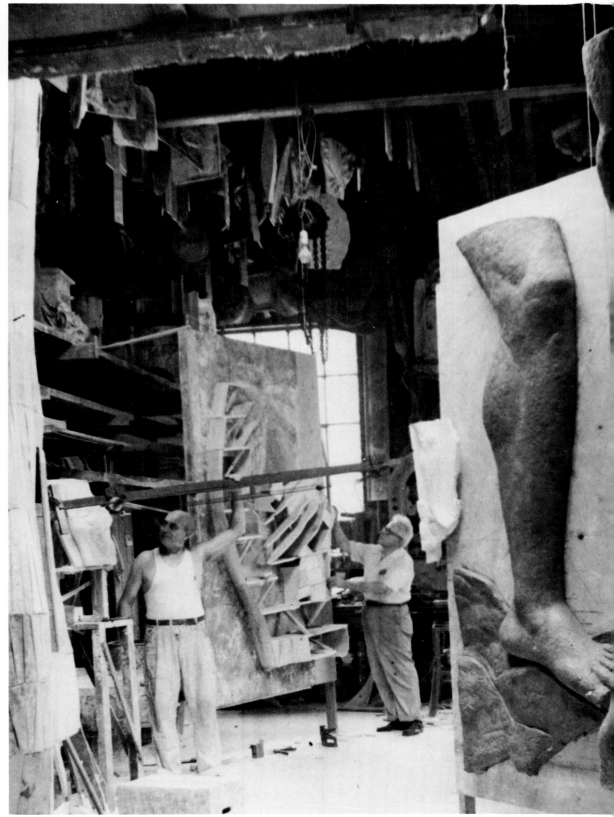

tion. In Munich or Düsseldorf, Vienna or Rome, artists either obscure or in stylistic rebellion could count on a certain understanding and even a sense of community. America was still too new and too vast to afford this; and when they could, many American artists took extended refuge in Europe, where, according to Nathaniel Hawthorne, they continued to "shiver at the remembrance of their lonely studios in the unsympathizing cities of their native land."

An independently American art, and hence an independently American studio, was still far off. Throughout the late nineteenth century, American artists who had opted to live in Europe were, as Church dryly observed, "as plentiful as ants in an anthill," and there was not a single academy or open atelier from London to Rome that could not boast a transatlantic pupil. Thus the latest European attitudes in art were regularly shipped back to America. Before returning to his native Philadelphia, where he taught at the Pennsylvania Academy of the Fine Arts, Thomas Eakins studied under Gérôme — whose atelier at the Ecole des Beaux-Arts in Paris also included Frederic A. Bridgman, Abbott Thayer, and J. Alden Weir. The situation did not change greatly in the early years of this century. At the time of the Cubists, dependence on Europe was still sufficiently absolute for one of the most percipient connoisseurs of the period, Gertrude Stein, to declare, "Painting in the 19th century was only done in France and by Frenchmen, apart from that painting did not exist, in the 20th century it was done in France but by Spaniards." Before such massive oversimplification could be definitively rejected, American artists had to take a long, lonely leap into the dark.

The most dramatic of the figures through whom the transition to a more specifically American art took place was undoubtedly Arshile Gorky. Born and brought up in Armenia, before emigrating to the United States in 1920, Gorky remained keenly aware of the importance of first assimilating the great achievements of the modern European artists. "I was *with* Cézanne for a long time," he told his future dealer, Julien Levy, "and now naturally I am *with* Picasso." Each apprenticeship was undertaken with such fervor that this latter attachment earned Gorky a nickname as the "Picasso of Washington Square." During a Picasso exhibition in New York in

1937, some fellow artists chaffed Gorky about the fact that Picasso had begun to allow his paint to drip. "Just when you've gotten Picasso's clean edge," one of them lamented sarcastically, "he starts to run over." "If he drips," the undeterred Gorky replied, "I drip."

Gorky's studios in New York announced a new degree of desolation in American art. Even the most criticized and controversial of his immediate forebears, the members of the so-called Ash Can School, would have been alarmed to find an artist reduced to such poverty and isolation. Robert Henri, for instance, the leader of these "apostles of ugliness," lived in reasonable comfort in his studio on Walnut Street, Philadelphia: it became a regular artists' club where aesthetic discussion was frequently interrupted by all kinds of games and generous servings of Welsh rabbit and beer. Similarly, William Glackens and the Prendergast brothers organized a tranquil life, despite fierce criticism, in the house they had split up into studios at 50 Washington Square in New York City. Gorky lived in obscurity on the same square for a while, then found another room for his studio on Union Square. The barren walls of this atelier were relieved to some extent by fading reproductions of some of the artists he most admired, notably Uccello, Piero della Francesca, and Mantegna. Admiration for the "purity" of Ingres' line was also apparent in the photostat of his *Self-Portrait at the Age of Twenty-Four*, which Gorky kept beside him while he worked. The only other prominent feature in this unaccommodating room was the cast of a Hellenistic female head from which Gorky drew the large, highly simplified eyes that he used in the early portraits of himself and his family.

This atmosphere of want and loneliness was heavily underlined by Gorky's own appearance. He was a tall, gaunt man, and his leanness was dramatically underlined by the ragged, outsize overcoat he wore like an emblem of his artistic status, a being beyond ordinary society. But the air of arrogant poverty reflected not only Gorky's precarious material situation but his despair at the task looming each day before him. How could the American artist come out of the shadow of the European heritage and forge a language of his own? In his melodramatic fashion, Gorky summoned a number of New York artists to his Union Square studio and announced his conclusion: "Let's face it," he told the as-

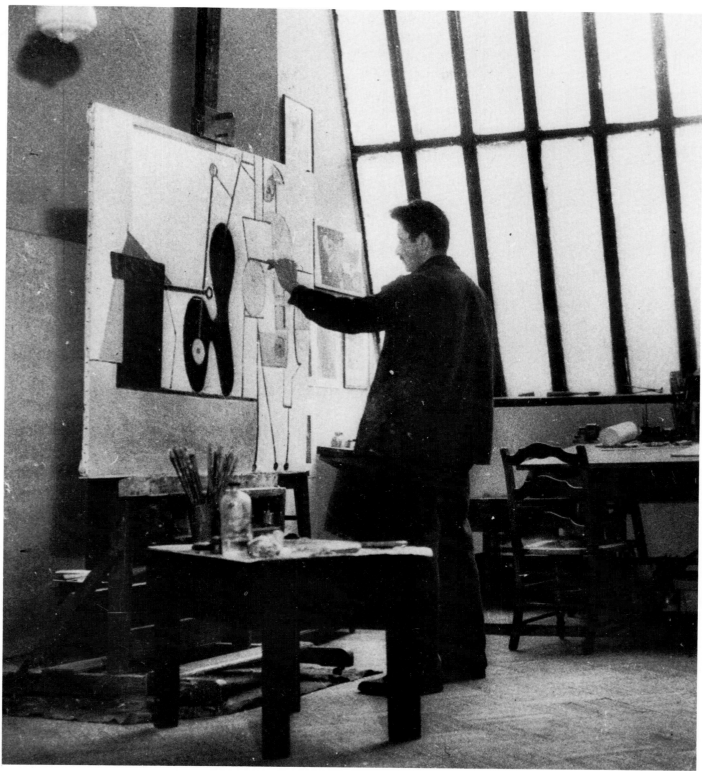

Painfully isolated and dogged by misfortune, Arshile Gorky personifies the neglect in which the most original American artists of his generation were forced to live.

Photographed here in 1934–1935 in the stark studio space he rented at 36 Union Square in New York, Gorky can be seen at work on Organization.

sembled company, "we're bankrupt," and he went on to suggest that the only satisfactory work they might do would be collective — with one artist providing the overall project, another drawing it, a third selecting the colors, and so on.

By the time Gorky had evolved a distinctly personal style of painting, misfortune overclouded any sense he might have had of his achievement. In his last years he had begun to paint in a barn in Sherman, Connecticut; in January, 1946, this rough and ready studio burned down. "Paintings, drawings, sketches, and books, all were burned to ashes, not a thing was salvaged," he wrote in despair. At least twenty-seven paintings were lost in this way. The following month, Gorky underwent an operation for cancer. Physically undermined, he decided to settle in Sherman. But his health was once again seriously affected by a bad automobile accident. Shortly thereafter, in July 1948, he hanged himself.

Similarly tragic ends cut short the lives of many of the other artists, major and minor, of that self-assertive and painfully isolated generation. Jackson Pollock's headlong career and sudden death have now, like Gorky's, become woven into the larger myth of the *artiste maudit,* the Promethean seeker punished by the gods. His studio-barn in East Hampton, Long Island, has acquired a corresponding aura as one of the high places of contemporary creation: an ordinary space rendered magical because an excitingly original approach to painting was evolved within its walls. Pollock had begun working there in the mid-1940s, leaving the Greenwich Village area for the summer (like so many other "loft rats," as soon as they had the chance). In winter, the bitter Atlantic winds whistled through the loose planking of the barn, making it virtually unusable. Pollock had it properly insulated in the last years to enable him to work all year round; but not before he had broken a two-year abstinence by downing a glass of whisky to help him thaw out after an icy session in the studio — thus going back for good to his addiction to alcohol.

The East Hampton barn's large, plain space clearly had its effect on the development of Pollock's new style, which he began to practice from 1947 onward. Here was a "studio" that certainly had nothing to do with any traditional concept of what the artist's working space should be. Centuries of precept and method fell away: a

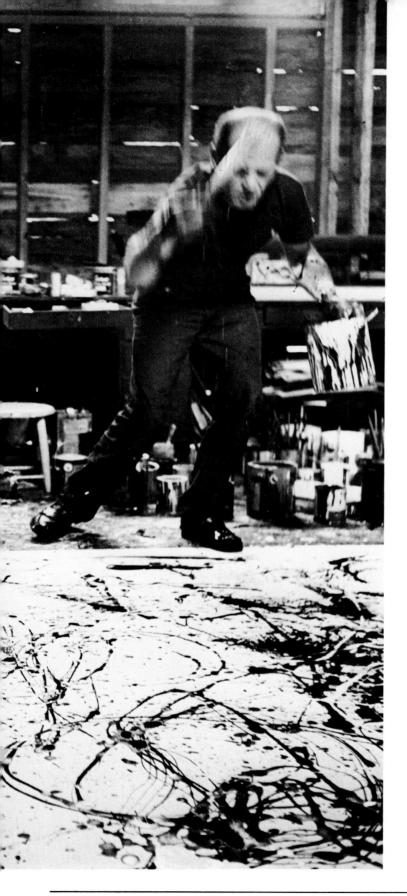

Jackson Pollock at work on an action painting in his studio barn on Long Island remains one of the most highly charged images in the history of American art. With the finished works propped against the walls and the floor covered with paint drippings, the studio came to look like a gigantic, three-dimensional Pollock painting.

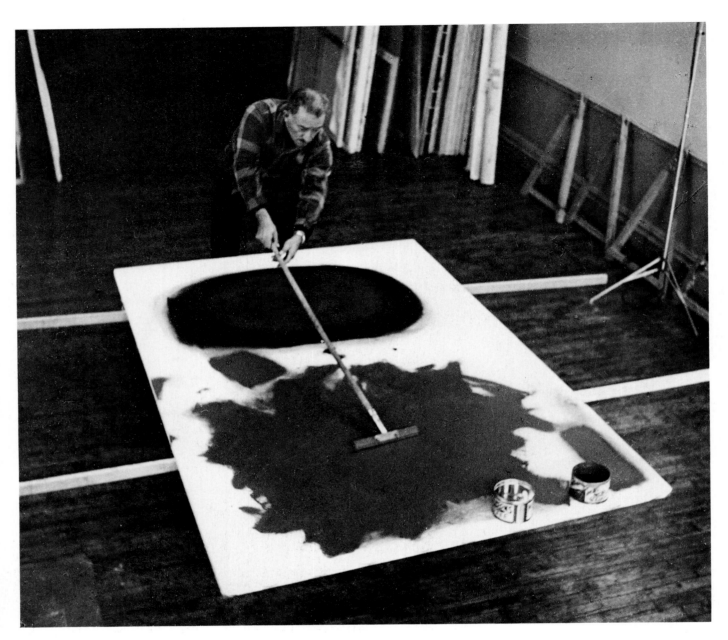

structure normally used to house cattle or a plow made no claims on art history. Neither did the artist. Before him there were nothing but huge, virgin canvases and quantities of industrial paint. A medieval painter would have supposed the space to belong to an artisan of the crudest kind, and it is unlikely that many contemporaries would have linked it to any notion of creativity. But Pollock wanted instinctively to begin at the beginning. The strange war dance he performed went back to the most primitive ritual; beside it, the cave paintings of Altamira or Lascaux are incomparably sophisticated.

In modern art, radical changes of style have generally been accompanied by distinct changes in technique. Neither easel nor palette, nor the slightest suspicion of tubes of oil paint (in themselves a relative novelty), can be seen in Adolph Gottlieb's New York studio. His famous "burst" paintings are inseparable from industrial-sized cans of paint and the unhesitatingly expressive squeegee.

Without the telltale paintings, it would be difficult to identify this quiet corner as Franz Kline's studio overlooking Fourteenth Street in New York. One notes that beside the huge brushes and the five-gallon pots of paint the artist favored for his large compositions, there were also more time-hallowed tools such as traditional brushes and an easel.

Yet this primitivism was in no way faked. It sprang from a real need, an almost physical need to come at painting as if no one had ever painted before.

Pollock nevertheless proved quite articulate about the elemental methods he used. "I hardly ever stretch my canvas before painting," he explained. "I prefer to tack the unstretched canvas to the hard wall or floor. I need the resistance of a hard surface. On the floor I am more at ease. I feel nearer, more part of the painting, since this way I can walk round it, work from the four sides and literally be in the painting." Several theories have been advanced to suggest how Pollock might have been

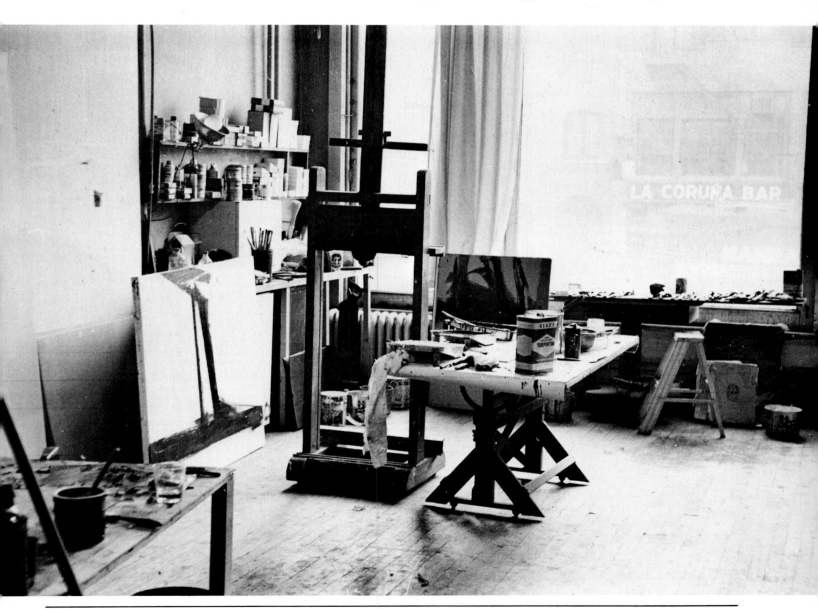

Photographed in the bare seclusion of his summer studio at East Hampton in 1964, Mark Rothko contemplates a recent canvas of characteristically large dimensions. Rothko claimed that to "paint a small picture is to place yourself outside your experience," while "however you paint the larger picture, you are in it." For Rothko and many of his contemporaries, this preference for large canvases automatically necessitated large studio spaces.

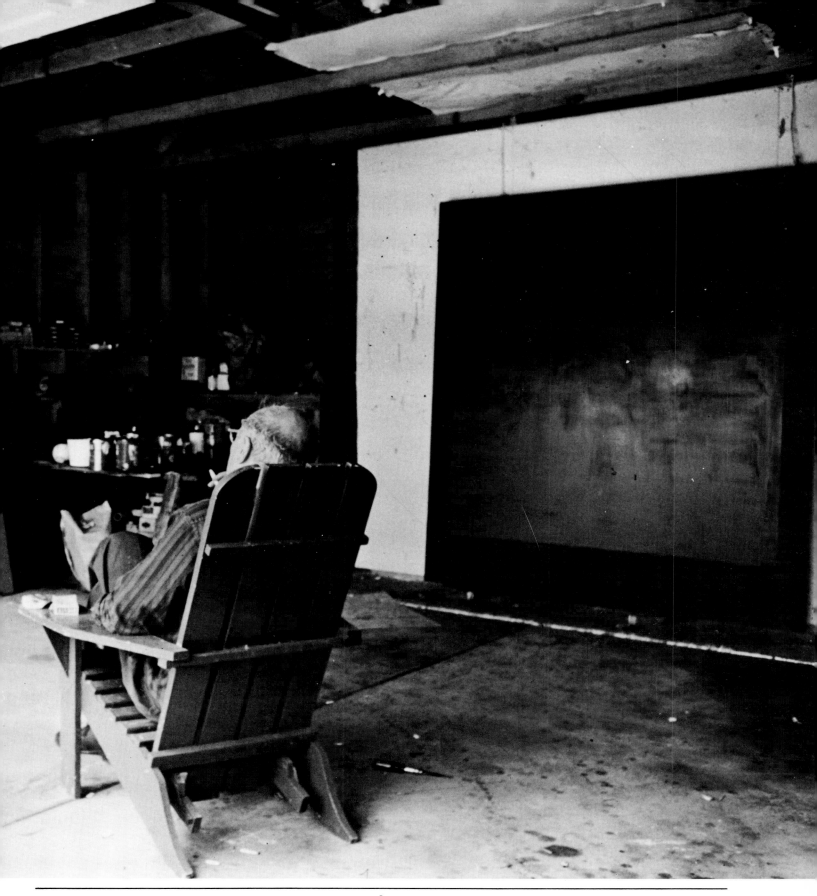

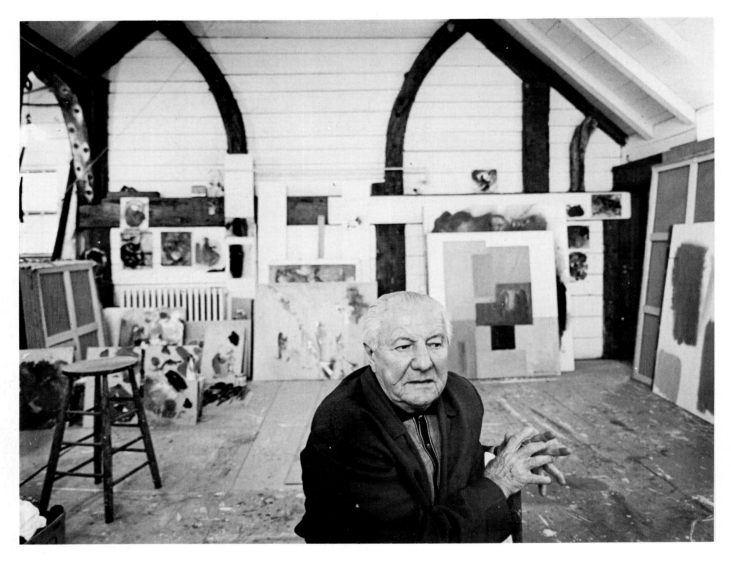

led to his revolutionary dripping technique. The time he spent in 1936 at the experimental workshop opened in New York by the Mexican painter Alfaro Siqueiros would — at the very least — have opened his eyes to a wider range of technical possibilities. Situated on West Fourteenth Street, the workshop promoted the use of spray guns and airbrushes, as well as the latest synthetic paints and lacquers; discussion between the artists there frequently turned to "spontaneous" or "gestural" ways of painting, and such seductive notions as "controlled accident" were also bandied about. Pollock himself referred to his interest in the ritual and techniques of Indian sand painting; but once he had established the bases of his own method, his dominant concern was to take the experiment as far away from conventional practice

The doyen of the New York School, Hans Hofmann was important both as teacher and as painter. His studio school on West Eighth Street remained a hub of influence throughout the 1940s and 1950s. At a time of great self-doubt among American artists, Hofmann was able, according to his ex-pupil Larry Rivers, to "make art glamorous."

as possible. "I continue to go further from the usual painter's tools such as easel, palette, brushes, etc.," he emphasized. "I prefer sticks, trowels, knives and dripping paint or a heavy impasto with sand, broken glass and other foreign matter added."

For a decade, the Long Island barn — much photographed and even filmed — remained the scene of Pollock's efforts to achieve a dynamically new pictorial statement. With finished works and others in progress tacked to its walls and a floor heavy with the interlacings of countless paint drippings, the studio came to look like a vast three-dimensional Pollock picture — an archive of past "accident," but also a matrix suggestive of new beginnings. Cut off from tradition as well as contact with the contemporary world, it became a world unto itself, a universe of pure paint.

Outside the private universe of the studio, there were few enough places for New York artists of that postwar generation to go to find the sort of stimulus that their Parisian counterparts expected in café discussion groups or that London artists looked forward to in certain restaurants, pubs, and clubs. "I don't see why the problems of modern painting can't be solved as well here as elsewhere," Pollock had stated defiantly, but he was keenly aware of the greater isolation in which American painters and sculptors did their work. The main places where artists met outside their studios were the Waldorf Cafeteria on Eighth Street and Sixth Avenue, and the Cedar Tavern, on University Place, both in Greenwich Village. After a disagreement with the Waldorf management about their right to keep a table all evening for the price of a cup of coffee, a number of artists decided to rent space on Eighth Street, thus founding the Eighth Street Club, which became the focal point of the New York School's extrastudio activities until the end of the 1950s. The club proved a boon above all to artists who had moved out of Manhattan and who, like the sculptor David Smith, made regular trips into the city to visit the galleries and "run into late-up artists chewing the fat."

Smith, whose life, like Pollock's, was cut short by a driving accident, set up his studio in the mountains above Lake George, in Bolton Landing, New York, in 1940. Called the "Terminal Iron Works" after the waterfront welding shop in Brooklyn where Smith first welded sculpture, the studio resembled a personalized foundry

Baptized the "Terminal Iron Works," David Smith's foundrylike workshop at Bolton Landing, New York, was filled with every kind of metal imaginable, from gleaming sheets of stainless steel to rusted old cogs. Transformation was all: out of four discarded turnbuckles that had been lying around for months, for instance, Smith suddenly fashioned four soldiers at the charge.

189

more than an "artistic" place of work. After a visit there for *Art News* magazine, Elaine de Kooning gave this highly evocative summary of its contents: "The huge cylinders, tanks and boxes of metal scrap; the racks filled with bars of iron and steel-plate; the motor-driven tools with rubber hoses, discs and meters; the large negatively charged steel table on which he executes much of his work; the forging bed nearby; and the big Ford engine that supplies the current for welding...." Added to this were the mountains of materials that Smith required. "Sheets of stainless steel, cold and hot rolled steel, bronze, copper and aluminum are stacked outside;

Hat blocks, balustrades, baseball bats, and lavatory seats have long been grist to Louise Nevelson's mill, but a large black cow still surprises. The five stories of her house on Spring Street, New York, are stacked high with found objects, collected objects (such as African masks), and her own finished works.

lengths of strips, shapes and bar stock are racked in the basement of the house or interlaced in the joists of the roof; and stocks of bolts, nuts, taps, dies, paints, solvents, acids, protective coatings, oils, grinding wheels, polishing discs, dry pigments and waxes are stored on steel shelving in his shop."

Smith modeled in wax, carved in wood and marble, but steel was what he called his most "fluent" medium. "Possibly steel is so beautiful," the sculptor suggested, "because of all the movement associated with it, its strength and functions Yet it is also brutal: the rapist, the murderer and death-dealing giants are also its offspring." Smith's creative "fluency" stemmed in part from the apparent ease with which he transformed discarded bits of metal and machinery into arresting sculptural concepts. Perpetually on the lookout for promising elements, Smith amassed mountains of rusted scrap, then reflected at leisure on the new role he might give

Alfonso Ossorio's studio wall speaks for itself. Like words in a language waiting to be used, the most ordinary and the most outlandish elements hang there until a new role is found for them. Like Nevelson, Ossorio is constantly on the lookout for all kinds of useful odds and ends.

them. Thus he salvaged four discarded turnbuckles and had them hanging in the studio for a couple of months before, suddenly, he "recognized them as the bodies of soldiers with the hooks for heads." Out of that flash of recognition came a sculpture representing four soldiers at the charge.

Hawthorne, whom we quoted earlier, would have been astounded by this profusion of metals and machines or by the equally forgelike atmosphere of Calder's workshops, with their forests of mobile and static form (page 164). "The studio of a sculptor," Nathaniel Hawthorne observed in *The Marble Faun*, "is generally but a rough and dreary-looking place. . . . Bare floors of brick or plank, and plastered walls; an old chair or two, or perhaps only a block of marble . . . to sit down upon; some hastily scrawled sketches of nude figures on the whitewash of the wall." Though far from the teeming

"We all have our tricks," De Kooning has said of artists, and these well-filled tables in his Putney, Vermont, studio suggest that Jim Dine is no exception. Despite the comparative complexity of his techniques, Dine travels frequently and, like his friend David Hockney, is able to set up a studio wherever he feels like working.

A pristine space for pristine painting, Barnett Newman's studio on Wall Street, New York, appears in this photograph of 1954 as the luminous matrix of his art. Newman, who preferred working downtown, subsequently occupied studios on Front and White streets.

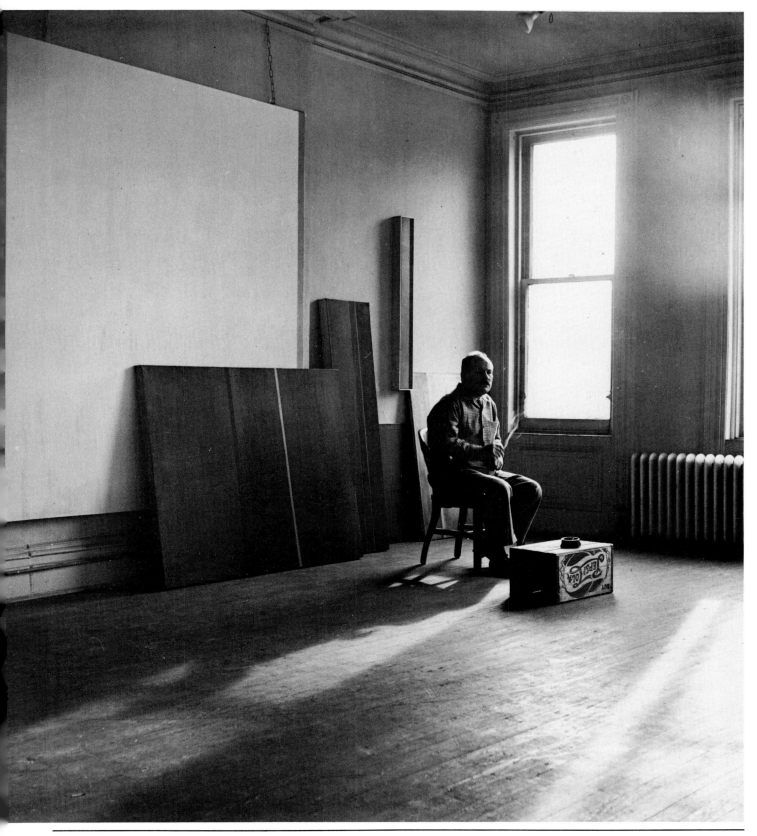

worlds of Smith and Calder, this description closely evokes the desolate air of the places where the New York School's most illustrious survivor, Willem de Kooning, began working. The material difficulties that dogged De Kooning for many years are sufficiently well known to have merged into the broad romantic myth of the artist struggling to establish a new vision amid poverty and neglect. The hardships were nonetheless real, and De Kooning's gift for survival may well be related to his taste, while at work, for unfavorable odds, setbacks, and repeated risks — "because," as he says, "when I'm falling, I'm doing all right; when I'm slipping, I say, hey, this is interesting. It's when I'm standing straight that bothers me. . . ."

This instinct at least made him one of the first artists to realize that former button or toy or hat factories in downtown Manhattan could provide large, cheap working spaces. Once inside, all the indigent artist had to do was to remove partitions and slap on a lot of white paint, thus creating (to quote De Kooning's biographer Thomas Hess) "a room as serene as the nave of a Cistercian chapel." So the "artist's loft" was born, furtively enough, since such spaces were limited by law to commercial use only and required careful vetting of any unexpected knocks at the door, as well as a bed that could be folded instantly out of sight. De Kooning's loft on Tenth Street had nothing "homely" about it; apart from a small gallery, a circular table, and a few chairs, the whole area was given over to work. A glass table top served as a palette, and the walls were easily transformed into easels by tacking the canvas directly onto them; thus De Kooning could also dispense with stretchers until he felt a painting was complete. Among the shelves stacked with materials, the portfolios of drawings and the paintings in progress, the one vaguely extracurricular note was a bulletin board on which, beside drawings and art-book reproductions, the artist kept sports photos, the odd pinup, letters, and telephone numbers.

Later De Kooning took over the top floor of another building on Broadway, transforming it into a more elegant affair with sanded and waxed floors. New York's crystal light — compared by Matisse after his first glimpse of Manhattan to "the light in the skies of the Italian primitives" — and the unbroken, unfussy spa-

Before moving to a custom-built studio at Springs, Long Island (see page 165), Willem de Kooning worked in the barest of rooms in downtown Manhattan. Requiring an open, uncluttered space yet having little money for rent, he naturally gravitated to the kind of disused commercial premises that later became fashionable as artists' lofts.

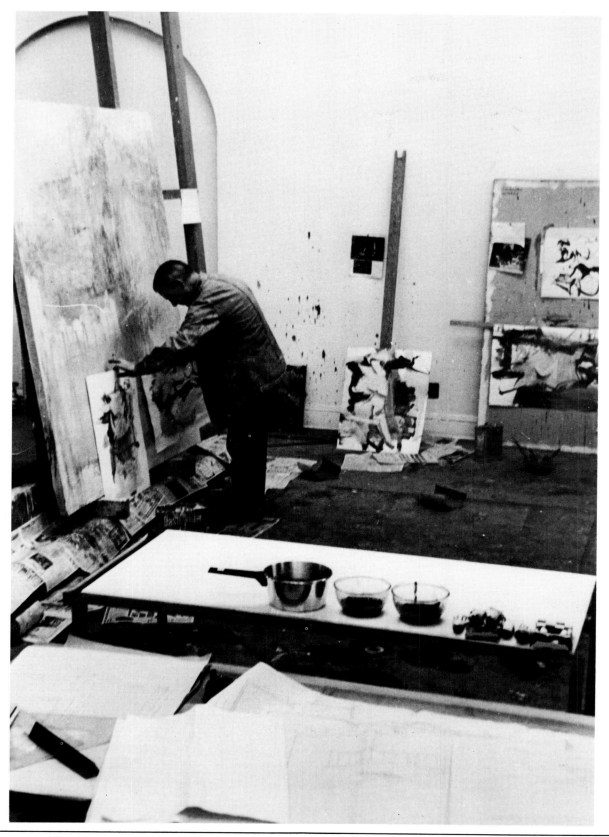

Designed by the artist and the French architect Pierre Chareau, Robert Motherwell's former studio at East Hampton, Long Island, was basically a cunning conversion of U.S. Army surplus Quonset huts. The floor was sunk some four feet below ground for both insulation and aesthetic reasons. Motherwell has since built himself another magnificent studio in Greenwich, Connecticut (see Chapter Ten).

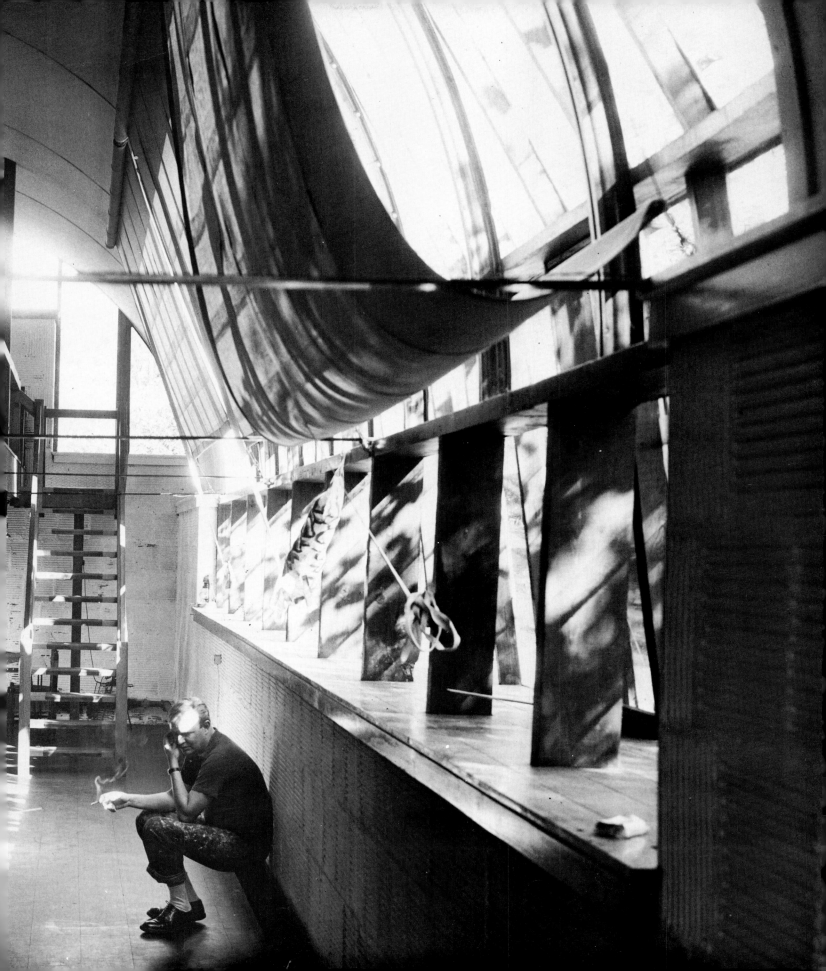

ciousness of the loft helped to free the artist in his search for an expressivity untrammeled by preconceived notions as to what a painting should be. Unlike his friend Mark Rothko, who kept the skylight of his converted carriage house on New York's Upper East Side shrouded with a parachute, De Kooning has always favored direct natural light. The unusual luminosity of Springs on Long Island was one of the factors that decided the artist to build his new studio there (see page 165); and since 1963, De Kooning has been able to paint (and, latterly, to sculpt) in an environment entirely of his own choosing. Throughout that time, his preoccupation with questions of pure technique has continued to be as intense as ever. "We all have our tricks," he remarked a few years ago; but his own "tricks" possess a near-medieval complexity. To his oil paint, for instance, De Kooning has at one time or another added kerosene, safflower oil, and even mayonnaise — less to taste than to achieve a particular consistency. Another account of his experiments, worthy of Cennino Cennini, mentions generous dashes of turpentine, stand oil, and dammar varnish. Housepainter's brushes came naturally to this resilient iconoclast at a time when such a choice seemed an act of deliberate derision. But the iconoclasm was seconded by a painstaking application that leads De Kooning to rework certain passages of his canvas over and over again to achieve the greatest illusion of "spontaneity" possible.

As with the chicken and the egg, it would be hard to say which came first: a typically "American" painting and sculpture, or a typically "American" studio. The truth is, no doubt, that they have always been inseparable, the one shaping and defining the other. And the loft type of studio, with its unpretentious, unvarnished appearance and its emphasis on a freer, more artisanlike approach to the task in hand, was created in the image of the new American artists' needs. Since then, it has been adopted, with its fresh set of attitudes and techniques, all over the world. It now constitutes the contemporary studio par excellence, and its basic formula is sufficiently flexible to allow of any number of future variations. But however representative and protean, the loft remains — as we shall see in the final chapter — only one of a range of artists' studios as astonishingly diverse as the spectrum of contemporary art itself.

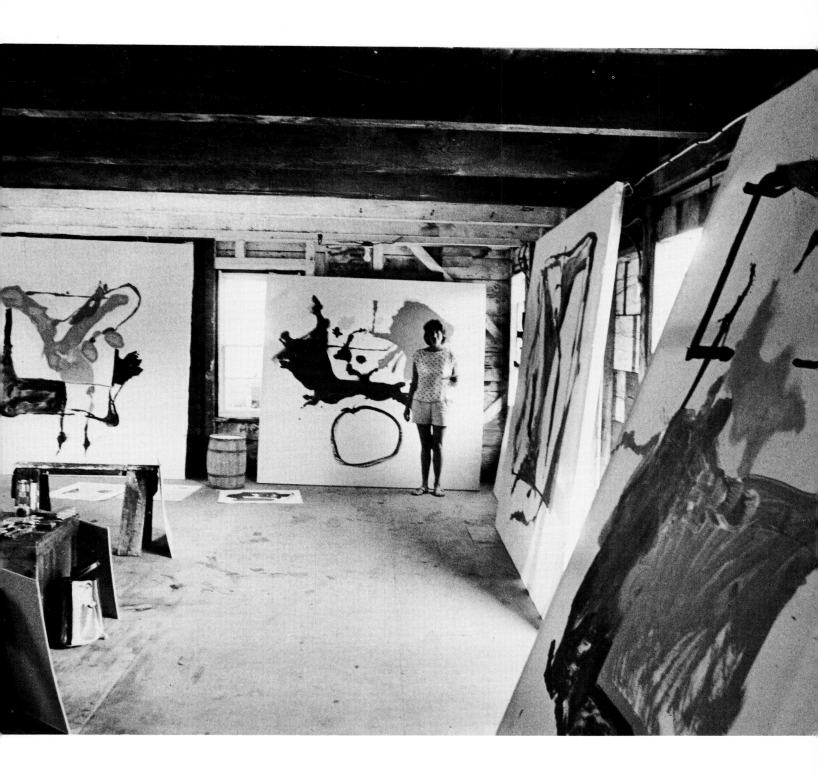

Helen Frankenthaler's own paintings create the essential atmosphere in the studio she occupied in Provincetown, Massachusetts, long a favorite summer haunt of American artists. Her atelier in New York City must rank as one of the most enviable on any continent: situated on the Upper East Side, it consists of one thousand square feet of converted stables that are well lit and within walking distance of her home.

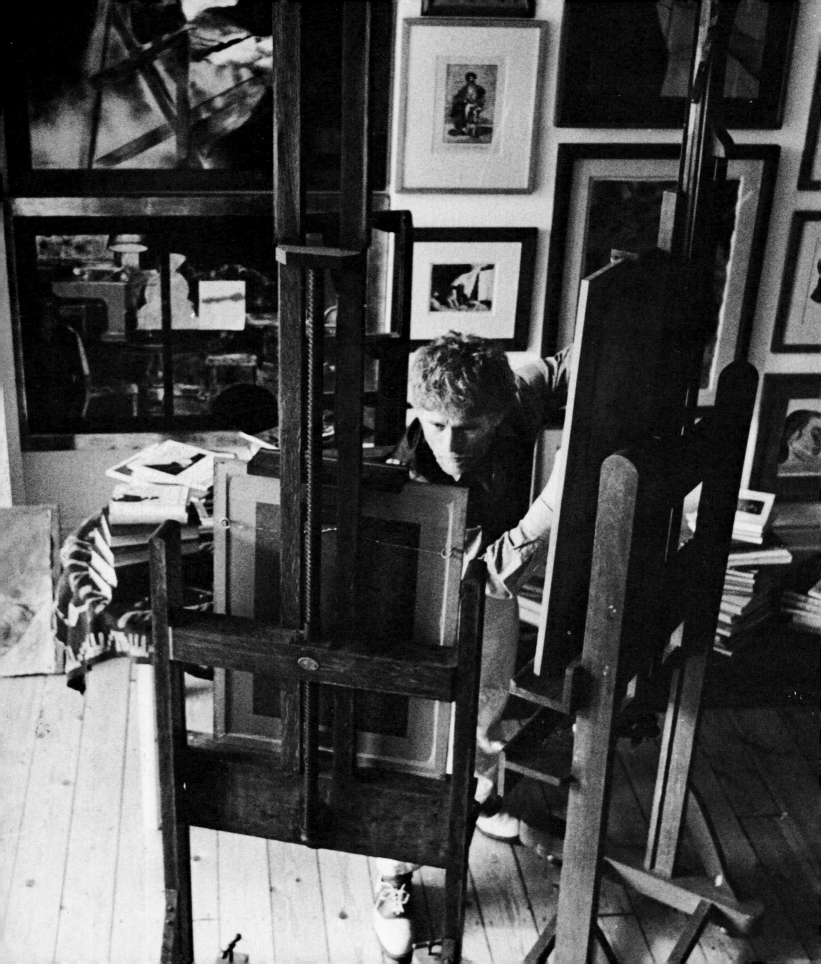

The Contemporary Spectrum

Studios of all the periods discussed in previous chapters have revealed certain features in common. Renaissance workshops shared not only a similar range of theme and formula, but also the vital hierarchy of master, assistants, and apprentices. The studio style established by the academic artists of the nineteenth century flourished in every major city from Vienna to Boston, to say nothing of the wilds of Fontainebleau and the Hudson River. Even the small rooms where most early twentieth-century art was invented resemble each other both in shabbiness and in their occupants' refusal of the contents, techniques, and materials of the traditional European atelier.

A glance at the leading studios of the last quarter-century, however, discloses far fewer links — in fact, frequently no links whatsoever. Contemporary studios appear to have nothing in common but their diversity. What is there, for instance, to connect Pollock's paint-whipped barn to the orderly, book-filled calm of the studio of another American, R. B. Kitaj, in London? Can one imagine worlds farther apart than those of a minimalist or conceptual artist and a photo-realist? How can Christo and Lichtenstein (page 167), Arakawa and Botero be brought under one roof when in subject matter, method, and equipment each of them forms a separate species?

Given this extraordinary range of activity, one is not surprised to find contemporary artists at work in every imaginable kind of space. Abandoned bakeries, bank-rupted printing shops, and restructured warehouses have by now become almost commonplace as studios; where artisans move out, one may confidently expect artists to move in. Deconsecrated churches and chapels have also been in vogue for some time. Similarly, studios in converted cars, riverside barges, or even zoos (for the odd modern *animalier*) seldom arouse more than an amused interest, for one has come to accept, indeed expect, that artists will find the most unlikely or outlandish places to their taste. What is surprising, perhaps, is that alongside these spectacular loftlike ateliers the more time-hallowed types of studio continue to exist. The "society favorite" type is still going strong wherever academic traditions survive, which is to say in all western cities of any historical consequence. Society portraitists and tradition-bound landscapists not only exist, after all, but exhibit and even thrive; and in some cases their studios are perfect heirlooms of the late nineteenth century. Between such fascinating antiques and the emphatically modern loft one also finds a host of highly private, anonymous rooms of the kind Delacroix haunted before he was sufficiently well established to build his own, secluded atelier. Some of these rooms, these secret universes of dream, are kept so closed that (as with Chardin, over two centuries ago) no one ever sees the hermitlike inhabitant at work. Less retiring artists, of course, are equally numerous, and many of them vie with one another to make themselves — their temperaments, their work, their studios — as conspicuous as possible. The *pompier* practice of having oneself photographed amid the paraphernalia of one's art has become

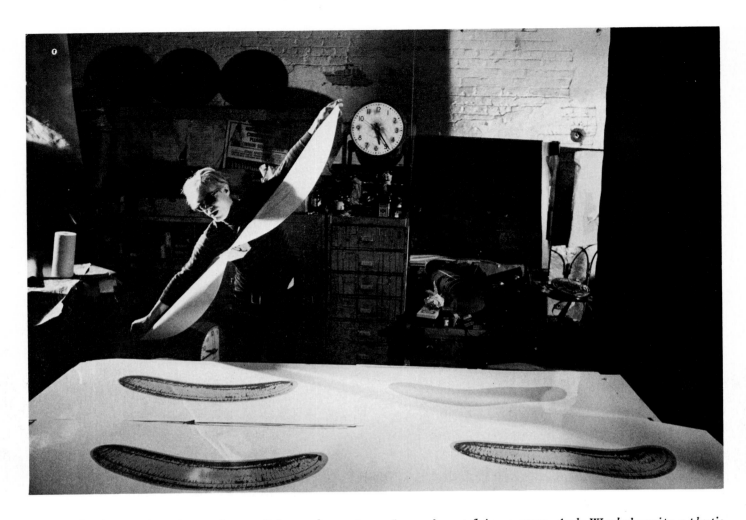

(as this book shows) an integral part of the modern artist's methods of getting himself known. Picasso's studio antics, for example, became familiar to thousands who knew nothing of his art, just as Dali has gained his widest audience as a sort of inspired clown.

The two attitudes — extreme secrecy and complete acceptance, not to say courtship, of publicity — have always existed side by side. While Géricault could not bear a whisper while he worked and Delacroix barred his door, Courbet used his studio as a platform for launching new artistic and social ideas. With a similar flair for attracting attention, but a rather different outlook, Andy Warhol made his Factory on East Forty-Seventh Street in New York the focal point of a generation; an area where not only a new art, but a style, another approach to life, was being fashioned. Whichever the attitude, it has a dominant influence on the kind of studio the artist chooses. Alberto Giacometti did not move

In an elegant flying gesture, Andy Warhol unzips a plastic banana before transferring it to his work in progress. Warhol's "Factory" studio on East Forty-seventh Street in New York became a focal point for an entire generation, not only for the art it produced but for a whole style and attitude toward life.

out of his crumbling little tenement behind Montparnasse even when he had the means to buy a large luxurious atelier. The poky, dust-laden studio had become his shell, his second self, where the memory of so many previous attempts to fix the elusive human image helped the artist to continue his despairing quest. In time this room assumed a special significance not only as the source of all his work, but as a Giacometti itself, an enclosed concentrate of the artist's vision. When the building was demolished, the studio walls — covered with sketches, scribbles, and odd notes — were expertly preserved, and now, when they are exhibited (for instance, at the Fondation Maeght, in the South of France), they conjure up Giacometti's presence with uncanny power.

The reclusive attitude is shared by two other major artists of the same generation, Balthus and Francis Bacon. Patrician and resolutely inclined to privacy, Balthus

International success did not induce Alberto Giacometti to leave the small gray room behind Montparnasse where, since 1927, he had pursued his obsessive vision of the human figure. After his death in 1966, the studio walls — with all the sketches and notes he had made on them — were removed from the building and put on exhibition.

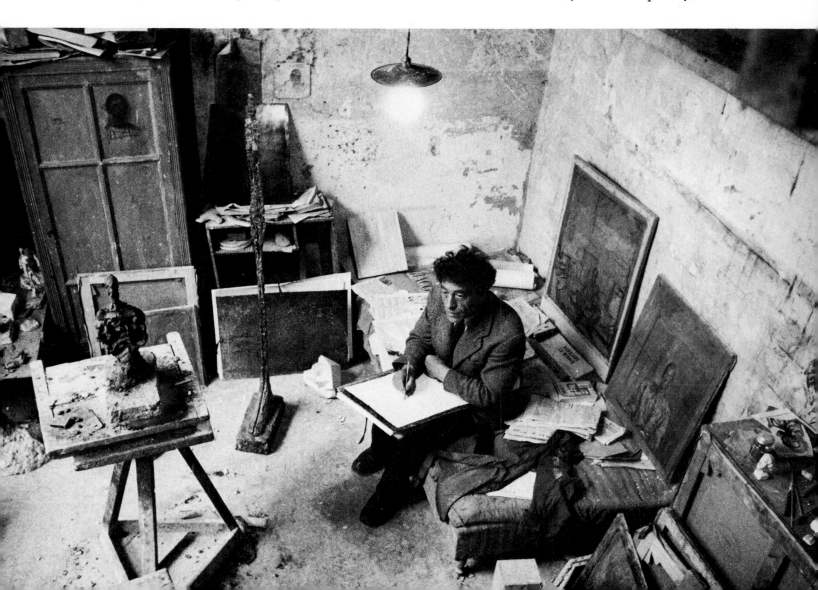

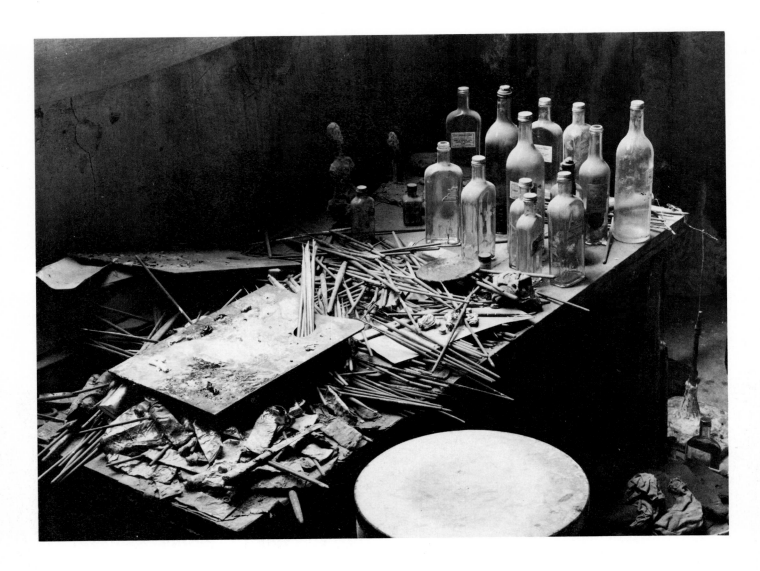

However dilapidated, every corner of Giacometti's dusty little atelier proved unusually photogenic. The room's fascination derived not so much from picturesque disorder but from the aura of the powerful and haunting images that had been whittled into existence there.

has long favored castles as the most propitious settings for his studio (though, as a young man, he had to borrow Derain's atelier to paint his large *Mountain*). The castles have tended to be more severe than comfortable, and Balthus' working rooms — first at the Château de Chassy, south of Paris, then at the Villa Medici (where he was long director of the French Academy) in Rome — had a nobly desolate air against which the beauty of his paintings became particularly potent. From the suave, brightly colored backgrounds to Bacon's pictures, one might expect the artist's London studio to have something of the same tense, immaculate spaciousness. On the contrary, though not as impoverished-looking as Giacometti's, the English painter's atelier is small and spectacularly chaotic: the floor lies ankle-deep in books,

photos, rags, and other paint-splashed, eye-catching rubble, while the walls have been so thoroughly daubed with trial brush strokes that they resemble giant palettes. Another London-based painter, Frank Auerbach, has a studio that, like Bacon's, is remarkable for sheer omnipresence of paint (both studios could be regarded as three-dimensional action paintings of the most unconscious and revealing kind). Auerbach's paint-encrusted room, situated in the area that he has repeatedly made the subject of his canvases (Camden Town), remains a reliable and eloquent witness of his attitudes and working methods. His gestures are recorded on it like a palimpsest, and they lead back to the basic theme of Auerbach's art, which is the inexhaustibly ambiguous, evocative power of oil paint.

Concentration of artistic activity in a single room — whether it be Giacometti's or Bacon's or Auerbach's — turns that particular space over the years into such a

An eloquent disorder of paint, tools, and pictures characterizes the London studio of Francis Bacon. Tucked away in a South Kensington mews, it is as private a room as Giacometti's and as dedicated to trapping the mystery of the human image. Reproductions of the artist's own paintings on the wall indicate the extent to which, having absorbed all kinds of visual phenomena, Bacon's art now feeds off itself.

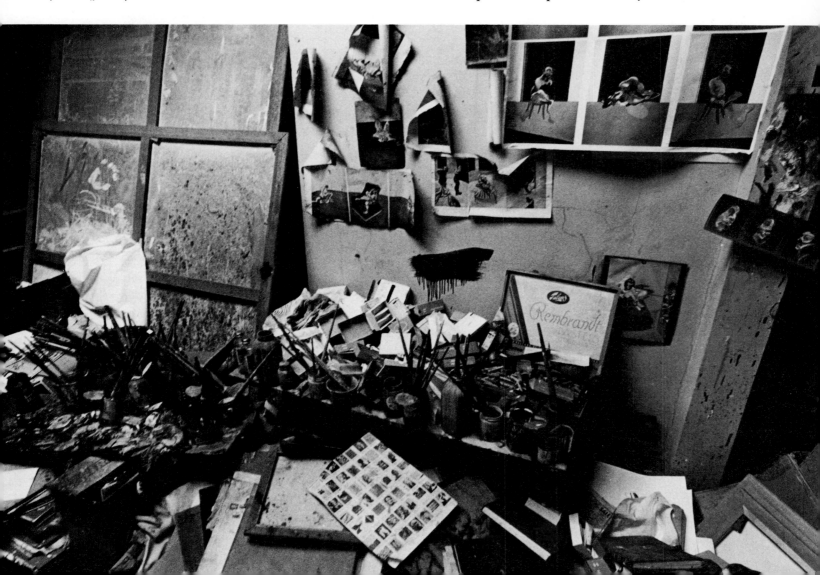

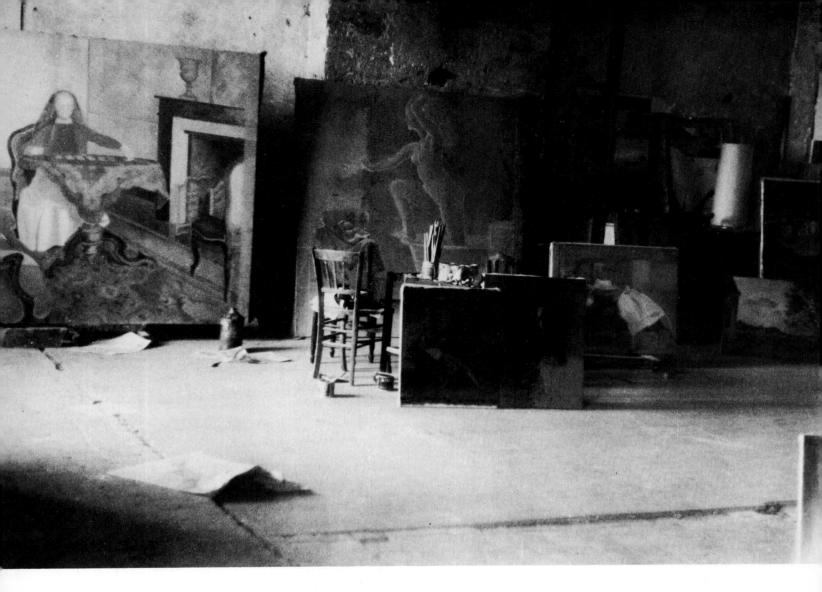

unique matrix that certain painters and sculptors feel that they could not work successfully anywhere else. Artists who are thus rooted to a single place of work have frequently expressed their envy of writers, who may settle in cafés or parks or trains and continue the book or poem they are engaged on. But painters of a more flexible temperament (for sculptors, the problems are clearly greater) manage to set up makeshift studios wherever they happen to be. Some artists have even worked for a while in hotel rooms. In New York the most obvious example of an artists' hotel is the Chelsea, which welcomed (among many others) Christo, Arman, and Martial Raysse after they had shaken the dust of Paris off their heels. Paris itself is still extraordinarily rich in small hotels that not only tolerate but actually take pride in the itinerant artists at work within their

Though as uncompromising a space as Bacon's or Giacometti's, Balthus' studios have tended to be in grander circumstances. For many years the French painter worked in the Château de Chassy in Burgundy, where this photograph was taken in 1956. Well to the fore here is Balthus' favorite theme: adolescent girls in various states of self-absorption or reverie.

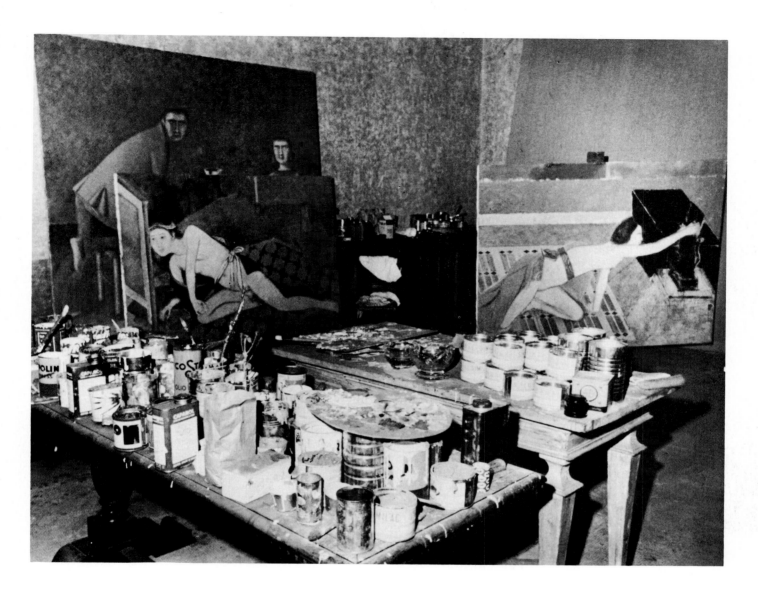

Long director of the French Academy at Rome, Balthus, like Ingres before him, did not let the pressures of his prestigious post prevent him from painting. In this 1972 photograph of his studio at the Villa Medici, one can see two of the most famous of his slowly evolved canvases to have been completed in recent years.

walls. One likes to think that New York's elegant Carlyle Hotel was equally enthusiastic when Jim Dine left his country studio during the winter to work in its more urbane surroundings. Dine's seasonal migration puts one in mind of Monet's stay at the Savoy: with characteristic determination and adaptability, the French artist worked as well in his river suite as in the more familiar surroundings of his house at Giverny.

An outstanding instance of how mobile the contemporary artist can be is David Hockney, who changes continents so frequently that he appears at times to be working in several places at once. London, Paris, New York City and Los Angeles are all home to him. Hopping from country to country would put most artists out of

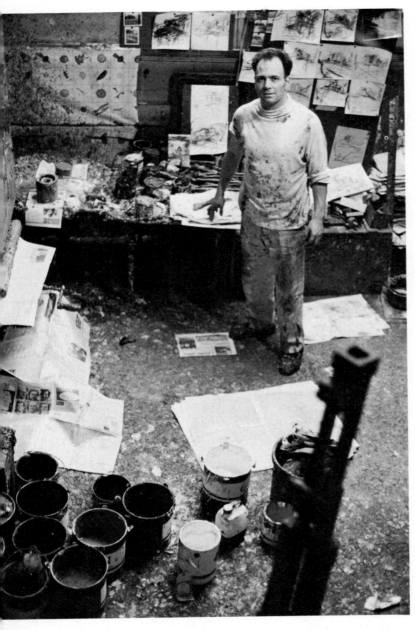

A multicolored crust spreads across the floor, up the walls and onto the artist himself in Frank Auerbach's London studio, shown here in 1974. The total physical involvement in paint reflects the style, the thick swirls of impasto, which Auerbach has practiced in this room for years.

action, but Hockney has an enviable capacity for being able to get down to work in almost any circumstance. Even when he has established himself in a permanent studio (page 168), he continues to find little difficulty in concentrating on whatever project is under way while visitors and friends mill around, chat, or use the telephone.

These friends, however, provide the artist with what has become a relative rarity in the contemporary studio: models. Most of Hockney's portraits are of people he knows well. Some of them have posed for him just as professional models or society people posed for artists throughout the nineteenth century; others have simply been on hand — reading, eating, sleeping — over longish periods of time. Giacometti had both his wife, Annette, and his brother, Diego, to hand whenever he felt the need of a model to work from; and many friends and admirers, from Eluard and Stravinsky to Sartre and Genet, sat to him. Bacon's portraits also represent close friends, but he prefers to work from photographs rather than be "inhibited" (as he puts it) by their live presence in the studio. Kitaj has taken quite recently to drawing from professional models who come in to pose for him on a regular basis. Sculptors like George Segal and Edward Kienholz obviously could not do without the models from whom they take their casts: theirs is the most "literal" use of models in the history of the studio. Since Picasso painted the ponytailed Sylvette, little interest has been aroused by what, for previous generations, was a source of keenest curiosity: the artist's relations with his model. Nevertheless, there are sure signs that models are regaining some of their former importance as an essential feature of the artist's studio. Even today, there are painters who (like Matisse) despair when their model becomes pregnant, as well as others — to take an example of the wide variety of inanimate "models" — who still build up an arrangement of fruit with the manic care of a Cézanne.

The workshop system of a master seconded by highly trained assistants finds an occasional echo in contemporary studios, particularly in those of sculptors. From its conception to its erection on a chosen site, a sculpture by Henry Moore, for instance, requires many skilled hands. Several full-time assistants work with Moore on his estate at Much Hadham in Hertfordshire, where he

has set up no fewer than nine studios. These range from a maquette studio, in which the original small plaster models are made (page 166), through carving, engraving, and drawing ateliers to a space specially created for polishing and photographing finished works. With its enormous activity dependent on close teamwork, the Moore studios recall a prosperous Renaissance *bottega* where the pressure of many large-scale commissions demands not only the highest level of technical skill but also a marked capacity for organization (which, since the Romantics, has rarely been reckoned among a good artist's attributes). Other artists who work on a monumental scale — Christo provides a striking example — have the same vital need as Moore for skilled assistance and clear-sighted administration.

The huge scale on which many contemporary works of art have been conceived has necessitated a correspondingly huge working space. The converse is also no doubt true, since it seems reasonable to believe that the lofts that Gorky, Pollock, and De Kooning used had a definite bearing on the size their paintings eventually assumed. At all events, American artists have certainly never looked back since. When Robert Motherwell came to paint his *Reconciliation Elegy* in 1978, for instance, he and his two assistants needed all the space of his huge workroom in Greenwich, Connecticut: the canvas, commissioned by the National Gallery of Art, measured twelve meters long by three meters sixty high. Today, artists are so accustomed to the idea of needing large studios that they flock as if by instinct to those parts of town which lend themselves to carving out lofts. The best-known example of an urban transformation of this kind is, of course, the SoHo area in New York, where innumerable premises that once served to make hats or celluloid dolls or optical instruments now exist as studios so spacious and seductive that the actual artistic work done there at times seems a mere by-product of the beautiful interior. In the 1950s and early 1960s, well before SoHo had become the rage, a hardy community of artists (including Ellsworth Kelly, Robert Indiana, Agnes Martin, and James Rosenquist) set up house on Coenties Slip, in what was formerly a thriving waterfront section on the southern tip of Manhattan, while a stone's throw away, on Pearl and Front streets, Barnett Newman, Robert Rauschenberg, and Jasper Johns were

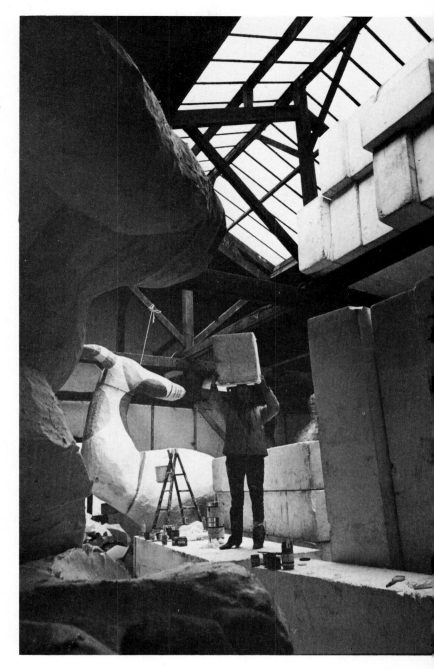

Making light of a future chunk of sculpture, Niki de Saint-Phalle is seen beside the monumental piece entitled Paradis Fantastique, *which she made with Swiss sculptor Jean Tinguely. The two artists worked in a Paris film studio, since their own studios proved too small. Niki de Saint-Phalle's own studio could hardly be called cramped, however, since it occupies the dining room of a converted inn outside Paris.*

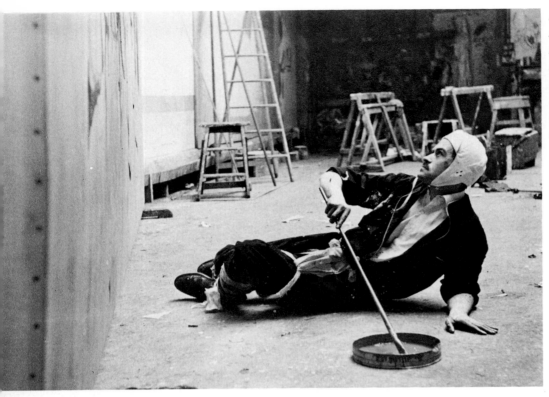

An exuberant champion of "lyrical abstraction" in France, Georges Mathieu has also had a considerable talent for attracting attention. His well-publicized eccentricities have in no way hindered his career, since he has been the recipient of numerous awards and many official commissions.

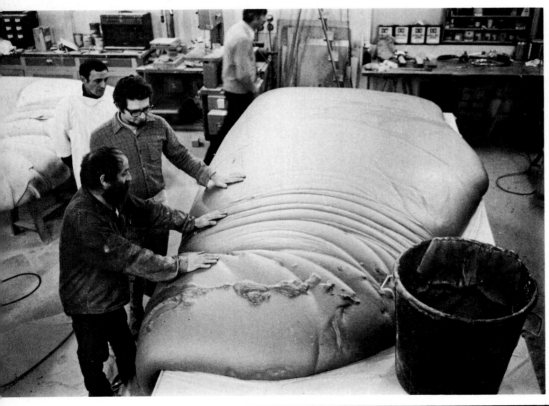

Ashcans became an essential part of the French sculptor César's equipment when he was pouring his "expansions." Deceptively simple-looking, these smooth polyurethane sculptures required expert assistance and the overall organization of a well-run workshop.

THE CONTEMPORARY SPECTRUM

pacing their respective lofts. Although such large, rough-and-ready ateliers are a more recent phenomenon in Europe, part of the London dockland has provided ideal working space for artists, while in Paris the furniture-making district east of the Bastille and the working-class Buttes-Chaumont area to the north have witnessed a steady influx of painters and sculptors over the last decade. This new dream of maximum space has become all the easier to accommodate now that natural light is no longer an absolute prerequisite, and many artists work in windowless warehouses or dim shops, regardless of the time of day.

However diverse the shapes and former functions of contemporary studios may be, the techniques invented or practiced within them are more varied still. The present-day range of tools and materials in fact bears almost no relation to what artists had at their disposal fifty years ago (a short enough period in terms of art history). To see this, one has only to compare the studios of two men born within a generation of each other, Henri Matisse and Jackson Pollock. Matisse's studios in Nice were in many ways the epitome of tradition. Even though he had revolutionized the very basis of painting by making color his overriding preoccupation (and for this Pollock was of course directly in his debt), the French artist rigorously upheld many venerable studio practices. His devotion to the model, to nature, to a harmony achieved through tireless application made him in many ways the most classical, certainly the most Apollonian, artist of the century. Pollock, with his Dionysiac frenzy, was at the opposite end of the scale. There were no models at the rough barn in East Hampton, no patient preparation through drawing, no finely preestablished palette or subtle reworking. There was not even an easel, and as for Pollock's gallons of household paint, his strange sticks and clogged brushes — to say nothing of his whirling-dervish, paint-dripping dance — they were foreign to the métier of "artiste peintre" as the French master understood it. The differences separating the two men appear as profound as those that separated Matisse from the eighteenth century.

But those differences exist in the same measure today even between contemporaries. To bring them into some kind of focus, one might imagine the problems that would bedevil the compilation of a manual of current

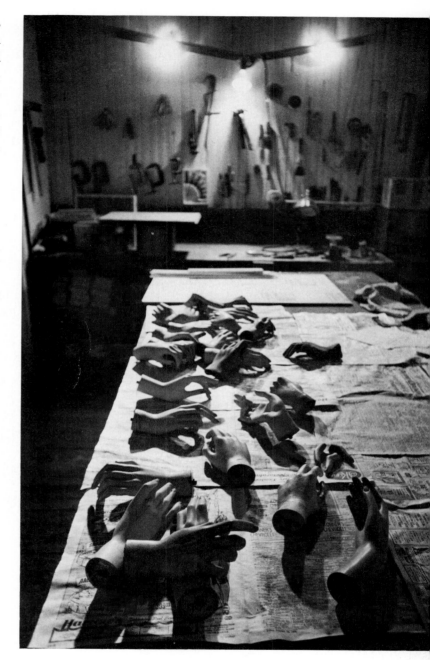

Many single hands went into the sculpture Arman later called Cold Petting. *Long a resident of New York, the French-born sculptor was obliged to move from his Spring Street studio (photographed here) because the noxious fumes of welded plastics began to affect the building's other inhabitants. Arman is now on Canal Street.*

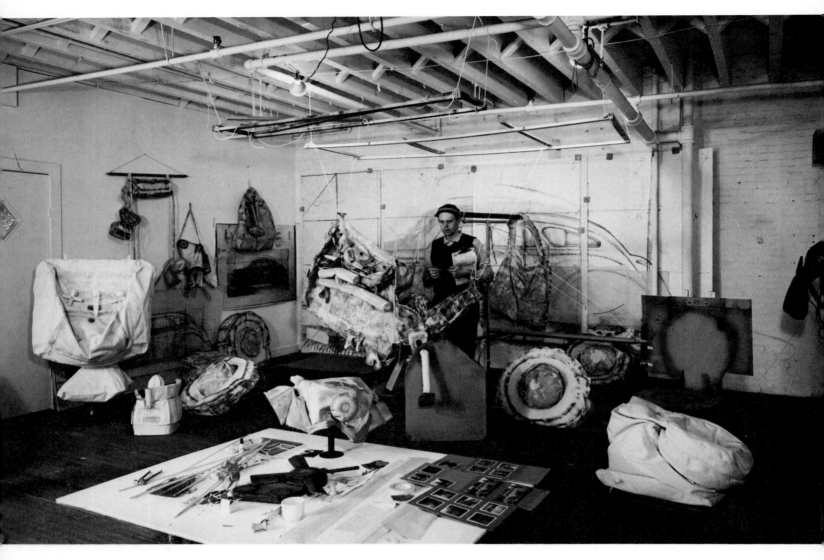

artistic techniques. How could one catalogue the constant proliferation of ways and means that has characterized the past two decades? How many volumes would one need to describe the methods and materials used in activities as far apart as happenings and holographs, earthworks and body art? The only common denominator to be found, no doubt, would be the belief — not much more than a century old — that each artist may invent his own technique. So much so, in fact, that it is frequently more to the point to ask contemporary artists not *what* they paint or sculpt but *how*.

The story of how a large, contemporary work comes into being is thus more enlightening than most subsequent commentary on its aesthetic merits. Robert Motherwell's *Reconciliation Elegy* can be viewed purely as a

A boyish-looking Oldenburg surveys an array of works finished and others in the making in his New York loft in 1966. Oldenburg's stunts have included opening a studio-store in the early 1960s on East Second Street in New York where passersby could walk in and purchase a variety of stock items ranging in price from $49.95 to $499.50.

technical feat. How does one go about a work of this size? Where can a piece of canvas twelve meters by three meters sixty be found? Is the execution of so mammoth an image entirely preplanned, or does it allow of some spontaneity? If one goes behind the scenes, one discovers that a canvas that large has to be woven to measure, that it was first given three coats of gesso by Motherwell's assistants, and that the painting began life as a small sketch, which was then enlarged photographically and transferred, fresco-style, by pinpricking the main outlines onto the prepared canvas. Special long-handled brushes, up to one meter twenty in length, were made for the artist, while large quantities of black acrylic were kept on hand and mixed with water for greater fluidity. The *Elegy*'s preparatory phase required

Roy Lichtenstein, Artist's Studio — "The Dance," *1974, Private Collection. Wine, flowers, Matisse, and music — everything seems fine in the artist's studio, if one did not sense Lichtenstein's very personal irony undercutting all. In a comic-book world, the studio would be just such an insouciant, lyrical place; in reality, as the artist well knows, things are more problematical.*

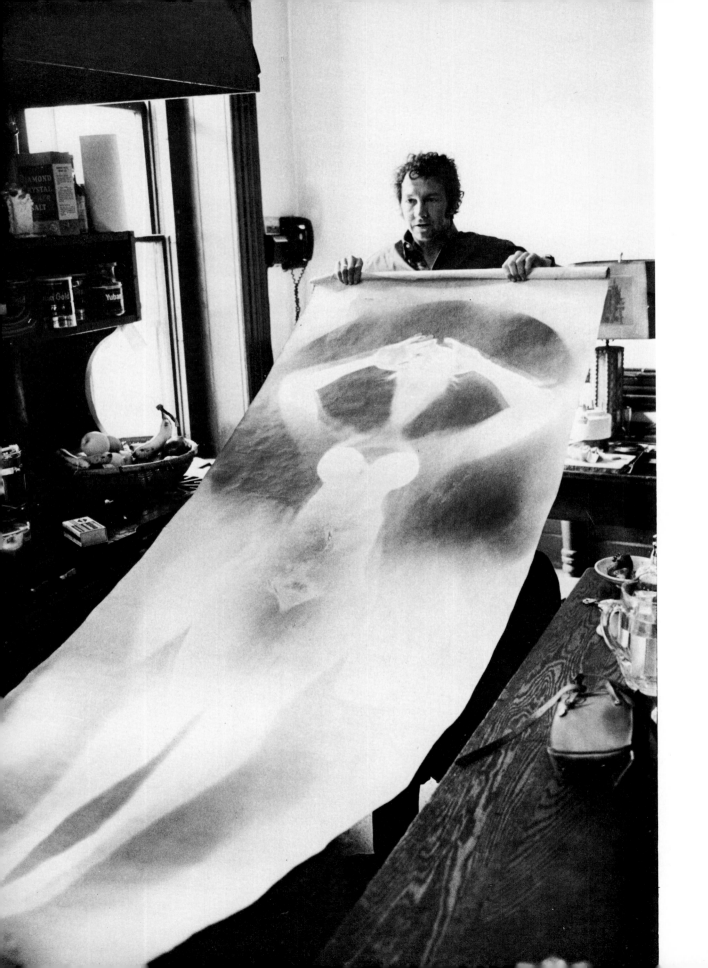

The plain volume and unfussy, workmanlike atmosphere of New York's lofts have played an essential role in the development of contemporary art. As one of the pioneers of loft-living, Robert Rauschenberg is used to working in any space; and if he finds the kitchen the best area for developing a new technique, that's all right too.

the expert assistance of several specialists and lasted for many months. When everything was ready, Motherwell asked his assistants to leave him alone with his "white whale" (as he called the gigantic empty canvas) and finished the painting itself within a fortnight.

Another artist might have carried out the same commission without using any of the materials or methods that Motherwell chose. The extreme elasticity of such a situation, in which no specific rules or criteria remain, is at the farthest imaginable remove from the way in which every detail of artistic production was regulated under the guild system. (One may reasonably argue that artists have always invented their own "recipes"; but their tools, materials, and subject matter changed comparatively little for centuries.) At present, for instance, an artist may perform a technical volte-face overnight without causing a tremor of indignation or surprise. Joan Miró may exercise his fantasy through the medium of rope, or César fashion a series of heads in bread; and this now seems perfectly natural. Indeed, of some artists one has come to expect curious materials and unusual techniques. Hat blocks, balustrades, lavatory seats, and baseball bats have long been grist to Louise Nevelson's mill, to the extent that they are collected, painted black, and stored in the artist's New York studio before their sculptural role has been determined. Although extremely "painterly," the Italian artist Alberto Burri's compositions derive their major dramatic effect from charred wood and torn fabric. Rauschenberg might seem to have taken the inclusion of "nonartistic" material to its furthest limits when he stuck a real quilt and pillow on his *Bed* painting of 1955; but since then virtually every substance under the sun, including much detritus, has flowed into the artist's studio and there, as in a mad scientist's lab, been transformed into one of the myriad forms of art.

The overall impression of bewildering diversity in the contemporary studio is further increased by the fact that many artists work in a number of different media. Miró's brief foray into rope has been mentioned, but there is hardly one form — whether printmaking, ceramics, sculpture, book illustration, tapestry, or stained glass — to which he has not turned his hand. Such protean activity does not lack precedents: Degas, Matisse, and Picasso, for instance, were all masters of several media.

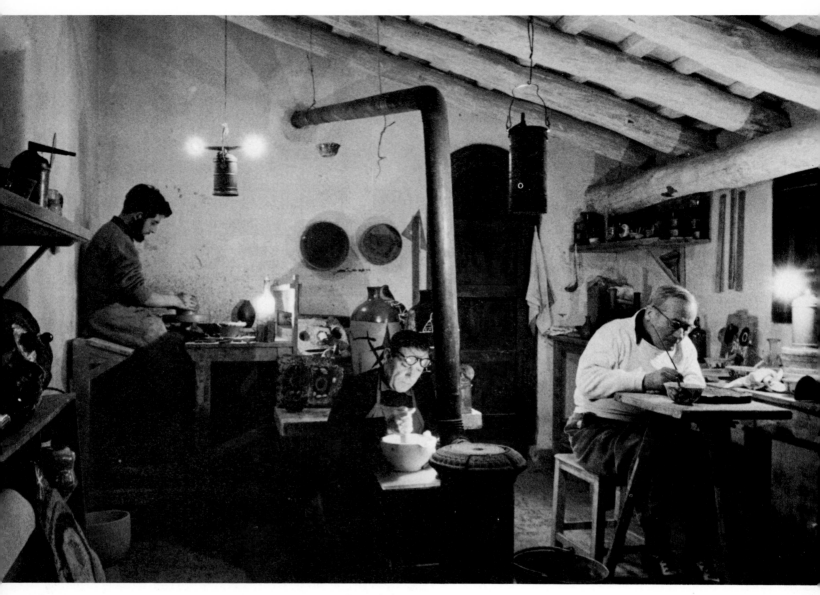

From tapestry to stained glass, book-illustration to ceramics, there is hardly a technique that Joan Miró has not practiced in his long career. Here he decorates a new piece of pottery in the studious calm of the workshop — a veritable bottega *— of the Spanish master ceramicist, Artigas.*

Like a director sitting among his actors on stage, George Segal seems to be waiting for the play he has rehearsed to begin. The sculptor's extensive working-space allows him to create in every format, from anatomical fragments of various figures to full-scale environments that give off ghostly echoes of contemporary life.

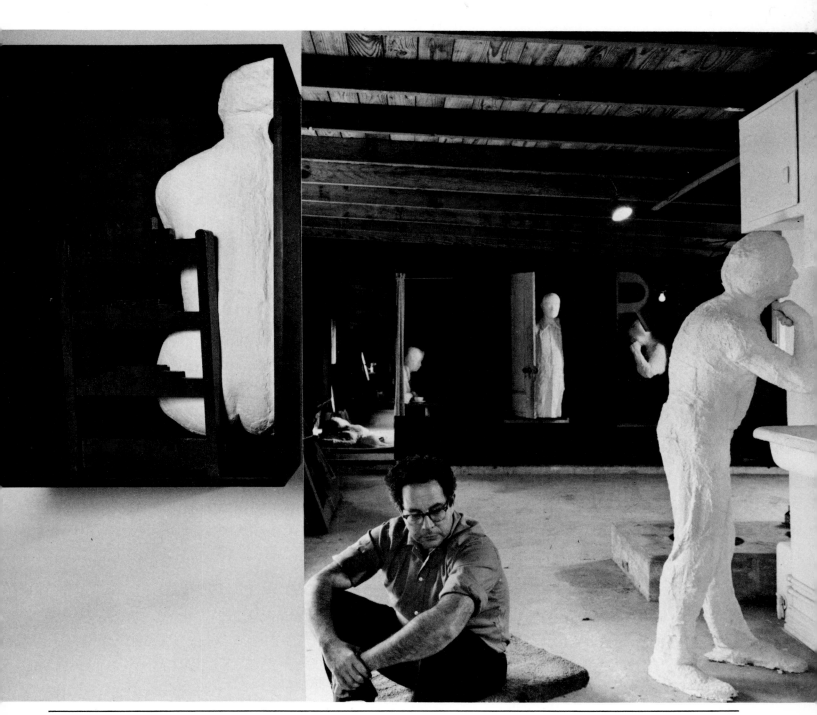

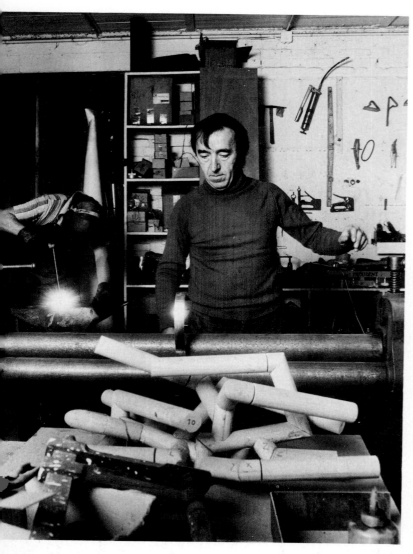

Belgian-born sculptor Pol Bury lives between Montparnasse and the country west of Paris, where he has set up an atelier large enough for his monumental pieces. With the maquette for a tentacular, mobile fountain before him, Bury rolls a strip of steel while his full-time assistant welds another component part on the studio anvil.

But it has become increasingly commonplace nowadays for an artist to produce abundant graphic work of various kinds and, like David Hockney, design stage sets as well as make films, take photographs, or sculpt. In recent years Fernando Botero, for example, has divided his time between painting and sculpture. The ground floor of his Paris studio (a secluded building in Saint-Germain-des-Prés, which once housed the famous Académie Julian art school) is given over entirely to sculpture, while a plain, almost severe room on the floor above serves for painting. Botero is that comparative rarity among contemporaries, a lifelong student of the painting methods of the old masters, and his own compositions are built up, by means of layers or glazes, until the overall chromatic harmony he requires has been achieved.

If there are as many techniques as there are artists, the same utter diversity is true of the contents of their studios. Books once formed a staple of studio equipment, and a basic knowledge of mythological and Biblical lore was fundamental to all artists from the Middle Ages on. Artists might remain in the popular imagination as creatures of strong passion and few words, yet some of them have been among the most literate, not to say the most learned, of their generation. Leonardo, Rubens, and Delacroix could talk or write fluently on any subject. The letters of the nineteenth-century artists remain proof of the breadth of their interests and their practiced ease with words. Literature continued to be a living force in all the early artistic movements of this century, partly because writers were frequently their most discerning and eloquent champions. This fruitful alliance between artists and writers still exists, but in an altogether minor way when compared to the brief golden age of Baudelaire to Fénéon and Apollinaire. The place of books in the studio has shrunk correspondingly; and now, where artists of the past might have had both a specialist and a general library, there is often only a small heap of magazines. Some contemporaries, however, do derive not only general enjoyment but specific stimulus from books. Balthus, for instance, was inspired by *Wuthering Heights* to make a series of drawings, and the emotional climate of the novel long remained important to his work. Bacon, an avid reader of classical drama and modern poetry, often mentions his indebted-

ness to what he calls the "atmosphere" of Greek tragedy and early T. S. Eliot. Books loom very large in the handsome London studio of R. B. Kitaj, who is unusual not only in that much of his work is sparked off by what he reads but also in the way he conceives of his figures as "characters" whose identity may develop, as in the chapters of a novel, from picture to picture.

Numerous contemporaries have illustrated literary works — one thinks of Jasper Johns' engravings for Beckett's *Fizzles* for example, or Hockney's color etchings for *The Blue Guitar* by Wallace Stevens. But artists with a distinct literary interest have undoubtedly dwindled in number, and the place that books once occupied in the studio is now taken by purely visual material: works of art, reproductions, and, above all, photographs. Photography did not kill art, as many nineteenth-century observers believed it would, but it has held art in a race for originality ever since its invention. Photographs owe their prime place in the contemporary studio to the way they not only offer new visual possibilities for the artist to explore but also stimulate him to absorb and surpass their effects. It would be superfluous to describe in detail photography's dominant role in the studios of the hyperrealist painters, who, in a spirit akin to that of Gérôme or Alma-Tadema, decided that if one could not outstrip the photo it was best to imitate it. On the other hand, a study of the use made of photography by artists as diverse as Warhol and Rauschenberg in America, Richard Hamilton and Michael Andrews in Britain, or Gérard Fromanger in France, for instance, goes to the heart of a great deal of contemporary creativity. So it appears certain that photography and art, far from extinguishing each other, will continue to develop along parallel, mutually stimulating lines. As for the works that artists collect, whether of past masters or contemporaries, their importance has decreased. Most artists collect a little, and some have enviable minor collections, but few, if any, show the passion for acquiring other artists' work that the Impressionists or the Cubists or Matisse had. This is partly because art has become vastly more expensive, and partly, no doubt, because artists today feel less vitally concerned by one another.

The change in studios — in the way artists live, work, and have their imaginative being in them — has been more rapid and radical over the last quarter-century

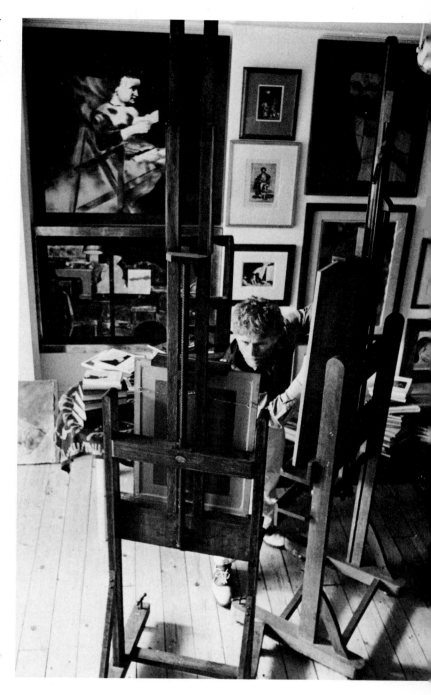

With oils by himself and etchings by Manet at his back, R. B. Kitaj gets down to some concentrated easel work in his handsome studio in Chelsea, London. Few contemporary artists have been as deeply inspired by literature as Kitaj, and wherever there are no pictures on his wall, row after row of books on every subject reaches from floor to ceiling.

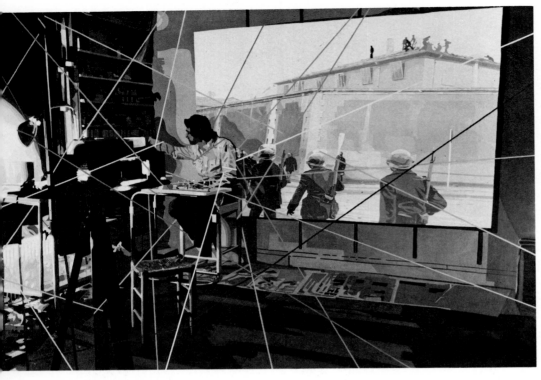

Gérard Fromanger, La Vie d'Artiste, *1975–1977. Ironically titled with a phrase that has specifically romantic overtones in French, this oil painting provides a graphic illustration of the array of new technical devices to be found in contemporary studios. Such new painting techniques as those inspired by slides, projector, and screen necessarily change the very nature of the art produced.*

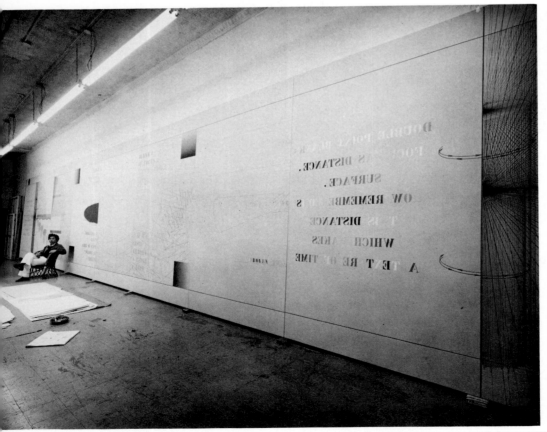

Shusaku Arakawa's loft on Canal Street in New York has become subtly colored by the paintings conceived there. Enigma hovers in the corners of this straightforward, utilitarian space. Even for large empty volumes, one realizes, conceptual art can prove to be catching.

THE CONTEMPORARY SPECTRUM

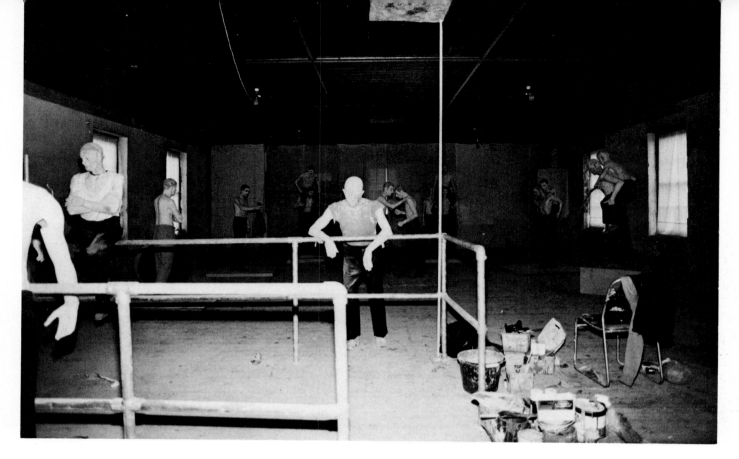

Delacroix dreamed of Michelangelo surrounded by his sculptures suddenly brought to life. The originator of this rather disquieting group, the young British sculptor John Davies, has let his figures completely take over his workshop in Kent. Here, in the most literal sense, the studio becomes an integral part of the work of art.

than at any other period in the history of art. One naturally wonders whether the process of diversification, of more and more studios operating in a markedly individualistic fashion, will continue or whether some new unifying principle will reassemble them around a smaller number of poles. It seems reasonable, after so great an explosion of individualism, to foresee a return to a more generally shared body of aims and techniques. Already, over the past couple of years, the range of "artistic activity" has become rather less bewilderingly vast; certain shams and lunatic fringes have been exposed, and a renewal of interest in traditional, stylistic aims has reconcentrated some of the diffuse energy. Moreover, there is a growing awareness among the youngest artists that a solid (if not academic) grounding in technique is, rather than a hindrance, an invaluable asset to personal expression. It may be that the artist will return to a near-medieval, artisanlike status one day, or at least be judged more on his technical excellence than on his "originality." Whatever the outcome, one may be certain that the studio will undergo an incalculable variety of transformations. Like imagination itself, it cannot cease to change.

Bibliography

Since very few books deal directly with the subject of the artist's studio, we consulted a wide range of publications in the course of gathering material for *Imagination's Chamber*. Only the most useful sources are listed here; they have been divided into three parts to correspond to the three main sections of the book.

GENERAL

Bailey, Anthony. *Rembrandt's House*. London: Dent / Boston: Houghton Mifflin, 1978.

Bataille, Georges. *La Peinture préhistorique*. U.S. ed.: *Lascaux*. Geneva: Skira, 1955.

Baticle, Jeannine, and Georgel, Pierre. *Technique de la peinture: L'Atelier*. Paris: Editions des Musées Nationaux, 1976. Exhibition catalogue.

Blake, K. J., and Sellers, E. *The Elder Pliny's Chapters on the History of Art*. London: Macmillan, 1894.

Blunt, Anthony. *Artistic Theory in Italy 1450–1600*. Oxford: Oxford University Press, 1940 and later eds.

Camesasca, Ettore. *Artisti in bottega*. Milan: Feltrinelli, 1969.

Cennini, Cennino. *Il Libro dell'arte* (*The Craftsman's Handbook*). New York: Dover, 1960.

Constable, W. G. *The Painter's Workshop*. London: Oxford University Press, 1954.

Gallwitz, Klaus, and Koltzsch, Georg-W. *Maler and Modell*. Baden-Baden: Staatliche Kunsthalle, 1969. Exhibition catalogue.

Goldwater, Robert, and Treves, Mario. *Artists on Art*. New York: Pantheon, 1974 / London: John Murray, 1976. 3rd ed.

Hauser, Arnold. *The Social History of Art*. New York: Knopf / London: Routledge & Kegan Paul, 1951 and later eds. 4 vols.

Hautecoeur, Louis. *L'Artiste et son oeuvre*. Paris: Gazette des Beaux-Arts, 1973. 2 vols.

Honour, Hugh. "Canova's Studio Practices," *Burlington Magazine,* March, April 1972.

———. *Neo-Classicism*. Harmondsworth: Penguin, 1977.

Januszczak, Waldemar (ed.). *Techniques of the World's Great Painters*. Oxford: Phaidon, 1980.

Kelly, Francis. *The Studio and the Artist*. Newton Abbot: David & Charles, 1974.

Martindale, Andrew. *The Rise of the Artist in the Middle Ages and Early Renaissance*. London: Thames & Hudson / New York: McGraw-Hill, 1972.

Murray, Peter and Linda. *Dictionary of Art and Artists*. Harmondsworth: Penguin, 1979. 4th ed.

Pevsner, Nikolaus. *Academies of Art, Past and Present*. Cambridge: Cambridge University Press, 1946.

Rheims, Maurice. *La Vie d'artiste*. Paris: Grasset, 1970.

Rudel, Jean. *Technique de la peinture*. Paris: Presses Universitaires de France, 1978.

Taylor, Joshua. *The Fine Arts in America*. Chicago: University of Chicago Press, 1979.

Theophilus, ed. C. R. Dodwell. *Diversarum artium schedula*. London: Nelson, 1961.

Vaisse, Pierre (ed.), *Dürer — Lettres et écrits théoriques*. Paris: Hermann, 1964.

Wittkower, Rudolf and Margot. *Born under Saturn*. London: Weidenfeld & Nicolson / New York: Random House, 1963.

Zervos, Christian. *L'Art de l'Epoque du Renne en France*. Paris: Editions du "Cahiers d'Art," 1959.

NINETEENTH CENTURY

Amaury-Duval. *L'Atelier d'Ingres: Souvenirs*. Paris: Charpentier, 1878.

Angrand, Pierre. *Monsieur Ingres et son époque*. Lausanne: La Bibliothèque des Arts, 1967.

Balzac, Honoré de. *Le Chef d'oeuvre inconnu*. Paris: Gallimard, 1970.

Baudelaire, Charles. *Oeuvres complètes*. Paris: Gallimard, 1961.

Beauté, Georges. *Il y a cent ans — Henri de Toulouse-Lautrec*. Geneva: Cailler, 1964.

Bellony-Rewald, Alice. *The Lost World of the Impressionists*. London: Weidenfeld & Nicolson / Boston: New York Graphic Society, 1976.

Bénédite, Léonce. *Meissonier*. Paris: Laurens, 1910.

Boime, Albert. *The Academy and French Painting in the Nineteenth Century*. London: Phaidon, 1971.

———. "Ingress et egress chez Ingres," *Gazette des Beaux-Arts,* April 1973.

Boyle, Richard. *American Impressionism.* Boston: New York Graphic Society, 1974.

Castagnary, Jules Antoine. *Les Artistes au XIXe siècle.* Paris: Librairie Nouvelle, 1861.

Clarétie, Jules. *L'Art et les artistes français contemporains.* Paris: Charpentier, 1876.

Clark, Kenneth. *The Romantic Rebellion.* New York: Harper, 1974 / London: Futura, 1976.

Delacroix, Eugène. *Journal.* Paris: Plon, 1932. 3 vols.

Delécluze, E.-J. *L. David, son école et son temps.* Paris: Didier, 1855. 5 vols.

Eitner, Lorenz. *Neoclassicism and Romanticism, 1750–1850.* Englewood Cliffs, N.J.: Prentice-Hall, 1970. 2 vols.

Elsen, Albert E. *In Rodin's Studio.* Oxford: Phaidon, 1980.

Gaunt, William. *Victorian Olympus.* London: Sphere, 1975.

Harper Mead, Katherine (intr.). *The Impressionists and the Salon.* Los Angeles County Museum, 1974. Exhibition catalogue.

Hawthorne, Nathaniel. *The Marble Faun.* New York: New American Library, 1961. First pub. 1860.

Honour, Hugh. *Romanticism.* New York: Harper, 1979.

Huyghe, René. *Delacroix, ou le Combat solitaire.* Paris: Hachette, 1964.

Joyes, Claire, Gordon, Robert, et al. *Monet at Giverny.* London: Mathews, Miller Dunbar, 1975 / New York: Two Continents, 1976.

Latour, Marielle (intr.). *L'Orient en question.* Marseilles: Musée Cantini, 1975. Exhibition catalogue.

Lethève, Jacques. *La Vie quotidienne des artistes au XIXe siècle.* Paris: Hachette, 1968. *Daily Life of French Artists in the Nineteenth Century.* London: Allen and Unwin / New York: Praeger, 1972.

Maas, Jeremy. *Gambart, Prince of the Victorian Art World.* London: Barrie & Jenkins, 1975.

Merson, Olivier. "Les Logements d'artistes au Louvre," *Gazette des Beaux-Arts,* 1881, 2e. période, vol. 23, pp. 266–270; 276–288.

Moore, George. *Confessions of a Young Man.* Montreal / London: McGill-Queen's University Press, 1972. First pub. 1888.

————. *Impressions and Opinions.* London: T. Werner Laurie, 1913.

Moreau-Vauthier, Charles. *Gérôme.* Paris: Hachette, 1906.

Nicolson, Benedict. *Courbet: The Studio of the Painter.* New York: Viking, 1973.

Rewald, John. *History of Impressionism.* New York: Museum of Modern Art, 1961. First pub. 1946.

Stanton, Theodore (ed.). *Reminiscences of Rosa Bonheur.* New York: Hacker Art Books, 1976. First pub. 1910.

Van Gogh, Vincent. *The Complete Letters.* Boston: New York Graphic Society, 1958, 1978. 3 vols.

TWENTIETH CENTURY

Apollinaire, Guillaume. *Les Peintres Cubistes.* Paris: Hermann, 1965.

Ashton, Dore. *The New York School.* New York: Penguin, 1979. First pub. 1972.

Bragaglia, Anton Giulio. *Fotodinamismo futurista.* Turin: Einaudi, 1970.

Cikovsky, Nikolai, Jr. "William Merritt Chase's Tenth Street Studio." *Archives of American Art Journal,* 1976, vol. 16, no. 2, pp. 2–14.

Cooper, Douglas. *The Cubist Epoch.* New York: Praeger, 1971 / Oxford: Phaidon, 1976.

Crespelle, Jean-Paul. *Montparnasse vivant.* Paris: Hachette, 1962.

Diamonstein, Barbaralee (ed.). *The Art World.* New York: Artnews Books, 1977.

Elderfield, John. *Matisse in the Collection of the Museum of Modern Art.* New York: Museum of Modern Art, 1978.

Feaver, William (intr.). *Frank Auerbach.* Zürich: Marlborough Gallery, 1976. Exhibition catalogue.

Fourcade, Dominique (ed.). *Henri Matisse: Ecrits et propos sur l'art.* Paris: Hermann, 1972.

Genet, Jean. *L'Atelier d'Alberto Giacometti.* Paris: L'Arbalète, 1963.

Glimcher, Arnold B. *Louise Nevelson.* New York: Dutton, 1976.

Grundy, Owen J. "This Vanishing Village," *Greenwich Village News.* November 18, 1960, p. 5.

Haverstock, Mary Sayre. "The Tenth Street Studio," *Art in America,* September / October 1966, pp. 48–57.

Hess, Thomas B. *Willem de Kooning.* New York: Museum of Modern Art, 1968.

Hughes, Robert. *The Shock of the New.* New York: Knopf, 1981.

Kramer, Hilton (intr.). *Brancusi: The Sculptor as Photographer.* New York: Callaway Editions, 1979 / London: David Grob Editions, 1980.

Leiris, Michel (intr.). *Alberto Giacometti.* Paris: Galerie Maeght, 1979. Exhibition catalogue.

Levine, Gemma. *With Henry Moore.* New York: Times Books, 1978.

Levy, Julien (intr.). *Arshile Gorky.* New York: Museum of Modern Art, 1962. Exhibition catalogue.

Lieberman, Alexander. *The Artist in His Studio.* New York: Viking, 1970.

Malraux, André. *La Tête d'obsidienne.* Paris: Gallimard, 1974.

McNaught, William. "Studios of Nineteenth-Century Artists," *Horizon,* February 1980, pp. 65–68.

Motherwell, Robert. *Reconciliation Elegy.* Geneva: Skira, 1980.

Namuth, Hans. *Artists 1950–1981: A Personal View.* New York: Pace Gallery Publications, 1981.

————, ed. Barbara Rose. *Pollock Painting*. New York: Agrinde, 1980. New ed.

O'Doherty, Brian. "Willem de Kooning," *Art International* vol. 12, no. 10 (December 1968), pp. 21–29.

O'Sullivan, Thomas. "Studios of Victorian Artists." *The Crayon,* Summer 1980, pp. 1–6.

Overy, Paul. *Kandinsky: The Language of the Eye*. London: Elek / New York: Praeger, 1969.

Paulhan, Jean. *Braque le patron*. Paris: Gallimard, 1952.

Penrose, Roland. *Picasso: His Life and Work*. London: Gollancz, 1958 / New York: Harper, 1959.

Peppiatt, Michael. "Francis Bacon," *Connaissance des Arts,* May 1981, pp. 40–49.

————. "R. B. Kitaj," *Connaissance des Arts,* September 1981, pp. 28–35.

Richardson, Anthony, and Stangos, Nikos (eds.). *Concepts of Modern Art*. Harmondsworth: Penguin, 1973.

Richardson, John. "The Ateliers of Braque," *Burlington Magazine,* June 1955.

Russell, John. *Braque*. London: Phaidon, 1959.

————. *The World of Matisse*. New York: Time-Life, 1969.

Scharf, Aaron. *Art and Photography*. Harmondsworth: Penguin, 1968.

Sylvester, David. *Interviews with Francis Bacon*. London: Thames & Hudson, 1980.

Warnod, Jeannine. *Le Bateau-Lavoir*. Paris: Presses de la Connaissance, 1975. U.S. ed., *Washboat Days*. New York: Grossman, 1972.

————. *La Ruche et Montparnasse*. Paris: Weber, 1978.

Index

Illustration Credits

page 158 Photo Henri Cartier-Bresson, Magnum Paris
159 Photo Sabine Weiss
160 Photo © Harry Holtzman. © SPADEM, Paris/VAGA, New York, 1982
161 Museum of Modern Art, New York
162 Photo André Ostier
163 Photo Roger Guillemot, courtesy *Connaissance des Arts*
164 Photo Michel Desjardins, Top/Rapho
165 Photo Hans Namuth
166 Photo Michel Desjardins, Top/Rapho
167 Photo Pascal Hinous, *Connaissance des Arts*
168 Photo André Ostier
169 Courtesy *Art News*
174 The Pennsylvania Academy of the Fine Arts. Bequest of Henry C. Carey
175 Collection Albany Institute of History and Art
176 top Copyright © 1980 by Jacob Burckhardt
176 bottom Copyright © 1980 by Jacob Burckhardt
177 Museum of the City of New York
178–179 Museum of the City of New York, lent by Miss Rosamond Gilder
179 right Archives of American Art, Smithsonian Institution (Downtown Gallery Papers)
181 National Archives, catalogue number 69-N-3179-C
182–183 Courtesy *Art News*
184 Courtesy *Art News*
185 Copyright © 1962 by Fred W. McDarrah, courtesy *Art News*
186–187 Copyright © 1978 by Hans Namuth
188 Courtesy *Art News*
189 Archives of American Art, Smithsonian Institution
190 Photo Pedro Guerrero

191 Photo Hans Namuth
192 Courtesy Jim Dine
193 Photo Hans Namuth
195 Archives of American Art, Smithsonian Institution. Photo Fred W. McDarrah
196–197 Photo Hans Namuth
199 Photo E. Youkilis, courtesy Helen Frankenthaler
202 Copyright © by Hervé Gloaguen, VIVA. © Andy Warhol
203 Photo Sabine Weiss
204 Photo Doisneau–Rapho
205 Photo Jesse Fernandez
206 Photo Pierre Matisse
207 Photo Pierre Matisse
208 Courtesy Marlborough Fine Art (London). Photo Peter Stark
209 Copyright © by Hervé Gloaguen, VIVA
210 top Photo Robert Descharnes, Magnum Paris
210 bottom Copyright © by Hervé Gloaguen, VIVA
211 Copyright © by Hervé Gloaguen, VIVA. © SPADEM, Paris/VAGA, New York, 1982
212 Photo Geoffrey Clements, courtesy Sidney Janis Gallery, New York
213 Courtesy Leo Castelli Gallery, New York. © Roy Lichtenstein
214 Copyright by Henri Cartier-Bresson, Magnum Paris
216 Photo Sabine Weiss
217 Photo Hans Namuth
218 Copyright © by Galerie Maeght. Photo Claude Gaspari
219 Courtesy Marlborough Fine Art (London). Photo Peter Stark
220 top Courtesy Gérard Fromanger
220 bottom Courtesy Ronald Feldman Fine Arts, Inc., New York. Photo Eeva-Inkeri
221 Courtesy Marlborough Fine Art (London). Photo Peter Stark